The Cineaste Interviews 2

on the art and politics of the cinema

The Cineaste Interviews 2

on the art and politics of the cinema

Gary Crowdus
Dan Georgakas

Lake View Press

Chicago

ISBN 0-941702-51-0 cloth
0-941702-50-2 pbk

Library of Congress Control Number 2002101158

LAKE VIEW PRESS

P.O. BOX 578279
1741 WEST FLETCHER STREET
CHICAGO, ILLINOIS 60657

CONTENTS

Acknowledgments *vii*

Preface *ix*

1 The Taviani Brothers: *We Believe in the Power of Cinema* 2

2 Jack Lemmon: *Spread a Little Sunshine* 10

3 Akira Kurosawa: *Making Films for All the People* 24

4 Lizzie Borden: *Labor Relations* 30

5 Robert Redford: *Combining Entertainment and Education* 40

6 Costa Gavras: *Keeping Alive the Memory of the Holocaust* 50

7 Krystyna Janda: *Woman of Marble* 60

8 Peter Greenaway: *Cinema as the Total Art Form* 70

9 Spike Lee: *Our Film Is Only a Starting Point* 82

10 Susan Sarandon: *Acting, Activism, and Hollywood Politics* 94

11 Sally Potter: *Demystifying Traditional Notions of Gender* 108

12 Arthur Penn: *The Importance of a Singular, Guiding Vision* 114

13 Mike Leigh: *I Find the Tragicomic Things in Life* 138

14 Francesco Rosi: *Investigating the Relationship Between Causes and Effects* 154

15 Tomas Gutierrez Alea: *Strawberry and Chocolate, Ice Cream and Tolerance* 160

16 Abbas Kiarostami: *Real Life is More Important Than Cinema* 170

17 Atom Egoyan: *Family Romances* 178

18 Gianni Amelio: *Beyond Neorealism:*
 Preserving a Cinema of Social Conscience 196

19 Marlene Gorris: *The Lighter Side of Feminism* 210

20 Tim Robbins: *Between Ethics and Politics* 218

21 John Sayles: *Borders and Boundaries* 232

22 Milos Forman: *Porn Again* 240

23 Oliver Stone: *History, Dramatic License,*
 and Larger Historical Truths 250

24 Fred Zinnemann: *A Past Master of His Craft* 262

25 Ken Loach: *The Revolution Betrayed* 276

ACKNOWLEDGMENTS

We wish to express our gratitude to those who have done the interviews in this volume. Sometimes the sheer logistics in getting an interview would have discouraged interviewers with less enthusiasm. In all instances the interviewers did enormous background research for their contribution(s), took care in shaping creative queries, and worked patiently with us through the final editing. That the majority of interviews not done by ourselves were done by individuals editorially associated with *Cineaste* for many years should not be surprising. These *Cineaste* stalwarts are Richard Porton, Cynthia Lucia, Robert Sklar, Dennis West, Roy Grundmann, Lynne Jackson, and Pat Dowell. These individuals also have often helped shape interviews done by others by providing questions, background, or editing. Brian Neve, a *Cineaste* associate, merits special attention for the liaison work he has done for us in England. Pat Aufderheide is another interviewer with whom we have had a long relationship and who has assisted *Cineaste* in innumerable ways. Michael Szporer, Lee Ellickson, Mikelle Cosandey, Marcia Pally, and Kyoko Hirano were freelancers who took on a subject of particular interest to them. Copyediting and fact-checking for this collection were done by Barbara Saltz. Our cover photograph is from *Una Pela Cubana Contra Los Demonios* (A Cuban Battle Against the Demons) and is from the private collection of Tomás Gutiérrez Alea, as is the photograph of the director. The photographs of Arthur Penn, Costa Gavras, Gianni Amelio, Jack Lemmon, and Milos Forman are by Judy Janda; the photographs of Sally Potter, Abbas Kiarostami, Atom Egoyan, John Sayles, Marlene Gorris, and Mike Leigh are by Robin Holland; the photograph of Francesco Rosi is by Cori Wells Braun; the photograph of Spike Lee is by Jesse Algeron Rhines; and the photograph of Tim Robbins is by Sam Jones. We also thank Warner Bros. for the use of the photograph of Oliver Stone, Photofest for the use of the photographs of Robert Redford and Susan Sarandon, and New Yorker Films for the use of the photographs of Krystyna Janda and of Paolo and Vittorio Taviani.

PREFACE

By Gary Crowdus and Dan Georgakas

Some thirty years ago as editors of a fledgling film quarterly dubbed *Cineaste*, we were thrilled that emerging filmmakers such as Costa Gavras and Bernardo Bertolucci were willing to sit down with us to discuss the how and why of the making of films such as *Z, The Conformist,* and *Spider's Stratagem.* We were sure that others who loved films as much as we did would be interested in reading what such filmmakers said about their work. We were also determined that these encounters could be more than the usual public relations goodwill session or journalistic chitchat. We thought of them as exchanges of lasting value, not unlike the interviews with novelists then appearing in *The Paris Review.* Although many years have passed since that time, and a variety of personalities have helped edit the magazine and do interviews, our self-imposed mandate to do quality interviews has not altered.

The interviews in the present collection were made in the 1980s and 1990s. As with our earlier collection which contained interviews done in the two preceding decades, these interviews fall into two broad categories. The first is a career interview dealing with an already acclaimed body of work. The second generally focuses on a single film and the cinematic and social contexts to which it relates.

Among the career interviews is that with Fred Zinnemann, which was made just days before his death and is likely his last public comment on filmmaking. Arthur Penn and Susan Sarandon also offer observations on a lifetime in film. Jack Lemmon and Krystyna Janda deal less with their own careers or the travails of acting than with the industries in which they did such outstanding work, the Hollywood that took shape in the 1950s and the Poland of the Solidarity Movement era. Akira Kurosawa, terse as a haiku poem, speaks about his work at a time when he had just released *Ran.* Atom Egoyan and Abbas Kiarostami speak about the films which first brought them to international attention. Tomas Alea in discussing *Strawberry and Chocolate* reflects on all the challenges facing Cuban filmmakers.

For many years, *Cineaste* has described itself as a magazine about the art and politics of the cinema. We see these categories as interacting with one another rather than being opposing or distinctive poles. Interviews revolving around a single film often bring out that perspective rather strongly. Going against mainstream political assessments are our conversations with Oliver Stone about the making of *JFK*. Feminist issues are probed in interviews such as those with Marlene Gorris on *A Question of Silence,* Sally Potter on *Orlando,* and Milos Forman on *The People vs. Larry Flynt.* Ethnic politics and ideology figure strongly in interviews such as those with Spike Lee on *Malcom X,* Gianni Amelio on *Lamerica,* and Ken Loach on *Land and Freedom.* The interviews with Robert Redford and Tim Robbins are distinguished by their account of trying to make socially relevant films in contemporary Hollywood. Another group of interviews are with filmmakers whom we have interviewed on more than one occasion. Our continuing dialog usually begins with a film that has recently been released but ranges over the filmmaker's entire work. Among this group are interviews with Costa Gavras, Lizzie Borden, Mike Leigh, Francesco Rosi, and Paolo and Vittorio Taviani.

As noted in the preface to our first collection, we regard interviews as a literary form. Our emphasis has always been on films and their impact on society rather than anecdotes about filmmaking. We avoid abstract ideology in favor of investigating how theories about film or politics are actually manifested in a particular film or group of films. We usually deal only with completed projects rather than proposed projects. While we recognize the importance of the latter for journalistic and even historic purposes, given that most film projects are never realized, we have opted to use the limited time and space available to us as a quarterly for completed films available to the general public.

Considerable effort has been spent on devising queries that would not be hostile or antagonistic but would nevertheless candidly probe controversial issues or projects that had failed in some important way. Through the years we have discovered that filmmakers have terrific radar in regard to judging the interviewer's intention. Once filmmakers are satisfied that the interviewer is well prepared on the topic and not pursuing some sensationalist agenda, they usually welcome even the most challenging questions.

No one believes that simply turning on a camera and making a print of whatever happens constitutes filmmaking. Similarly, we feel that tape recording a conversation and printing the transcript is not the same as shaping an interview. We treat transcripts as so much raw footage that needs editing before it can be presented to the public as a final cut. Comments from various moments in the interview are often consolidated into a single answer. Repetitions and some asides are cut, and all responses are honed for clarity. Grammatical errors of the kind that occur in speaking as opposed to writing are corrected unless this violates the manner in which the interviewee actually speaks. The sequence of

questions and answers is often changed to achieve greater continuity or effect. We frequently pare down the length of the questions. This is done to keep the emphasis upon the interviewee rather than the interviewer, on the response rather than the query.

Whenever possible, we return the interviews to the filmmaker for approval, changes, and additions. This is done to make the interview as factually accurate as possible and to faithfully reflect the thoughts of the filmmaker. In terms of controversial issues, we have discovered that when interviewees make changes, rather than soften their comments, they often make them sharper. If they have a point to make, they usually will do so in no uncertain terms.

We understand that other interview methodologies can be valid. A popular alternative format is to make the interviewer at least coequal to the filmmaker. The scholarship, wit, or personality of the interviewer becomes a key component of the exchange. Often the circumstances under which the interview are made or the difficulty in getting it are emphasized. This can result in an interesting exchange, but we have found that these situations often tend to have an obsequious quality about them in which the genius of all concerned or at least the trajectory of their careers becomes the guiding principle. At the other extreme there is sometimes an attempt by the interviewer to provoke the filmmaker into saying something scandalous.

Another sometimes interesting format is that which involves minimal editing. All the "ands," "ers," and "buts" that characterize the spoken language are retained. Parens indicate laughter or unusual movements, and the interview is presented almost verbatim. All this offers a kind of "interview vérité." Such an effort seeks to capture the energy of a good rap, the unique aspects of a specific time and place. While this can be rewarding sometimes or at least entertaining, more often than not, it is neither.

One major difference in the interviews in the present volume from our first is that we have focused exclusively on directors or on actors who mainly speak about the industry rather than the craft of acting. In contrast, our first volume included interviews with scriptwriters, producers, critics, and others in the filmmaking community. This change does not signal that we have come around to the director-as-auteur theory of film. Rather, the present focus stems from our plan to do three collections of interviews over the next three to four years. In this volume, we are concentrating on directors and the kinds of concerns directors deal with. In a forthcoming volume, which seeks to explore the collaborative nature of most filmmaking, we are going to include interviews with filmmakers who are not directors: cinematographers, composers, set designers, casting directors, scriptwriters, producers, and actors (speaking about the craft of film acting). A third volume will deal with the special needs of making a feature length documentary. Among filmmakers slated for that volume are Fred Wiseman, Emile De Antonio, and Barbara Kopple.

In the ongoing critical discourse about whether any one person should be regarded as the author of a given film, we believe that no one model explains all films. Directors, of course, are critical, as this very volume indicates; and, increasingly, the director's name precedes the title in the manner of the author of a novel. We believe this is sometimes merited, but often obscures the collaborative nature of filmmaking. One of our purposes in doing interviews is, in fact, to determine how the film or group of films under discussion was conceived and realized. How were the various elements of filmmaking brought together successfully, or, in the case of a failure, what went wrong?

We believe our interviews are part of an important data bank regarding the art of filmmaking. What filmmakers have to say about their work, what they thought they were doing, where they think they have succeeded and where they think they have failed is invaluable. Like any primary data, these first-hand accounts are not to be equated with veracity. Nevertheless, many assumptions about given films are quickly invalidated when one hears directly from the filmmakers, and new ways of considering that same film or a body of work may open. The stories told about the enormous challenge of making any film are sometimes hilarious, often amazing, and sometimes extremely sad. What always comes through is the wonder the medium of film can elicit. That wonder keeps us going to the movies and that wonder keeps us asking their makers the questions that begin to form as soon as the credits cease to roll and the screen goes black.

The Cineaste Interviews 2

on the art and politics of the cinema

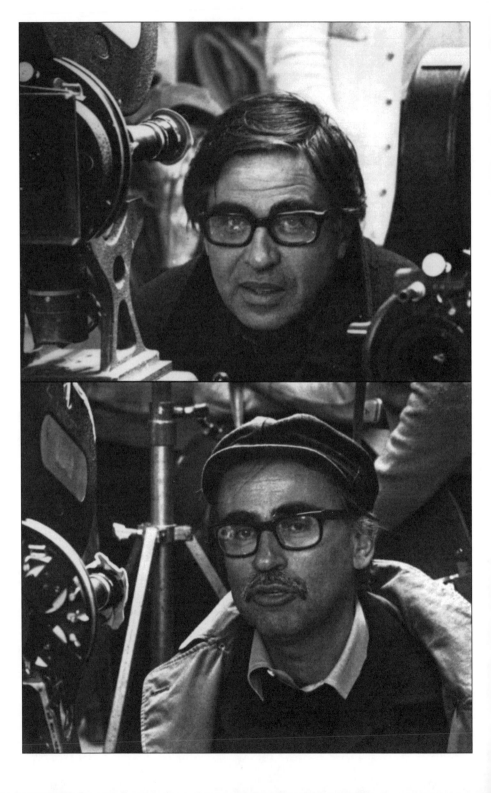

1 THE TAVIANI BROTHERS

We Believe in the Power of Cinema

The cinema of Paolo and Vittorio Taviani first came to public attention in the U.S. with the 1977 release of Padre Padrone, *which won the Palme d'Or for Best Film and the International Federation of Film Critics Prize at the Cannes Film Festival. The Taviani brothers were not exactly newcomers, however, since their film-making career had begun some twenty years before with a series of documentary films, including* Italy is Not a Poor Country, *coproduced with Joris Ivens. Their fea-ture-film debut came in 1962 with* A Man for Burning, *introducing Gian Maria Volonté in his first screen role. Subsequent features included* The Marriage Outlaws *(1964),* The Subversives *(1967),* Under the Sign of Scorpio *(1969),* St. Michael Had a Rooster *(1971), and* Allonsanfan *(1974).* Cineaste *editor Gary Crowdus spoke to Paolo and Vittorio Taviani during their visit to New York for the premiere of* The Meadow *(1979). Their conversation in Italian was simultaneously translated by Carolyn Heard.*

Cineaste: *As the children of neorealism, as so many contemporary Italian film-makers are, how do you define your relationship to that historic film movement?*

Vittorio Taviani: When we began our filmmaking career, we had just seen all the neorealist films by Rossellini, Visconti, and De Sica, so naturally they were a major influence. We were in high school in those days. Since we came from a small provincial town in Tuscany, we knew virtually nothing about cinema. We loved theater, musicals, and nineteenth-century melodrama. We went to Pisa from our small town of San Miniato to go to school. We had just gone through the trauma of World War II when one day we happened upon a film called *Paisan.* We saw this great trauma that we had gone through reflected up on the screen, and seeing these wartime experiences portrayed in Rossellini's film made us even more dramatically aware of what we had gone through. That day we decided that the cinema would become our life, and that is where our relationship with neorealism began.

Our first documentary was produced with Cesare Zavattini, who was De Sica's collaborator. When we started our first film, however, we realized that neorealism was degenerating. It had become an expression of petit-bourgeois, heavily naturalistic stories. So, when we embarked on our career in the cinema, we wanted to depart from neorealism, to make it react to something new and something old—the something old being the tradition of Shakespeare in the theater and Giuseppe Verdi in the opera, and the something new was to be something completely our own. In this sense, we felt as though we were burying a beloved father. Although this "father" is dead and buried, he remains a very strong influence in our memory.

Paolo Taviani: In postwar Italy, during the neorealist period, the feeling was that good and evil were two very distinct things which could clearly be distinguished from one another. As the years passed, good and evil became more difficult to distinguish from one another—they seemed to blend into one another. Those who came out of the neorealist movement found themselves constrained to find new instruments, new tools with which to express themselves, and that's how the cinema of the Sixties came about.

Cineaste: *In a sense, then, you have tried to reinvigorate neorealism, to infuse it with new expressive elements. How would you define the style you are trying to achieve?*

Paolo: Ours is a classic cinema that tends toward the epic.

Cineaste: *How important is Brechtian theory in your work?*

Paolo: Our cultural background owes a lot to Brecht, but we are also Italians and Neapolitans. Brecht played a great part in our background, but mixed in with the gesticulations, the entire tradition, of the *commedia dell'arte.* Brecht came from the North, and we grew up under the sun of the South.

Vittorio: We certainly have a relationship that's detached from and independent of Brecht, but in order to really detach ourselves we had to have been at first vitally involved with this tradition. Our films can be likened to a Scottish

shower, which begins hot and ends cold. Brecht's estrangement phenomenon, his *verfremdungseffekt*, became irony for us.

Cineaste: *Would you comment on your nonnaturalistic use of music and sound effects, which is such a striking characteristic of your films?*

Paolo: Vittorio commented earlier that we have been strongly influenced by the tradition of nineteenth-century music, so in terms of our film career, we were born musical. We feel that the cinema is the heir to this musical tradition. We have never considered music to be merely a commentary upon the image. Music has just as much narrative and expressive importance as a character. Let me give you an example. In *Padre Padrone* there is a religious procession where all the young men carrying this statue sing a German song, which makes them think of their future escape to Germany. The father and the other patriarchs are singing a very traditional religious song of Sardinia. A kind of struggle begins between the two songs, first one drowns out the other, and then vice versa, and finally the song of the young men is the one that dominates.

While we were filming, we took many close-ups of both groups, the old fathers and the young sons, and then finally we took one high-angled shot from above the field. But it seemed to us that the sheer use of music, and the struggle that was depicted in that music, illustrated better the point we were trying to make.

For some directors, cinema is another means of dramatic or narrative expression—for Visconti, narrative, for Pasolini, figurative—but, for us, the structure of a film is very close to the structure of a musical composition. I don't mean that we're trying to analyze a musical composition. We do cinema, but we make films in which music has a very definite weight. It has to transform itself into cinema.

Vittorio: I'd like to talk about sound effects in general. Sounds can be noises, voices, or it can also be silence. In *St. Michael Had a Rooster,* our protagonist remains isolated in a cell, in absolute silence for a good third of the film. Many years of solitary confinement await him. He decides that he wants not just to survive, but to live, so he decides to fill his cell with every kind of manifestation that reminds him of the reality from which he is isolated. During the course of the film, the cell is filled with the sounds of the sea, an evening spent with friends, a piece of music. We're very far from that cinema which is similar to the theater as a form of narrative expression.

Cineaste: *At what point do you conceive of the sound effects to be used in your films? During the scripting, on location, or during the editing?*

Paolo: When we write the script. We meet with the composer first and decide together where the music and sound effects will enter in each scene. When we were writing the screenplay of *Under the Sign of Scorpio*, we listened over and over to Stravinsky's *The Rite of Spring*. When we finished the film we used a completely different piece of music, but the film's structure is actually the same as that piece by Stravinsky.

Vittorio: Do you remember the scene in *Allonsanfan* where Fulvio wakes up in his father's home? The piece of music in that scene—the "dirindindin" chorus—

was really the point of departure for us. Listening to that music made us conceive of the way the scene would go. We conceive of many sequences in our films as the function of a particular song or piece of music.

Cineaste: *Almost all your films involve formal experiments of one sort or another. In this regard. which of your films do you consider the most successful, and why?*

Paolo: Each film is an adventure that we confront with enthusiasm, otherwise we wouldn't do it. In regards to the use of cinematic language, *Under the Sign of Scorpio* was extremely important for us because it represented the desire to invent everything. 1968 had a particular cultural climate in which many of us were projecting ourselves towards the future, forgetting that which was past. Many films made during that period—Marco Ferreri's *Dillinger e Morto*, Bertolucci's *Partner*, Bergman's *Persona*—were looking for something new in language. Likewise, in our film *Under the Sign of Scorpio* the question of language is a vital element, and it is a constant provocation for the public. We, of course, cannot say if the result was successful. but that's what motivated us to make that film.

Vittorio: The film that we consider most successful is our latest film, *The Night of the Shooting Stars*. In *Scorpio* the language was deliberately provocative, but in our other films the elements are somewhat more harmoniously blended. It's very difficult, though, for us to say which experiments are the most successful.

Cineaste: *Are you concerned about being too avant-garde, being too far ahead of your audience?*

Vittorio: We always keep the audience in mind, but we never make any sacrifices for the sake of how we think the audience may react. We are on our guard sometimes when we feel that our research into new forms of linguistic expression may be somewhat over the heads of the audience. When we conceived and wrote *Padre Padrone*, we kept the public in mind. Distributors told us time and again that we were crazy to be making a film of this nature, that nobody would go to see it. It's very difficult to determine what the public can or cannot accept. Today we feel that it's important for us to achieve great clarity and great simplicity, but without giving up any audacity.

We intend our films for a public that searches, whether it's in Italy, Germany, or Africa. There are audiences for our films in all those places. For us, there is no unimportant audience. If an audience is looking for something new, then our films will help this audience in its search.

Cineaste: *Many of your historical films have contemporary political implications, but why haven't you made more films on contemporary Italian society?*

Vittorio: Filmmakers will always use their own tools in order to express themselves in any film. We can speak of the past as we speak of the present, and many times when we speak of the present the result is a film that is already passé. Renoir's 1938 film on the French revolution, *La Marseillaise*, is one of the most significant films of that period in terms of understanding what was really going on then. Likewise, even though our film *Allonsanfan* is a period piece, it makes clear references to the situation in Italy today. The film is set in the nineteenth

century, but the reactions to it were very strong. The film's ideas were communicated very well. We sometimes like to set the story in a historical period in order to achieve a detachment, to get away from a direct involvement with contemporary situations. Our first two films, however, *A Man for Burning* and *The Subversives*, take place in the present. *The Meadow* is also a film of today.

Cineaste: *What sort of statement did you intend to make in* The Meadow?

Vittorio: After having made *Padre Padrone*, which portrayed a young person's dramatic achievement, we felt the need to turn our attention to the subject of young people who were not able to achieve their dreams. The young people in *The Meadow* live, as it were, split in two. Each of them must take a job that does not correspond to his or her ideals, because society does not allow them to do so. They are characters who have to live in a schizophrenic way. Beyond this very painful contradiction, there's another even more personal one. In love and in their personal relationships, they're trying to apply a certain way of life for which they are perhaps not yet ready, so they have this sense of disappointment, confusion, and profound melancholy. When Giovanni commits suicide, for example, he does so not in order to negate something, but in order to affirm something that is denied him by others, in order to affirm his right to deny that which others deny him. Do you understand?

Cineaste: *Yes, but I don't know if I buy it. The impression left by the film is that he has simply succumbed to the despair of his personal situation.*

Vittorio: But in the totality of the film it's an affirmation of the injustice of the fact that young people feel constrained to give themselves up to the despair that you speak of.

Paolo: Perhaps it's not right to lay all of the significance of the film on the finale. Vittorio was speaking of the film in its entirety, including the film's pied piper sequence, which should represent the recapturing of the right to happiness. If this sequence communicates the possibility of this harmony, this happiness, it in a way mitigates the pessimism. During the film, for example, Eugenia says that she believes in happiness, and the other characters, too, show that they believe in happiness. Happiness is not obtained, however, because of the social structure and certain circumstances of reality that constrain them. Nevertheless. the consciousness, the awareness, of the possibility of this happiness should always remain. Even if the story itself is full of melancholy, the film in and of itself should not be. The film finds its significance in its language, for, if one thing is certain, it is that we still believe in the power of the cinema.

Cineaste: *Speaking of interpretations,* Allonsanfan *is a devastating critique. It's almost a satire, at times, of a group of well-meaning but hopelessly naive revolutionaries. Is it possible, however, that some might interpret the film not just as a critique of this particular group's political strategy, but, beyond that, of the futility of revolutionary hopes altogether?*

Vittorio: We hope not! [laughter] The audience should see the film as an argument for the need for patience while making the revolution. It's also

important to consider the historical period in which the film takes place and the reality in which we live. *Allonsanfan* is set in the Restoration. How do the revolutionary groups react during this period? On one hand, we have a group of young revolutionaries that is going toward a future that is too far into the future. On the other hand, we have Fulvio's escape into the past, a going backwards, and, in the middle, we have Allonsanfan and utopia. Utopia is the only winning element in the film, and it is that which punishes Fulvio, and that which gives Allonsanfan the strength to go back into his dream. And it is that desire for utopia which inspired us at the end of the film to write "Allonsanfan" in big letters and to underline it with the music.

We screened the film at the University of Turin and afterwards had a long discussion with about 2,000 young people. "In making this film," they asked us, "what were you advising us to do? How do you propose that we go about achieving this utopia that we're all looking for?" We answered them, as we answer today—a film does not give out messages or solutions, it only asks questions of our time. As we leave the cinema, we must ask ourselves what to do and look for the solutions. If the question has moved you so much, something must come about as a result.

Cineaste: *I believe that the Italian cinema is one of the best in the world. It's also one of the most political. Why do you think that's so?*

Vittorio: In the U.S. politics has a completely different meaning than it has in Italy. Italians are very, very politicized. Everyone has political opinions. Politics is not something that's apart from the average Italian citizen. I would say, however, that this is losing some of its momentum, that it's diminishing somewhat. There's a certain amount of cynicism setting in among the Italian populace. It's a great crisis, one involving the questioning of values, many hopes that were never realized, myths that have fallen forever, a very difficult economic situation, a time of flux.

Cineaste: *How do you define your own politics? Are you members of any organization?*

Vittorio: We are Communists.

Cineaste: *One final question, a question that surely you have been asked a thousand times before. How do two people direct a film?*

Vittorio: Filmmaking has always been a collaborative effort. There is the screenwriter, the director. the assistant director, camera people, set designers, make-up artists, and so on. What is perhaps unusual in our case is that there are two directors. We like to think that each of us is one-half of a neurosis coming together to make a complete neurosis.

Actually, first one of us directs a scene, then the other takes over. It's extremely scientific, and much more difficult to describe than it is to do. We work very well together, we're very efficient, and, in fact, a working day goes by much more quickly with the two of us directing. While one of us is working on one shot, it means that he has taken command and everyone in the crew must follow his orders, and the other one remains silent. Then we find

that when the command shifts to the other one, he's very fresh, invigorated, and energetic.

In order to understand why we work so well together, we did a horoscope. He's a Virgo, and I'm Scorpio, so we're opposite but complementary signs. The day that we cease to complement one another will be the day that we take up knives against one another.

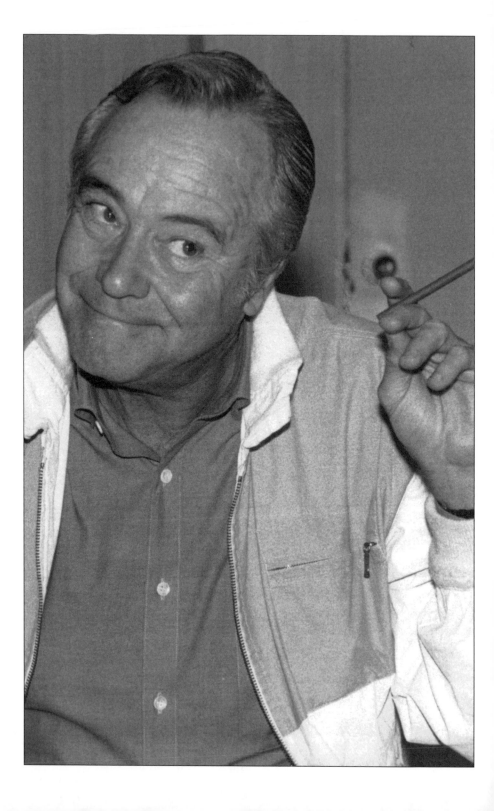

2 JACK LEMMON

Spread a Little Sunshine

Jack Lemmon is one of America's most versatile and accomplished actors. He has been nominated eight times for Best Actor or Best Supporting Actor by the Academy of Motion Picture Arts and Sciences (only two other actors have received as many nominations: Sir Laurence Olivier and Spencer Tracy) and he has won once in each category, for Best Supporting Actor in Mr. Roberts *(1957) and Best Actor in* Save the Tiger *(1973). Although best known early in his career for comedy roles in films such as* Operation Madball *(1957) and* Some Like It Hot *(1959), his Academy Award-nominated performance in* Days of Wine and Roses *(1962) established Lemmon's credentials as a dramatic actor as well, and he has since successfully alternated between comedic and dramatic roles.*

*In December 1985, Lemmon accepted an invitation to attend the 7th annual Festival of New Latin American Cinema in Havana, Cuba, where three of his films—*Missing, The China Syndrome, *and* Some Like It Hot*—received special screenings. During his one week visit, Lemmon met with Cuban filmmakers and other artists, as well as Cuban President Fidel Castro, and, before a standing ovation from an audience of over 5,000 at the Karl Marx Theater, Lemmon received a Life Achievement Award from the Cuban Film Institute. During the festival,* Cineaste *editors Gary Crowdus and Dan Georgakas spoke with Lemmon, whose interview below also incorporates responses to questions posed at a festival press conference.*

Cineaste: *What would you like the American people to think of your visit to Cuba?*

Jack Lemmon: Coming here, and fortunately having been joined by Bobby De Niro, Treat Williams, Chris Walken and Harry Belafonte, I do hope that it will have a beneficial effect on our fellow citizens in making them realize that there should be a cultural exchange between our countries, an interchange between people that could help ease whatever tensions exist. I am no political pundit, but just as a human being it seems very logical to me that people cannot begin to really understand one another if there's a complete absence of rapport. Otherwise, why have a summit meeting. There was Gorbie and Ronnie, so now there's Fidie and Jackie!

Kidding aside, I'm basically here because I was invited, and I'm honored and privileged to be here, but I truly do hope that it has more of an effect than just for me. I would like more people to realize that we should be doing this all over the world, to get as close as we can to each other. Something like this transcends politics; it has to do with people.

Cineaste: *Do you think there will be any negative response in the U.S. to your visit here?*

Lemmon: As far as my trip here having any negative repercussions in the U.S., I think there will always be a handful of people in this country or in the American press who are extremely conservative in their politics and who might criticize my coming here, but I think it's inconsequential. It is inconsequential to me personally, and it's absolutely unimportant compared to the importance of my being here.

Cineaste: *Early in your career you were known only for light comedy roles, but since then you've been successful in a broad range of dramatic and comedic films.*

Lemmon: One of the difficulties for an actor in the American film system is typecasting. My first few films happened to be comedies, and *Mr. Roberts*, which was my third or fourth film, was extremely successful, so the problem was that from that point on everybody thought of me only as a comedic actor. It was quite a while before I could get a good, serious dramatic part. *The Days of Wine and Roses*, which was the story of an alcoholic, was the first one, and it fortunately helped make people think of me in terms other than comedy. For some years now people have thought of me for both comedic and dramatic roles, but usually you get locked into one or the other. Another problem is that all too often in theater and in film, we forget that both comedy and drama are inevitably intertwined in our day-to-day life. In American films, in particular, there is a tendency to label films either as drama or comedy when, in essence, there is no reason why both cannot exist in the same play or film and still be very legitimately depicting life. That's why I admire films that combined the two, such as Billy Wilder's *The Apartment* or, more recently, *Tribute*. In life, as we all know, no matter how dire the circumstances, funny things do happen and if we didn't have some humor in our lives, I think we'd all go crazy.

In this regard, I felt that *Tribute*—which I did as a play first, then as a

film—was an exceptional story because it dealt with a character who suddenly finds out in middle age that he's got cancer, which is possibly terminal, and in facing that problem he relies to a great extent on humor. I was pleased because after people had seen the play or the film, many told me that the character I portrayed had influenced the way they faced that particular problem. *Tribute* also dealt with the generation gap between a young man and his father who are able to eventually reconcile their different points of view and restore the love they once had. I felt that overall it was an entertaining film that also had something to say.

Cineaste: *Comedies do not always have to be escapist, do they? Is it possible to make social statements in comedy?*

Lemmon: Yes, and I think one can and should make points with comedy whenever possible. For some peculiar reason, people will remember a point made with comedy even more readily than they will a point made with drama. I also believe, particularly in this day and age, considering the world problems that we have, that any time we can laugh it is a great benefit. Obviously, I love drama and comedy both, but I must admit that there is a great personal satisfaction in being able to bring some joy to people through laughter. One of the last things my father, whom I adored, said to me before he died about twenty years ago—and I don't mean to be maudlin—but he was very ill in the hospital, and one of the last things he said to me was something that he had often said to me. He looked up at me, smiled, and said, "Spread a little sunshine." Basically he was saying, give a little joy, and actors are fortunate enough to be in a position to do it.

Cineaste: *You must be pleased, then, that in addition to* Missing *and* The China Syndrome, *the Cubans are showing* Some Like It Hot *here this week.*

Lemmon: One of the things I find gratifying is that, after twenty-five years, *Some Like It Hot* is still extremely popular not only all around the world but in America, too. Billy Wilder, its writer-director, is very close to me as a friend, and I consider that film to be one of the best written and best directed farces that I have ever been fortunate enough to be in, or to see. I just wish I could find another one like it!

Cineaste: *How do you account for your ability to successfully play such a broad range of roles?*

Lemmon: When I was at Harvard, I regretted that there were very few courses I could take in the performing or creative arts, which is what I wanted. However I think that the general, broad education that I got, and the opportunity to be with so many people from different parts of the world and from different backgrounds, was very beneficial to me as an actor later on because it exposed me to different ways of thinking. It gave me a broader point of view when I would approach different characters. In general, I have been attracted to contemporary parts and, as a result, I use my own personal experiences in life or my observations of other people to help me arrive at the characterization.

Right after Harvard, during my early days in New York, I took any kind of

a job I could get. At one little night club where I worked I had about seven jobs at the same time—I was the full orchestra, which meant playing on one little piano with only half of the keys working, and I was also the headwaiter and the bouncer—that was not very easy because I weighed only about 148 pounds.

The greatest benefit really came in the early days of live television, although I don't think any of us actors realized it at the time. There were no TV stars yet because the industry was too young, and, as a result, once you began to become known and were able to get parts, you might get five lines one week and a hundred lines the next. You also got a wide variety of parts, from broad comedy to heavy drama and, in looking back on it, I think that is one of the reasons why I was able later in film to play both comedy and drama.

I used to do a TV show, for example, called *The Ad Libbers*. There were six of us—four guys and two gals—with Peter Donald, who was a darn good M.C. at that time. We were in a little theater in New York, everything live, of course, with three cameras and an audience. Peter would pick out two actors and we'd go out to center stage. Then Peter would point to someone in the audience who'd stand up and just say a line—"Close the door" or whatever. One of the two actors then had to turn to the other and say that line, and the two of them went for three minutes and made up a scene, dramatic or comedic, hopefully comedic, because a red light went on in the foots when you had thirty seconds left and you'd better end funny. Well, some of the scenes were wonderful and others were . . . oh God, it was the tortures of the damned, you know, when it wasn't going right and you didn't get on the same wavelength, but it was invaluable.

Cineaste: *How would you describe your technique as an actor?*

Lemmon: Usually I work from the inside out. In other words, I think it's very easy just to learn the lines, but it really isn't as important what the character says as why he says it—in other words, what truly motivates him and the way he thinks. Once you understand the character, then the way he moves, the way he looks, his attitudes, the way he dresses, all of those surface mannerisms, are the last things. Sometimes, however, you can work from the outside in. Laurence Olivier has said he very often does that. It's a dangerous way of working because I think sometimes you end up with a caricature rather than a true character. In *Some Like It Hot*, for example, I did work from the outside in because I felt that how the character moved and looked, the external behavior, was very important, so I worked for about a week in front of a mirror with the makeup and wigs. I remember working for a few days just with lipstick, finally coming up with those bee-stung lips, because I wanted to create a certain look whenever he, or she, smiled. Once I'd achieved how I wanted the character to look, then inside I would make the character behave in a particular way to get that result.

Cineaste: *What appealed to you about* Missing?

Lemmon: *Missing* is a film that was, and still is, very dear to my heart because, now and then, if an artist is fortunate, he may be involved in a film or a play which can go beyond just entertaining an audience and hopefully can also

enlighten them. In the case of *Missing*, I felt that it had something very important to say, but, at the same time, I felt that it was a wonderfully written, dramatic, intelligent, literate piece of work. On top of which it was being directed by Costa Gavras, and therefore I knew it would be tasteful and, artistically, extremely well done. I was extremely proud to be a part of it. I also felt that another important element was the fact that it was not fictional, it was a true story, and one that should be known not only throughout the world, but especially by all the citizens of America. Possibly the most important thing about *Missing* is that it is a film that criticizes alleged behavior of our government, but it was made in America and with no restraints—and I know for a fact that has deeply impressed peoples of other countries that do not have such freedom of expression.

Cineaste: *Is the director an important consideration for you in deciding which film to do?*

Lemmon: I think especially in film that it is vital to work with the best possible directors. No matter how much experience an actor may have had, in film the director is in more control than in any other medium. Unlike the stage, if a film director insists on your playing a scene a certain way, that is it. It is impossible to change the performance on the next show or the next night as you can on the stage. Also, if the director is not a good editor or doesn't have a good editor, your performance can be ruined. I have always been extremely conscious of that. When I've decided that I want to do a film, the script is the most important thing, but most certainly I would also be very influenced by who the director was.

Cineaste: *What kind of research did you do for your role as Ed Horman in* Missing?

Lemmon: The only thing I could do with Ed Horman was to make sure that I didn't meet him, and I'll tell you why in a second. I tried to do all the reading I possibly could and to talk to people who knew a hell of a lot more about it than I did. Like most of us, my recollections of the whole overthrow of Allende were only what I read on the front pages of newspapers, which was hardly anything more than the surface. Other than that, I approached it precisely as if it were not historical and was totally fiction, and that's why I didn't want to meet Ed Horman. If he had been a known quantity, as an actor you've got to pick up mannerisms, the voice, the looks, and so on—like Greg Peck playing MacArthur—because people know the figure. But Ed Horman provided me a liberty. I could approach him and make my own character as far as mannerisms, speech patterns, and so on, so I didn't want to meet him and get locked into something. I wanted that leeway to create my own character, because it didn't mean I wasn't playing the real Ed Horman, it was my interpretation of the character and the way he felt and thought. So the rest, aside from the research I could do, depended on the script and my lengthy discussions with Costa, who, of course, did know Ed Horman. But I didn't want to impose on myself the way Ed would walk or look or talk, any of the exterior things. After I met Ed, I was pleased because as I got to know him, I did feel that the man I was portraying

was hopefully very much like him personally, and that made me feel good. There's a certain contained dignity about that man and a rock solid honesty about him, a directness and a simplicity.

Cineaste: *What did Ed Horman think of the film?*

Lemmon: It was really interesting to be with him towards the very end of the production, which is when we first met, through the development of the film into its final form, and then all the previews and openings. It was another whole emotional experience for me to be with Ed and Elizabeth because it affected them deeply. They were very emotionally involved, and they loved the film itself, every bit of it. We became very close and, to my knowledge, there's nothing in the film that Ed quarreled with at all, that he felt wasn't as honest as he had been in his mind.

After all the various screenings and openings, we all ended up at the Cannes film festival. I've forgotten the number now, but Ed must have been seeing it for the thirteenth or fifteenth time. We were in the front row of the balcony at the Palais, and Ed was sitting in the row right behind us. After the film ended, the lights went up, the whole bloody audience stood up, looked back at us, and started a terrific ovation. It was very moving, and as I stood up, smiling, and looked back at Ed and Elizabeth, Ed was still sitting there with tears streaming down his face. It's been an emotional experience that's been very dear to me. What it has done for Ed, which is really terrific, is to have accomplished tenfold what he was trying to accomplish with the lawsuit. What he wanted out of the lawsuit was not a dime, what he wanted was for people to understand that something like this could happen.

Cineaste: *How did you approach the character in* The China Syndrome?

Lemmon: For the engineer in *China Syndrome* I had to do a lot of research. I have personally been very involved in the antinuclear movement, but that was different from playing an engineer, so I did as much there as I could, talking to guys from a technical point of view, and all through the film we had an advisor. It wasn't as if I could walk in and do even a menial job without training—and we know what happens even when they're trained!—but I did as much as I could.

It was a fascinating part because I've never had a part that was technically so involved in the character's work, his profession, and one of the things that fascinated me about the part was to see if I could pull that sucker off and keep people interested. It's fascinating because, I swear to you, for about the first fifty percent or so of the script, over three-quarters of that man's dialogue is unintelligible to the average person, it's so technical. But somehow we have to understand the problems that he's going through and know the dangers involved, so it was a terrific, very exciting thing for an actor to make that technical stuff dramatic. It was one of the attractions of the part for me.

Cineaste: *There was a lot of propaganda against the film from the nuclear power industry.*

Lemmon: There was a lot of subterfuge going on, they were undermining us before the film was even finished. At a couple of plants where we shot, they

booed us when we walked in, screaming at Jane and calling her a commie, because they already knew what we were doing. There's always a reaction from the fringe that you expect, but I have found that when you do a film that may be controversial, if the film is good, you really don't get a heck of a lot of back-lash. On the other hand, I think we would have been in trouble if the film had been overloaded in trying to sell you the point of view as opposed to entertaining you with a hell of a strong dramatic story, with its point of view as the icing on the cake.

Cineaste: *We are criticized a lot on the left for supporting that particular approach.*

Lemmon: If you can get people into the theater and hold them dramati-cally, then I think they'll listen and at least think. I don't think it is necessary for a film to have a political, social, or economic point of view. Primarily a film should entertain; in other words, it should be on the highest possible level of cinematic art. The wonderful thing is that sometimes you can combine the two, as in the case of *Missing* or *The China Syndrome*, and that brings a level of craft up to a level of art.

When one thinks about it, a truly outstanding work in any art form will always have a point of view. I don't think there's a great novel or poem or painting that will not upset somebody and have people disagreeing with it because it does have a point of view. A feature film is not supposed to be a docu-mentary, however, and I don't think you should make a film just to carry a message. I think that primarily it should exist within that craft as a work of art and then, secondarily, make its points.

When you can combine art and politics successfully, then I think you can move people, you can touch them, and you can enlighten them by making them think more or make more people aware of something they might not have been that aware of if that film had not existed. It isn't even that important that everybody agrees with you—because who says I'm right or right enough that I'm supposed to influence everybody?—but even if people just think more than they would otherwise, that's terrific.

Cineaste: *You've frequently put your money where your mouth is by appearing in films at a lower salary than you were able to command or, as you did for* Save the Tiger, *at no salary, in favor of a deferred percentage of the box office gross. Do you think more serious, worthwhile films could be made in Hollywood if more actors took that approach, or do you think the problem is just a basic lack of good scripts?*

Lemmon: Well, both. I don't think that good scripts have ever been that easy to come across, even in the days when it was easier to get films made and more films were made. A good script never comes that easy—writing is the hardest and the loneliest of all the creative crafts. Another problem is that the studio heads back away from all the films we've mentioned so far because they don't seem to have any built-in ingredients that would ensure the box office return. They want the built-in ingredients, but they don't know what they are. Nobody knows.

Cineaste: *Not even bankable stars like Jack Lemmon?*

Lemmon: It won't do it. There are maybe only a few like Stallone or Eastwood, but not Lemmon alone. In fact, I don't think there are any of us at the moment who can guarantee that you'll make your money back. You can improve your chances but there is just no guarantee. There is now such a shrunken, solid core of moviegoers that unless you get good word of mouth, helped by reviews and so forth, they're just not going to go on a huge scale like they used to. The days are long gone when a studio could literally tell you in advance what their profit on a picture was going to be—you know, if we have Gable and Tracy in a film, we'll make $7 million, which then was like $100 million.

Cineaste: *How were you able to get* Save the Tiger *made?*

Lemmon: That film would not have been made were it not mainly for Bob Evans, and also Frank Yablans. That script was turned down for two solid years, and I never thought it would be made. Everybody in the studios kept saying that it had no appeal. Just as they had with *The Days of Wine and Roses*, they all admired the script and said, "Yes, it's great writing and the writer will probably win the Academy Award. In the meantime, whatever it'd cost, forget it, because that money will go right down the drain, it's not going to make a penny."

Bob Evans finally came to Steve Shagan, who wrote the picture, and said, "OK, I'll tell you what. I don't honestly think that picture is going to make one red cent, but I think it should be made, so here's a million dollars. If you can do it for a million dollars, OK. Anything over that, you guys are responsible for." *Save the Tiger* cost $1,000,280.00. We were responsible for the $280 over the million, but Bob Evans said, "Well, I think we'll pay it."

The astounding thing is that we rehearsed for two weeks with a full cast and shot from page one straight through in sequence and kept all the actors on salary. That was the only way you could keep them, because after rehearsals they may not work for another four weeks. We did it for a million bucks, and I would not have wanted to have seen ten cents more production on the screen— we had everything that we needed. It was John Avildsen's first crack at a big feature—mainly he had done films like *Joe*, which he said he did for under $250,000—but the man knew how to shoot fast, to get the takes and not waste film. It was just one of those things where we had the right people, a really terrific company, and everybody was excited.

Cineaste: *How was the film finally received? Do you think that critics and viewers were able to see beyond the film's surface pessimism and appreciate its concern about the false values so many of us must live by?*

Lemmon: Yes, in fact, I'm aware of several fist fights that broke out in theater lobbies afterwards between guys who were either so for the film or so against it, because it hit too close to the compromise that guys feel they must make and that they will defend. The studio heads had always said that only a small cult of people who'll think it's great would go to see the film, but that the kids would never go to see it. They were wrong, thank God, because what happened with the word of mouth is that the younger viewers comprised the biggest part of the audience eventually because they were looking at their

father. They may not have liked it, but they understood. I can't tell you the mail that I got on that picture.

Cineaste: *You have said that you find a role particularly challenging when, on first reading the script, you don't know how to play it.*

Lemmon: Yes, because I think if you feel that you've already played that character, or important aspects of that character, there's not that much point in doing it again. It would probably be difficult, for this actor at least, to get the old adrenaline going because there's not that much to search for or to find, there are no revelations to come upon and you're certainly not going to stretch yourself. In general that's what interests me in approaching a part.

Cineaste: *You've said that you think Walter Matthau is one of the best actors you've ever worked with because he acts with you and not at you.*

Lemmon: I think that a lot of actors, including some good ones, don't really act with you. I'm not saying that I do it myself all the time. I know I do it some of the time, and that's when the scenes are the best. It isn't that easy to act with somebody—I mean real, pure acting—and when it happens it's not just because of me or my talent or anything else, it's because of the combination of two people. Very often when I have done a scene, I'll think it was terrific because it felt good, but that doesn't mean the audience is going to feel it. On the other hand, sometimes the best scenes have been when I've said, "Oh God, let me do another take," but, sure enough, when we look at the rushes, the director will be right. I felt better in the other take, but it wasn't as good.

There are times, however, when I've done a scene and it not only felt right but it turned out to be right, and in retrospect I have realized that with the other actor during that scene I was totally unaware of cues. I spoke when I felt and all I was thinking of was the point I was trying to make. I never thought of my words and I never thought of listening to a cue. I was listening honestly to that other person—I was not playing the scene, but doing the scene. I was in the scene, that's the big difference. It doesn't always happen—in fact, most of the time it doesn't happen —but Walter can really do it. We're on the same wavelength, anyway, we're very close, so it's terribly easy to work with Walter, and that helps.

Cineaste: *In that regard, do you think that was one of the secrets of the old Hollywood studio system when you played with the same people in several films and, after a while, there was an unconscious cuing in to each other?*

Lemmon: Yes, absolutely. With that idea in mind, let me tell you about a picture I just did called *Crisis*—I don't know if that's the final title or just a working title—produced and directed by Blake Edwards. Julie Andrews plays my wife, Chris Lemmon plays our son, and the two Edwards daughters play our daughters. You want to talk about nepotism, this is the ultimate! Felicia plays a gypsy fortune teller who seduces me, and I think our maid is in there somewhere, I don't know. Anyway, it's the best home movie I've ever been involved in.

What we really did was get that nucleus together, plus some marvelous character actors, and we wrote the script through improvisation in rehearsal.

Blake had very sound reasons for wanting to use us as a family, however, because you don't go spending a few million dollars just to have fun with your kids. If I'm going to do scenes with Chris, who is supposed to be my son, I've got a big head start because he is my son. I know him, I really know him, and I think it will show on the screen. The same goes for the daughters, because we became such a close-knit little group with such good rapport that I think it will help enormously.

Cineaste: *Is this the first time you've extensively used improvisation in a film?*

Lemmon: Yes, I've never done it in a film before. I'd not done improvisation, in fact, since the old days of live TV, but it came back to me like swimming, and it was exciting as hell. We all know each other and we'd all had some experience in doing improvisation because, as I explained earlier, it can be wonderful or it can just be a total shambles.

Blake would very often shoot with two cameras because each scene would be different. We would block a scene, but not totally because you never knew what would happen. Something might suddenly happen in a scene with somebody and we'd go with it, but as long as you've got two cameras on it, you can cut, otherwise you're going to have trouble matching. We would always shoot on videotape first and run that back through rehearsals after each take to get an idea of how it went. I'm pretty excited about the film. I may be crazy, but I think it may be very good. I really do.

Cineaste: *We understand that you met Fidel Castro last night. What was that like?*

Lemmon: That was one of the wildest, most wonderful experiences for my whole family and me. We sat in an area like this, with about ten or twelve people around a table, and for about three and a half hours we just talked. It was something else. He is one of the most charismatic people that by far I have ever met, or will likely ever meet, in my entire life. He is enormously attractive, bright, with incredible recall and knowledge about anything and everything. I mean it was not a big political discussion at all. His sense of humor is incredible—there is not a standup comic in the States who can work a room like that guy. Nobody even comes close. Milton Berle would salivate! I mean, he is a genius at it.

The wonderful thing is that he loves to talk, and he knows he's good at it, but he genuinely enjoys it. If he asks you a question and you answer in one sentence, but you happen to go on for a while, he will never interrupt you, never stop you, but will look at you and listen until you are through. He is a very unusual man with incredible qualities. I really felt privileged. The talk was totally apolitical, thank God! I was in the presence of a very unusual man, the likes of whom you may never meet. It was really just a great experience. It's my fond wish that there would be a few more political leaders, on both sides, who could communicate like him, because I think we'd get a lot done, I really do.

Cineaste: *Do you think that President Reagan is aware of your visit here?*

Lemmon: I'm reasonably sure that President Reagan knows I'm here, and, more than reasonably sure, I'm positive that he will know I have been here.

I would like to relate one story about President Reagan. As fellow actors, I had known him for quite a long time before he became President. We were not friends, I did not know him that well, but we knew of each other. Now, in case no one knows it, President Reagan is a Republican and I happen to be a very staunch Democrat. But I must say that, as critical as I may have been of him very often in the past, he did one thing that I admire him for very much, and it was purely personal. When *Missing* came out, it caused a big commotion and created a great deal of controversy in the U.S. For the first time in the history of American film, in fact, the State Department issued a very long and involved public denunciation of the film, all of which made more people go to see it.

Five days after this occurred, I was in Washington promoting the film, and President and Nancy Reagan invited my wife Felicia and me to the White House for a private meeting with them. It was purely social, and it had nothing to do with the film, although quite obviously he was totally aware of everything that had happened. Nevertheless, he did invite us and we spent several hours together and they could not possibly have been more pleasant—very open and very warm, I must say. I give him great credit for that. I thought it was a lovely thing to do. I hope it happens again.

Cineaste: *What do you think of the recent trend of films such as* Rambo *and* Red Dawn?

Lemmon: That's something that bothers me tremendously, but I don't think it's just an American problem. When you think about it, the entire world is rapidly becoming an armed camp—there is literally no section of this world that is not ready to explode. God knows I am not in favor of any form of censorship, but I think there has to be a self-realization by our filmmakers that we are feeding this problem to an incredible degree by the proliferation of all forms of violence. Hopefully,different types of films can become commercial smashes so that we can have a more humanistic approach to life reflected in our films.

One of the reasons I feel so fortunate to be an actor is that I find that the vast majority of artists are very sensitive to the human condition. They are basically humanists, and, no matter what their particular politics may be, in their souls they are liberals. I think that without any question they have a profound effect on the way that people think, that it is a positive effect and that it will continue, God and Reagan willing.

Cineaste: *Speaking of Reagan, do you think there's any chance for a re-occurrence of the political repression that took place during the McCarthy era?*

Lemmon: That's a very important question, and I wish I had a definitive answer. I think that indirectly there may have been a great benefit out of the McCarthy era, but that benefit will occur only if we keep reminding people of what did happen not too long ago, and that it could happen again if we allow such an extremely conservative attitude to pervade. I personally hope, and think, that it won't happen again because I like to believe that we are more enlightened and politically less naive than we were at that time.

I think that the danger will be if we lose what I think is the most precious commodity, if you will, in our form of democracy, and that is the inalienable right

to stand up and scream and holler and criticize, to be able to say that something is wrong, without anyone being able to stop you or label you as un-American. America was built on self-criticism, and I think that is the most important reason why, with whatever faults it may have, our particular form of government has worked so well.

Cineaste: *What have been your impressions of Cuba so far?*

Lemmon: It's even more than I had hoped for. I've been fortunate enough to travel to many different countries,and experience different cultures, different backgrounds, different traits, but people everywhere are really basically the same. I knew that would happen here because, you know, people are not suddenly going to be different just because the politics are different. People's attitudes are the same all over the world when you really get down to the roots of the human spirit, to what motivates us and what's important to us. What we do is put blocks up so we don't understand each other to reach the common goals that would be good for all of us.

The Cuban people are warm, open, generous, and they've made us feel wonderfully welcome. I don't think it's just because I'm a movie star or have appeared in some very popular films—sure that helps, but it isn't that alone. To an unusual extent they have genuinely made us feel totally open and relaxed. They are so vibrant, so vivacious, there is such a bubble of energy here, but the only thing is that we've got to get someone to teach them to sleep. I mean, they stay up for twenty-four hours, they're incredible! They totally forget about sleep, and I'm worried that they're all going to get sick, they're going to start keeling over and die young. I'm only here for a week and I'm having such a good time that I'll hate to leave, but if I were to stay one more day, I might not make it. Hell, I don't even drink and I'm a mess!

Just in the brief time that we've been here, we've seen so much wonderful art and talent. Talent is everywhere, of course, it's true, but Jesus, I'm looking for an untalented Cuban and I can't find one. A number of sculptures, woodwork, and ceramics were given to us that are just incredible. I also went to the big art institute [*the Instituto Superior del Arte at Cubanacan*—ed.] where they have about 2,000 students studying all the arts, and they take them from elementary school all the way through college. It's very much like the California Institute of Arts where my son Chris went. The music school there is very good. Both Chris and I are . . . well, I'm a half-assed musician, but Chris went to school to be one and he got a degree in composition. The music that we have heard here is beyond belief. I don't know if you were at La Maison last night, but that ten-piece orchestra that played is one of the best I've ever heard. The majority of those guys are only two to three years out of school, but that orchestra would be a smash hit if they toured America. Chris was boggled by some of the chords and structures in their songs, they were really brilliant. We've got to find a way out of this embargo nonsense and get an economic and cultural exchange going.

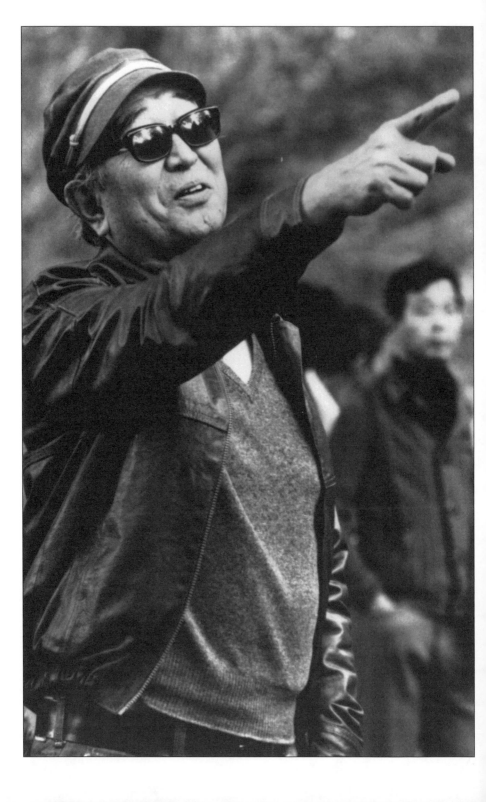

3 AKIRA KUROSAWA

Making Films for All the People

The nomination of Akira Kurosawa for the 1985 Academy Award as Best Director seemed an official, if belated, recognition of the fact that Kurosawa, Japan's greatest living film director, is also one of the world's greatest directors. Ran (1985), Kurosawa's long-dreamed-of adaptation of Shakespeare's King Lear, *was his twenty-seventh film in a career that broke many cultural and artistic barriers. During Kurosawa's visit to New York in conjunction with the screening of* Ran *at the New York Film Festival, the usual taciturn director agreed to be interviewed for* Cineaste *by Kyoko Hirano who also translated their discussion from Japanese.*

Cineaste: *You mentioned in an interview in a Japanese magazine that in* Ran *you wanted to depict man's karma from a "heavenly" viewpoint. Will you elaborate?*

Akira Kurosawa: I did not exactly say that. Japanese reporters always misunderstand or conveniently summarize what I really say. What I meant was that some of the essential scenes of this film are based on my wondering how God and Buddha, if they actually exist, perceive this human life, this mankind stuck in the same absurd behavior patterns. *Kagemusha* is made from the viewpoint of one *kagemusha* [*shadow warrior*—ed.] who sees the specific battles which he is involved in, and moreover the civil war period in general, from a very circumscribed point of view. This time, in *Ran*, I wanted to suggest a larger viewpoint . . . more objectively. I did not mean that I wanted to see through the eyes of a heavenly being.

Cineaste: *What kind of audience did* Ran *attract in Japan?*

Kurosawa: A very wide audience. Of course, it includes long-time fans of my films. Somehow, this time, many women went to see it, and I do not know exactly why. I know some rather old ladies who are working as caddies at golf courses near Mt. Fuji, where part of the film was shot, and who went to see *Ran* in Tokyo. They liked the film very much and asked me to make another.

Cineaste: *You used to make films depicting political and social concerns more directly, for example* Scandal *(1950) and* The Bad Sleep Well *(1960). Recently, your films tend to be set in the past, and seem to have become more philosophical.*

Kurosawa: I believe that the world would not change even if I made a direct statement: do this and do that. Moreover, the world will not change unless we steadily change human nature itself and our very way of thinking. We have to exorcise the essential evil in human nature, rather than presenting concrete solutions to problems or directly depicting social problems. Therefore, my films might have become more philosophical.

Cineaste: *Did you think this way when you were young?*

Kurosawa: No. I did not think so when I was young, and this is why I was making such films. I have realized, however, that it does not work. The world would not change. This is not a matter of simply moving things from right to left. I have been tackling problems which transcend specific periods. I am confident that I am saying what I should say in my films. However, I don't think that the messages of my films are very obvious. Rather, they are the end products of my reflection. I am not trying to teach or convey a particular message, because the audience does not like it. They are sensitive to such things and shrink from them. People go to see films to enjoy themselves. I think that I have made them aware of problems without having to learn about them consciously.

Critics may be affecting today's audience negatively: they see films here [*pointing to his head*—ed.]. No! I want to tell them to see films here [*pointing to his heart*—ed.], because I make films thinking that way. I do not want them to try to reason everything. The people who pay to see films will see a film as it is. Furthermore, I do not believe that film is simplistic, but multifaceted. Ideally, a film should be spherical. This is physically impossible; however, it is possible to

approach such a shape. A film should appeal to sophisticated, profound-thinking people, while at the same time entertaining simplistic people. Even if a small circle of people enjoy a film, it will not do. A film should satisfy a wide range of people, all the people.

Cineaste: *Were you subjected to any political pressures when your films dealt more directly with political problems?*

Kurosawa: At the end of *Ikiru*, for example, after the funeral, everything goes bureaucratic again at the protagonist's office. The vice president of the film company told me that we had criticized bureaucracy enough before that scene and we did not need that last scene. I answered, "You are welcome to cut this scene out; but in that case, please cut all the scenes from this film as well." The company was at a loss, so they finally told me that the film would be all right as it was.

The film companies have tried to suppress such potentially problematic parts when I try to make straightforward statements, although I have not succumbed to such pressures. You mentioned that I have not made films about contemporary themes. I suspect that if I chose contemporary problems as my subjects, no film company would dare to distribute such films. If no company would distribute such films, I would have no reason to make them.

In the last scene of *The Bad Sleep Well*, everyone in the audience must have deduced that it must be the then Premier Kishi who is the ultimate source of corruption and who is talking at the other end of the telephone. This is why the company has never re-released the film, although everybody has been anxious to see it again. Francis Ford Coppola said that it is his favorite film. The company would not have distributed it if this unidentified character had been identified. I intended it to be obvious, although the film executives had not been able to understand it when they had read the script. That is why they approved the script and invested their money. Film executives are the people who understand films least.

Cineaste: *Are they worse than film critics?*

Kurosawa: No question about it. We write scripts cleverly, and we submit them. The film executives really do not understand. As for critics, there are all kinds. Many Japanese film critics are strange. They write reviews as if there are certain rules among them—like, "This time, I will write a good review, so you will write a bad one." It depends on who pays them, not on their own will or their own opinions.

Cineaste: *Recently in Japan, some film criticism has become intellectualized as academics have begun to write about films, employing such new disciplines as structuralism. Do you believe this has helped upgrade the quality of film criticism?*

Kurosawa: They use extremely pedantic terminology. I do not believe in such rationalization or jargon. Film should be more related to human feelings, more candidly. For example, what about "perpendicular thought in film"? They want to indulge in such jargon, but I really do not understand what it means. It is particularly so in music criticism, too. Toru Takemitsu and others have been

saying that these critics do not understand anything, wondering what they mean by this jargon.

Mr. Hideo Kobayashi [*a famous art critic*—ed.] said that after writing so many critiques, he concluded that the only ones he approved of, after all, were those which praised the works in question. He believed that the role of critics is to encourage artists by finding the good points in their works: to point out bad points is merely absurd. It's better to shut up. Even if you criticize harshly, the work will not improve. If you really hate it, just ignore it. That's what he said.

Artists and critics will never get along. Artists want to be praised, whether or not they deserve it. Moreover, the worst thing is for a critic to write a negative review to spite the rave reviews by others, doing so not because he believes what he writes but because he wants to stand out. Also, critics are free to criticize and say bad things. What I will not tolerate is to attack me with hatred, calling me foolish and stupid. I really do not understand what I have done to this guy to deserve this. Criticism should be done out of affection, not out of hatred.

The critics in Japan say incomprehensible things. This time, for example, they claimed that I made *Ran* to make money. If so, I would have made an easier film. This film was very difficult to make. Well, I am used to slanders. It would be a lie to say that I don't mind. I just ignore everything.

Cineaste: *Once you said that the most important thing for young people aspiring to become directors was to read world classics. Do you still believe so?*

Kurosawa: Definitely. To read everything is almost impossible, so you must find writers that you like. Then, to find favorite works of these writers, and read them again and again. Therefore, your understanding of the characters in these works is deepened. One's level of understanding after reading a work once, and after reading it ten times, is naturally different. It is important for actors as well to understand the characters they are going to play.

The best thing is to write screenplays. This is basic to filmmaking, because an excellent screenplay can become an excellent film even in the hands of a third-rate director; a bad screenplay, however, could never become an excellent film even if made by a first-rate director. Therefore, you have to realize the importance of screenplays. Also, when you want to study filmmaking, using film stock and constructing sets cost a lot of money and usually you are not given such opportunities. To write a screenplay, however, you need only paper and pencils. Especially in Japan, television needs many good screenplays, and in films, they are desperately looking for good ones. If you write a good screenplay, it means immediate money. I have always told young people to write screenplays, but they don't.

Balzac once said that the most important thing for novelists is to put up with the boring labor of writing line after line of the letters of the alphabet. These young people are not patient enough to put up with it. Furthermore, they don't want to make the effort even to read novels. Though they believe themselves talented, they have nothing to show for it. This time, with *Ran*, I solicited young,

aspiring assistant directors. I chose three, out of many applicants, based on their proposed screenplays. I have been trying to encourage young talent. There was a young Italian man who became an assistant director for *Ran*, too. He learned how to speak and write Japanese.

Reading and writing should become habitual; otherwise, it is difficult. Nowadays, young assistant directors do not write screenplays, claiming that they are too busy. I used to write all the time. On location, a chief assistant director's work was extremely hard and busy, so I used to write at midnight, in bed. I could easily sell such screenplays, and make more than my assistant director's salary. It meant that I could drink more. Therefore, I wrote, and I drank, then, when I got broke, I wrote again. My friends were waiting for me to write screenplays and make money for drinking. When we went to drink, we talked about films all the time. Some of these talks became part of the next projects. Even now, when we drink together with actors and crew after the day's work at locations, we talk about our work, and sometimes these are the most important talks we have.

Cineaste: *The large screen at Lincoln Center makes* Ran *look surprisingly dramatic, compared with the small screen at press screening rooms.*

Kurosawa: In Paris, *Ran* was shown in 70mm. The battle scenes looked particularly magnificent. With a six-channel stereo system, it was really exciting. The people who could not get into the theater were making a lot of noise outside, however, which was heard in the theater. On the other hand, very delicate, psychological scenes may not work in such a theater. I sometimes feel that these scenes are more suitable for rather modest and quiet theaters. There are not many 70mm theaters. In Tokyo, there must be only two. It also costs a lot to produce a film in 70mm. I believe that the best 70mm films are Wyler's *Ben Hur* and Lean's *Lawrence of Arabia*. In particular, the chariot race scene in the former film would not have been so exciting if it had not been shown in 70mm.

4 LIZZIE BORDEN

Labor Relations

Lizzie Borden studied painting at Wellesley College then went on to write art criticism for Artforum. Having evolved more as a critic than as a painter, she feels school ruined painting for her. Borden decided to teach herself filmmaking in order to maintain the "necessary naiveté to just do something and let it be as silly or as crazy as it could be." Born in Flames, Borden's first feature film, was a science-fiction fantasy about social transformation, set ten years after a socialist revolution in the U.S. It seemed to ask, "What if women of all races, classes, and sexual persuasions banded together against the patriarchy?", which in the film still maintains the position of power it has today. Borden was criticized from all sides, from feminists who condemned her film for embracing violence to critics such as John Corry who attacked the film in The New York Times for its production values, politics, and even the Public Broadcasting System's decision to air it last year. Nonetheless, Born in Flames has become a feminist classic and is praised by many as one of the most important feminist films of the Eighties. Borden's Working Girls (1986) created a similar commotion. Can a woman condone prostitution and still be considered a feminist? Borden situated prostitutes solidly in the realm of work, presenting the women as "employees" in the sex industry. Although many ask if that is enough, Working Girls does pose some important questions, not only about prostitution but also about many related social issues. Lynne Jackson spoke with Lizzie Borden about her new film shortly before its New York City theatrical opening.

Cineaste: *How did the idea for* Working Girls *develop?*

Lizzie Borden: A lot of my theoretical position on prostitution developed during the production of *Born in Flames* because of women who worked on it like Flo Kennedy and Margo St. James of COYOTE. That film came out of contradictions I saw in the feminist movement where white women, black women, Asian women, lesbians, prostitutes, and others were just not working together. Many of them didn't even consider themselves feminists, although they were all engaged in separate but similar struggles. The whole point of *Born in Flames* was to create a microcosm in which they all worked together.

With prostitution, there is a parallel. I had been interested in it theoretically but was aware that groups such as Women Against Pornography were really putting working women—not just prostitutes but also other women in the sex industry—in a bind. The conventional social criticism, of course, says that, "These are bad women, fallen women, degraded and victimized." Then the feminists who criticize these women for perpetuating the sex industry also tell them that they are victims. Many working girls, however, have chosen their jobs and do not feel like victims. Women in the sex industry have been so reviled on both sides that there must be a way in which we can establish a dialogue which is not against women who work in this way. I wanted to eliminate that automatic sense of degradation for women who have worked as prostitutes or done anything like it.

When you start meeting women who "work" and get over your own moral reaction, you start to see how close you can come yourself to being able to do it. You start to wonder if you really want to be doing a horrible job for very little money. What are your options? That is where it starts becoming very personal. I mean, I would certainly rather work in a house for two days a week than work as. . . well, I've had teaching jobs that were very unpleasant. I have also had waitressing jobs and worked on a low level in film jobs and even in an art museum where I was a lackey.

Cineaste: *What research did you do that makes you feel qualified to make a film about prostitution? Born in* Flames *was made collectively in the sense that many of the main characters wrote their own dialogue. Was* Working Girls *done this way?*

Borden: Not really. I scripted it after I had done a lot of research—meeting many women who worked, going to houses, hanging out, talking to different madams, different johns. Some of the women were already friends of mine, so it wasn't as if I were going into a totally strange situation and having to gain trust.

The structure of *Born in Flames* likewise evolved from meeting a lot of black women, working with them and trying to create a film that expressed more than my own point of view, to make a bigger statement than I could make on my own. Making a film always seems to be about transgression on some level, about finding your way into something that you don't know anything about. *Born in Flames* was about black women, a group that was closed to me. In some ways, the world of prostitution was the same kind of thing, though certainly of quite a different nature.

Cineaste: *How would you describe your approach in this film?*

Borden: In *Working Girls* I wanted to explore middle-class prostitution because the only visible prostitutes are street hookers and there is already a highly developed cinematic imagery about them. When you see a hooker on screen, you know she is going to be punished for being a bad girl—either beaten by her pimp, arrested by the police, or killed by a john. A more romantic cinematic image is that of the high-class call girl like Jane Fonda in *Klute*. In these movies, prostitution is presented less as an economic question than a psychological one—once the woman undergoes analysis and falls in love, she can quit "the life."

I wanted to place prostitution solidly in the context of work as opposed to sex since, for prostitutes, it is not about sex at all. Most people think that prostitutes must feel something sexual or "get off" in their work, but that's not true. Prostitution is a business transaction, pure and simple, between prostitute and john. Even many women have a prostitution fantasy because the prostitute represents sexual freedom. I wanted to show women what prostitution is really like, to deromanticize it.

There is also much more middle-class prostitution than people think, and the kinds of women involved in it run the gamut from students to working mothers. Middle-class prostitutes never get counted because they don't identify themselves as such, they never get in the police records as prostitutes, and they never come out and talk about it. Many women have done it for short periods of their lives, and many other women have traded sex for a lot of things. Women who have worked as prostitutes don't emerge as walking basket cases. Many women whose names I could never mention have worked. You would know who they are, they are in our mutual world. A lot of women who consider themselves feminists work. In some ways, this is what *Working Girls* is all about.

Molly's whole stance as a working girl is as a feminist. She is living with a woman, and she doesn't particularly need men, although she doesn't hate them by any stretch of the imagination. When she sees a client, it is on a contractual basis—X amount of time for X amount of money. She can deal with it, be nice, and do what she has to do.

Cineaste: *But why no analysis, particularly of consumer relationships?*

Borden: The consumer bit is implicit. It is there in the fact of what money buys, in the madam who is the ultimate consumer, selling these girls and constantly going out shopping. I didn't want to get into any psychological analysis, because then it becomes too easy to make a cause and effect relationship to explain why a character is working. Prostitutes don't all have daddy problems, they don't all hate men, so to get into anything heavy about it would be false. People insist that working as a prostitute has got to mean something more, but it doesn't really. Many women do it, and the reasons all come back to money.

I wanted to try to neutralize prostitution a bit because it is such a loaded issue. If a woman works forty hours a week, being paid $4 or $5 an hour, even though she may have a degree in something, why is that any different? Why is it any less obscene that she comes home at the end of the day, with no creative

energy left, and cannot do anything but turn on the TV? Many feminists, Flo Kennedy among them, have pointed out that when you marry someone you are selling your body, but when you are a prostitute, you are simply renting it. A lot of women who work do it because they would rather give up something in the rental of their bodies and have extra time or more money.

A parallel situation exists for those people who sell their minds, which is just as difficult, although less tangible. I know people who have been destroyed by the advertising business, serious writers who couldn't write again, or people who have been destroyed by other ways of prostituting their talents. I don't think either kind of prostitution should exist, but they do. In that context, I don't think the body has to be put on such an extraordinarily high level. I guess the horror about selling sex is based on the mystique that sex is so intimate.

There are problems involved in prostitution, but I wanted to strike a balance in *Working Girls* between, on the one hand, demystifying and demoralizing it, without, on the other hand, making it look like the best job in the world. But it sounds like you have a lot of reservations about the film.

Cineaste: *Isn't validating something that we shouldn't have to do in the first place like the snake that eats its tail? If they didn't have to do it for money and they could choose to do it. . .*

Borden: They wouldn't do it if they didn't need the money. Any working girl I have ever met, except the madam who was making too much money to get out, would stop the second she got enough money to get out, period. There is no question about it. No looks back, nothing. The standard idea is that if money changes hands for sex, the woman is automatically victimized, and this makes it worse than other service jobs like being a secretary or a stewardess. I personally don't see that much difference.

It's ironic that prostitution on this middle-class level parallels other parts of our culture, such as singles bars and how we as middle-class women have been educated to make men feel comfortable. Even the same conversations—"Can I get you a drink?" "What do you do?" "How was your afternoon?"—that very rote way of doing all the interactional shit work in conversations with men, is all reflected in a place like that.

Cineaste: *So you see your film portraying a parallel with more general power relationships between men and women in society?*

Borden: Yes, exactly. In a way, it's much less about prostitution than about heterosexual codes and rituals in our culture. In this context, I wanted the film to bring up, by implication, all the times women have slept with men for other than romantic reasons. Everybody has had that happen at least once. It happens in gay relationships, too. You go too far with someone, flirt and mess around, and then you say, "Oh God, how do I get out of this?" In high school and in college, for instance, there is a lot of social pressure on you to like someone you may not really be attracted to. Or someone takes you out for an expensive dinner and you're supposed to sleep with him. A momentum is set up, so you end up having some kind of sex and you wonder, "Why am I not feeling anything?"

What's the difference, for that matter, from a husband who forces his wife to have sex with him? He wants it a lot but she doesn't. She thinks, "If I do it now, he'll be asleep in a half-hour. If I don't, he'll be bugging me for the next five hours." Every woman has had an experience like that, so the disjunction of sex from passion is something which happens in a lot of relationships. I would love one day to do a film about eroticism—where eroticism remains free and not rote within a relationship. Most relationships in our culture end up policing and framing sex to a level of routine. Marriage, in particular, seems to end up routinizing sex for both men and women.

The reason brothels do such big business is because of married men. Very often it's just the desire to do it with someone different, or to engage in some kind of sex that their wives won't do, and I'm not even talking about extreme stuff. In fact, sex is such a small part of prostitution. It is less about sex than about fantasy. The sex takes five minutes out of a half-hour, and the rest is talk. Then they spend another week fantasizing about it. It points out such a contradiction in our culture that I wonder what their wives are getting on the other end. They are still in the position of being the good women in the virgin/whore dichotomy.

All of these questions are not about trying to make the job of a prostitute look desirable, but to take prostitution out of the realm of over-moralization which I feel is totally damaging. There is such a double standard. For example, when a pimp beats up a prostitute, everyone may say that this is sick, but they also feel the woman is getting what she deserves. But when a wife stays with a husband who batters her, everyone sort of understands that—she's a victim, but it *is* her husband after all. Both relationships are equally sick, and, just as the battered wife needs feminist support, so does the prostitute. But in our culture the prostitute takes the fall for wives, girlfriends, mothers-in-law, everyone. As the "bad girl," she gets everything dumped on her, whereas everyone else can manage to be the "good girl" and somehow be saved from that negative judgment.

Cineaste: *In* Working Girls *the conflict is actually not so much between the girls and the guys as it is between the girls and the madam.*

Borden: Yes, I wanted *Working Girls* to echo other employment situations. For some people the film works on that level. They have had jobs where their battle wasn't with the customers but with the employer, the conditions of employment, and the manipulation that goes on between employer and employee.

Cineaste: *You have one scene where Molly becomes very upset. She almost has a breakdown, locks herself in the bathroom, and breaks out in a sweat.*

Borden: I wanted to put it on the same level as a double shift anywhere. I have had long editing jobs where I couldn't stand up by the end of it. I was nodding out, freaking out, crying in the bathroom. Things weren't going right. Molly would have been fine if she had left at 6 o'clock when she was supposed to have left.

Cineaste: *It's the double shift, then, that pushes her over the edge.*

Borden: Yes. When a secretary or a stewardess comes to the point of questioning their job, they wouldn't say, "I'm being humiliated and used. This is

horrible. I'm going to leave my job." Their decision to quit would be more over one long thing that hits them. Work pressures you up to a point, it is cumulative and not based on any ideological humiliation that has taken place. People have different goals. For prostitutes it is a money goal—$500 or $8,000 or $10,000. They'll take anything up to that point. That was the implication with Molly. It is not an easy job. It is tough, it is ugly, but it is not the way other movies have made it look.

Cineaste: *How do you reply to people who say prostitutes aren't like those in your film?*

Borden: Those preconceptions are very hard to overcome. That is why I wanted this film to be simple and to satisfy a basic curiosity. This is how a brothel works. This is what a session is like. This is how it feels inside a place like that. Without giving such a detailed look, I didn't think anyone would believe this film—they would just say it was atypical.

Prostitutes aren't all stupid, drug-addicted, neurotic women. I wanted people to come out of *Working Girls* thinking they could relate to Molly. A lot of guys think she is like their sister or the girl next door. One of the things that struck me about working girls is that they are very much like Molly or any of the girls in the film. After I cast my film, the actresses came to rehearsals wearing what they fantasized a hooker would have on. I made them all go to a brothel and apply for jobs, and they came back shocked because the women there were like their college roommates. It changed their minds about it.

Cineaste: *Aren't there more dangers involved in prostitution than in other professions?*

Borden: In a middle-class brothel, there really aren't any more dangers than in any other place. Women who work in a brothel are probably safer than a bank teller, for instance, because the number of times a bank gets robbed is more often than the times anyone with a gun would come into a brothel. You see, I wanted to do the opposite of what most films on prostitution do. It is the traditional cinematic representation of prostitution—women in short skirts and high heels being attacked by men—and not the actuality, that is pornographic. People think that because women are out there flaunting their sexuality, it drives men crazy, so of course they kill. Thousands of women do it but when ninety-nine percent of the movies about prostitutes show them getting killed, it's absurd. I wanted to make a dramatic film, but not one that was dramatic in the expected way.

Cineaste: *But violence does happen.*

Borden: Yes, it happens, but not to the majority of prostitutes. Women aren't that stupid. Even street hookers have a good sense of who is picking them up in a car, and they have much more control than films show. And as horrible as the pimp/prostitute relationship is, the pimps do protect their women— they're watching and see the guys who are customers—because if they didn't, they'd be out of a job.

Cineaste: *What about diseases?*

Borden: Prostitutes in a middle-class brothel are safer than women who sleep around. A woman who works in a house is free to say to a john, "You have to use a condom." The job is not completely free of danger, but to show only the danger is unfair. So is not showing the parallels with a woman who sleeps around. Look at Spike Lee's film, *She's Gotta Have It*, where a girl is sleeping with three guys! Who knows who they have slept with? A woman is not always that comfortable asking a guy to use a condom. It is not a sexy mode of birth control. There is a scene in *Working Girls* where the madam says, "You won't get busted, you won't get hurt, and you won't get sick." And one of the girls says, "That's because we take care of ourselves." In a house they do. They see a doctor once a month. They are cleaner than anybody else. Very often ordinary women might get some kind of infection, but they ignore it and it gets worse. In brothels they take special precautions and go through regular medical screening procedures. I think it is as safe in many ways as any other kind of job.

Cineaste: *But a prostitute is not free to say no to a customer.*

Borden: Yes she is. One woman in the film kicks a guy out because her moral system was that she wouldn't kiss and she wouldn't do anything weird, like spanking someone with a ping pong paddle. That guy did something she didn't like so she gave him his money back and threw him out.

Cineaste: *There are moments in the film where the prostitutes don't really seem totally in control. Molly and a few of the others become very humiliated.*

Borden: Women in a house would not have absolute control, but the only time it got ugly for Molly was with the Asian guy because she couldn't speak with him. I wanted that to get very nasty. It was, "Ugh, get rid of him. Just give him a quick hand job and get him out." It also got heavy with Paul, the artist. His sadism, however, was similar to what could happen in a "straight" relationship with a guy like that. The kind of mental cruelty in the session is not atypical of the kind of cruelty that goes on between a man and woman where he puts her down or manipulates her into an inferior position. That was the implication there. Molly was foolish enough to be attracted to him. Since she lost her distance, she lost her control. That's why she knows she has to leave the brothel. But that kind of humiliation is the worst it gets. She doesn't get slashed or beaten.

Cineaste: *Why are all the men in the film made to appear so ridiculous?*

Borden: Because they are tricks, and these guys are called tricks for a reason. The women are constantly tricking them into giving more money for less, and they aren't going to give anything they don't have to give.

Cineaste: *It just seems like such a cheap shot. They weren't ever likable. Was poking fun at the men your intention?*

Borden: Not at all. I wanted a whole range of men. Neil, for example, the teacher who just wanted dating advice, was sweet and sort of likable.

Cineaste: *But he was so pathetic.*

Borden: Sweet and pathetic. The vulnerability of men in that place is very apparent, and the thing that makes that place work, as it does in every place of employment, is the sense of camaraderie among the women. The butt of their

humor has to be the men. The vulnerability and pathos of men in relation to prostitutes is hardly ever seen. What I find interesting is that guys who like the film identify with Molly. That is wonderful because we as women have been forced to identify with men in films so often. There are no men to identify with in *Working Girls*, not one in the entire movie, because I really wanted men to identify with Molly.

Cineaste: *What do you think about the possibility of your film objectifying women's bodies and being a handmaiden to titillation?*

Borden: I think I undercut that by the way I shot the bedroom scenes, so that the female body never becomes a sexual object. In none of the scenes was the female body looked at by the camera in order to titillate the audience. In fact, the intention was to make it as unerotic as I could.

Cineaste: *But titillation is in the eye of the viewer.*

Borden: It could happen, of course, but the impulse was not to titillate, and my experience talking to viewers is that it does just the opposite. Even guys who come to see the film to get turned on, don't. I haven't heard of one person who got turned on. In fact, if there is a disappointment with the film, it is because it is not sexy. People who come to see it for those reasons usually walk after ten minutes. The film demystifies sex and the female body. By the end, I wanted Molly to take off her clothes without anyone even noticing any longer that she is nude. Since the sex is shot from the women's point of view, it is the men who are objectified. The one time Molly is objectified is the scene with the musician, who objectifies her as a whore, and this is shot in a very lyrical, romantic way. The bedroom scenes are my favorites, in fact, I feel they succeeded exactly as I wanted them to, particularly since I was able to be very free with the camera and do wackier stuff than downstairs, which was all about horizontals and verticals in a "normal" living space.

Cineaste: *So you aren't concerned that* Working Girls *will implicate the audience as voyeurs in the way that* Blue Velvet *operates, voyeuristically investigating sexual transgressions and forbidden sex?*

Borden: Voyeurism implies some kind of sexual response and I wanted to satisfy people's curiosity as opposed to eliciting a sexually excited response. I think the sex in my films is not erotic, and I did that purposely. One shot shows Molly putting in her diaphragm. In another shot Gina washes out her diaphragm filled with blood because, as a working girl, she is not allowed to have her period. The film demystifies female processes, too, like Molly peeing when she wakes up in the morning. How can anyone have an excited response to that?

Cineaste: *Have there been any problems with censorship in terms of the film's distribution?*

Borden: The film's going out unrated because, even with no hard-core sex scenes, it would get an X-rating. It is so difficult, so political, because the censorship boards are not really fair. That is one reason why I am against censorship on the part of women. Films like mine will get censored before violent films like

those of Brian de Palma. I couldn't even get a contract with the Screen Actors' Guild because they read the script and said it was pornography.

Cineaste: *How was Working Girls funded?*

Borden: I shot it on about $120,000. Some of that came from grants—The National Endowment, The New York State Council on the Arts, The Jerome Foundation, and so on. We also set up a limited partnership which kept one step ahead of production, with $3,000 and $6,000 amounts coming in from time to time. Including the blow-up from Super 16mm, it ended up costing about $300,000.

Cineaste: *Your film directly confronts a lot of the moralizing that is going on in the white middle-class feminist movement, such as that at the 1982 Barnard Conference on the Politics of Sexuality. Do you want to address people like B. Ruby Rich, who says there are more important issues for us to address than our sexuality?*

Borden: I think Ruby was responding to the Women Against Pornography movement. I feel the same way. There is so much energy going into that instead of looking at the more fundamental structures that generate those problems. For me the problem isn't prostitution, the problem is capitalism and the employer-employee relationship, the problem is the nuclear family and all the problems inherent in being female in this culture. *Born in Flames* was in a way the desire to blow the whole world up and start something new. It was a hope. But it didn't deal with how the women in the women's army supported themselves, it didn't deal with work or the practical side of our culture. We can't just wish something away.

I think everyone shares a vision that one day prostitution will cease to exist, that the nuclear family as we know it will stop being so oppressive for women, that free child care will be available, and that women will get equal pay for equal work. In our lifetime, however, prostitution is not going to end. To invalidate prostitution, then, to simply say it is bad, that it shouldn't exist, truly hurts women who are in it because it doesn't give them any other options. We need to create a greater level of awareness about prostitution and less of a negative value judgment regarding the women who work in it. A feminist position on prostitution would involve getting more control over it. Women have to start controlling the images about prostitution and the conditions in which it happens. There has to be better protection for women on the street, there should be some kind of union. There must be some way of protecting women instead of saying, "They deserve what they get." In this sense, I hope *Working Girls* will help to validate prostitution, or at least to raise some serious questions about the way it is perceived in our society.

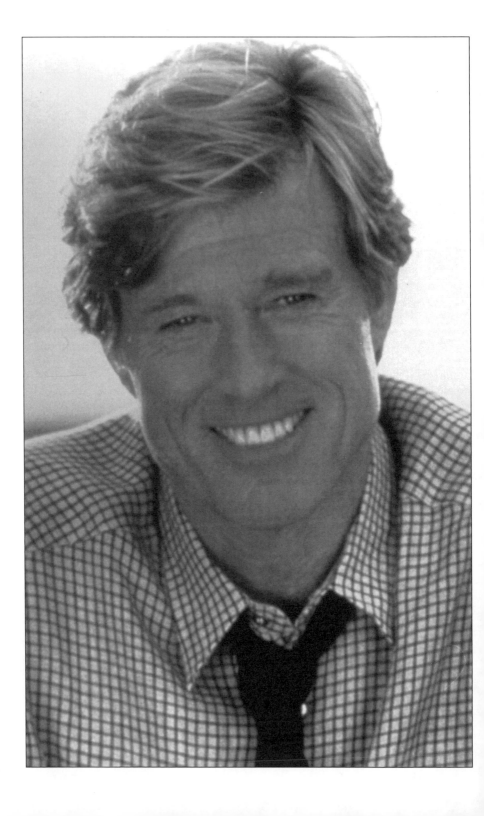

5 ROBERT REDFORD

Combining Entertainment and Education

Although Robert Redford began making regular film appearances in the mid-Sixties, it was his 1969 costarring role with Paul Newman in Butch Cassidy and the Sundance Kid *that launched him to stardom. During the following decade he became one of Hollywood's top box office draws as a romantic leading man in films such as* The Way We Were, The Sting, *and* The Great Gatsby. *Having earlier produced several of the films in which he starred—including* The Candidate *and* All the President's Men—*Redford made his directorial debut in 1980 with* Ordinary People *which not only won the Academy Award that year for Best Film, but also won Redford the Oscar for Best Director. That same year, Redford founded his Sundance Institute to help develop new filmmaking talent and specifically to assist in the production of independent feature films. Redford has also long been known for his involvement in liberal political causes, including Native American rights and environmental issues. His decision to bring to the screen John Nichols's novel,* The Milagro Beanfield War, *grew out of Redford's interest in portraying America's minority cultures. This interest, as well as other related issues, were discussed by Redford in a conversation with Michelle Cosandry in the fall of 1987 on the New Mexico location for the film.*

Cineaste: *You've been coming to New Mexico a lot over the years. What is it that draws you here?*

Robert Redford: I'm not sure I know entirely why. It's got a lot to do with the land, the culture, and history, separately and combined. I think those three things combined creates an aura about New Mexico, particularly northern New Mexico. But taken separately, just the land itself, I think it's beautiful country. And the culture to me is very, very interesting. I grew up in a Mexican-American culture in southeast Los Angeles; I came from a very poor background. Also, through my mother's side of the family—her roots were in southern Texas (San Antonio and Austin), and I would spend my summers there—I was juxtaposed to that Hispanic influence.

Northern New Mexico is different because it has the tricultural, the Indian mix. I happen to be very prone to Indian culture. I've spent a lot of time in it, around it, and studying it for the last twenty-some years. So it just stands to reason that this would be a place that I would like to come to.

Cineaste: *How much did the feelings you have for New Mexico attract you to making* The Milagro Beanfield War *into a film?*

Redford: Well, there are specific things I look for in a film. As for this book, I happen to be a fan of the author's. I like Nichols's work very much. I've been aware of his work for twenty years, and when I read the book I really liked it. It also had these connections with things that I care about—the little guy against the big powers that overwhelm him. Particularly a culture, a situation that involves the possible squeezing out of a culture, part of our heritage by development, profit. It's the David and Goliath context that I like. The land, yes. Just the fact that it's this part of the country. This could have been shot anywhere, by the way. Outside of LA, in Oxnard Valley, the Imperial Valley; southern Arizona, to guarantee that you would have good weather, but I really don't think I would have made the film anywhere but here. There were a couple of times when that was jeopardized, but I always intended it to be here.

Cineaste: *With your film crew, you're bringing money into a community that needs it, and you're doing it in a way that development would not. You're not going to change the landscape, you're not going to move and alter the lifestyles here. Do you see, or have you thought about, what the solutions are to the problems the book raises about integrating a Milagro-type community into the twentieth century economically, and not sacrificing the cultural integrity of the people?*

Redford: That's a great, *huge* question, and I'm not sure I have the answer to it. I have a hunch it has a lot to do with the people themselves that are the culture. In our case, our coming into this community, we wouldn't have gone anywhere where we weren't wanted. The people would have to want us here. I would absolutely, for example, respect any group that said, "We don't want our situation changed by your coming here. We feel it would threaten our cultural stability, our heritage, our right to conduct our lives the way we want to. Therefore, we think you're going to come in here with your equipment, all your Hollywood glamour that'll attract the wrong kind of people, and all of a sudden

we'll have tourists everywhere—we don't want it. I would completely respect that. I'm not sure that I would want it. On the other hand, if the people felt OK about it, then I think there are a lot of positive elements. You do increase the economic base of the community while you are here, you do draw attention to that area geographically, because it's immortalized on film.

People are often influenced by things they see on movie landscapes. I know when we made *Jeremiah Johnson* in the Wasatch Mountains in Utah—most of it was made on property I own there—what happened was suddenly a lot of people wanted to visit that part of the country. The local economies benefited enormously by the influx of people coming to the area that they thought looked beautiful on film. And that could very easily happen here—Truchas could very well find itself with an increase in visitors. Now, whether they want it or not, that is their business, not mine. And that, in a way, also has to do with their future. If the people want to preserve their culture, there's enough of the population to band together, to work together to prevent things they don't want to have happen. What usually happens in a situation like that is that cultures get divided by the attraction of the dollar. You know, a developer usually comes in and makes it very attractive for a person to give up their land. And usually, it's purely money. Very often you come into impoverished communities where industry has left, there's no longer farming or ranching possible because our society and our world has moved on, and we have more advanced needs for extracting goods out of the ground and so forth, so people can't farm and don't know what to do. So they say, what's the point anyway? I might as well sell this, take the money and go retire and live happily somewhere else. The developer gets what he wants and people supposedly get what they want. What gets lost in that is the maintenance of cultural heritage. So, it really is up to the people.

In terms of Indian culture, I think the single most important thing that could happen to preserve their culture is educational scholarships for the kids on the reservations to attend universities. They can become educated so they can come back and help their own people. That would be the single most important thing. You can't fault developers for wanting to develop—that's what they're here for. But if people don't like the results, then they should stop. I think a lot of the development in this country we could do without. I think development is very important, and I think certain kinds of development are essential, but a lot in our country is so much waste. What we waste per year, per day, other countries could live on. I have real strong feelings about the amount of waste, and I think a lot of development, a lot of second home development, a lot of recreational development, is not necessary. Some of the best recreation is just visiting the pure, raw countryside. But, for people who are interested in just turning a profit on development, they couldn't care less about it. That's what these cultures are going to be up against. They're going to have to decide their own future.

Cineaste: *There's a dilemma here, because the American way is for people to make money, to get ahead, to get out of where they are.*

Redford: Yeah, but we're a schizophrenic country. Here we are, a country that was established through liberalism, that was formed by a group of people who were liberals. They left a situation in another country because they wanted freedom, a new way, they wanted to be more liberal in their lives. They came to a new land, discovered it, inhabited it, developed it, and then they adopted conservatism in order to hold it. I think it's really ironic that the thing that brought us here is liberalism, but the thing that's holding us here is conservatism. There's a kind of main trunk, a main body running through this country that's conservative, and now the liberal elements are sort of on the fringe. It's just the reverse of what it started out to be. So there's a built-in schizophrenia in this country: we claim we want independence and freedom, we came here because of it, yet, on the other hand, when groups start espousing freedom and independence, the conservative elements in this country call it communistic, threatening, stopping progress, what have you. What you've got built in, therefore, is a very schizophrenic quality. It applies straight down the line. It applies to cultures which face the question: "Do you want to change or do you want to stay the way you are?" Some people feel staying the way you are is doom and disaster, and others feel it's a wonderful way of life, and you should stay that way. To me it's endlessly fascinating.

Cineaste: *You said in a press conference several weeks ago that you really like history, that it's a chief interest of yours. History is a great teacher, teaching us about ourselves. Film does that, too. Do you see your role when you make a film as being not only entertaining and artful but also edifying?*

Redford: Absolutely. At the risk of sounding pretentious, if I have the opportunity, film for me is always the chance to educate and to entertain at the same time, in equal balance. I don't believe many people respond to being hammered over the head—you know, there are many films out there that have a quality to them that says, "You must see this because it's good for you." It's like taking medicine, or going to church. But the film may be bad—boring and uninteresting. People go to it because they're made to feel it's their responsibility—it's about a situation involving a minority, or a family being relocated, or something. And yet, it's not a very good film, so it's not entertaining. It's just straight education.

Other films are just straight entertainment and have no educational benefits at all. I've always believed that you could entertain people while at the same time educating them as to how things work. *Jeremiah Johnson* was an education as to what mountain men were really like. They were a part of our pioneering history—our earliest pioneers were mountain men. *The Candidate* was a real education about how the political system works behind the scenes. And yet, hopefully, it was also entertaining. *Downhill Racer* was about how athletics works, about the emphasis and priorities in athletics in this country. *Ordinary People* was about feelings, if you want to put one word to it. This country has very complicated notions about feelings. At the same time that film told you about a part of our country sort of isolated from other areas,

other realities—a slightly privileged, upper-middle-class section north of Chicago. Hopefully, it told you how people live in that part of the country. Hopefully, *Milagro* will do the same thing. So, yes, I believe it's possible to combine entertainment and education in a film, and, in fact, I prefer that.

Cineaste: *In* Ordinary People *the camera movement was discreet, you didn't have a lot of motion. You really kept the camera on the actors—everything came from them. Are you going to change your directorial approach with* Milagro?

Redford: There will be more movement here because there's more land to see. The land is a great element in this film—it's literally another character. There will be shots that feature the land more, there will be more camera movement. But what doesn't change is that the focus is on these people. Therefore, it will be on the actors, on the characters. The attractive thing about this project is the wonderful characters that inhabit the story. The difference with *Ordinary People* is that it was very contained, very intimate. What I had in mind with that film was to suggest peeking into someone's life, looking through a keyhole into someone's life. Here, it's more opened up to a whole community of characters. But it's still the same. It's a matter of heart—where's the heart?

Cineaste: *With* Ordinary People *and* Milagro *there's a healing process that goes on. In* Ordinary People *the drama involves Conrad healing himself, and also the peripheral people who become involved in that healing. In* Milagro *the characters experience a healing where their cultural integrity is mended, strengthened. Experiencing a film can provide a vicarious sort of healing or strengthening, when you understand a character's motives. Do you see this as a valid thing for a film to do? Do you aim for that?*

Redford: I think a film is a journey for the audience to share with a character. The character takes the audience on a journey, and you go with them through their experience. So it's up to the actor to present him or herself in a way that has the audience feel like they're going with them. And so, if that's the case, they can go with them. And then it becomes not quite such an objective experience, but more of a subjective experience. I guess that's when film works for me—when it becomes an intimate experience. By that I mean you go with the person and feel what they feel, or share with them, maybe even some bad stuff, for two hours. That's why to me there are no real villains and no real heroes. If you really are with them closely enough you'll at least understand why they do some things. You may not approve of it, but you understand it. And if you understand it, you'll go with them.

There are a lot of villains in motion picture history that audiences love, because they've gone with them. *Ordinary People* was not just about that boy. The boy was the stalking horse for the other characters. It was through the boy's problem that you were brought into their lives. They behaved in a way that they didn't know you were coming in, they thought you were coming in to look at the boy, but you were really coming in to look at them. So it was as much about the father, and the father and mother, and the father and son, and the mother and son, and the son's friends, and the community, as it was about the boy.

In *Milagro* it's the same thing: each character has his own space in this film, and yet it is a composite of all these people that make up what the town is. So by going in, it'd be like looking at a painting by Brueghel or Hieronymus Bosch. Just looking at the painting you get one overall feeling. Then you go in and pull out one character or another, examine that character and look at it, and then you put it back in and it all fits. That way you're kind of going along with these characters. Hopefully, if it's done right, there could be a lot of experiences to share, a lot of things to look at and to feel. It's also mystical, which *Ordinary People* is not.

Cineaste: *I got the feeling in* Ordinary People *that when you directed that you put a certain energy in that was from the gut, sort of intuitive. . .*

Redford: It is from the gut. There's an intellectual overlay, but finally, your gut is what speaks to you. When we're here making this film, it's the gut that's really making it. That's the way it has always been with me—in sports, and in painting, when I was an artist. I always went from that, rather than from the head. I tried very hard to get my head to catch up with my gut, but never quite pulled it off. I had no real education, you know. I've tried to educate myself.

Cineaste: *You seem to be self-educated and to have a genuine, natural curiosity about things.*

Redford: Really. That's absolutely true. So, whenever you go into a situation your gut sort of tells you where to go with it, and you try to bring your mind up to speed, justify what you've done, intellectually or whatever it is, or *add* to it, enhance it. I'm trying to think of a film director who'd be maybe the opposite. . .

Cineaste: *Hitchcock?*

Redford: Uh, no, I think Hitchcock worked from his gut because he was scared shitless. I think Hitchcock was so badly scared as a child that it forever directed what he did, and he operated out of his gut, which was fear. Everything he did was affected by the fact that he was a man, at some point in his life, scared to death. Now, he *crafted* it, he was in control. He worked it all out before he went in there. Why do people respond so much to Hitchcock? I don't think it's his head. They get *scared*. Most of his films really, truly scare us, because he knew what it was like to be scared. So his gut led him. Alain Resnais is a French filmmaker who, I think, works more from his head. By the way, I'm not saying that one is preferable to the other. It's just the way it is—one person works this way, another that way. There are a lot of directors and actors who work both ways.

Cineaste: *Do you tend to have a clear visualization of what you want, but, when you actually work on it and work with the actors, do you let it flow, do you let it take a direction that you may not have anticipated?*

Redford; Absolutely. I think that's the best thing in film. I don't think I could ever make a film where I locked it all up beforehand, because you're eliminating the excitement of what happens when you get live, on the spot. Film can capture live things happening, including accidents. Like today, it was a simple shot of just a guy plowing his field. It's going to be a piece of a montage, that's all. It'll last about five seconds. I got out there and looked at it, and suddenly got

the notion of him being with his boy on the tractor, with his boy throwing fertilizer. So we quickly improvised a shot with the boy, just an idea on the spot. So a lot of times you might change your mind completely about something. I'm quite suspicious of someone who never changes his or her mind.

Cineaste: *How does being an actor give you skills or qualities that help you with your directing?*

Redford: The truth of a scene, on what is being acted. I can empathize much more with the actors and their problems—how they need to go, how they need to work to get to where they need to be. In many cases, I can almost take on the actors' roles with them, so I can go right along with them, I can feel it. Like the scene we're doing here, I have a very clear idea of what each character feels. So I can get in there and feel the same thing and help them.

Cineaste: *Do you ever actually go through the motions and show an actor what you want, or do you always let them do it first and work from there?*

Redford: It varies. It depends on the actor, and on the situation. In this case, we have a very difficult situation because many of the performers in this film have either not acted, or are from another profession, or have very little experience, or are very old and can't hear very well. Some prefer to be talked through it by the numbers; some forget; some are self-conscious about the fact that they've never acted in front of a camera and you have to work a special way with them. An actor who is a professional, you can let alone. You tell them what you want and sit back and watch them. It varies, and so it's really kind of a balancing act, particularly when you have them all working together—that's a killer.

Cineaste: *Since you extend yourself to feeling the actors' roles with them, how do you keep yourself from being exhausted?*

Redford: I don't! I get tired. These are long days; we're here till eight o'clock at night. Yeah, you get tired, but have you ever gotten tired enjoying your work? I enjoy this, I really do. I'm physically tired, but I'm feeling good. I can be worn out, hardly able to lift my head, and all I have to do is get in the car and drive that road down to my home. You also are working with a lot of energy that actors give you—it rejuvenates you. You can take it and work it that way, or you can let it defeat you. And I just so love actors! I happen to think actors are among the world's greatest living creatures. I think they're the most courageous, the funniest, most interesting. I mean they're just *out* there with it all, and I just love that.

Cineaste: *So you take the energy and use it in a way that doesn't deplete you, but replenishes you.*

Redford: Yeah, to me it's very replenishing, and it's a gift, you know. If someone gives you the gift of their energy, it should be thought of as that, as a gift. You treat it carefully. I did it enough times myself over the twenty-some-odd years I've been acting, where you walk on a set or the stage, and you don't know the director and he doesn't know you, and you give him part of your id. You say, well, I don't know you and you don't know me, but here it is! What are you going to do with it? It's pretty tough, and many times in my life that was abused. That

openness, that giving of yourself and putting it in the hands of someone, only to have it abused, that was tough. So I'm very sensitive to that. I wouldn't want to abuse it if it was given to me.

Cineaste: *Speaking of film as an art form in general, do you have any thoughts about the future of film? Has it reached its full potential, does it have to change?*

Redford: A lot of the way I feel about film is involved in the institute I started over in Utah—the Sundance Film Institute. It's an entity to help new filmmakers with other kinds of stories to be told. The film business is becoming so centralized and expensive and monogamous, it worries me that the quality will decline. The only way to keep it up is to encourage diversity in the industry, with things that don't cost a fortune to make. If a film costs $30 million, chances are quite poor it'll make its money back. So I would like to see more films made more responsibly, having to do with subjects that might affect us, might touch us, inform us, as opposed to just shocking us, or scaring or titillating us. Not that those are bad—I think the industry will always have a place for that—I just wouldn't want it to be at the expense of the wonderful stories to be told about our country and about the people who live in it. That's what interests me.

The Institute is a process where resource people from my industry, veterans of the industry—writers, directors, cameramen, actors—come up there and give some of their time to help new filmmakers with their projects. They bring a project to Sundance, and we work on it. We help them get it made. Most of the projects that come here would never have gotten made because the subject matter was about Puerto Ricans relocating in the Bronx; or immigration problems along the border of Mexico; sanctuary; old people being forced to move into a retirement community—you know, little subjects like that are not exactly the stuff that Hollywood has jumped off bridges for. But a well-made film on any of those subjects could teach people. So that's what we're trying to do there.

There aren't enough writers in the film industry. It's become so entirely visual. I mean, what kind of writing talent do you think it takes to make an MTV video? It's visual slapdash, it's visual sleight of hand. It's pretty Philistine stuff. There's not a lot of incentive for writers. And yet, outside of actors, I think the most important ingredient is a good script, a good story. What I love about *Milagro* is that it has a wonderful story. So we're trying to encourage that at Sundance—people learning how to tell a story, learning how to write a screenplay.

Cineaste: *What do you find most personally rewarding about filmmaking?*

Redford: To me it's always been—I hate to sound Eastern about this—but the *doing* is thrilling to me. Of course, you want the result to reach people, but I've always had odd trouble with the result. When I was in athletics as a kid, the joy was in the competition, not getting the ribbon. Oddly, for me, it was always a letdown, after the first couple of times. That kind of rush—"Gee, I won that thing! You will recognize *me*!"—I realized that the enjoyment I got was in the

doing. The thrill of the award didn't mean as much. Of course, you want the result to reach people, and you like the appreciation of it, you like to know that people have been reached, but the awards, the critical reaction, are not important to me. That's not to say that you wouldn't read a review, or be affected if it was a bad review, or feel pleased if it was a good one. It just doesn't mean that much to me, because nothing can ever quite get close to the doing.

6 COSTA GAVRAS

Keeping Alive the Memory of the Holocaust

The name Costa Gavras has become virtually synonymous with the phrase "political cinema." His provocative political films include Z *(1969),* The Confession *(1970),* State of Siege *(1973),* Special Section *(1975),* Missing *(1982),* Hanna K. *(1983), and* Betrayed *(1988). This internationally acclaimed filmmaker, who has lived and worked in Paris since the early Fifties after leaving his native Greece, has since the early Eighties often found himself making American films for major Hollywood studios, including* Missing, Betrayed, *and* Music Box *(1989). The latter film portrays an American family thrown into crisis when the father is accused of having committed war crimes in Hungary during World War II. In March 1989* Cineaste *editor Gary Crowdus spent three days watching Costa Gavras and crew at work on the courtroom set of* Music Box *in Chicago. When the director visited New York in December of that year in conjunction with the film's U.S. opening, Crowdus discussed the film with him, as well as his working methods as a director.*

Cineaste: *Was the Demjanjuk trial in Cleveland the inspiration for Joe Eszterhaz's script?*

Costa Gavras: No, it wasn't really the point of departure for either Joe or me. The Demjanjuk trial is the most famous one, it got a lot of publicity, but there have been dozens if not hundreds of such trials. From time to time, Judge Zagel[1] gave me transcripts of some of them. He also explained how they try to keep these trials from becoming public. Having your father named as a war criminal is something devastating for an entire family, so judges try to do these trials as discreetly as possible.

I hope the Israelis never execute Demjanjuk, because through that trial he played his part, which is to keep the memory of the Holocaust alive. It's important that we're occasionally reminded—that people's memories are refreshed, if I can put it that way—because too often we forget. Sometimes we forget because of economic or political interests, such as when Reagan went to the Bitburg cemetery in Germany where Nazis are buried. Or how about all the chiefs of state who attended Hirohito's funeral recently? If someone had said during the Forties, when Hirohito was considered a war criminal, that one day his funeral would be attended by chiefs of state from all over the world—even someone like Mitterrand, whose decision to attend disappointed me very much—you wouldn't have believed it. But economic interests obliged all those world leaders to just forget that he committed war crimes.

Cineaste: *There is widespread ignorance among young people in the U.S. about the Holocaust. Most school systems here, for instance, have not made it a mandatory course of study. Is the situation any different in European schools?*

Costa Gavras: In Europe I think students are somewhat better informed on this subject because it is studied in schools. But they don't know all the details and with the younger generation there is always the attitude that—as my generation used to say about the First World War—we've heard enough about that. Remembrance of the Holocaust is very important, though, so I think it's necessary to use books or movies or some other means to treat the subject, something more appealing to youngsters than school lessons, because they're bored with those.

Cineaste: *Holocaust remembrance and the bringing to justice of war criminals is the most important theme in* Music Box, *but another important theme, especially for American audiences, is how our government allied itself with Nazis, including major war criminals, in an anticommunist crusade against the Soviets.*

Costa Gavras: What is fascinating to me is how cynical some American politicians were after the Second World War—not a few years after the war, but *immediately*. There's an extraordinary book called *The Belarus Secret*,[2] which I found absolutely astonishing in this regard. The author, John Loftus, a lawyer at the Justice Department's Office of Special Investigations, who had a background in military intelligence, succeeded in gaining access to top secret government archives in Washington. Among other things, he discovered that early in 1945 a Byelorussian brigade, Nazi collaborators who had exterminated

thousands of Jews, fell under the control of General Patton. He wanted to add them to his army because, as he said, "These guys are good because they can help us tomorrow to fight against the Bolsheviks." Loftus also reveals how U.S. secret service officials actively recruited Nazis, creating an entire army of German spies who were given money, passports, everything. Klaus Barbie was obviously not an exception, he was just one among hundreds.

A more recent book called *Blowback*[3] by Christopher Simpson, who worked with Marcel Ophuls on his film about Barbie, also provides some extraordinary information on the U.S. government's Nazi recruitment policies. Another very important book is *Quiet Neighbors*[4] by Allan Ryan, which I like for its dispassionate tone. All these guys are very serious authors, they're not wild-eyed leftists or anything.

Cineaste: *I understand that you actually had key members of the cast read some of these books.*

Costa Gavras: Yes, I sent them to Jessica, Frederic Forrest, and Armin Mueller-Stahl. When Donald Moffat heard about this, he said, "Hey, why didn't I get copies of those books, too?"

Cineaste: *Harry Talbot is one of the film's more intriguing characters. His anticommunism seems to include a strong component of anti-Semitism.*

Costa Gavras: Of course, he's part of that generation. Before the war, anti-Semitism was obvious, it was everywhere. I don't have so much information about the U.S., but in France, for example, newspapers like *La Croix*, the Catholic newspaper, were openly anti-Semitic. In France in the Thirties, you could see graffiti on the walls saying, "Better Hitler than Blum." Leon Blum, the French Prime Minister at that time, was a Jew. Céline wrote extraordinary, very important books in the Thirties, but they were openly anti-Semitic. Anti-Semitism was everywhere. Talbot comes from that generation and he hasn't changed his mind. He has to be a little quieter about it now, because the younger generation doesn't accept such attitudes.

Cineaste: *What kind of research did Eszterhaz do for the script?*

Costa Gavras: He does extensive, in-depth research. He knows all the techniques of research because he used to be a journalist. I know he went through the transcripts of several war crimes trials because he gave me some which I read just to get the flavor of them. I didn't really ask him where his research came from, because I also always do my own research, although we compared notes once in a while. I would say I had read such and such a book, and he'd say, "Yeah, I have that one, too."

Cineaste: *What research of your own did you find helpful?*

Costa Gavras: Terry Simon did some very good research for me. She went through the newspapers because it was important for me to know the role played by all those anticommunist organizations, especially the Ukrainian ones, during the Cold War in the Fifties. The conservative GOP administrations used them, and Cardinal Spellman used them a lot. Even George Bush, during his presidential campaign [*George H.W. Bush's campaign in 1988*—ed.], went

around to these same Ukrainian associations. In terms of research, my experience is that you can find anything you need in the U.S. For *State of Siege*, for example, we first went to Latin America to try to find material, but then we came to America and at the Library of Congress we found everything we needed, even Mitrione's salary!

Cineaste: *Is the film's reference to the Soviet "Operation Harlequin" something Eszterhaz came up with in research? I'm familiar with the Czech-Soviet Operation Neptune but I've never heard of Operation Harlequin.*

Costa Gavras: No, it's invented. Joe based it on Neptune and a couple of other small operations. He had it in the script and I said, "OK, let's do it, but it's not necessary to develop it any further."

Cineaste: *My understanding is that this type of KGB defense has been consistently disproved in these trials.*

Costa Gavras: I have a book written by a judge, Paul Zumbakis, which includes a chapter called "Soviet Evidence in North American Courts" in which, among other things, he refers to a *Los Angeles Times* journalist who claims to have proof that the KGB actually falsified Nazi documents. On the other hand, neither the Jewish advocates' union nor any of the judges who have tried these cases have ever found any evidence of forged documents.

If one wanted to carry this notion further, you could say that the final proof, the photos coming out of the music box, have been fabricated by the KGB. But why would all this machinery be used against Laszlo? If he were someone really important, who led an important movement, it would be understandable, but he's a very small fry.

Cineaste: *To what extent were you involved in working on the script and at what stage did you decide on the visual approach to the material?*

Costa Gavras: For the first time on any of my films, I did not participate from the very beginning in the writing of the script. During the editing of *Betrayed*, Joe said he had a script he would like me to read. I read it and told him, "Yes, this interests me," and I immediately began to think about it. After some discussions between us, Joe made some minor revisions, and, little by little, as I was working with these different drafts of the script, I began to conceive of my visual approach. I decided, very quickly, to do it the simplest possible way, to just stay with the characters, and not to let any sense of cinematic *savoir-faire*, or know-how, take over.

Cineaste: *Were you concerned that so much of the script consisted of courtroom scenes?*

Costa Gavras: At first, yes, but very quickly I understood that all the dramatic dynamite was in the relationships between the characters. Even Joe was a little concerned about this, and I told him we could trim some of the dialogue scenes, if necessary, but that the relationships provided us with all the strength we needed to make the drama.

Cineaste: *There are several visual moments in the film that I found very impressive. For example, when Ann Talbot is preparing to leave the apartment of*

Tibor Zoldan's sister, she sees the photo, and the impact on her is literally phys-
ical, and she stumbles against a wall. As she begins to go down the staircase, the
camera pans with her, then it begins to pick up speed, leaving her behind, and
continues a spiraling movement down the staircase for another few seconds. It's
sort of a visual flourish that, combined with the Philippe Sarde score, deepens the
dramatic impact of the scene. Is that a shot you decided to do on the spot?

Costa Gavras: No, I had that idea earlier. After she sees the photo, it hits
her very hard, and I wanted to give that impression. We had to make a huge
installation for that shot, because it was very difficult to have the camera go
down three flights of stairs in that circular motion.

Cineaste: *The staccato rhythmic effect of Sarde's score used in that scene*
reminds me of your use of Theodorakis's music in some scenes in Z.

Costa Gavras: It was somewhat funny working with Philippe on this score.
He doesn't like to travel. He prefers to stay in his room, with all his machinery,
where he writes everything. I asked him to travel to Budapest with us, and he
came, but he was very pissed off. One night I said. "Come on we're going to see
folklore dances and music." He said. "Folklore dances! What for?!," but he went
with us anyway. It was very nice, because they had this large group of dancers,
and there was one moment when they started dancing accompanied by this
rhythmic clapping. I said, "Hey, Philippe, could we do something with that?" He
said, "Yes," so when we recorded the score we brought in thirty dancers, and, in
that scene and a few others, you hear the same dance steps and clapping that
you hear in the film's opening dance.

Cineaste: *Jack Burke's motivations in prosecuting the case are never force-*
fully conveyed, and, for a prosecuting attorney, he often seems to be thrown on the
defensive by Ann Talbot.

Costa Gavras: His character is a very decent type, not aggressive, but
someone with a quiet sense of certainty about what he's doing. He isn't prose-
cuting someone who could be innocent, he knows all this is real, so he doesn't
have to make any big speeches. He is disappointed because she uses courtroom
tricks to destroy the witnesses instead of dealing with their testimony. He
doesn't want to fight with her, though, because there is a sort of mutual respect
between them. Actually, both of the attorneys and the judge, all three of them,
represent a somewhat romantic notion of Americans as we Europeans tend to
see them—fighting with great strength and courage for the truth—but it is a
romanticism with a certain basis in reality.

Cineaste: *What sort of rehearsals or preparation did you have with Jessica*
Lange and the other performers?

Costa Gavras: Before we began filming, we spent three days in
Charlottesville, Virginia, where Jessica lives, with the four major actors—
Jessica, Frederic Forrest, Armin Mueller-Stahl, and Lukas Haas—in long
sessions where we discussed the script, line by line. I felt it was important that
they understood that we should not play the script too suspensefully, not to have
them underline certain lines in order to give the impression either that he's

guilty or that he's not guilty. I wanted them to read the lines straight, for each of them to remain within the convictions of his or her character.

I also felt it was important to discuss the historical background with them somewhat. Frederic Forrest, for example, was very naive about this. He's a typical young American from the South, and although he could distinguish between the good guys and the bad guys, he didn't understand all the whys and wherefores, all this European complexity about Nazis and Communists and all these other movements. It was a good discussion, and Armin, who's German, was great, because he gave us even more information.

Later we had rehearsals with Jessica for a few scenes, especially the one with her father at the end. We had to work on that scene a lot, rehearsing it just for the movement, changing small things here and there, because I wanted to film the scene in one shot. We had a technical accident during the filming—a microphone fell apart at one point—but I let them continue anyway. We then had to do the scene a second time, somewhat closer, so in the film that scene is cut. Sometimes, for a more difficult scene, I like to get together with the actors on Saturday or Sunday, when we're by ourselves, without all the machinery around us, so we can discuss how we're going to do it. Then it's much easier to do the next day.

Cineaste: *Some of the best known American filmmakers are noted for meticulous pre-planning, including storyboarding, so that virtually every image in the film has been conceived long before production begins. I noticed that you prefer to block out the action on the set, employing a more improvisational* mise-en-scène. *Have you always worked that way?*

Costa Gavras: Yes. The problem is that if you storyboard, you've blocked the action before you can see the set or the actors performing on it. I think this is very bad for the actors because it forces them into a very rigid framework, and you can never arrange their movements completely right. Filming a scene is somewhat like writing a book—to achieve certain rhythms, you select the words you want to use, perhaps certain adjectives. In filmmaking, this is replaced by camera angles or movements, so it's better for me to rehearse with the actors on the set so I can decide how to do it visually.

Cineaste: *In working with Patrick Blossier, your Director of Photography (DP), I noticed that you take the responsibility for setting up the shot, selecting the lens, camera position, and angle, and then Patrick comes in and lights the set. Is that more of a European tradition?*

Costa Gavras: Yes, most European directors of my generation work this way. This is part of the writing, part of the film's style. A film could lose its style, otherwise, because too many DPs tend to do the same thing on all their films. It would be like trying to write a book or tell a story, but having someone else write it for you. A director should use his own words, his own style. Even if you make a mistake in positioning the camera, it's your own mistake, it's part of your expression.

I remember during the first scenes we filmed with Jack Lemmon for *Missing*, I was explaining to my camera operator, Philippe Brun, what I wanted to do, and he was saying, "Yes, OK." Lemmon later told me that he was waiting for a fight to break out because things are not usually done like that in the U.S.

Cineaste: *Most of your technical crew—your DP, your editor, and your sound crew—are French or European. Why is that?*

Costa Gavras: I feel much more comfortable with them. They're my people, they know exactly what I want and react immediately to that.

Cineaste: *Is it more than just a common language? Is it a tradition or a style of filmmaking?*

Costa Gavras: It's a tradition, a way of working. I think French technicians—particularly the French—from the moment they start working on a film, they're completely part of it. It's not just a job. There is no union problem. They are always there, participating, completely involved, all the time. You can count on that kind of commitment. I don't know so much about American technicians because I haven't worked with them, but I'd like to try sometime.

Cineaste: *Are there some things the American film industry could learn from the Europeans?*

Costa Gavras: First of all, you can learn not to say "industry." We never say industry in Europe, because we don't consider making movies an industry. An industry makes cars, or cameras, or coats, whatever, but we make one movie, we are artisans, we make prototypes, and I hope we make art.

Cineaste: *But that's how Hollywood has worked for decades. It's a factory.*

Costa Gavras: I know, that's what makes it an industry, but we say profession. People here also refer to films as "products," but we don't make products, because we're involved in an artistic endeavor.

Cineaste: *Early in your career you were reluctant to make films about American subjects—you explained to me that years ago you were approached to direct a film based on Robert Kennedy's* The Enemy Within, *and you refused, saying, "Look, I can't do this, I'd have to live in America for a year," and so on— but within the last decade you've made* Missing, Betrayed, *and now* Music Box. *What changed your mind?*

Costa Gavras: It was a young producer named Peter Guber who proposed to me *The Enemy Within*. Beginning in the early Seventies, right after I'd made *State of Siege*, up until the time I made *Missing*, during those ten years or so I visited the States several times. A couple of times I came with my family and spent the summers. My kids learned English, and my own English improved a little bit. *Missing* is an American movie, but it doesn't take place in the U.S. It was a first step, a sort of shy step, toward making an American movie, and it was a very satisfying experience. Working with American actors was very nice and presented absolutely no problems for me. Because the working relationships were very good. and I had begun to feel more comfortable, I came back to do *Betrayed*, and now *Music Box*, so it's been progressive steps.

Notes

[1] During preproduction, Costa Gavras met with Judge Zagel to seek technical advice and surprised him by suggesting that he play the judge in the film, which he did, credited as J.S. Block, so as not to exploit his professional status.

[2] John Loftus, *The Belarus Secret: The Nazi Connection in America* (New York: Paragon House Publishers, 1982).

[3] Christopher Simpson, *Blowback: America's Recruitment of Nazis and Its Effects on the Cold War* (New York: Collier Books, 1988).

[4] Allan A. Ryan, Jr., *Quiet Neighbors: Prosecuting Nazi War Criminals in America* (New York: Harcourt Brace Jovanovich, 1984).

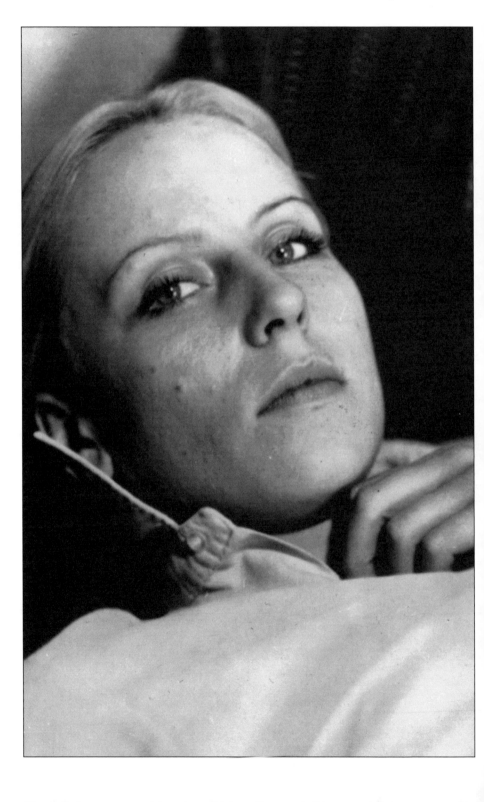

7 KRYSTYNA JANDA

Woman of Marble

Krystyna Janda is one of the leading Polish actresses of her generation. Born in Starachowice in 1952, she studied at the College of Drama in Warsaw and made her remarkable film debut in Andrzej Wajda's Man of Marble *(1977), one of the most significant films made in postwar Europe. As Agnieszka, a student at the film academy who brooks no obstacles in her determination to complete a documentary on a Stakhanovite hero of the Fifties, no matter what unpleasant historical truths it may expose, Janda forged a gutsy, independent new model for screen actresses, with critics dubbing her the "Woman of Marble." Alternating between film and theater work, Janda made subsequent appearances in three other films directed by Wajda—*Without Anesthesia *(1978),* The Conductor *(1979), and* Man of Iron *(1981)—as well as Isetan Saab's Academy Award-winning* Mephisto *(1981). For her powerful performance in Ryszard Bugajski's* Interrogation *as a falsely imprisoned cabaret singer who resists Stalinist terror Janda earned the Best Actress award at the 1990 Cannes Film Festival. Janda was interviewed for* Cineaste *by Michael Szporer.*

Cineaste: *Your screen roles have made you into a symbol of the rebellious generation that signaled the beginning of the end of the Soviet empire. I suspect that with this image comes a good deal of responsibility to the public, especially now in the new Poland.*

Krystyna Janda: Times have changed. Of course, I cannot spoil the image which Andrzej Wajda has created, and I still have to be careful about what I play, what I say, and with whom I work. In this respect, I have to act responsibly. I wouldn't want to destroy the image because it would simply be a shame. On the other hand, I can now develop creatively in other directions. I can play comic roles, perhaps even in comedies about martial law. I can relax a bit and laugh. I can play roles like the one in the TV mini-series *Modrzejewska* or to be completely apolitical as in the role of Giselle in *Two for the Seesaw*. Before I rejected many roles, even roles which, as an actress, I really longed to play, simply because I had to live up to my image.

I think I'm a "natural" when it comes to acting, and occasionally I regretted holding back. There were times when I yearned to walk down the aisle in feathers with the other show girls, or to sing, or to play something totally stupid. People proposed excellent roles for me that were not my "type," and I had no choice but to reject them. I also had to watch what I said in public and even in private. When I made a TV appearance, I had to be very careful. Even when I went out in Warsaw or said something at a private party, I ran the risk of being called in and interrogated. This actually did happen to me once after I told a couple of jokes about the ZOMO [*paramilitary police units*—M.S.] at a party. But living up to my screen image was actually quite uplifting; it wasn't like I sinned. Now I am still careful. Please don't misunderstand me. I'm willing to put my own signature to anything I've said. I never said anything I didn't agree with. But now I can also be an actress in the wider sense of the word. I can play negative roles, or permit myself to splurge a little.

Cineaste: *You have been called not only the icon of Solidarity but also of the emerging feminist consciousness in Eastern Europe. What makes your roles really attractive is this feminist sensibility, which is really quite unprecedented in Polish film. You play very decisive women fighting not for some stereotypical set of values but for a deeply human individualism. You play strong, determined, independent-minded, and, above, all, thinking women. How do you see your energetic activism on the screen as reflecting what Polish women today think?*

Janda: I really believe that this strength of character comes from our tradition. In our literature or other forms of cultural expression, women are much stronger than men. The woman in her role as the mother figure is certainly cherished. In contrast, all our romantic male heroes fail. They have their weaknesses—they want to kill the tsar but catch fever. Kordian, Konrad, Gustaw—they are all weaklings. These men have terrible doubts and problems. The women, even though they don't play principal roles, are really the ones who endure, who wait, who suffer, who really make do under trying circumstances.

Women are marginal but strong. There are no winners in our tradition as far as the hero is concerned but the women hold their own.

I'll tell you a funny story about my positive role. When Andrzej Wajda first gave me the part in *Man of Marble*, he told me that in whatever I do, I had to enchant, anger, or irritate, because I had to carry half the film. And about my being up-to-date—several days later, he said, "Damn it, Americans are making films with just men. What the hell am I doing working with a woman? Can you do it like a man?" And I said, "I'd be happy to." That joke started the ball rolling. I suspect at some point Andrzej realized that I behaved on the screen without much thought; I acted on impulse, by instinct, because I knew such girls in my crowd. I blew them out of proportion a little but the role was real. It took awhile, but Andrzej sensed that aggression, that self-confidence, that dynamism, and that fortitude as an expression of new thinking, and he understood that there was a chance to show this emerging ethos on the screen. He told me that my role should announce to the world: "Watch out, here comes a generation that will not only open doors which were closed for so long. It will force them off their hinges." And he was absolutely right because my age group created Solidarity. He deliberately exploited my behavior and my personality to forge a new idea.

No woman before acted like that in our films; such a role never existed. In *Man of Marble*, there is not a single moment when I am self-involved. Aside from a brief scene with my father when I express some personal doubts, I don't think about myself. I'm always forging ahead, attacking the matter at hand, pursuing an idea, taking care of someone else. I move forward. I make the decisions. This determination was a real innovation. Until *Man of Marble*, women in our films were flowers to look at and admire. They just floated across the screen and really didn't hold power. They were self-involved, not other-involved. I really have to credit Andrzej with validating that determined woman who was in me—for telling me that's how it really ought to be.

And then, it was sheer luck that Ryszard Bugajski wrote a scenario that explored this positive figure from a woman's point of view. Immediately after reading it, I realized I had the opportunity to create a hero who was virtually nonexistent and could not be beaten by the totalitarian system. Tonia triumphs by her simple means—by sticking to her testimony and her personal dignity. Nothing more than that. I understood I could show everyone in the audience that even they could beat it. Of course, many people watching probably went through far worse and many of them were bigger heroes than Tonia. Neither Bugajski nor I were really exaggerating—I had the right to play that girl for them, to give them hope, especially the young.

The young have absolutely no idea. They take *E.T.* as truth, but they come out of *Interrogation* saying, "No, this couldn't be. This isn't true." They can't believe that such things, or far worse, actually happened. The younger generation doesn't understand or want to know that that's how it was in the old police state. This is why Ryszard's film was so important to us, and why I had to create a role which would reach even the fourteen-year-olds. That's why the film has certain

hues that seem improbable to those who lived through it. But we were making the film with the new generation in mind—to get to them. I had been told that if this role was played by an older actress who remembered the times or lived through them, she would not have been able to bring herself to such displays of triumph, to be so clear-cut in this particular role. It had to be done by a different generation. So we return to the point we discussed earlier—that only my generation could slap the face of the system and throw things out into the open. The older generation was much too self-conscious and carried too much pain inside. So everything hinged on a character who was drastic, who followed through on her actions, who had optimism, who was above all effective and clear about where to go and what to do, who could not be distracted and would never look back.

Cineaste: *Do I detect a deep feminization in this emerging vision, an anti-patriarchial quality that accompanies antitotalitarian thinking?*

Janda: Sure, in retrospect, but was it really intended? If they found a man like that, they probably would have used him. But such a man didn't exist.

Cineaste: Interrogation *really is a film about women. Do you think Bugajski has a special interest in the concerns of women?*

Janda: Yes, this is very unusual. There are few directors who can take the woman's point of view. Films are mostly made by men and about men.

Cineaste: *You play strong, unbreakable women. Nonetheless, when one contrasts Agnieszka of* Man of Marble *and* Man of Iron *with Toni of* Interrogation, *they are very different women. One is an intellectual who looks for her roots, who uncovers the secret history of her nation. The other is a rather ordinary woman who does not allow herself to be broken and struggles for her dignity without giving it much thought. She is not fighting for everyone, only for herself. The film has very little to do with ideology. Which of these roles is closer to you personally, which came more naturally?*

Janda: It's very difficult for me to respond to this question. I think that Agnieszka was closer to me at the time because I couldn't play or construct anything other than what I understood and knew and my knowledge of the Fifties then matched Agnieszka's—zilch! I learned as I learned the role. The heroine of *Interrogation* is really a fantastic idea for a film—starting with a person without any ideas or convictions, who is oblivious of the political system she lives under. That initial innocence really appeals to the spectator. Here is a blank sheet of paper that literally writes itself in front of our eyes. You experience her growing awareness. But Tonia was staged by me. Agnieszka was really me; Tonia was me the actress creating a role.

Cineaste: *So you grow with your films. . . become more of an activist?*

Janda: Of course. My development is obvious in *Man of Iron*, which came four years after *Man of Marble*. My Agnieszka changed, that is to say, I changed along with Agnieszka. For example, I knew Agnieszka wouldn't enter the shipyard. I knew that, as a woman, I should stay with the child. We considered for a long time whether I should participate in the strike. And Andrzej said, "No, because now you have to make yourself over into another symbol—the mother

who protects the future. Because that's how it ought to be. And you have to play it like that. This is already the next stage in the historical development."

Cineaste: *And then came* Interrogation, *another stage in the development.*

Janda: Yes, *Interrogation* looks at the problem in yet another way. That it's a woman this time makes it easier to tell the story. Using a woman made the experience more painful. If the point of view was of a man, it would have been told differently. A woman enabled us to explore the human frailties and to introduce playfulness into the part that would not have been accepted otherwise; using a woman gave us more flexibility. A man could not have experienced such moments of weakness and maintained audience empathy. Also, the story was really based on the lives of two real women who lived through the Stalinist hell: Tonia Lechmann and Wanda Podgorska, the secretary to Wladyslaw Gomulka [*former Communist Party Secretary*—M.S.] Mrs. Podgorska, who spent six years in prison, including two in an isolation cell, served as my consultant on the film. She told me what I could and could not do, how impudent I could get and what I could get away with, or how playful and still be tolerated. We had to make sure we documented the film very well, because we had to defend everything we did in front of a review board. That is why the French reaction at the Cannes festival showing, that the film was unreal, made me angry. It was remarkably factual.

Cineaste: *Your key roles have been in films about the Stalinist period. Would you agree that the different ways in which Wajda and Bugajski portray the period reflect the viewpoints of two different generations? Wajda shows us a slice of history, a bildungsroman of working class consciousness; his approach is more rational, an attempt to fill in historical gaps. Bugajski shows us the fragile, human side of this reality.*

Janda: Yes, he proceeds from detail to gestalt. However, one shouldn't forget that Andrzej's film was really a milestone, the first to deal with the Stalinist period. It had to be done that way. It breached a taboo subject. It opened the door for films like *Interrogation*.

Cineaste: *I understand, but that doesn't take away from the contrast. Bugajski's film gives us a slice of life of those times; it is really a period piece exploring a human tragedy in a deeply personal way. Do you think the differences in vision can be explained by the generational gap?*

Janda: That's likely. Or perhaps it is Wajda's personal style. He has a real flair for the social, for being a "social activist," a label which in Poland is sometimes used pejoratively. He envisions himself in the role of the teacher of the nation. Ryszard simply made a film about a detail that appealed to him, while Andrzej knew that he was making one of the most important films in the history of our cinema to raise the consciousness of a new generation that had no idea about Stalinism. Fully aware he was dealing with a taboo subject which couldn't be discussed or written about, Wajda knew he was making history. I suppose you could take it as a generational trait, but I really think Andrzej simply has it in him, that flair for the masterpiece. That's why he made *The Wedding, The Shadow Line, The Promised Land*—all these films hit a high note. He likes grand

gestures. Ryszard picks up a detail which appeals to him, and, if it strikes a deeper chord, that's another matter. He didn't make much of it. He was looking at the Fifties from the vantage point of a new generation that looked at it as interesting history. Andrzej thinks in terms of the big picture, while Ryszard gets it out of the details. For him the Fifties, nine years after Wajda, was a known quality. He knew he was making a film for people who knew what it was about. Andrzej's film for my age group was a real eye-opener. He started with the ABCs and taught us letter by letter.

Cineaste: *How was making films under the pressure of censorship changed now?* Interrogation *was one of the first Polish films made without censorship.*

Janda: Yes, it was one of two films made without permission from the censor, without submitting the scenario for review, during those eighteen months of anarchy when we were free to do anything we wanted. And we hurried to finish before the situation changed.

Cineaste: *And it was actually edited during martial law.*

Janda: When we were making it, I couldn't believe we were making it, that it was possible to do it. Eighteen months was not a whole lot of time to get used to the idea that it was possible. We thought perhaps we were mistaken. When I look back at this role and review nine years later how I acted [*Interrogation* was shelved in 1982 and released on December 13, 1989—M.S.], I suspect if I were doing it now, I would reflect on it more, I would construct it more carefully. I know much more now. But then and there, with the growing realization that happened so suddenly—that it was possible to do it—it was a sudden outburst of hate. I gave myself completely over to that brief scream without really reflecting on it.

I guess what I am saying is that I was really a faithful child of that nightmarish system, a good girl who went to that school, watched that television, read those books, attended those military defense classes—who diligently studied Poland, the Fatherland, the road to communism, and so on. Oh, I was such a good student and so carefully indoctrinated. Only a person like that, who comes to a realization what has been done to her, could possibly generate such an outburst of hate. Today, I would try to balance the sides, I would wonder whether it wasn't too rough, whether it wasn't too much. At that time, I didn't think, I simply screamed. We all did. It was as if we found water after being in the desert for twenty years. I remember that we filmed on Sundays, at night, impossible even in Poland. On this film, no one objected, from the lighting engineer to the stand-in. It didn't even enter our mind. "On Sunday? Hell, let it be Sunday!" Everyone knew we were doing something unprecedented, something never done before. We knew we had to do it as fast as possible and as good as possible. How we used to argue, how we used to yell at each other. By the end, we didn't talk normally, we just screamed. Never before in my life had I made a film in such an atmosphere.

Cineaste: *Can you imagine a situation where lack of censorship can be detrimental to a film? It has been said that censorship contributes to suggestiveness and symbolic texture. By contrast,* Interrogation *has none of that. It strikes*

me that your role in the film was without any make-up, and Bugajski's film is very raw. It has a documentary look.

Janda: There is something to what you say. There was a time when Polish audiences knew that certain subjects were taboo, so, when it was possible to get something past the censor with a wink, it was all the more satisfying. Those who made films and those who watched them were in a conspiracy against a common enemy. For someone looking in from outside, the audience reaction must have seemed puzzling. Everything was based on this aesthetic of winking the eye and looking for a deeper meaning. Now this is over; we have to reestablish real norms, but it's not easy. Several directors told me they are unable to make films without censorship; that thrill of suspense, that added edge of putting somebody in confidence by some oblique means has vanished. I remember Andrzej Wajda once started making a film about priests and met with an even worse censor in the church [*laughs*]. So he dropped the project after a week—you can't do this and you can't do that. It was an excellent idea with something about Solidarity in it. But he reflected: if it was allowed, then there was no reason to make the film. He dropped the project because he realized that only in our sick system would such a film have any real value. A film is made because you can't make it, but, if you could, would it be worthwhile? Many people today have serious problems making films in a world without censorship. We don't know how to make other films yet.

Cineaste: *For years, artists here have been in opposition to the regime. This has recently changed. A maverick, a dissident, is suddenly "official" in post-Soviet Poland. What psychological effect has this new order on the artist and her creative abilities? How are you coping with being "establishment"? Can you be critical or might it be construed as blasphemy? Do you foresee a cabaret about Walesa in the near future, for example? And does this changing situation bring about new uncertainties, a new form of self-censorship, or even a new tendentiousness of some other kind?*

Janda: You hit on the most perplexing problem confronting the artist in Eastern Europe today. That is, the cabarets are down and nobody really knows what kind of films we ought to be making. No one would dare yet, no one has figured out how to make a comedy about such subjects as martial law, which is what the audience really wants. The audience is way ahead of the artist. The letters I receive from fans are precisely about that—they want comedy, they want us to laugh at ourselves. Unfortunately, we are still not up to it. Yet it is the first duty of the artist to be in the opposition. But whom to mock? Not the current government—they haven't had enough time yet; not the old regime, that's already a low blow. No one knows what to do. I read a lot of scenarios by young people, and they either still want to dwell on the Fifties, which nobody wants to see, or on martial law, which everyone has seen, or do science fiction or ballroom dramas, and that's it. They are incapable of doing anything else because they haven't gotten used to the new times, to telling real stories about real people. I have not read a single scenario recently in which I want to act. Nothing has genuinely moved me. Not one of these scenarios has struck a chord I'm certain

the audience wants to hear. What's more, a lot of artists are suddenly in politics. This is a transitional period, but I'm really banking on the very young, on those who are just beginning. They will strike that new chord and set a new tone for our cinema. Some hopeful signs are already there—for example, the young director Mark Koterski who made the film *Madhouse* and who recently wrote a play, *Teeth*, a comedy that mocks all our national sacred cows and which no theater is courageous enough to put on. He might be an early swallow before the oncoming storm.

Cineaste: *In your opinion, is art in Poland today completely free, or is some new ideological hue taking shape? And what about the new economic conditions, how will these affect filmmaking?*

Janda: This is a very difficult question, since filmmaking here is really being restructured from the ground up. No one is in the position to say what will be its future or, more concretely, to predict what will happen to the industry when government subsidies run out in 1991. Can film survive without subsidies? The most catastrophic picture of what might happen already exists for writers and poets, since some books will now not be published and some are not even being accepted. No one knows how to finance them. Many theaters are likely to be disbanded, and there might be only two or three left in Warsaw. Who will play in them, no one knows. Our situation reminds me of a woman past her prime who is powdering herself and doesn't want to admit she is getting old. Everyone seems to be pretending they don't see the writing on the wall. We had time to reorganize, but it's running out. As for the audience, it doesn't want to see us as sickly, poor, ugly, and bad, but as beautiful, rich, and happy. But no one thinks that way yet. I think young directors already understand that if they really want to do something, they will have to go abroad and find money, then come back and shoot their idea here. But then these ideas, these themes, must be international, European in scope. They can't be narrowly defined by our local problems.

We won awards because we were different. Our cinema until now has been completely involved in our internal problems, which the world outside didn't understand but which we tried to show, sometimes so feverishly and with so much passion, which they have long forgotten possible. *Interrogation* is a very hot statement which must have been a shocker to anyone looking at it outside of Poland. Even when they raise serious questions, films made in the West are smooth, pretty to look at, and, by comparison, much easier to digest. When *Interrogation* was shown at Cannes it must have seemed like hysteria, particularly after the collapse of the bloc. No one was quite sure how to take it: whether to dislike it, to be angry, or to take slight offense. Some well-known producers with a number of excellent films to their credit came out of the showing with the habitual, "Thank you for a most enjoyable evening." No, I don't expect to always be known for political films. Not all my roles have been political and our situation has changed. But the police state terror was very real, and films like *Interrogation* are not just fairy tales of horror. What we showed wasn't pretty, but it was true.

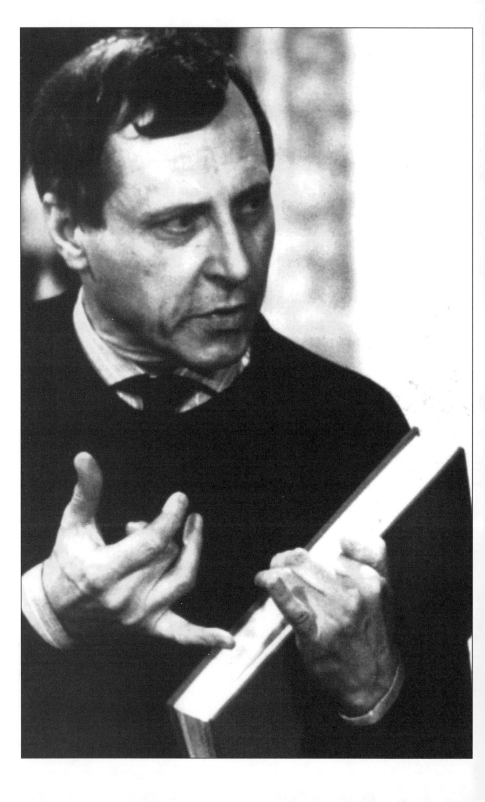

8 PETER GREENAWAY

Cinema as the Total Art Form

Born in England in 1942, Peter Greenaway attended what he calls "a minor English public school that preserves the worst traditions—fagging, burning the pubic hair of new boys, that sort of Godawful activity." After completing the Forest Public School, Greenaway resisted his parents' plan to send him to university and went instead to the Walthamstow School of Art in east London. He exhibited for the first time at Lord's Gallery in 1964. In 1965 he became a film editor with the government's Central Office of Information, where he cut educational documentaries for a decade.

Greenaway made his first films, Train and Tree, *in 1966. By the time he earned, in the late Seventies, his first 7,500 pounds from the British Film Institute for* A Walk Through H *(40 minutes), he'd made over a dozen films, while keeping his hand in painting book illustrations and novel writing. In 1980 Greenaway made the three hour* The Falls. *It won the prestigious BFI Award and landed the funding agency in a crunch. No other organization was likely to finance such kaleidoscopic, non-narrative works, yet the BFI had obligations to other up-and-coming filmmakers and to the new Thatcher government, whose backing helped support it. The controversy about funding Greenaway resolved when the new Channel Four Television agreed to cofinance him with the BFI, provided he kept to a few conventional guidelines. That pact yielded* The Draughtsman's Contract *and Greenaway's career in feature films. Greenaway was interviewed for* Cineaste *by Marcia Pally.*

Cineaste: *Since density is such a hallmark of your work, would you talk about how you fill up your screen, how you select and order so much stuff?*

Peter Greenaway: It may be banal to say that cinema is an art—certainly in many parts of the world it is not regarded as such. But if it is an art, it should be allowed everything we accredit to the novel, the symphony, and so on. Works of art refer to great masses of culture, they are encyclopedic by nature. I want to make films that rationally represent all the world in one place. That mocks human effort, because you cannot do that. But the works of art that I admire, even contemporary ones like *One Hundred Years of Solitude* or any three-page story by Borges, has that ability to put all the world together.

My movies are sections of this world encyclopedia. What I'm manipulating is our cultural illusions—all the very potent, meaningful language of illusions that Western culture has. In *Cook Thief* [*The Cook The Thief, His Wife, and Her Lover*—ed.] I'm looking at cuisine—the very careful effort to arrange and present one of the most primal human activities. It's an effort to de-food food, just like we try to de-chaos chaos. In *A Zed and Two Naughts* I look at creation myths, Genesis, and Darwin. Genesis is a nice way of ordering the beginning of things with a very pretty myth. Darwinian theory is a nineteenth- and twentieth-century myth that's trying to do the same time.

I've always had the desire to organize things—where that comes from I don't know. I'm a lousy mathematician, but I am interested in rationality. I suppose it comes from my classical English education and three years in a rather academic art school. My ten years at The Central Office of Information were spent editing films that portray, supposedly, the English way of life through statistics. How many sheepdogs are there in South Wales? How many Japanese restaurants are there in Ipswich? It's all about the organization of ephemera.

My early movies are very much about this sort of organizing. That's what art is about, isn't it—trying to find some order in the chaos? That's what civilization is about, some way to understand, contain this vast amount of data that's pushed at us all the time. Even those who do those false arts—the small Cs, couture, coiffure, and cuisine, all with French names, by the way—they look for a way to order their efforts.

The French chef in *Cook Thief* is a deliberate cliché that critiques those small-C arts, but he is also me. With each film, I invite people to my table and I make the meal. I take the cultural systems I admire and try to set them out in one place. I demand, as we all do, some sense of coherence, of order in world. And we are always defeated. This is the human condition.

Cineaste: *Some artists respond to the need for order by clearing everything away and drawing the one necessary stroke. Your impulses are quite the opposite. Your screen overflows.*

Greenaway: I do hope that all the objects and events in my films are germane to the content. Obviously, in a film where I examine cuisine I would examine how other artists have used food in their work. The cook presents cuisine as a piece of civilization. In seventeenth-century Dutch painting, which

I refer to in *Cook Thief*, food was also thought to reflect the civilizing forces of that era, the power and wealth of the high bourgeoisie. It declared the success of the political and economic structures emerging at that time.

I think the most successful of all painting has been that of the Dutch golden age—I refer to it in much of my work—because it was done when each individual painter was most understood. It's very bourgeois, not the privilege of the church or state. It was the time when art became most democratic and so most understood by the most people on both its literal and allegorical levels. A woman who holds a mandolin with three broken strings probably means she's had two abortions. If she's not wearing shoes it means she's a loose woman. All that language has been lost to us, but it was commonly understood by the bourgeois Dutch, by the people who commissioned the films . . . er, paintings . . . sorry, Freudian slip. It was their language. Painting today has again divorced itself from mainstream activities and become a rather rarefied object.

I would like my movies to work the way Dutch painting did, on literal and metaphorical levels. If you've got that as a premise it's no problem at all to find all the information that ought to go in the frame—all the cultural, allegorical material.

Cineaste: *How do you choose the organizing art or science for each film?*

Greenaway: I try to choose them to be germane to the thematic material. It's very important for satisfactory art that there be a very happy marriage between form and content. Take, for example, *A Zed and Two Naughts*. It's a film about twin scientists who try to organize the plant and animal universes, the beginning of things. One of the central organizing structures of the film is the alphabet, which I chose because most cultures use it as the basic template for organizing information.

I use number series for that reason, as well. *Drowning by Numbers* is about game-playing; I begin the film with a little girl counting to a hundred because counting is one of the basic ways games are organized. The film is filled with number games. For instance, the coroner's son is named Smut, which begins with the letter S. So there are one hundred things in the film that begin with S. You don't have to know that to see the film, but it somehow enriches the fabric of it, makes the film again encyclopedic in nature.

Symmetry is an important element in *Belly* because the problems of construction—or civilization—and decay are seen from the point of view of a classical architect. It makes sense to express civilization with the sorts of constructions he'd be most familiar with. The only time the symmetry collapses is at the end of the film when the architect dies and the audience sees the film on the diagonal. It suggests, I hope, that the Apollonian universe that he tried to maintain has been destroyed.

In *Cook Thief* I wanted to use color as an organizing principle in addition to cooking, because color has become so divorced from meaning in twentieth-century painting. We no longer have to paint the sky blue simply because we observe it to be blue, so color has become decorative, even cute. I wanted to make

a film where each color had a meaning within the language of the movie. The room where the thief eats, where the violence happens, is red. The car park is blue because it's the cold nether regions of this world. I made the lavatory white obviously with some irony. The book depository is golden to suggest the golden age of books, the gold color of old book bindings.

The kitchen of the restaurant where the cook works is greenish because it suggests safety and vegetation, where food comes from. Because it is a gray-green, stony color and a very large, cavernous room, the kitchen can also be seen as a cathedral. The cook sits at a kind of altar in a rounded apse area. The kitchen boy has a nimbus around his head and sings the 51st Psalm, which is about being an unworthy sinner—which the thief certainly is—and is the low point in the Catholic year.

There are other religious references in the film. The lovers who make love naked amid the food and foliage of the kitchen recall Adam and Eve. When they leave, they go to the book depository, the Tree of Knowledge. They are driven there in a van of rotting meat, which can suggest their journey through hell. The van can also suggest the Trojan horse myth. Since the van belongs to the thief, he has unwittingly provided that way for his wife and her lover to escape him.

All these minute references rely on the great cultures of Western civilization (the Greco-Roman and the Judeo-Christian), which has tried to order and explain the world to its inhabitants for over 2,000 years. These devices should emphasize to viewers that they're watching artifice, a construction overlaid on the world. It is not natural, not slices of life. *Cook Thief* opens with curtains and closes with curtains. It is a performance. The very effect of placing cultural artifacts into a filmic frame is an attempt to order them.

I'm in no way a neorealist. Neorealism and naturalism in cinema is a chimera anyway. You can't be real in cinema; you make a decision about form and artifice for every twenty-four frames per second of film. All those theoreticians who concern themselves with realism in cinema seem to be barking up the wrong tree entirely. I think the most satisfactory movies are those which acknowledge their artificiality.

I'm looking for ways of structuring films that coexist with my thematic material but that also have their own identities and interest. In some ways my films are more satisfactorily explained by the aesthetic one brings to painting than to movies. The sense of distance and contemplation they require has much more to do with painting. When you go into an art gallery you don't emote, by and large, like people do in the movies. I know my work is accused of being cool and intellectually exhibitionistic. But I'm determined to get away from that manipulated, emotional response that you're supposed to have to Hollywood cinema. Human relations are considerably harder and harsher, and much more to do with contracts than with any glossy ideas that are so much in the current media package. Most mainstream cinema tends to glamorize, deodorize, romanticize, and sentimentalize. I'm very keen to not do those things.

My other bugbear about Hollywood cinema is that it's based on the nine-teenth-century psychological novel, and the psychological novel represents only a tiny space in two thousand years of European cultural game-playing. I want to investigate some of those other forms, like Jacobean drama or landscape painting.

Cineaste: *In most of your films, men are the civilizers, the people who combat chaos. Women give birth and murder. Your sympathy seems to be with the men—until your last film,* Cook Thief, *where for the first time you give the woman the civilizing efforts.*

Greenaway: My films have been accused both of misogyny and of championing the supremacy and confederacy of women. On one hand, women always end up as the dominant force—especially that last line in *Cook Thief* when the wife forces her husband to eat the body of her dead lover. "Why don't you eat the cock?," she says. "It's a delicacy and you know where it's been." It's seen as the final humiliation of the male. In *Drowning by Numbers*, which is about impo-tence, the central man desperately tries to express his sexuality, and he fails.

On the other hand, I'm accused of misogyny because I force these women to go through such humiliating experiences—as though the fact that they win is just my cop-out for all the rest. I don't think I'm a misogynist; I hope I'm not. In *Cook Thief*, the woman begins cowed and bullied, and ends by finding strength—and she is motivated by love. After all, *Cook Thief*—though this surprises many people—is motivated by love, not hate or misanthropy. She ends up triumphant, though there is an irony to her triumph. She has to use the violence of her husband to turn it on him and win.

The twentieth-century male has desperately to reorganize his sexuality in terms of the emancipation of the twentieth-century female. We all know we have a hell of a long way to go. In my films, women make the decisions that make the action. Men may be vile and barbarously destructive or they may make attempts at civilization, but the women make the decisions that count.

Cineaste: *But there's been a change in the sorts of decisions your women make. In* Cook Thief, *the wife kills the thief in the name of civilization. The women in* Drowning *tolerate men only as long as the men give them sex and children, and then murder them by drowning—all that womblike water. This is the primal view.*

Greenaway: One of the projects I'm working on now is a twentieth-century reconsideration of the Medea myth. It is a monstrous idea that a woman would murder her own child, but I want to try to place the audience in sympathy with her. Her action will have to do with a bid for absolute freedom without any trammels whatsoever. Medea was a powerful woman who organized her life and fate. She also represents woman as witch, an idea that has permeated all European culture. Men are so shit scared of female activities, especially if they are clandestine.

My movies are cathartic attempts for me to work out certain problems. My characters are the same age as me; as I get older, they do too. I want to make movies for people who have the same anxieties, hopes, fears, and ambitions that I have as a man approaching middle age.

The most personal movie I ever made was *Belly of an Architect*. For architecture, write film; for architect, write filmmakers. The architect in *Belly* is trying very hard to put something up in the world, but he's very doubtful so he's doing it by proxy—by mounting an exhibition of the work of an architect who lived hundreds of years ago. He believes that we can make ourselves immortal by creating one grain of sand on the beach of civilization—not by religion, which fades, and not by politics, which fades very rapidly, but through art. Though we know very little about Egyptian religion or statecraft, for instance, we do have their art. It seems to survive, as a talisman that's passed on. Man has been able to make these magnificent structures which do seem worth preserving.

The irony of *Belly* is that this guy, who's put all his efforts into making art, loses out. He loses his wife, his child, his health, and, ultimately, his life. Many architects end up as paper architects; they never make the final product they've been dreaming about. This is also true of filmmakers. Moreover, the financiers, critics, politicians, and producers are all apparent in the form of a film, in its architecture and perception of the world.

I'm first now understanding how personal my films are. There's a way in which all my films are about my father. He died of stomach cancer, like the architect in *Belly*. He was a huge man, an anti-intellectual businessman who lived in London and had a great desire to be an ornithologist. He prepared to take early retirement and go to the country with a pair of binoculars, but just at that moment he went down with stomach cancer.

I'm in the extraordinarily fortunate position of being allowed to make signature movies. I have many more ideas—eighteen or twenty scripts lined up to be done. I feel that ultimately I'll be defeated, that there won't be the time to do them.

At the end of *Belly*, the audience hears the cry of a child, which might indicate that the best way we can be immortal is through the female ethic—even if bearing children for the male is mostly an involuntary process. This may sound like a very corny, clichéd attitude, but if we're concerned with immortality—and I'm sure all of us fear the vacuum of not being here—then we are concerned with that Picasso idea of leaving a stain on the wall.

My films try to address that problem for myself. What is all this about arcane cultural information that I'm trying to construct into a film? What am I doing looking over my shoulder at past ages and dragging all this past culture into some organization, some art, for the present day—this postmodernist concern with trying to make history and culture relevant to now?

Cineaste: *Do you have children?*

Greenaway: Two daughters. My purpose on earth was finished a long time ago. I do believe in that Darwinian idea that we are here as sperm and ovum carriers.

Cineaste: *It's fairly common today to believe that men and women can contribute both children and work—art or science and so on—to the world. Do you disagree?*

Greenaway: The Medea character in my new project is an archeologist.

Archeologists are concerned with organizing history in a very empirical way. Maybe there's an answer to your question in the future.

The Media film is not the very next project; that I hope will be a version of *The Tempest*. We're calling it *Prospero's Books*, but we're using the Shakespearean text. Gonzalo throws some books in the bottom of Prospero's boat, and the rest of the film is seen through those books. It's as though books maketh man. *The Tempest* suggests that ultimately books led Prospero the wrong way. Again, the film is a concern with organizing, learning, and knowledge—especially for an old man.

There are basically only two subject matters in all Western culture: sex and death. We do have some ability to manipulate sex nowadays. We have no ability, and never will have, to manipulate death.

Cineaste: *Do you feel frustrated trying to pass on knowledge through your films?*

Greenaway: I get a kick out of the pursuit of knowledge. The sheer garnering of information, the collecting and collating, the finding, reading, and research is of great interest to me. I enjoy it, and it's the stuff I want to use to make my movies.

Borges once said it's much more difficult to read a book than to write one. In a peculiar way, he was right. Think of what a work of art demands of an audience. It's OK for me because it's my world; I made it. It's much more difficult for you to inhabit a world of my making.

For instance, my relationship with my father was never a happy one. I'm sure I'm reprising aspects of it in my work. But to make autobiography work for anybody else, it has to be refashioned into something less personal and self-indulgent. I dislike the psychological approach to art. It's too limiting. For instance, do we really know more about Van Gogh's painting of sunflowers because we also know that he cut off his left ear and gave it to a prostitute? Is it important that the author make himself very apparent behind the work? I have the feeling that the work is itself important, and what you know about the author doesn't necessarily throw more light on it. It's a terrible misalliance of appreciation.

Psychoanalysis is also used to blame our parents and our heritage for everything that goes on, as if to absolve us of personal responsibility. I object to this a great deal. I have to make my films somehow readable to an audience and financially responsible. Fortunately they have so far been successful enough at the box office, in European terms, for me to go on making them.

Cineaste: *How are your films financed?*

Greenaway: A Dutch producer, Kees Kasander, financed *Zed*, *Drowning*, and *Cook Thief.* Most of the money comes from European sources—for example, the organizations contributing to *Drowning* include Film Four in England, the Coproduction Fund for the Dutch Broadcasting Corporation, Elsevier Vendex Film, Prokino in Germany, BAC Films in France, Progres film in Belgium, and so on.

The films are made extremely cheaply. *Cook Thief*, for instance, cost something like $2.8 million. And they are organized very economically. Everything is written down; even the smell of flowers is marked if it needs to be there for the actors. Initially, we break even, and after perhaps three of four years we gradually slip into profit.

Cineaste: *Do you get BBC funding?*

Greenaway: I never have. It's always been Channel Four, till *Cook Thief*, which they found much too tough for British television. I've always had very large input from French sources. I think my best audiences are French, because they are great delighters in the accumulation of knowledge and they understand what I'm doing.

We still have that anti-intellectualism in Britain. The recognized channel for intellectual information in Great Britain is the theater. You can do anything you like there, but not in films. Tom Stoppard, for example can get away with anything. Should you attempt a cinematic essay on grand ideas, there's a feeling that film can't hold it together. It's a form of snobbism that ends up an anti-intellectualism.

Cineaste: *Anti-intellectualism in the U.S. crosses all art forms; there's no exception for theater.*

Greenaway: You have a fantastic cultural Puritanism over here. For example, all the attention you pay to frontal male nudity in films. It's too bad for me, really, since the nude-naked nexus is one that interests me. There are a great many issues about the body besides the sexual one—like vanity, for instance. From the European perspective, it seems quite pronounced in America—this coy concern with youth, all the jogging and harsh dietary regimens. It has to us an arch feel, as though you feel guilty about yourselves and are unable to accept what mortality is all about.

I don't know if the recent popularity of Puritanical restrictions—in all the fundamentalist movements we see nowadays—is linked to the panics that traditionally develop at the end of millennia. I'm writing a novel, *The Historians*, about the second between the year 1999 and 2000. It describes three centuries—past, present, and future. It's really about all of history. I'm fascinated by the panic around the Western world when the year 999 became 1000. People were jumping off cliffs, slitting their wrists, and so on.

Fundamentalist religions are a shield, of course. Without imagination or effort, it solves all the unanswerable questions. It pushes the responsibility somewhere else, which is what's so incredibly dangerous. Fundamentalism is also part of the anti-intellectual ethic—the denial of rationality and imagination. To be an atheist you have to have ten thousand times more imagination than if you are a religious fundamentalist. You must take the responsibility to acquire information, digest and use it to understand what you can.

Cinema is an ideal medium to do that in. It can contain metaphorical, allegorical, and literal meanings. It's the system Wagner always dreamt of, the total art form—and already it's dying, technologically and socially. The statistics in

England say that in the 1950s every family used to go to the cinema at least three times a week. They hardly go three times a year now. There are other indications that we're picking at the corpse. It seems every city in the world now has a film festival. And there are thousands of critics, which is always terrifying. It's like ballet: as soon as the critics become more numerous than the dancers, you're in great danger.

No one can do anything abut this death of cinema. *Draughtsman's Contract* was paid for by television money, and I was bitterly disappointed when I saw it on a television screen. It just didn't work. But there's no use complaining. I thought cinema was a vocabulary that had all the letters of the alphabet. Television has only vowels—primary colors, simple soundtracks, large closeups, no wide shots. Keep the picture moving, don't hold a still.

It's also disastrous as a capitalist vehicle. In Great Britain, the Sixties and Seventies saw the Golden Age of television. Now we're on this slippery slope to get the highest ratings. The quality goes down, monopolies of the media are held in more and more banal hands. Attempts to be innovative, exploratory, or investigative are disappearing.

I don't want to get too carried away talking about the death of cinema because of television. Cinema is related to 2000 years of image-making in Europe. When the electronic media get switched on around the world, there will still be painting and draughtsmanship—that goes back to the caves. The continuity of the effort continues, only the tools change. If you look at painting at its prime, it is a form of visual philosophy. Its crucial elements can still happily be contained in cinema and television. Now we're into holograms and so forth, but I don't think that matters. These machines are only as good as the imagination that uses them.

Cinema is about one hundred years old. If you examine the West's large cultural movements, they all last about one hundred years. Fresco painting did, easel painting, and so on.

Cineaste: *In the face of social or technological change, there's always alarm that the new technologies will never be what the old ones were.*

Greenaway: Nostalgia. We're always so frightened of the new—people put wallpaper in their caravans. John Cage used to say there's a fifteen-year gap between the cutting edge of culture and when even the highly educated follow on. The general public has just about caught up with Impressionism.

In Jane Austen's time, people complained that the young learned bad moral impulses from the novel. Exactly the same arguments were used in the 1920s against cinema, and again today, about television. It's part of that silly "They don't make 'em like they used to" cry, or the ridiculous notion that now, today, it's worse—more decadent, more corrupt—than it ever was. Of course this is what every generation says.

I always thought my children would know what Jericho and who Hercules were. There is some indication that these two main mythologies of Western civilization are fading and need to be replaced. OK. What is replacing them?

Superman? Batman? When you have no idea of what culture preceded you, you're limited to what can be invented at the moment.

On one hand, our knowledge about the past always diminishes. Content always atrophies. Poussin's paintings, for instance, are rather recherché in their classical references, and most people don't know what the hell they're about. Yet we still admire and enjoy a Poussin painting. The form exists long after the content fades. On the other hand, Judeo-Christian and Greco-Roman traditions determine so much of life today—from our legal system to our buildings and streets—that if you know very little about them you inevitably know little about the forces that run your life.

Cineaste: *How do you find the time to make films, television programs, write novels, paint?*

Greenaway: I don't do all that much research, and what research I do gets done after the fact. I write the script and then collect the background. For example, I know only the architecture that was necessary to do *Belly*. I don't employ researchers. I read the architectural magazines and take what's necessary from the general culture.

My films often start with some quite minor characters whom I fantasize about and make my own. One impetus for *Belly* was my interest in an eighteenth-century architect whom I studied marginally in art school. The other impetus was a painting by Bronzino of a man called Andrea Doria, a Genoese statesman, age 45, done in the nude. I was intrigued that this 45-year-old man of great social standing would want to have himself painted so vulnerably. I began looking for someone who looked like Andrea Doria. I was very lucky to find Brian Dennehy.

There are also certain cultural traditions that I use repeatedly in my films because they are very important to Western Civilization—like Dutch painting—or because they are especially germane to my themes of order and decay, like Jacobean theater. It was the theater looking over its shoulder at the grand Elizabethan age of exploration and comparative financial success. England is still looking over its shoulder at the loss of empire. The Jacobeans had a great sense of melancholia—think of the funereal colorations of the poetry of people like John Donne. There seems to be a parallel in contemporary Britain—a peculiar nihilistic fatalism, as if to say, "These are simply the way things are."

I'm also interested in the theater tradition of the evil character. There are very evil characters in *Draughtsman*, for instance, and there are a couple of lines in *Cook Thief* where the thief gives away his desperate, vile identification with people like Mussolini. He keeps his tiny private army of cronies who dress up in pseudo uniforms and parade themselves very much like some swaggering, emasculated army. He associates grandiosity with the bully's figure.

Cineaste: *Are you making a connection between dying civilizations and bullies who try to goad power where there is none?*

Greenaway: Perhaps. Think of all those evil, late Roman emperors or those larger-than-life terrorists of the late French revolution. Is this characteristic of

late twentieth-century Britain? It's certainly uncharitable to think so, though the current Tory party in Britain has made one or two adjustments in that direction.

Another tradition that reappears in my films is food and the uses of food in centuries of theater and painting. Eating tells you a great deal about people—like all those young middle-class people, the yuppies, who go out to eat all the time at places where it's more important that the tomatoes match the wallpaper than it is that the food tastes good or is nourishing. They don't go out to eat so much as to show off their clothes or the way they can handle a knife, fork, and wine glass. Food is a very good way to critique the people who eat it. Today's dining critiques a society where consumerism has run riot.

Certain technical, painterly problems also keep reappearing in my work, like the problems of masking that first appeared in European table paintings—arranging people around a table so that no one is obliterated by anyone else. Or the problem of choreographing characters in the space of a film, and the physicality of bodies.

Cinema usually uses people as personalities rather than as bodies. You do see a lot of naked people but usually to reveal something about sexuality. Since I spent a lot of time drawing nudes when I was in school, I want to see the physicality of an actor, the size, the bulk, the shadow they cast on the wall. Brian Dennehy was especially good for this as the architect in *Belly*, where his considerable figure moves through all those fixed architectural spaces.

So there are cultural traditions and disciplines that always interest me and there are the specific triggers for a film, like the one about Andrea Doria that I mentioned.

When you publish this, will you edit for clarity and such? I'm concerned with being absolutely clear. When people sit around and talk as we have, information tends to get disorganized, so when you edit this . . . I do want to be clear.

9 SPIKE LEE

Our Film Is Only a Starting Point

Spike Lee won the Student Award of the Motion Picture Academy with his first film, Joe's Bed-Stuy Barbershop: We Cut Hair *(1980), a documentary made as his master's thesis at New York University. After failing to complete an auto-biographical film project, Lee made a sensational feature film debut as writer, director, producer, and actor in* She's Gotta Have It *(1986). Made on a shoestring budget, the comedy became a hit with arthouse and black audiences. Studio money backed a lackluster* School Daze *(1988), a satire on black colleges, but cashed in on Lee's first commercial hit,* Do The Right Thing *(1988). This sizzling examination of racism in Brooklyn was followed by examination of the jazz scene in* Mo' Better Blues *(1990) and black-white romance in* Jungle Fever *(1991). Lee's next film,* Malcolm *(1992), had a background involving years of political wrangling over who was best equipped to do such a film, and Lee's insistence that a film about such a major American figure demanded the same kind of budget enjoyed by films like* JFK *(1991).*

In the following interview Lee explains his primary desire to introduce Malcolm X to young viewers and his awareness that the time limits of even a nearly three-and-a-half hour movie prevented him from producing anything more than a "primer" on one of America's most charismatic black leaders. He comments on the pragmatic and political considerations involved in arriving at a fully informed appraisal of the cultural and political significance of the life of Malcolm X. Spike Lee spoke with Cineaste *editors Gary Crowdus and Dan Georgakas in mid-December 1992, just three weeks after the film's nationwide premiere.*

Cineaste: *What sort of research did you do for the film? And what was the role of your historical consultant, Paul Lee?*

Spike Lee: I read everything that I could, including a new book by Zak Kondo about the assassination that was very important in helping us re-create the assassination in the film. Paul Lee was a great help because he's someone who's really devoted his life to Malcolm X. Paul, who lives in Detroit, was in the Nation, I think, when he was twelve years old. As far as scholars go, I don't think there's anyone who knows more about Malcolm X than Paul Lee.

I also talked to a lot of people, including Benjamin Karim, who's Benjamin 2X in the film; Malcolm's brothers, Wilfred, Omar Azziz, and Robert; his sister, Yvonne; Malcolm's widow, Betty Shabazz; and Malcolm Jarvis, who's Shorty in the film. I also went to Chicago and talked to Minister Farrakhan. That's where a lot of the good stuff came from, going around the country and talking to people who knew Malcolm. Not just his relatives, but people who were in the Nation with him, in the OAAU (the Organization of Afro-American Unity), and so on.

Cineaste: *Have you had any dealing with the Socialist Workers Party? They got to Malcolm early, gave him podiums numerous times, and published a lot of his speeches.*

Lee: Pathfinder Press? No, I just used their books, because they're fine documents.

Cineaste: *Of the various screenplay adaptations of* The Autobiography *that had been written, why did you feel that the James Baldwin/Arnold Perl script was the best?*

Lee: I read 'em all—the David Mamet script, Charles Fuller's two drafts, Calder Willingham's script, and David Bradley's script—but the Baldwin/Perl script was the best. James Baldwin was a great writer, and he really captured Harlem and that whole period. He was a friend of Malcolm's.

Cineaste: *What did your rewrite of the Baldwin/Perl script involve?*

Lee: What was lacking, I felt, in the Baldwin/Perl script was the third act— what happens during the split between Malcolm and the Nation, between Malcolm and Elijah Muhammad. A lot of stuff about the assassination had not come out then. William Kunstler was a great help on that. He represented Talmadge Hayer and gave me a copy of Hayer's affidavit where he 'fessed up to the assassination. I mean, if you look at the credits of the movie, we name the five assassins, we *name* those guys—Ben Thomas, William X, Wilbur Kinley, Leon Davis, and Thomas Hayer.

I just wanted to tie the film into today. I did not want this film just to be a historical document. That's why we open the film with the Rodney King footage and the American flag burning, and end the film with the classrooms, from Harlem to Soweto.

The speeches in the Baldwin/Perl script were not really Malcolm's best speeches, they did not really show the growth politically of Malcolm's mind, so we threw them all out. With the help of Paul Lee, who gave us copies of every single speech that Malcolm gave, Denzel and I chose and inserted speeches.

Baldwin had stuff out of order. He had Malcolm giving speeches at the beginning of the movie that didn't really come until 1963 or 1964, so we had to get rid of those.

Cineaste: *So Denzel was involved somewhat in working on the script?*

Lee: Yeah, Denzel was very involved. He has a good story sense. We both knew a lot was riding on this film. We did not want to live in another country the rest of our lives. We could not go anywhere without being reminded by black folks, "Don't fuck up Malcolm, don't mess this one up." We were under tremendous pressure on this film. We can laugh about it now, but it was no joke while we were doing the film.

Cineaste: *Given the difficulty of portraying about forty years of a man's life in any film, even one nearly three-and-a-half hours long, are there some aspects of Malcolm's life you felt you weren't able to do justice to?*

Lee: No, this is it, this is the movie I wanted to make. Our first cut was about four hours and ten minutes, I forget exactly, and we had more speeches and stuff, but this is the best shape the film can be. Of course, people say, "Why did you leave this out and why did you leave that out?," but you cannot put a man's whole life in a film.

People have told us, "The most important year in Malcolm's life was his final year," and "Why didn't you show his whole pan-Africanism thing?" But it's limited. We've never said that anyone who sees this doesn't need to know anything else about Malcolm X. I mean, the man had four or five different lives, so the film is really only a primer, a starting point.

Cineaste: *But don't you think that showing him meeting heads of state in Africa would have added to his dimension at the end, especially for people who don't know?*

Lee: But people don't know who Kwame Nkrumah is anyway. Besides, we didn't have the money. I mean, we just barely got to Egypt. We shot in the U.S. from September 16, 1991, up to the Christmas holiday, and after the holidays we did what we had to do in Cairo and then we went to South Africa. But I don't think we would have gained anything by showing him meeting with Nkrumah or others. Besides, at that point in the film, we're trying to build some momentum.

Cineaste: *Cassius Clay/Muhammad Ali is sort of dropped from the film, too.*

Lee: What, and get someone to impersonate him? I think it was important to have Muhammad Ali in the movie, but we show him in a newsreel clip in the montage at the end.

Cineaste: *You don't think it dissipates some of the anti-Vietnam War feeling that was in the Nation?*

Lee: They weren't really anti-Vietnam. Malcolm was, but Elijah Muhammad never said anything about the Vietnam War. And by the time Malcolm spoke out against the Vietnam War, he had already been kicked out of the Nation.

Cineaste: *Do you feel a film of this financial scale has built-in "crossover" requirements in terms of its audience?*

Lee: We felt so. We felt that everybody would want to see the film, and we've received a large white audience to date. This is my first PG film—the previous five have all been rated R—because we wanted to get a young audience. We feel this is an important piece of American history and people, especially young kids, need to see this.

Cineaste: *Is that why the few sex scenes in the film are considerably milder than those in the published screenplay?*

Lee: Yes, because we made the decision for a PG-13 rating. We did not want to give teachers, schools, or parents an excuse why they could not take their children to see this film. I think when you weigh it, it's much more important for young kids to be exposed to Malcolm X than to see that other shit. We're preparing a classroom study guide on the film that'll be out in January.

It's amazing, I've seen this film with ten-, eleven-, and twelve-year-olds, and they're just riveted in their seats. You know the attention of young people at that age—they're usually throwing popcorn at the screen—but there's not a sound, they're riveted for three hours and twenty-one minutes. A whole generation of young people are being introduced to Malcolm X, and people who've heard of him or had limited views of him are having their views expanded. Above all, we hope that black folks will come out of the theater inspired and moved to do something positive.

Cineaste: *What sort of message would you like white viewers to come away with from the film?*

Lee: I think that, as with any film I've done, people will take away their own message. For a large part of the white audience, however, I think we're helping to redefine Malcolm X because for the most part their view of Malcolm came from the white media, which portrayed him as anti-white, anti-Semitic, and pro-violence. It's funny, when we had the national press junket for this film, many of the white journalists said they felt they'd been robbed, that they'd been cheated, because they'd never been taught about Malcolm X in school or they had only been told that he was anti-white and violent. A great miseducation has gone on about this man.

Cineaste: *In that regard, we heard that Warner Bros., presumably concerned about defusing any controversy about potential violence at screenings, held advance showings of the film for police departments around the country.*

Lee: That was Barry Reardon's decision. I did not agree with that. I thought it was inappropriate. I mean, if they do that to us, they should do it to *Terminator.* How many cops got killed in those films? Actually, it was the exhibitors. Before the film came out, exhibitors were calling Warner Bros., they were scared shitless, they were requesting extra police protection. One theater in Chicago even installed metal detectors!

Cineaste: *What was the response at the police screenings?*

Lee: Oh, the cops loved it. In Los Angeles, they showed it to Willie Williams, the new Police Commissioner there. It was the exhibitors and also the press who were waiting for that violence, so they could destroy the movie. *Do the Right*

Thing was really hurt at the box office when the press—people like David Denby, Joe Klein, and Jack Mathews—predicted that the film was going to create riots. In Westwood, in Los Angeles, for example, nine police were at the theater on the opening weekend, some mounted on horseback. What's interesting for me now in reading a lot of the reviews of *Malcolm X* is how so many critics had predetermined that the film was going to be inflammatory.

Cineaste: *To a great extent that's because of their unfamiliarity with Malcolm X other than what they've read in the mainstream press.*

Lee: And with me, with the combination of Malcolm X and Spike Lee. They were expecting a film that for three hours and twenty-one minutes would be saying, "C'mon, black folks, let's get some guns and kill every single white person in America," but in the end the critics were saying, "This film is *mild*."

Cineaste: *In the published screenplay, there are two sort of "dramatic book-ends" scenes. In the first scene, Malcolm brushes off the well-intentioned young white woman outside Harvard who asks how she might be of help in his struggle. The second scene, which occurs later at the Hilton Hotel in New York, involves the same type of encounter, but this time Malcolm has a completely different response. The two scenes emphasized Malcolm's evolution on this question, but only the first scene appears in the film. Why?*

Lee: We shot that other scene, but the acting just didn't work. Anyone who's read the book knows that Malcolm's response to that young woman was one of his biggest regrets. I wanted to give Malcolm a chance to make up for it, so I wrote the scene where he could answer that same question again, but it just didn't work.

Cineaste: *Are you concerned with how the dramatic weight has now shifted to that first scene? At the two screenings we've attended, that scene always gets a big laugh.*

Lee: Who's laughing? Black viewers or white viewers?

Cineaste: *They've been mixed audiences.*

Lee: White people don't laugh at that, because for the white audience that young white woman is them. We shot the second scene, but it just didn't work, so what were we supposed to do? In any case, I think we see Malcolm change when he comes back from Mecca.

Cineaste: *In terms of* The Autobiography's *portrayal of Malcolm's youthful criminal career and the extent of his drug abuse, Malcolm was much more critical of himself in the book than the film is. Do you think that aspect of the book is exaggerated?*

Lee: I've talked to Malcolm's brothers, and they said that he was not that big of a criminal. He was a street hustler and not even a pimp, just a steerer. I think he was a wannabe, a wannabe big-time gangster, but he wasn't. The description in the book was not so much to build himself up but to lower the depths from which he rises. That's OK, but I don't buy this Bruce Perry bullshit that Malcolm was a homosexual, that he used to crossdress, or that Malcolm's father burned down their house in Queens. That's bullshit! He did a lot of

research, and some of the interviews were good, but Bruce Perry's book reads like *The National Enquirer.*

Cineaste: *Many feminists are critical of the Nation of Islam's sexist attitudes towards women. In fact, one of their well-intentioned slogans refers to women as "property."*

Lee: We didn't make that up. That was an actual banner.

Cineaste: *No, we understand that was historically accurate, but since you've taken so much heat from feminists in the past . . .*

Lee: Hey, you know who should be taking more heat than me? Oliver Stone!

Cineaste: *Oh, he has taken a lot of heat.*

Lee: Not as much as me, though, about women.

Cineaste: *In a historical film like this, the dilemma seems to be whether one can—or should even attempt to—provide a critique of the Nation's attitudes towards women.*

Lee: We just showed it the way it was.

Cineaste: *We thought you dealt with this issue well in at least one scene where you intercut Elijah Muhammad's various strictures against women with Malcolm's conversation with Betty where he parrots pretty much the same line.*

Lee: Yeah, he's a mouthpiece. [*Lee at this point does a pretty good impersonation of Al Freeman as Elijah Muhammad*] "She should be half the man's age plus seven. She must cook, sew, stay out of trouble." [*Laughs*] Sure, I've been at some screenings where women go, "Ugh!," but, look, those are not my views.

Cineaste: *You often have scenes where there's no obvious interpretation, you leave it up to the viewer.*

Lee: A lot of my work has been done that way. Some things I'll slant, but a lot of the time I let people make up their own minds.

Cineaste: *We're thinking especially of the scene where Denzel is watching television, and you intercut newsreel footage of police repression of civil rights demonstrations with a slow zoom into his face.*

Lee: Yeah, and with John Coltrane's "Alabama" on the soundtrack.

Cineaste: *There are a couple of different levels of interpretation there. You can think that he's despising Martin Luther King, Jr., and his nonviolent approach, or you can think that he's regretting that he's not involved in action like that. In this regard, we also wondered about the little smile you see briefly on Malcolm's face just before he's shot.*

Lee: That was Denzel's idea.

Cineaste: *I guess that's also open to interpretation.*

Lee: Well, Denzel and I felt that he just got tired of being hounded. In actuality, you know, there were several assassination attempts. The CIA tried to poison him in Cairo, and the Nation tried to kill him numerous times. There was a big assassination attempt in Los Angeles, another in Chicago, and one night he had to run into his house because guys with knives were chasing him. So he was hounded for a year, the last year of his life, and Denzel and I thought about it and just felt that, you know, he was happy to go. It was Denzel's idea to smile

right before he gets the shotgun blast—like, "You finally got me," and it was over.

Malcolm knew that he was going to die—even in the book he says, "I'll be dead before this comes out"—and that idea is played through that montage where Malcolm, his aides, and the assassins are all driving in separate cars to the Audubon Ballroom—an idea we got from *The Godfather*, by the way ("props" to Francis)—accompanied by the Sam Cooke song, "A Change Is Gonna Come."

Cineaste: *In terms of FBI and CIA involvement in the assassination, do you think it was more a case of them letting it happen rather than actually doing it?*

Lee: In my opinion they definitely stirred things up between Malcolm and the Nation. The FBI's COINTELPRO operation had infiltrated the Nation and was writing letters back and forth. Then I think they just stood back and let it happen. I don't think the FBI or CIA needed to assassinate Malcolm, because, if you read *Muhammad Speaks* at that time, the Nation was going to do it themselves.

Cineaste: *The FBI did the same thing on the West Coast, fomenting a rift between the Black Panthers and Ron Karenga.*

Lee: Oh yeah, they're great at that. A very important book in this regard is *Malcolm X: The FBI File.* Two new books coming out—*The Judas Factor: The Plot to Kill Malcolm X* by Karl Evanzz and *Conspiracys: Unravelling the Assassination of Malcolm X* by Zak Kondo—both say the Nation was responsible. Of course, Amiri Baraka's saying that I'm part of some great government conspiracy and that the reason the studio let me make the film is because I was going to pin the assassination on black people. That's bullshit!

The five assassins were from Temple No. 25 in Newark, New Jersey, and the orders came from Chicago. I don't know if they came from the Honorable Elijah Muhammad, but it was from somewhere high up. That's the truth. I mean, Baraka should talk to Betty Shabazz, he should ask her who killed her husband. She told me the same thing. I'm not part of some conspiracy to turn black folks against the Nation Of Islam. That's bullshit!

Cineaste: *Has the Nation had a response to the film yet?*

Lee: The Thursday before the movie opened we had a special screening in Chicago for Minister Farrakhan.

Cineaste: *How did that go?*

Lee: He was there, and I got a note from his secretary saying he was going to respond by letter, but we haven't heard from him since. But Minister Farrakhan has been supportive. While we were shooting the film, he said, "Look, Spike, I support your right as an artist." That's been it.

Cineaste: *Do you think they'll make an official pronouncement, one way or another?*

Lee: I think they'll just let it blow over.

Cineaste: *In making this film, did you arrive at a more sympathetic understanding or appreciation of Islam?*

Lee: Yeah, I mean you had to have respect. Denzel and I were reading the Koran before we began to shoot. We *had* to. If we didn't have a sympathetic attitude toward Islam, why would the Saudi government allow us to bring cameras

into Mecca to shoot the holy rite of *hajj*? You have to be a Muslim to enter Mecca, so we had two second units, Islamic crews, who in May 1990 and June 1991 were permitted, for the first time ever in history, to film in Mecca.

I think the Saudi government realized this film could be good publicity for Islam. I mean, Islam and the Arabs in general have been taking a bashing in the West—what with Khomeini and the Gulf War and everything—and in Islam Malcolm is considered a martyr. That's why they let us bring cameras in.

Cineaste: *Will the Islamic countries be an important overseas market for the film?*

Lee: Yeah, we're going to try. We've got to be careful, though, because the same people who gave us the stamp of approval, the Islamic Court, are the same cats who sentenced Salman Rushdie to die, so we don't want to fuck around.

Cineaste: *Some felt that the film's Mecca scenes were a little saccharine, somewhat like Christian movies of Jerusalem.*

Lee: If the man says this was a deeply religious experience, you have to be true to that, no matter how you feel personally about religion. I mean, if up until that point the man felt that every single white person was a blue-eyed, grafted devil, and he no longer believed that after his visit to Mecca, something must have happened.

Cineaste: *A very powerful scene in the film is when the young man, after seeing Malcolm and other members of the Nation confront the police, approaches Malcolm and says he wants to become a Muslim. It showed the power of the Nation to influence people and change their behavior.*

Lee: People can talk about Elijah Muhammad all they want, but there's never been a better program in America for black folks to convert drug addicts, alcoholics, criminals, whatever. Elijah Muhammad straightened those guys out and, once they were clean, that was that.

Cineaste: *A lot of people felt Malcolm would have left Islam, but we always thought he was as devout a Muslim as King was a Christian.*

Lee: No, he would never have left Islam. He would have moved on to other stuff, but he would have remained a Muslim. He would not have made it a requirement to join his organization, because he saw it was too regimented. He wanted to include as many people as possible. People wanted to follow him, but they weren't willing to give up pork, or sex, or whatever.

Cineaste: *There was always this tension between Malcolm and King, which some people saw as a contradiction, but which we saw as more of a dynamic tension.*

Lee: I agree. At the end of *Do the Right Thing*, when I use the statements from Malcolm and King, I wasn't saying it's either one or the other. I think one can form a synthesis of both. When Malcolm was assassinated, I think they were trying to find a common ground, a plan they could both work on.

Some people felt I took a low blow at King in the film in the scene where John Sayles, as an FBI agent listening in on a phone tap on Malcolm, cracks, "Compared to King, this guy is a monk." I don't think that's a low blow. J. Edgar Hoover had made tapes of King with other women, and he confronted King with

them, saying, "If you don't commit suicide, I'm going to send these tapes to Coretta," and he did. Afterwards things weren't the same between Coretta and Dr. King, but I'm not taking a low blow at King. The low blow was the FBI doing this to Dr. King. But some black people told me, "Spike, you know, you shouldn't have done that."

Cineaste: *They have a hard time dealing with King as a sexual being. Baldwin also thought that there was this dynamic, this dialectical tension, between Malcolm and King. Toward the end, Malcolm seemed to be saying, "You'd better deal with King, because, if you don't, you'll have to deal with me." It's the Ballot or the Bullet.*

Lee: He said that all the time. He told King, "I'm good for you."

Cineaste: *Some people would have liked you to have included the scene where Malcolm went down to Selma and spoke to Coretta King. Did you think of putting that in?*

Lee: [*Covers his head in a defensive manner and laughs uproariously*] We couldn't do everything! We knew going in that, at best, we'd just get the essence of the man, that's the most we'd be able to do. Besides, Henry Hampton of Blackside—you know, the guy who did *Eyes on the Prize*—he's preparing an eight-hour series on Malcolm. They'll be able to do a lot more than we did, and I'm glad.

Cineaste: *We've also heard that there are plans to re-release, at least on video, the 1972 feature documentary on Malcolm.*

Lee: Marvin Worth's film. It's good. I think if more people can learn about Malcolm X, that's cool.

Cineaste: *We thought you might have done more with Ossie Davis's eulogy.*

Lee: What, you mean see him delivering it? Then we'd have to restage the funeral, and I didn't want to see Denzel in a casket. Besides, by that time we show footage of the real Malcolm X. I gotta give my props here to Oliver Stone. Barry Brown [the editor who cut *School Daze* and *Do the Right Thing*] and I saw Oliver Stone's *JFK* the first day it came out, and I said, "Barry, man, look what they're doing. C'mon!" The film gave us great inspiration.

You remember the opening newsreel montage in *JFK*? Well, we tried to do the same thing, or better it, with our montage at the end where Ossie Davis delivers the eulogy. We also had some of the black and white thing going, like newsreel footage.

Cineaste: *So you were directly influenced by* JFK?

Lee: Yes. There are other similarities between *Malcolm X* and *JFK*, but what makes our film stand out is the performance of the lead actor. I think Kevin Costner is an OK actor, and I know that's probably the only way Oliver could have gotten the film made with the amount of money he wanted to, but I love that film *despite* Kevin Costner's performance. In *Malcolm X*, Denzel *is* the film, he's in every single scene. I hope he gets nominated for the Academy Award, and I hope he wins.

Another thing we're really proud of with this film is the craft. Far too often

with my films the craft is overlooked, but I think everything here—Barry Brown's editing, Ruth Carter's costume design, Terence Blanchard's score, plus the source music we used, and Ernest Dickerson's cinematography—is outstanding.

Cineaste: *The cameo appearances in your film are another similarity to JFK. In some ways they're amusing, and people love them, but, on the other hand, they seem to disrupt the dramatic intensity, because people are saying, "Hey, that's Al Sharpton," or "There's Bill Kunstler," or "Did you see Bobby Seale?"*

Lee: Not that many viewers know who these people are, and for me it just added weight to the stuff. I don't think I was making jokes or trying to make it campy or funny. I actually wanted Clint Eastwood to play the cop in the Peter Boyle scene, but he was shooting *Unforgiven.*

Cineaste: *Has Warner Bros. been supportive in terms of the advertising campaign and the national release?*

Lee: Yes, ever since they saw the rough cut. I mean, for a while there during production we went at it toe to toe, but since they've seen it they've been behind the film. We're on 1,600 screens nationwide. I have no complaints.

Cineaste: *In terms of the highly publicized dispute during production between yourself, Warner Bros., and the Completion Bond Company, to what extent do you feel racism was involved?*

Lee: Racism is part of the fabric of American society, so why should the film industry be exempt? I think it's a racist assumption that white America will not go to see a black film that's not a comedy, or that doesn't have singing and dancing, or that doesn't star Eddie Murphy. I think there are racist tendencies that keep this glass ceiling on the amount of money that is spent on black films, to produce them or to market and promote them. I mean, how is it that Dan Aykroyd, a first-time director, can get $45 million to do *Nothing But Trouble?* $45 million! They're willing to give more money to these white boys right out of film school than they are to accomplished black directors.

In terms of the controversy, films go over budget all the time, so why I am on the front page? I wasn't calling up these newspapers and saying, "I'm over budget and the Completion Bond Company is taking the film over."

Cineaste: *Wasn't there some sort of misunderstanding about the delivery date of the film?*

Lee: No. Here's what happened. Any time a director and the lead actor are shooting, that is first unit, that is principal photography. The Completion Bond Company tried to say that what we did in Africa was second unit. But Denzel and I were shooting, so that's principal photography. We finished shooting in Soweto in late January 1992, and five weeks later they wanted a first rough cut!

The Bond Company was mad because they were getting stuck by Warner Bros. and were having to deal with a $5,000,000 overage. Usually the studio will help out the bond company, but in this case Warner Bros. said, "Fuck you. We paid you a fee, and this is your job." So the Bond Company said to us, "Look, until we work this agreement out with Warner Bros., we're not paying you anything." So they fired all our editors. We had no money coming in to complete the film, so

that's when I made the phone calls to these prominent African-Americans—Oprah Winfrey, Bill Cosby, Magic Johnson, Michael Jordan, and others.

Cineaste: *And their contributions were gifts.*

Lee: These were gifts—not loans, not investments. So for two months we continued to work, and neither the Bond Company nor Warner Bros. knew where the money was coming from. That really fucked 'em up. I chose to announce what we had been able to do on May 19, Malcolm's birthday, at a press conference at the Schomburg Center. Miraculously, two days later, the Bond Company and Warner Bros. worked it out. They say it was just a coincidence, that it would have happened anyway. I say bullshit.

But I hope this will be a precedent. Next time, maybe myself or some other filmmaker will bypass Hollywood altogether for financing and go directly to people like Oprah or Bill or Magic or Michael, who'll finance the production, and then just go to Hollywood for distribution once the film is done. There are plenty of black people with money, plenty of black entrepreneurs. It can be done.

Cineaste: *Are there other major black historical figures that you'd like to do films on?*

Lee: Yeah, Walter Yetnikoff and I are working to acquire the rights to Miles Davis's life story. I heard that Robert Townsend may direct and star in a film on Duke Ellington. Right now, Touchstone is getting ready to do the Tina Turner story, with Angela Bassett, who plays Betty Shabazz in *Malcolm X*, as Tina and Larry Fishburne as Ike Turner. What we hope, what we're praying for, is that with the success of *Malcolm X*, you'll be able to eventually see films about Miles Davis, Paul Robeson, Harriet Tubman, Sojourner Truth . . . you can go right on down the line.

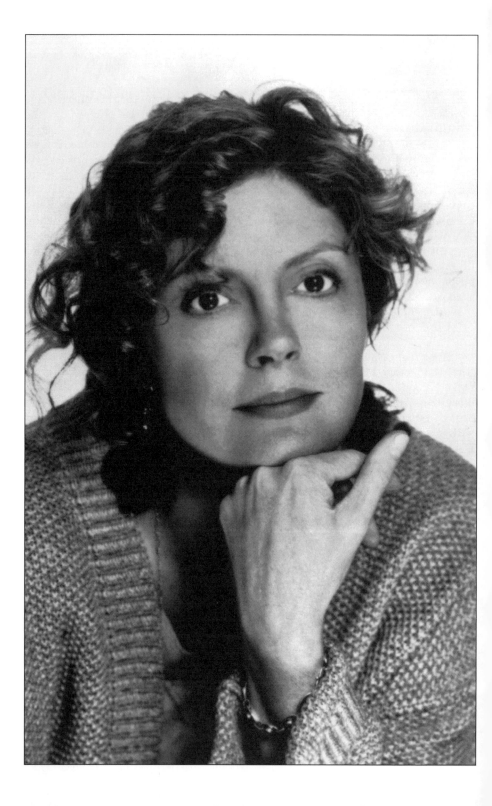

10 SUSAN SARANDON

Acting, Activism and Hollywood Politics

Despite the "big star" status first conferred upon her by the critical and box office success of Bull Durham *(1988) and later confirmed by* Thelma & Louise *(1991), Susan Sarandon aggressively situates herself outside the Hollywood establishment. In both films, as in many of her thirty film roles, she plays characters not unlike herself in many respects—straight-talking, independent women who attain the self-knowledge which enables them to ask questions and take charge of their lives and their sexuality. It is no surprise, then, that Sarandon, who lives in New York with actor/director Tim Robbins and their children, remains outspoken about myopic Hollywood practices and politics which limit our ways of seeing women and other minorities, turning a nearly blind eye, as well, to such crises as AIDS, homelessness, and global injustice. "How can we empower ourselves and fight sexism in our industry without first addressing our own racism, for instance?," asked Sarandon in an address to the New York Women in Film luncheon in 1990.*

Such outspoken political positions have sometimes offended Hollywood insiders, as happened during her protest against the Gulf War and, at the 1993 Academy Awards ceremony, where she and Robbins spoke pointedly against U.S. immigration restrictions barring admission to Haitian refugees, particularly those suffering from AIDS. One Academy spokesperson suggested that her comments marked the last time Sarandon would be asked to present an award. At a time when social protest has become fashionable and almost mandatory among celebrities, however, Sarandon stands apart—her commitment to political activism came long before her rise to stardom. Speaking out and spending time when no cameras or journalists are present, hers is a deeply-rooted, self-defining sense of moral necessity. She has been actively involved in the Anti-Violence Campaign, raising consciousness about bias-related crimes against gay men and women; has traveled to Nicaragua as a member of MADRE, delivering baby food and milk to hospitals there; has been working in a program for schizophrenics at Mount Sinai Hospital in New York; and has been active in fighting for First Amendment freedoms and abortion rights.

*While Sarandon admits that she did not take her acting career all that seri-
ously for a decade or so, having landed her first role in* Joe *(1970) by
happenstance when accompanying her former husband, Chris Sarandon, to his
audition, Sarandon clearly has taken the potential power of acting and of film
quite seriously, attempting to choose roles in which women's lives are portrayed
honestly. In* Lorenzo's Oil, *Sarandon plays Michaela Odone, the determined
mother of a boy suffering from the rare and fatal disease adrenoleukodystrophy
(ALD). Inspired by the actual Odones, who courageously challenged the barriers
to drug testing erected by the profit-conscious medical and pharmaceutical estab-
lishments, and who went on laboriously to discover their own treatment which
retards the progress of the disease (the eponymous oil), Sarandon, along with
Nick Nolte as her husband, Augusto, spent much time studying medical research
and visiting with the Odones and their seriously impaired son, Lorenzo. "If you
say to Michaela, 'What would you ever do if you get your son back?,' she'll say,
'This is my son,'" Sarandon relates. "It's about being with someone no matter
what—he is there. She never gave up faith that he was there." Interested, as well,
by the parallel with drug approval in* AIDS *research, Sarandon insisted that an
explicit reference to* AIDS *be added to the script. The film not only indicts the
profiteering impulses of the pharmaceutical industry, it also critiques the parents
who head an* ALD *support group, suggesting that they have collaborated with the
powerful medical establishment.*

Having long admired Sarandon's on- and off-screen work, Cineaste *editor
Cynthia Lucia met with her on a brisk January day, a short time before the
Academy Award nominations were announced. Sarandon reflected upon the
nomination process, the status of independents, and the position of women in
film. With eyes amazingly unflinching and direct, Sarandon spoke about the
current political climate in Hollywood and the intermeshing of her own politics,
family life, and career.*

Cineaste: *You've often said you got into acting by accident, but what has
kept you there?*

Susan Sarandon: It's impossible to get it right, so acting becomes addic-
tive. Every time I see one of my performances, there's always something I think
I could have done clearer, better, faster. When a film is finished, you see, in hind-
sight, what it was really about. When you see it you think, "Wow, I was on the
right track with that, I wish I had been braver. I wish I had been committed
100% to that mistake." Secondly, I'm kind of shy, and I'm somewhat lazy. Acting
forces me to be aware. It's almost enforced compassion that develops because
you take on these various personae and circumstances and realize how much
you have in common with everyone and how, given certain circumstances, you're
capable of things you never dreamed you'd be capable of. Just in terms of trying
to work on yourself to stay an open, aware person who's trying to go towards

some kind of humanity, it's an enforced work program. The extremes of filmmaking also appeal to me. Men and women work side by side in non-gender-designated roles, under incredible pressure. It's a cooperative effort. At its best it's magical, it's what community should be; at its worst it's a nightmare.

Cineaste: *Have you been deeply moved or influenced by specific films you've seen?*

Sarandon: The last film that I saw in a theater was *Malcolm X*, and I really loved that film. I thought it was very brave. Denzel Washington and Al Freeman, Jr., gave extraordinary performances. It moved me, challenged my perspective, which is what I think film should do. I remember being very moved by *East of Eden*; and the Russian films, *A Slave of Love*, and recently, *The Lover*.

Cineaste: *In addition to* Malcolm X, *have you admired other explicitly political films?*

Sarandon: *Bob Roberts*. It was a remarkable film not only because it was funny, but it got a lot of information across to people who normally don't have access to it. *Bob Roberts* is also special because it's fair. The "hero" is certainly questionable. He probably is the only one who has the truth, but he's so borderline fanatic that he's not a white knight. And Gore Vidal has the role that probably lends the most resonance to the film—he's within the system so not exactly the hero either. I think it's interesting to make a film where the bad guy is likable and the good guy is all right but not necessarily charming—it makes a much more interesting dynamic. You long for a hero that you can root for, but life isn't always like that. It's like my character in *Lorenzo's Oil*—not particularly sympathetic. I remember when Tim [Robbins] screened *Bob Roberts* and the head of CBS, I think, saw it and was ranting about how outraged he was. And I thought, well then, you know you're doing something right if it affects people that way.

Cineaste: *Do you see* Thelma & Louise *as a political film?*

Sarandon: I think any film where somebody is encouraged to take action is political, or film that challenges the audience's perspective is political. I don't think of it necessarily as a feminist film. In selling *Thelma & Louise*, that label did it a disservice because the film is very entertaining. Those who say women can't be intelligent and sexy are the same people who say you can't have entertainment in a film that's about something. Now if a film is about some-thing that's political, why categorize it in that way? It's detrimental on many levels.

Cineaste: *Do you consider yourself a feminist?*

Sarandon: No, I don't. I don't have the faintest idea what feminism is now. I consider myself a humanist—only because if you label yourself a feminist at this point in time, most people are so defensive that you can't accomplish anything. Surely if you're a humanist it encompasses everything that is feminist. People want to call me a feminist because I'm strong and I'm a woman who has some opinions. I certainly wouldn't go against it, but it's become a very divisive term—why not go for something broader? I don't disown the feminist movement,

but I'm into something that encompasses the rights of men, the rights of children, the rights of gays. I think it's time for human rights.

I'm sometimes *very* confused about what's politically correct these days. You can go to the opening of *Miss Saigon* that's a benefit for Lambda and step on someone's toes because they didn't cast all Vietnamese. There are moments when I'm not sure what's right. I'm very much against outing [*publicly revealing a person's homosexuality*—ed.], for instance. Maybe you make an exception in the instance of someone who's blocking a certain piece of legislation and is in the closet. When I get asked questions about my sexuality, I feel it's a real violation of my privacy; I, therefore, protect other people. I think it's mean, and it doesn't accomplish anything. I don't know if that, then, makes me politically incorrect.

Cineaste: *There are many people within the gay community who are actually against outing.*

Sarandon: Absolutely, because what is the gay community, anyway? It's very diverse. Or, say, the black community—what is the African-American community? It's hard to say. I'd like to know what feminism is now.

Cineaste: *One-and-a-half years after the release of* Thelma & Louise, *what do you think of these characters? Do they stick with the American public?*

Sarandon: Yes, I think it's a watershed of some sort, because all we did was take a genre and put women in the parts that had been held by men. For that to cause such a reaction shows how strongly that territory was held by white, heterosexual men. That was a real eye-opener. These characters weren't doing anything that hasn't been done before except having maybe a *little* more sense of morality about what they did. Women and men were so threatened on such a basic level and were so *moved* on such a primitive level that I think we *completely* underestimated just how bad things were.

The film also came at a time when minorities of every kind were very, very, frustrated. To see *anybody* fighting back and saying they weren't going to settle obviously meant a great deal. Had this film been directed by a lesser filmmaker who hadn't given it such a heroic vista, had he been a feminist—which I assure you he is not—maybe the film would not have been so entertaining and therefore would not have allowed people to go on that journey.

Cineaste: *Some directors claim that actresses who had been formerly interested in roles that explore female sexuality or that require nudity are no longer interested in those roles after having children. You seem an exception to that pattern.*

Sarandon: I did *White Palace* when my son was five-and-a-half months old. What interested me in that film was the dynamic of the relationship, rather than exploring sexuality. The film was really about class differences. America *pretends* that there are no class differences, and the fact that they sold *White Palace* in some other way shows that they were not hip to new ideas. I was very much frightened by the sex, not because of my children, but because it was a difficult scene that could have gone off and been wrong in so many different ways. Who *wants* to do nudity anyway? I've never wanted to do it. It's tough.

In fact, I've had very few sex scenes, but the ones that I *have* done have turned out to be pretty infamous. There are *no* sex scenes in *Atlantic City*, but everybody thinks there are. *The Hunger* was the first sex scene I ever had, and that was with a woman and was a beautiful scene. In *Bull Durham* they were just silly scenes. I think the sexiest moment is when people choose to really *see* each other and when they connect. You can completely upstage yourself with nudity; people don't hear a thing you're saying for at least ten seconds when they see breasts. And being a nursing mother, I think I know what it goes back to. If you're doing something important, why would you upstage yourself with your own body?

Cineaste: *In Hollywood films motherhood and sexuality don't coexist very often.*

Sarandon: That's a different question.

Cineaste: *What do you think is behind that?*

Sarandon: Well, I hope not mothers, because there are a number of people with children that I hope are still having good sex lives. Maybe it's another way of compartmentalizing women—you have your slut, your mother, your ice princess who's smart—but you can't be a mother who has a brain and also has fun. That's unfortunate, but we're dealing with pretty simplistic formulas. I thought Annie in *Bull Durham* broke through some of that because she did have a good time and was smart, and she didn't have to die in the end. I've been very clear about my age and that I have a family. Most people don't seem to find that a deterrent.

Cineaste: *Once an actress plays a mother on-screen, it seems to mark a turning point in the roles that she's going to be offered.*

Sarandon: Absolutely, that's true. But, of course, the first mother I played was in *Pretty Baby*, then *Compromising Positions*, and *The Buddy System*.

Cineaste: *Did that concern you when considering your role as a mother in* Lorenzo's Oil?

Sarandon: I had those thoughts and my agents did, too, but I didn't think that was the main point of the movie really. My character ages in the film, too. It can be very unsettling to look worse when you come out of makeup than you did when you went in. But I thought of her as purifying herself through the difficulty of her son's illness.

Cineaste: *Why does* Lorenzo's Oil *spend so much time with the conflict between parents and parents rather than more strongly criticizing the powers above them?*

Sarandon: The bulk of the film is trying to understand the who-done-it of the disease. If you look at how many scenes are about the parents, there's only the first conference and the dinner at the Odone's. The second conference scene, when Lorenzo's levels are already down, shows that the medical profession is *still* not allowing information out. That scene is directed against the doctor. I wanted a scene between the Odones and the doctor. After it all, when the real Odones got the levels down and they told the doctor, he said, "It goes against my

grain that you're not doctors." The letter that I read from the real doctor was so arrogant and preposterous. I felt that every time the doctor was a bad guy, it happened offscreen; you *heard* about it. Unless you're listening carefully to the scene with Wendy Gimble later in the film, you don't know that the Odones are taking the oil to the black market to deliver it to people *because* the doctor has refused to let anybody else know about it. There are lots of phone conversations, but it's not dramatized. If you have a child who's going to be dead in eighteen months, you should be allowed to know *any* alternative. It's like being afraid to give morphine to somebody who's dying because they might become addicted. It's ridiculous. It's like blind testing in AIDS. Some of the protocol has to be rethought when you have kids who are dying.

Cineaste: *While* Lorenzo's Oil *is a political film in taking on the medical establishment, it's somewhat disturbing that the harshest attack is aimed at the two parents who head the ALD organization; they almost become scapegoats, allowing the film to sidestep a direct and total attack on the medical and pharmaceutical fields.*

Sarandon: I don't agree. The couple that lead the ALD organization are well-cast; they are two extraordinary actors. And they're very moving. The dinner scene with that couple and the Odones is just heartbreaking, because we are allowed to understand who they are and what they don't want to do. The couple is given a very good shake at not being one-dimensional. The fact of the matter is that they *blocked* the information; it's *not* fair that they didn't allow people to know about the oil. Isn't it their responsibility, if they publish a newsletter for ALD parents, to let them know *everything* that's going on? They sided with the pharmaceutical tyranny and still do.

It would have been nice to see the bureaucracy taken on even more, but already I've gotten a nasty letter from the AMA, so obviously they think the film was pretty tough on them. What do you do when your child is dying? Some people pray. The Odones came from a tradition of knowledge, so they wanted to know. And we're taught from the very beginning that you don't eat of the tree of knowledge or you lose your life of convenience. You can stay in the garden of paradise, just don't ask any questions. We're told that by government, by law, in school—all down the line—don't question authority and you'll be taken care of. And it's become ever more clear as we're coming out of a presidency that has been all about the powers of the executive branch over everything else. *Lorenzo's Oil* is extraordinary because it encourages people to be the protagonists in their own lives. The Odones questioned, but there are other people who said, "You're going to rock the boat, don't do it." Some ALD parents still think the Odones are quacks.

Cineaste: *But maybe these people are not as privileged with education and money as the Odones.*

Sarandon: The Odones didn't have the money—they absolutely didn't. Their house is double mortgaged. They had courage, tenacity, and outrage—qualities you can find, regardless of education. But after seeing a child suffer for

so long, you also can understand why some parents would say, "Just make him comfortable, just let him go." That's made very clear in the film when Michaela Odone says, "Fly to baby Jesus." She's giving her son that option. There are people who have gone on the line in just as big a way by not giving their child, say, an operation or medicine because of their religious beliefs. If their child dies, they become villains. The Odones were making it up as they went along; they didn't know if it would turn out OK. They would have been labeled fanatics had he died.

Cineaste: *The film does suggest that these two parents who head the ALD organization are trying to protect their own power. Could they simply have been afraid the medical community would abandon them and their organization?*

Sarandon: Maybe. But so what? Everybody's afraid. They are protecting their power as the heads of that organization. Absolutely. Because that's the only thing that gives them control over their lives and control over other people. They were writing nasty letters to us during filming, telling us we shouldn't be any part of the film. I think they were very generously depicted.

Cineaste: *The parallels in the film with AIDS and the self-help of PWAs which is being evoked is clear and has also been widely acknowledged in reviews. The message is that it's important to find new forms of treatment and not relent against the medical establishment. But do you think the parallels between AIDS and ALD end at some point?*

Sarandon: Because they're different diseases, yes, but that's the whole reason I was interested in the movie. I heard tapes Michaela Odone had done four years before director George Miller ever got involved. She was at the height of her frustration, at the point when they had Lorenzo's levels down and couldn't get anybody to deal with the oil, even as a dietary supplement. And, meanwhile, children were *dying*. So you can imagine the Odones' frustration in coming so far and proving the oil works, yet not being able to distribute it to anybody. She specifically said, "I don't want to sound as though I'm happy AIDS exists, but thank God for the AIDS lobbyists and activists because now people will understand what's going on in medical research and with the AMA in terms of trying to get treatments developed and approved quickly." She was quite clear about that early on, and that's what initially interested me in the project.

Cineaste: *There is the term "AIDS people" in the film. It's an interesting term because it does hit home to people in a concise way. On the other hand, within AIDS caring and within the community there has been the debate that AIDS now needs to be acknowledged as a disease with diverse facets—yes, it is a gay disease, a disease of drug use, but it is a disease that has a lot to do with poverty, as well as a disease that has a lot to do with reclaiming identities. The term in the film is so general.*

Sarandon: That line wasn't even in there until I insisted that it be included. There was no reference to AIDS at all. There was an *enormous* amount of information that had to move forward in this movie. Nick and I had so many scenes that were just downright unactable because they were just scientific

exposition. You had to find some way of making it immediate, passionate, funny, and visual. An hour of the film has been cut. To even hear the word *AIDS*, to have people feel the resonance of what that problem is and to draw the parallel, was a major accomplishment in the midst of everything else.

Cineaste: *In* Lorenzo's Oil *the opening African setting is based on the Odones having lived in the Comoros. Did Lorenzo's friend actually come to the States to be with him?*

Sarandon: Yes. Omouri is still with them. He was also not quite as unsophisticated as the film presents. He spoke three languages, and he already had a degree. He didn't arrive in his native dress. They've had their ups and downs, but he's still there. The moment in the script when he takes Lorenzo's hand and starts singing, after you're prepared for him to be appalled, I think is one of the simplest, most beautiful moments in the film. It's a real testimony to his dignity and intelligence. It's about accepting.

Cineaste: Lorenzo's Oil *is not a standard Hollywood film—it's long, the editing is quite complex, the way it's shot, the topic itself. . . .*

Sarandon: It's very unusual, and it's a testimony to the studio that they made it.

Cineaste: *Is* Lorenzo's Oil *a liberal film?*

Sarandon: I don't know. It's an unusual film. It's great that it got made. They were trying to make a film that was *about* something, but it's certainly not *left*. It's a political film in that what the Odones do is political, but I think the point of the film is not who it's against but the fact that these people are not passive in their tragedy.

Cineaste: *Do you think producers say, Susan Sarandon is a political actress, we can use her in this or that part?*

Sarandon: No. They probably would never hire me. If they had thought that, why would they have gone to Michele Pfeiffer first for *Lorenzo's Oil*? They don't think that way. If anything, they're apologetic that you are maybe, in their opinion, a little bit too outspoken.

Cineaste: *It was great that you were wearing an ACT UP [*AIDS Coalition to Unleash Power*] button at the last Academy Awards when everyone else was wearing red ribbons.*

Sarandon: At the last Academy Awards nobody was wearing anything, or maybe it is the year before I'm thinking of. The year when I wore the button, though, that was it—Tim and I were it. Last year maybe there were some more. But I think it would have been great if Clinton or Hillary had worn a ribbon.

Cineaste: *My point is that the ribbons really don't cut it.*

Sarandon: Not in themselves, but at least for two seconds people think about it. On David Letterman a few days ago I wore an ACT UP button.

Cineaste: *That's a big difference.*

Sarandon: But some people don't even know what ACT UP is; if you go into Minneapolis maybe they do know about the ribbons. It lets people who are living

with this every day know that others are thinking about them. Maybe we're getting too used to red ribbons, they've become a fashion accessory, like the peace symbol has—that's what happens. It then has a different kind of power but is not as shocking.

Cineaste: *Your political activities include endorsing a tape by the gay Anti-Violence Campaign. The tape is terrific, but some radio stations refused to air it because of explicit language like faggot.*

Sarandon: I introduced a pro-choice tape with excerpts of speeches by Bush and Quayle saying "abortion," and no one would play it. I believe it was done by NOW, and it wasn't even a public service announcement; they were paying. I'm not surprised that they wouldn't air a tape with the word "faggot" if they wouldn't allow "abortion."

Cineaste: *As part of MADRE you went to Nicaragua to help distribute baby food, and you also spoke out against the Gulf War. Now the U.S. is distributing food in Somalia with the weapons they used in the Gulf War. What do you think about that?*

Sarandon: They're recycling *[laughs]*. We should examine the problem we've set up of arming the wrong guy, letting a country implode, and then going in and saving the day. I certainly think that what was happening in Somalia was horrible. I would only ask that we let them self-determine, that whatever solution there is has some justice involved, and that we also start thinking about feeding the hungry in this country.

Cineaste: *In your speech at the Women in Film luncheon, you said that maybe it's time for women to stop playing with the big boys. It's time to build our own ball park and rewrite the rule book. What exactly does that mean for working actresses?*

Sarandon: That was an easy speech to write because I was talking to people who weren't just actresses, who are, in a way, people without a country, but I was also talking to executives and other women who are integrating themselves into the system. I was speaking from experiences where the betrayal by women, I felt, was so much worse than being let down by male executives. For the most part, there are many intelligent actresses out there who are using that intelligence to question things, refusing to do parts that are demeaning. They're looking for parts where women are good, strong, or vulnerable—but parts with integrity. They're maybe even managing to get paid the same amount of money—very few—but it's happening. And there are agents out there who are trying to represent their clients in that way.

I was talking to the writers, the directors, the producers who are in a position to change things and who aren't hiring women, who aren't respecting women. There's an enormous amount of racism in Hollywood— we aren't addressing that either, which is as big or bigger a question. In that speech I was saying, instead of just going after the power, make the trip productive en route to that power. What is the point of seizing that

desk, if you're going to have to keep quiet and stay within the confines of that structure, imitating all their mistakes? Wouldn't it be better to have less power or our own independent power structures and be able to redefine how we work and how we accomplish things?

Cineaste: *Have you considered starring in or producing independent films?*

Sarandon: I've been in many independent films, which is why my price took years and years to get up. Almost every other film I've done has been for no money. Every time you do something for a small amount, they quote that last price.

Cineaste: *Can't you negotiate?*

Sarandon: You can if they want you badly enough. But a script comes along and you want to do it, so you take it for no money, and you're back to square one just about. Tim made absolutely no money last year, for instance. *Bob Roberts* cost him money, and *The Player* claimed bankruptcy, so he never saw his money from that. We're both always doing independent projects anyway.

Cineaste: *The lines between independent and studio-financed films sometimes seem to blur. At first we were surprised to learn that* Bob Roberts *was an independent production. Was that the case because the subject is too volatile to be made within the Hollywood structure?*

Sarandon: It was turned down by everybody, including the people who ultimately bought it. All the people working on that film had their hearts in the right place; everybody wanted to be there. Actors will always work for no money. John Turturro, Ellen Barkin, and others. Alan Rickman worked for nothing for three or four weeks on *Bob Roberts*. If there's a good project that people believe in, you can do it independently and do it fast, but then you have to subsidize yourself by doing something else. That's the price you pay for freedom. The funny thing was that we were both in Pittsburgh—Tim was making *Bob Roberts* and I was making *Lorenzo's Oil*, and Tim was making his entire film for less than Nick Nolte's salary (but not my salary).

It's very hopeful that so many good independent films are coming out now. The studios sometimes are the machines that can distribute these films, but it's naïve to go through the Hollywood system and expect it to be all that innovative. Even *Thelma & Louise* was pretty much independent. Alan Ladd, Jr., is not like any other producer; it was a bigger production than *Bob Roberts* so there was more money, but Ridley had final cut, which doesn't happen in a studio situation. He didn't change the ending. Now people speculate about a possible backlash from *Thelma & Louise* and that there aren't very many good women's parts in mainstream films, but there may be better female roles in independent films.

Cineaste: *There are, but they aren't being seen by a lot of people.*

Sarandon: That's the point. You're talking about films made by this enormous studio machine that spends an inordinate amount of money to promote them to qualify for consideration by the Academy. Seymour Casell, on the other hand, spent $5,000 of his own money to have *In the Soup* qualify—he sent out 1,200 tapes; his family put the labels on them; he did it all himself. Jodie Foster wrote a cover letter for him. While not a female performance,

films like his won't get consideration unless somebody does that. Martha Coolidge did it for her film last year. The point is that I'm not so sure there aren't female roles; I think that there aren't female roles maybe in the studio list of films.

When asked whether or not the Academy Award means a lot, I feel it does mean a lot to be nominated by your peers, but it would mean more if *all* the films released were considered. You get a book that lists all the films that have come out that year, but it's really not true that they're all for your consideration. I've had the misfortune of doing some great work in films that have been released far too early in the year. *Bull Durham*, for instance, was a fabulous film, but nobody sent it out on tape and nobody did a campaign. It wasn't possible to generate what needed to be generated so late in the season for that film to get consideration.

Cineaste: *Do you think you'll be nominated this year?*

Sarandon: Well, the way they're talking, it would seem that they're going to have to nominate people from last year, too, just to fill the category. I keep hearing that there's nobody to nominate, so I would think I'll be nominated, but in the year of *Bull Durham*, when I was given odds to win, I wasn't even nominated.

Cineaste: *Well, we think that you stand a good chance of winning.*

Sarandon: People thought that with *Thelma & Louise* last year. That was such an odd circumstance, so I don't know what goes into it. Emma Thompson has been winning everything. I don't know if anybody's *seen Lorenzo's Oil*—that's the other thing. They're not giving out tapes. *Howards End* is in everybody's living room—I have a copy. It makes a big difference. I haven't seen it yet, and I'm sure her performance is fabulous. But it depends on *so* many things—it's not just means, and I think people understand that. I think it's great to be nominated and I'll be very happy with the nomination, but I don't know if anyone will see the bottom half of my dress [*laughs*]. The dress I wore to the Golden Globes was designed by Todd Oldham, a friend of mine. So many people have said they wish I'd won to see what the rest of that dress looked like. Maybe I should just keep wearing it until I get to stand up—like when I'm eighty!

I got a list the other day called "Always a Bridesmaid," of all the fabulous actors who've never gotten an Academy Award and who've been nominated seven, eight times—I'm in very good company. I don't think it has to happen. The reason the Award is important is that it gets printed in the ads, and the studio gets excited enough that they'll re-release the film, so it's worth *a lot* of money.

Cineaste: *If you were going to write the ideal female role, what would that character be like?*

Sarandon: A well-rounded woman who gets to change in some way, has a sense of humor, and doesn't have to deny her intelligence or her sexuality.

Cineaste: *It seems as though sense of humor is something women aren't allowed to display too strongly.*

Sarandon: Do you think there's a lot of good *men's* humor in the movies? No, let's face it. And it's very difficult to do. It's much easier to accept a mediocre

action film than a mediocre comedy—there's nothing worse than a comedy that's not funny. People have to not take themselves so seriously, but when the bucks are that big, it's pretty hard to do. In those old classics, Jean Arthur and Carole Lombard had humor, and Katharine Hepburn was also funny in her own way. Most of those films had quite a bit of dialogue. But today there aren't many guys who can say more than two sentences in a row—there's a kind of non-verbal style that's happened in cinema. You don't see energy levels all that high when actors are bantering back and forth. It's kind of disappeared, partly because nobody reads, partly because nobody writes, and partly because nobody talks. So these actors have gotten by for a long time on being sexy and enigmatic and violent—not on having to actually converse.

Cineaste: *Have you accepted a new role at this point?*

Sarandon: No. I'm in the throes of really tough decisions, because if you're not going to do lots of movies, it's hard to find that one. I'm trying to find a romantic comedy that will have some integrity and will be fun, but not something that treats women badly. There's something else I really like, but it's kind of scary because it has a lot of sex in it; it's definitely not commercial, but I don't know how dark my mood is at the moment. You choose from what's available. Sometimes it's difficult, because you get one film that has a fabulous director and a terrible script or a good script and a mediocre director. I hope all those people who come up to me and say, "Thank you for doing strong women," will understand that maybe I'd like to play a weak woman who goes through some kind of change.

Timing is also an issue—Tim already has his next project, and we're trying not to work exactly at the same time because it's horrible on the family. I was supposed to work next, but he found a project that was just fabulous, which I really wanted to do. Careers are so strange. You can only think of them as being cyclical; you're bound to go down once you're up. You have to. There's nobody who manages to stay up there indefinitely, just because the number of good projects is limited. It's complicated by the fact that I have a family; they come everywhere with me. My children are young. I could do three films in a row, but I don't want to leave my kids or take them out of school. It's not that important for me. I've managed to take off over a year with each child, and each time I thought I'd never work again. Projects are coming my way now, but it's hard to find a balance. I'm very lucky that my problems should be about too much choice rather than not enough, so I'm not complaining in the least!

11 SALLY POTTER

Demystifying Traditional Notions of Gender

Sally Potter began making 8mm films as a teenager and later made several short films at the London Filmmakers Co-Op before training at the London School of Contemporary Dance and forming her own dance company in 1974. She returned to filmmaking in 1979 with the black-and-white short film, Thriller, which played at film festivals worldwide. Her feature film debut came in 1981 with The Gold Diggers, *starring Julie Christie in a story about the circulation of gold, women, and money. Subsequent film projects have included the TV films* Tears, Laughter, Fear *and* Rage *(1986), a four-part series on the politics of emotion, and* I Am an Ox *(1988), a documentary on the history of the postrevolutionary Soviet Union through images of women in cinema. Sally Potter was interviewed via telephone from London by Pat Dowell.*

Cineaste: *I understand that you read* Orlando *when you were quite young. What did it mean to you then?*

Sally Potter: I found it a very liberating book, because it broke all boundaries of time, gender, space, and place in a very light, kind of intoxicating way. It was as if Virginia Woolf was really in love with history and with imagery and, of course, in love with language. I remember the book burning its way visually into my mind.

Cineaste: *How old were you?*

Potter: Oh, about sixteen, I think.

Cineaste: *Has what the book means to you changed? When you started to make a movie of it, did you find that it was a different thing for you now?*

Potter: I think that over a period of time, when you work on a book or an adaptation or on a film, it has to grow with you as you grow, or it's something static. Certainly its meanings have changed, but probably the original impulse toward the book remains very similar.

Cineaste: *The theme of androgyny in the book is one that's, to put it mildly, in vogue right now. Certainly in the U.S. that's true.*

Potter: I think that it's true across the world at the moment, and Virginia Woolf was really ahead of her time when she was writing about these themes in 1928. But in a curious way they're also timeless themes. I mean, one has those themes going back through centuries in many cultures. It's just that, right now, it's as if there's a kind of crisis around masculinity and femininity, in the Western world at least.

Cineaste: *Why do you think this?*

Potter: I think that coming out of the last two decades of the women's movement, and men really asking themselves if they want to be the kind of man they are "supposed" to be has led to a sense that we really don't know any more what it is to be a man and what it is to be a woman. I think Virginia Woolf's hypothesis—that we're all born simply as human beings who are then shaped one way or the other, masculine or feminine, and that mostly it's how we're perceived by others that makes the difference, rather than what we are—that hypothesis really holds good.

Cineaste: *The central moment when Orlando becomes a woman and says, "Same person, just a different sex," raises a lot of questions. There's thinking, even among certain feminists, that there is something special about the female nature. Some would argue that women are superior because of those qualities. Woolf's idea, and your idea, seem really quite different from that.*

Potter: Yes, absolutely. I think that most notions of sexual difference are really about mystification, and that it's much simpler than that. The human race, like most species, is divided into two sexes simply for the purposes of reproduction and very little else. Most of what we think of as maleness or femaleness is simply taught, it's learned, it's acquired. There are some physical differences, of course, but they don't justify the extraordinary mystification of what it supposedly is to be a man or to be a woman.

Cineaste: *In the ways that you've changed the book, you come up against that to some extent, particularly in the ending—you give Orlando a daughter instead of a son and you have her losing Knole, the ancestral estate that the real-life Orlando, Vita Sackville-West, lost to male heirs of her family. The fact that you give the sex change a motivation in the film, when Orlando confronts war, suggests that there are inescapable qualities that go with each gender.*

Potter: In the case of Orlando's change of sex, what I simply wanted to do was put Orlando as a man into a kind of crisis of masculinity, in other words, to have to face the issue of whether to kill or be killed on a battlefield, which is the issue that most young men all over the world have to face as a possibility in their lifetime. I think that's an extraordinary thing to have hanging over your head, and most women don't have to face that. So if you work backwards from that, that has incredible implications for a young man growing up. To me that does not mean that men are more inherently aggressive or warmongering, but simply that that is the role expected of them.

Similarly, the notion that women are just waiting to be swept up into the arms of their hero, which is the common ending of so many stories and so many films, and that they will find their identity through a man, as if somehow a woman is inherently incomplete, is equally false. These are both false, acquired or learnt characteristics. I feel that we are born innocent babes with a whole gamut of possible lives, possible ways of being, that include the so-called masculine characteristics of courageousness and a positive kind of aggression and intelligence and curiosity, as well as the so-called feminine characteristics of nurturing and empathy and intuition. These are simply human characteristics that have been labeled with one gender or the other.

Cineaste: *You kept Orlando's motherhood, even though you felt free to change the novel to make it as modern now as it was in 1928. Did it ever occur to you— since the idea of finding true meaning in motherhood is a fairly common end in popular fiction and films for women—to just jettison the idea of motherhood?*

Potter: That's very perceptive of you, because the ending I rewrote, and then rewrote again—yes she will have a child, no she won't have a child, yes she will have a child, no she won't. And I realized that it was a sort of symbolic dilemma within the story that echoed the dilemma that I'm sure many of us feel in our lives. The reason for keeping the child and for having Orlando be a mother is, first of all, because the majority of women experience motherhood at some point. But I thought it was much more interesting for Orlando to have a daughter than a son, because, within the storyline, it would mean that Orlando would lose her property. I found that more interesting—the idea of Orlando finally, if you like, emerging from the shackles of the property-owning classes, emerging simply as a human being in her own right, not having to justify her existence through inheritance and not having the male line to carry her on. Also because it's, in a way, time for women to take up our inheritance, an inheritance

of a different kind. That's why the daughter is, at the end, playing with a little movie camera.

Cineaste: *It certainly projects the film into the future in a way and gives it a kind of triumphant air.*

Potter: History is so weighted on the side of women having sons, as if that is in itself some kind of triumph. In many cultures even now it's considered a subject of despair if a woman has a daughter. And I thought it would be nice if we could have a daughter at the end of the film in an atmosphere of transcendent celebration.

Cineaste: *I understand you've said that this film should not be construed as a feminist statement.*

Potter: What I was against was the use of the word *feminist* because it's become a debased word and people usually use it to categorize or ghettoize or write off, really, a whole area of thinking. If by feminist you mean in favor of the liberation and the dignity of the female sex, then that's great. But mostly when people use the word it tends to mean a movement with a rather limited appeal, with a certain kind of date on it. I think the film is for both men and women, and it's about celebrating, really, both sexes.

Cineaste: *It's amazing that the film cost $5 million. It looks like it cost five times that.*

Potter: It was actually $4 million plus rubles, and because rubles are not a hard currency, it's difficult to quantify them precisely. Indeed, in theory, the film should have cost five times that and would have cost five times that, in fact, had people not been prepared to work in very ingenious ways on an incredibly tight schedule, for very long hours, and often to improvise with meager materials. But I think if you accept that film is all about illusion and that what counts is what's in front of the camera and not behind the camera, then you can work magic with very little.

Cineaste: *"Improvising with meager materials"? Nothing about* Orlando *looks meager. Or improvised.*

Potter: Well, what I mean is that, however much you prepare with a film, at the last minute you always have to improvise with what's there. You can write a scene for 500 people on the ice in brilliant sunshine, and on that day it's snowing. So if you don't have the flexibility to change, you have to start incorporating the notion of snow into the scene in a way that wasn't there before. That's the kind of improvisation I'm talking about. Also, because we were shooting the winter scenes in Russia, in St. Petersburg, there was an incredible shortage of materials, and often we would have to change things or invent things that were originally planned in a different way. But I think none of us ever thought that that meant we would have to compromise, but simply change. You use the luck, sometimes, of things as part of your creative muscle.

Cineaste: *To cast* Orlando, *one might have done several things, including casting a man, or casting two people. How did you decide what to do, and why did you choose Tilda Swinton?*

Potter: I think if the role had been played by two different people, we would have lost exactly the sense of seamless individuality across the genders. This really is the story of one person who happens to be a man and then happens to be a woman, so it had to be one actor throughout. It could be played by a man, except it makes more sense to end up in the gender that the actor really is, rather than the other way around, and, of course, our story goes from a man to a woman.

In the case of casting Tilda Swinton, for me there really never was anybody else. As soon as I saw her on screen and then on stage and met her, it was absolutely clear to me that she was right for many, many reasons. Not just the way she looks, but the way she works her presence on the screen. It's a kind of extraordinary minimalism with which she manages to express very profound emotions and ideas. She has enormous technical skill. And she's a very committed individual to work with. We did endless preparation over a period of years together, for which she never had anything less than complete enthusiasm and commitment. So she was, as far as I was concerned, the perfect choice.

Cineaste: *There's no attempt to fool the audience into thinking she's a man to begin with.*

Potter: No, this isn't a trick. This certainly isn't a film that depends on a secret to be revealed. People might already know the book, the story, or might have read some advance publicity, or will anyway know that this is a woman playing a man, but really that's irrelevant. I think it's more about a suspension of disbelief that is echoed, for example, in the casting of Quentin Crisp as Queen Elizabeth I—that nothing is quite what it seems, but let's hope the audience goes with us on this journey. That was the premise of the casting.

Cineaste: *You thank Michael Powell at the end of the film, and* Orlando *certainly belongs to the tradition of British film that he exemplifies. What did Powell do for you?*

Potter: Well, his life's work, primarily. I think I learnt so much from just watching his films over and over, particularly *A Matter of Life and Death*, which I think is called *Stairway to Heaven* in the United States. But also I was fortunate enough, in the years before he died, to meet him. I first invited him to speak in a documentary I was making, and then I came to know him outside of that. He was very encouraging to me at the time when, really, nobody thought it was possible to make the film, and financiers weren't willing to take the risk. But he just looked me in the eye and said, "You *will* do it." And that was a great gift.

12 ARTHUR PENN

The Importance of a Singular, Guiding Vision

Providing a succinct summary of Arthur Penn's career is not easy, since his films are not Hollywood escapist fare but, conversely, are certainly not examples of rarefied avant-garde cinema. Penn's films often blend frequently unsettling violence with contemplative sequences; stark aggression coexists with cerebral anguish. Nonetheless, when reviewing Penn's work, particular moments of visceral power tend to overshadow the calmer, introspective interludes. It is difficult to forget, even after many years have elapsed, the raw immediacy of Billy the Kid shooting a bystander out of his boots; a well-meaning sheriff's bloody assault by racist yahoos; the brutal lyricism of Bonnie and Clyde's bullet-riddled bodies; or a psychotic father's murder of his newlywed daughter. These cathartic moments, culled from both the early and late phases of Penn's career, point to this director's determination to undermine his audience's complacency in a manner that is simultaneously shocking and thought-provoking.

Unlike contemporary film-school brats, Arthur Penn's apprenticeship began in the early days of broadcast television. Most memorably, he directed plays commissioned by Playhouse 90 *and* Philco Playhouse, *two of the most oft-cited representatives of the medium's so-called "Golden Age." He subsequently achieved great success on Broadway, where he directed such distinguished productions as William Gibson's* The Miracle Worker *and* Two for the Seesaw, *Lillian Hellman's* Toys in the Attic, *and* An Evening with Nichols and May. *There are vital links between Penn's work in television and theater, and his film career. His experiences as the floor manager at NBC's* Colgate Comedy Hour *influenced his jaundiced view of stand-up comedy that can be detected in* Mickey One *(1964), while something akin to Nichols and May's astringent satirical verve is evident in the darker humor of* Bonnie and Clyde *(1967) and* Little Big Man *(1970).*

At a time when flashy but empty blockbusters receive an inordinate amount of attention, Arthur Penn's career is more exemplary than ever. Penn's films are not hermetic intellectual exercises, but, like the best popular art, they do not pander to their audience's worst instincts. An entire generation of filmmakers has reaped the benefits of Penn's discovery that American films could transcend the limitations of the time-honored genres, while refusing to slavishly imitate foreign models. Arthur Penn was interviewed at his New York apartment in the summer of 1993 by Cineaste *editors Gary Crowdus and Richard Porton.*

Cineaste: *You had been working in TV for several years when you directed your first film,* The Left-Handed Gun, *in 1957. How did that come about?*

Arthur Penn: Fred Coe, the producer, asked me to direct it after he'd asked a couple of other people—Delbert Mann, I think, couldn't do it—and I said yes. Gore Vidal had originally written it as a one-hour *Philco Playhouse* directed by Bob Mulligan. It was a very nice interior . . .

Cineaste: *It's like a chamber play.*

Penn: It is, it's very small, but Leslie Stevens and I completely rewrote it.

Cineaste: *You made it into a Western.*

Penn: We introduced all the stuff that is sort of original in the film, like the Hurd Hatfield character. We took that figure historically from what was called "yellow journalism"—you know, those little yellow books written by dime novelists which turned people like Billy the Kid into legends. We just started to play with that idea and then figured he would be a terrific character.

Cineaste: *The treatment of violence is quite distinctive for a Western of that period. When one of Billy's buddies gets shot, he cries out, "I can feel my blood!" And there's a remarkable scene where one of the deputies is literally blasted out of his boots. Was that your contribution?*

Penn: Sure, that's my stuff, including the slow motion and fast motion of that shooting. It's done very quickly. Billy says, "Hey, Ollinger," and the deputy turns in slightly slow motion, and then, boom, he hits the ground in slightly fast motion. I was just playing with the medium. It was such a thrill to have a medium you could do that with, because that was not possible in live TV at all. We didn't even have tape yet—just as I left *Playhouse 90* they were getting tape—so we had to do everything live and didn't have a medium beyond the electronic image to work with. But the film's dialogue was Leslie Stevens's.

Cineaste: *Since it was your first film, you didn't have editorial control.*

Penn: I didn't have anything. After I finished shooting it, I never heard "boo" from Warner Bros. I never saw a cut, nothing, and then the film was released. The first I saw of it was when I went with my brother and sister-in-law to see it on a double-bill. It was amazing, a very strange experience.

Cineaste: *How would your version have differed?*

Penn: Oh, not a great deal.

Cineaste: *Is it a question of different emphases here and there?*

Penn: And rhythms, because, having come from live TV, I didn't understand the excesses of filming as they were practiced by the more knowledgeable directors, so l shot very little film. We did the film in twenty-three days, so l didn't cover anything that was extraneous. I could have wished for better rhythms in certain scenes and sometimes a more antic spirit—for example, when Billy and his two pals have that flour fight. There are a couple of other scenes likewise intended to be a little more antic to suggest a young guy, a kid, and those are done a little ponderously.

Cineaste: *You also said that Warner Bros. botched the ending?*

Penn: Yes, that's a terrible ending. It's flat and absolutely deadly. It's

that line of, "Well, we can go home now," the classic phrase used in a million films. Well, what's so great about going home?! Besides, Pat Garrett is not the principal character.

Cineaste: *What was your preferred ending?*

Penn: It was to be a ritualistic ending. Small groups of black-clad women, mostly, slowly assembling into a candlelit cortege. It was meant to seem both haphazard and deeply formal. We started to shoot it but never got there. The studio stopped us and told us to wrap the picture right there. The scene with Pat Garrett became the ending.

Cineaste: *Why do you think the French critics were more receptive to the film? Were they paying more serious attention to genre films?*

Penn: I think they were paying serious attention to the dark American films, the unusual ones. The problem with American film companies is that if a film doesn't click immediately, they just throw it away, and that's what happened with this one. It got a bad review in *The New York Times* and, bing, it was gone.

Cineaste: *You've said about* The Miracle Worker *that you were disappointed in your failure to fully adapt the stage play for the cinema. How would you have made it more cinematic?*

Penn: I think there should have been an almost silent film eloquence about the impact of Helen's affliction on the family so that we wouldn't have to have Captain Keller enunciate, "Two weeks, Miss Sullivan, two weeks, then the child comes back to us!" Those are lines that had to be said on the stage, but that I didn't need on the screen. As a result of my lack of belief in the cinema at that time, I took the expository material from the stage, like that artificial time limitation, and kept it in.

I think I would have had the same physical actions, only done with a more searching camera than one that was relying on the dialogue as well as the image. But there are parts of that film that I'm very proud of. The opening credits sequence, for example, probably more than anything else, illustrates what I mean—the danger to a child like that of a Christmas tree ball or of laundry hanging on a clothesline—because she had to be watched all the time.

Cineaste: *Most of the action is anchored in this house, which becomes very ominous.*

Penn: Yes, exactly. Years afterward, when I had my own children, I thought, gee, how that house must have resonated with the silence of that child, just moving as a presence, and people not being able to talk about her, even to each other, but just having to watch, with the child as the focus of all the behavior of the family. But we wouldn't need the words. We needed the words on the stage because there was no way to suggest how adversarial her malady was, beyond the fact that it was a demonstrated one. But you could do it in the cinema, and you could do it very well. The big fight scene at the table, for instance, is a wonderful scene. It's a good piece of cinema, because there was no dialogue and no need for it.

Cineaste: *Much of that scene was shot hand-held, wasn't it?*

Penn: Yes.

Cineaste: *And the shots are held for a fairly long time.*

Penn: Yes, because I didn't see the need to cut until certain events needed to be punctuated or you needed another view on them. I thought the film should really resemble those early silent two- or three-reelers where they just kept the camera grinding. Those films were usually comedies, but there's also a basic humor underlying this scene, which is really a little battle. You know, "You do that, I'll do this. You do this, I'll do that." It was sort of a *mano a mano*, in that regard.

Cineaste: *How did you achieve the visual effect used for Annie Sullivan's flashbacks?*

Penn: It's quite technical, and I won't remember exactly, but we took the camera eyepiece and blocked out everything but a little square of the frame in the center with the intention that we would then optically blow that up to be the full frame. We did tests first to find the right ratio—I think it was something like fourteen times—and then we made that piece out of metal and put it into the camera. When we blew up that portion to fill the frame, it got very grainy and began to break down to the point where the emulsion could just hold an image. We wanted to get to that point where the image almost disappears to be the equivalent of Annie's inability to see. She was virtually blind herself, you know, so that was all she ever saw of the world. She had many eye operations before she was ever able to go to Alabama.

Cineaste: *The lighting, especially in the interiors, often seems quite theatrical, with pools of light amidst surrounding darkness. Is that a carryover from the stage presentation?*

Penn: No *[laughs]*, but that's a wonderful story. Ernie Caparros, the cinematographer, had never seen the play. He was a debonair fellow, a rather cynical Cuban, but a good cinematographer. When we began shooting, the film didn't seem to him to mean much of anything. About three weeks or so into the schedule, we shot the scene at the pump, the big defining scene, and Caparros saw the emotional power for the first time and he saw the effect of it on the crew. I mean, there were grown men standing there weeping. Suddenly, he got the idea—Academy Award!—and from that moment on it was, "Oh, I have to light the chadows."

Cineaste: *Chadows?*

Penn: Shadows.

Cineaste: *Rembrandt lighting.*

Penn: Exactly, we're talking *chiaroscuro*, and I'm saying, "Come on, Ernie. Let's go, Ernie, we've got to finish this movie," and he's saying, "No, no, I must light the chadows."

Cineaste: *The sets seemed to be very sparsely decorated.*

Penn: They were sparse at my request. I told George Jenkins, our art director, let's have no pictures on the wall. Let's have it be a sightless house in that respect, so that we don't ever see a picture or part of a picture at the edge of

the frame. At first, he said, "Well, I don't know," but then he got the feel of it and leapt into it wholeheartedly. But it was a very strong intention about the film, to somehow convey the idea of a house that had lost its faith in sight and sound.

Cineaste: *What's the story behind the casting of Patty Duke in that part?*

Penn: We auditioned a lot of kids for the Broadway play, maybe a hundred or more. I'd say to them, "Show me how you'd walk if you were blind. OK, now show me how you'd do that if you were blind and couldn't hear." Well, they were all good, interesting kids, and then in came this little child and something just came out of her that was absolutely palpable, we all felt it. I had seen her in *The Goddess*, Paddy Chayefsky's film that Del Mann directed with Kim Stanley. She played a little part in it, but she was wonderful.

Cineaste: *Whatever your dissatisfaction with* The Miracle Worker—*and I think that's really a testament to your ambitions as a filmmaker—it is neverthe-less an incredibly powerful piece of work and is also valuable for preserving your Broadway stage presentation.*

Penn: I have no regrets about it beyond the fact that I wasn't so mature in terms of my ideas about cinema then. It was only my second film, and I was just putting my toe in the water, cinematically speaking, because I wasn't yet ready to plunge.

Cineaste: *You seem to have taken that plunge in* Mickey One.

Penn: Yeah, I was really doing the stuff that I hadn't done yet in *The Miracle Worker*. I was testing the medium, trying to see how metaphoric it could be, how nonlinear, what the poetic implications of the medium were, so it's pompous in many respects.

Cineaste: *You've said the film was intended to deal on a metaphorical level with the national atmosphere generated by McCarthyism.*

Penn: There are aspects of our government that I've always found offensive, but I think they came to a head during the McCarthy period. Looking at the new Anthony Summers biography of Hoover, what you see is that it was a government by a kind of terror, and that endured for so long and culminated in a period dominated by McCarthy, a complete alcoholic with a staff made up of certainly questionable people.

To define this very quickly, Alger Hiss is one of my closest friends. To have arrayed against a man of such dignity, clarity, and intellectual perception such a volume of scoundrels was not just a horrible experience in and of itself for Alger but also a paradigm of a kind of bloodthirst that had taken over in American politics. It probably was always there, but the means were not always as potent. You didn't have television, you didn't have those leaks to the media that McCarthy or Nixon used. I think the Hiss case is the real paradigm of the modern era of politics.

Now, I didn't think anybody was going to get all of that stuff about the McCarthy period, but I felt there had to be a kind of moving away from this fearful state of mind we were in. I was hoping that the country could get out of that McCarthy period and out of the Cold War paranoia I thought was

absolutely gripping us. I was wrong, of course, because we never did get out of it. But in simple-minded terms, the film was about saying "yes" instead of saying "no."

Cineaste: *Were you aiming at an art-house audience?*

Penn: Oh yes, it was clearly an American New Wave film. I knew that it was going to be *extremely* limited. It was more limited than I could have imagined because Columbia just hated it. I had a deal with them to make two films for no more than a million dollars each, and I would get paid a minimal amount. *Mickey One* was supposed to be the first of the two, only they never wanted the second one.

Cineaste: *Were there any particular film models or artistic theories behind the film? What was the genesis of it?*

Penn: The genesis of it was a play by Alan Surgal, who also wrote the screenplay. It's sort of an act from a play of his about a comedian who's in trouble with the mob. Once we'd decided to make a film of it, we began to add things. This was just the time when Jean Tinguel had that machine at the Museum of Modern Art that destroyed itself. I thought that was such a funny kind of model for our time, because this was also post-atomic bomb, so those were the things informing me.

Cineaste: *Critics have often mentioned the European film influences in your work, and, in this regard,* Mickey One *seems particularly relevant as a film that seems to bear the influence of the New Wave.*

Penn: Yeah, it does, but I've always held the sort of personal contention that the New Wave very clearly floated in both directions. I don't think enough has been written—in American criticism, at least—about the postwar influence of American filmmakers, especially what the French called *films noirs*, films by Walsh and others that revealed a dark side of America. I think those currents flowed in both directions. So, yes, I was influenced by the New Wave, but I was also trying to do something essentially American in *Mickey One*, and whatever the influence of the New Wave was, it was an American voice.

Cineaste: *You've said that the basic problem with the film is that there was too much symbolism and not enough story, that the film failed to engage the audience in a way that would enable it to even consider the larger implications.*

Penn: Yes, I wish I had done more narrative stuff. Beatty kept saying to me, "Too fucking obscure."

Cineaste: *After the experimental effort with* Mickey One, *you went to your first big studio production with* The Chase, *produced by Sam Spiegel. Would you comment on the script problems? Reportedly Lillian Hellman's adaptation of the original Horton Foote play was then reworked by Foote as well as by Michael Wilson.*

Penn: It was mostly Foote and Hellman. Michael Wilson did something, although I didn't know it. Wilson was one of the guys Spiegel had working on it, and he had another screenwriter, Ivan Moffat, working on *another* version of the script. It was really a dog's breakfast.

Hellman heard about this, got very angry, and didn't really finish the script. Foote was then brought in to finish it up and add more colorful dialogue, which he would know, and which Hellman protested that *she* knew, having grown up in New Orleans. But she didn't know about chopping cotton or working out in the fields. She came from a different background. But she had the great Hellman hard edge, no sentiment, and some of the scenes in there are pure Hellman. Most of them, however, are written by various hands. I mean, I would get sent dialog on the morning of the shoot.

I suspect that the script would often be tampered with by Sam Spiegel, too, because every once in a while I would get some pages sent down that had some of the worst dialogue you've ever read in your life. Sam was a smart and cultured man, I don't mean to suggest that he wasn't, but he had no skills as a writer. He had all these different sensibilities working on the script, so l think he put things together that, stylistically and in terms of diction, were just terrible choices.

Cineaste: *You also had problems with him in terms of not being able to oversee the editing of the film.*

Penn: Yes. I had a prior commitment to direct *Wait Until Dark* on Broadway, so we had an agreement to cut in New York so that I could be doing the play but still see the film. But at the end of the shoot, he called me up and said [*Penn does a Spiegel impersonation*], "Where do you want to edit this, dahling? In London or in Hollywood?" I said, "Sam!," and, boom, he was off to London. When I finally finished the play—which, mercifully, was a hit, because if it hadn't been, I would have been suicidal in addition to being so angry—I went to London, and they had already finished eight reels, scored and everything, and it was not a good cut. They left out some of the best material, including some of Brando's unique improvisations. Except for Spiegel's sense of authorship, I can't imagine why they would leave those out, because they were extraordinary.

Cineaste: *Do you think he behaved that way because he knew he was dealing with a director who was still somewhat new to big-time Hollywood studio production?*

Penn: Absolutely.

Cineaste: *He would never have tried to pull that with David Lean.*

Penn: No, Lean had just kicked Sam's ass all over the place. I think what happened here—something I had no real knowledge of or was just plain dumb about—was what this whole event meant to Sam Spiegel, which was to return in triumph to Hollywood where he had been a figure of contempt. He had been S. P. Eagle and now he was back as Sam Spiegel, the producer of *Bridge on the River Kwai* and *Lawrence of Arabia*, a member of the Board of Directors of Columbia Pictures, and a vastly wealthy man. He came back like a king returned to his throne, and he was going to rub Hollywood's nose in it. And included in that were abuses of power and broken promises to me that were really unseemly.

Cineaste: *Despite all the difficulties you've described, the film nevertheless*

succeeds in making some rather strong statements about racism, about gun culture, class relations, and religious zealotry, problems that are not confined to Texas or the South.

Penn: Certainly today's perspective on the film is more generous and enables one to see better things in it. At the time I think the critics, and the New York crowd in particular, were disappointed that it was not as radical as they could have wished. They really wanted us to bash that whole scene.

Cineaste: *Maybe they were surprised that the sheriff is a relatively liberal character. He's not Bull Connor.*

Penn: Yes, exactly.

Cineaste: *He's the one sane man in the film. Some of his lines are great, such as, "These people are nuts, just nuts." Or, when he has to arrest and jail a black man to protect him from a white mob, he says, "Those people should have been home reading a book."*

Penn: Quite a few of those lines are Brando's improvisations.

Cineaste: *His beating by the vigilantes is quite vicious.*

Penn: Yeah, that was Marlon's idea. He said, "You know, I think the beating should be really savage." And I said, "Yeah, but how are we going to do it so savagely." So he showed me how to do it, which was to film it with slow-motion acting and speeded-up camera. It doesn't show, it was just a few frames faster, but it was astonishing.

Cineaste: *On the other hand, I've read that he didn't feel he should beat up Bubber Reeves's assassin in the final scene.*

Penn: No, he didn't want to do that. But I said, "Marlon, we've got to have some purgation here. We can't digest all these events and then just have you drive away from them. Let us as an audience have some release." He didn't protest it, he just said, "You know, it doesn't seem to me the best choice." And I said, "You're right, it's probably not the best choice."

Cineaste: *Did he have an alternative?*

Penn: No, the alternative was to do nothing, to just drive away and leave that in everybody's craw. He didn't take a lot of persuading. He's a wonderful, much maligned guy, so willing to try new stuff—anything but the way he's been characterized. My two experiences with him were both just terrific.

Cineaste: *Would you have preferred to have shot the film on location?*

Penn: Sure, I think it would have had a texture of authenticity that we didn't have. I could feel all the time that it was a stage. It had that backlot feel. It lost the immediacy that on-location specificity would have given it, so it became almost a parable. I have no great pleasure in the film, and I've said so on a few occasions, but I don't mean about the film itself, the story idea, or the work of the actors. It's just all of these other aspects of the film that I wish I had made as compared to the film that is there. And the film I wish I had made would have been much tougher, grittier, with stronger racial problems, certainly stronger racial forces, and a lot sexier, too. Some things of that sort *were* shot, longer and more meaningful scenes, but they weren't chosen for the final cut.

Cineaste: Bonnie and Clyde *was an enormously popular film but also an enormously controversial film. How do you account for the absolutely vociferous critical response, at least from some critics, which condemned the film? Were you disappointed that your artistic intentions were so misunderstood?*

Penn: No, I was delighted because they were misunderstood by people who should have misunderstood, like Bosley Crowther, an old wave *New York Times* critic who at that time was on a crusade against violence in films in general. When he saw *Bonnie and Clyde* at the Montreal Film Festival, where it was first shown, he is alleged to have said to somebody that he was going to blow that film out of the water. Which he did, in his review, but it was the best advertising we could have had because people wrote scores of letters to *The New York Times*, which published them. Then Crowther wrote another attack, a Sunday piece, and more letters poured in, and Crowther responded again, and the more he frothed at the mouth, the more it enlisted support for the film.

It was not a film about violence, it was a metaphorical film. Violence had so little to do with it that it didn't even occur to me, particularly, that it was a violent film. Not given the times in which we were living, because every night on the news we saw kids in Vietnam being airlifted out in body bags, with blood all over the place. Why, suddenly, the cinema had to be immaculate, I'll never know. Crowther had philosophically painted himself into a corner by arguing that art, and particularly the cinema, has a social responsibility for setting certain mores and standards of behavior, which is a terrible argument, it just collapses in ten seconds. He was in that corner and couldn't get out of it and it cost him his job.

Cineaste: *Were you surprised by the popular appeal of the film?*

Penn: That film was a great surprise to everybody. The guy at Warner Bros. who was in charge of distribution said, on seeing the film, "This is a piece of shit." Literally, that's a quote. Warren said, "All right, give me forty-eight hours, and I'll buy it back from you." They wouldn't sell it, but Warren was prepared to go out and raise the $2.5 or $2.7 million or whatever it was, and he would have been able to do it. He had that much clout. I wish he would have, so that we'd have been able to open that film.

What Warner Bros. did with that film is terrible. You know, distributors make exhibition deals on every film, like it has to be in a theater for so many weeks or you can't book it. But they let theaters have it for a half week, while *The Graduate*, which came out at the same time, had a five-week minimum. Well, if we'd have had that, we would have gone through the roof. We'd be conducting this interview in a much more palatial apartment.

Cineaste: *How do you account for the film's enormous popularity, especially with young people?*

Penn: I think it caught the spirit of the times and the true radical nature of the kids. It plugged into them, it just touched all the nerves, because here were these two who, instead of knuckling under to the system, resisted it. Yes, they killed some people, but *they* got killed in the end, so they were heroic and

martyred in that respect. I must say, in our defense, we knew a little bit of what we were doing, because the studio asked us if we wanted to do it in black and white, and Warren and I said, "Absolutely not. It's gotta be a film about now. This is not a re-creation of Bonnie and Clyde, they were a couple of thugs. We're talking about two kind of paradigmatic figures for our times."

Cineaste: *So historical accuracy was never really a concern of yours?*

Penn: Never tried, never came near. Of course, they weren't like that. We were flagrantly inaccurate and said, right off the bat, this is metaphoric.

Cineaste: *So when critics wrote that the film romanticized Bonnie and Clyde, that's exactly what you were trying to do.*

Penn: Exactly. Far from trying to do anything accurate.

Cineaste: *And yet the film is not without social commentary on the period. The screenwriters, Robert Benton and David Newman, who have readily acknowledged you as the true auteur of the film, commented that they were more concerned with the mythology and that you were more concerned with social context and commentary.*

Penn: What caught my fancy about the script was what I remembered as a child from the Depression, which was people in New York neighborhoods being kicked out of their homes. When I was doing research by reading newspapers from the period, what struck me was the enormity of the banks' naiveté in holding these mortgages and then foreclosing on farm after farm after farm. It was stupidity of a monumental, punitive nature. They created a nation of displaced people who essentially began heading to California.

These kind of bucolic figures like John Dillinger and Bonnie and Clyde were called bank robbers by the FBI in order to aggrandize the agency when they tried to capture them. But they were really just bumpkins, who said, "The banks are foreclosing on the farms, so let's go knock off the banks." It's a very simple, retaliatory response, and on a small scale.

Cineaste: *So the sequence with the dispossessed farmer was your contribution.*

Penn: Yeah, that was a scene I built.

Cineaste: *Robert Towne received a credit as "Special Consultant." What was that for?*

Penn: He wrote certain little scenes in the film as well as some additional dialogue, but very telling dialogue. In the family reunion scene, for example, when they go back to visit Bonnie's mother, that scene was in the original script, but it didn't include Clyde's explanation to Bonnie's mother about how as soon as everything blew over he and Bonnie were going to settle down and live right down the road from her. And she says, "You do that and you won't live long." That's Towne. He made some very salient contributions.

Cineaste: *There is much made in the film of the media blowing the Barrow Gang's exploits out of all proportion. Hoover was in office then . . .*

Penn: Yes, but the FBI had not really been granted a national status, they were not able to go beyond state lines, and very few crimes were called national crimes. I think the Lindbergh kidnapping was one of them, so they began to call

almost anything kidnapping and that gave them jurisdiction. It was an effort on Hoover's part to build a *national* police force. But in this case, it was the local sheriff, Sheriff Hamer, who eventually did track them down to Louisiana—that part of it is accurate—and did blow them away. They fired something in excess of a thousand rounds of ammunition at them. It's amazing, the pent up rage must have been enormous.

Cineaste: *It's a remarkable scene in the film, and even in film history. How was it conceived?*

Penn: I had a kind of epiphany on this film where I saw the ending, literally frame by frame, before I even came near shooting it. In the earliest days, when Benton and Newman and I got together to discuss the script, I suddenly saw how that scene should look. I thought we had to launch into legend, we had to end the film with a kind of pole vault, you know, some kind of great leap into the future, as if to say, "They're not Bonnie and Clyde, they're two people who had a response to a social condition that was intolerable." So I thought, gee, the best way to do that is to be somewhat balletic, and, having seen enough Kurosawa by that point, I knew how to do it.

What I did do, which I think had not yet been done, was to vary the speeds of the slow motion so that I could get both the spastic and the balletic qualities at the same time. Technically, it was an enormous problem, because we had to gang four cameras together, shooting simultaneously from the same vantage point. The cameras were literally joined side by side on a stand. The problem, because of the very fast speeds needed for the slowest slow motion, was that we were using up gigantic magazines and we didn't even have time to say "action" because the film would go through the camera so fast. So we said, "OK, when Warren squeezes the pear, that's our cue, and everything goes."

Cineaste: *How were the bullet hits applied?*

Penn: There were bundles of wires going up their legs and a special effects guy would trip them by making electrical contact with nails sticking up in a row connected to a battery. Meanwhile, as the bullets are going, someone else was pulling an invisible nylon line that took off a piece of Warren's head, they were both going through contortions with their bodies, and all of this filmed in various slow-motion speeds in four cameras.

Cineaste: *How long did that scene take to shoot?*

Penn: It took three or four days. We would get one take in the morning and one take in the afternoon, because it took that long to prepare. It was one of those insane moments where, as a director, you're saying to yourself, "I see it this way, I see it no other way, so I'm not going to economize," and, meanwhile, you can see people whispering on the set, "This guy is nuts. What the fuck is he doing?"

I just had this vision. I knew what it would look like, and, when I got into the editing room, it turned out to be a true one. Dede Allen edited the film, but Jerry Greenberg, one of her assistants, edited that scene, and he was just shaking his head. I came in, and I said, "Here's how it goes—this shot, to this shot, then to that shot." It was as if I was reading it out of some

other perception. I knew exactly what it would look like.

Cineaste: *The various scenes of violence in the film escalate progressively in a very clear dramatic purpose. How would you describe your aesthetic strategy?*

Penn: The best example I can give, quoting from the film itself, is the sequence where Bonnie and Clyde, with C. W. Moss driving the car for the first time, go to rob a bank. They say "Wait here," and go into the bank, and C. W. proceeds to *park* the car. Now, everybody in the audience is titillated by that and is meant to be. Then the bank alarm goes off, and out come Bonnie and Clyde who are asking, "Where's the car?" It's wedged in between two cars, of course, because C. W. has parked it beautifully. So, into the car they go and scream, "Get out of here!," and this enormous comic tension is built up. We've got you laughing and laughing, and C. W. finally gets the car moving and, at that point, the guy comes out of the bank and jumps on the running board. Clyde, in a paroxysm of fear, turns and fires, and that first killing is the one that knocks you right out of the chair, because it's a guy getting it right in the face. The intention was to disarm the audience to that point where, bam!, the shooting occurs, and then comes the scene in the movie theater where Clyde is hitting C. W. and saying, "You dummy," because he's expressing his own remorse and panic about having killed somebody.

Cineaste: *In that scene Bonnie seems relatively unaffected.*

Penn: She doesn't mind. In our choice of what we were doing, Bonnie had a more romantic view of danger. Once she'd made the determination, from the very first scene, that she was going to go downstairs and join up with this guy, she was on the *qui vive*.

Cineaste: *Is that why you begin the film with her point of view?*

Penn: Yes, it begins with a big close-up of her lips, her hungry lips. I'm sorry it sounds so corny, but that's what it is—a hunger for something more than her present existence.

Cineaste: *Was the film's visual style influenced by the work of Walker Evans?*

Penn: Yeah, we used a lot of his photographs in the titles. The man who did them, Wayne Fitzgerald, kept saying, "God, there's something not right here. I'm going to take the credits home tonight, and I'll bring them back tomorrow." What he put in was the sound of that box camera click and suddenly it evoked the memory we all had from our childhoods of that clicking noise of the Kodak camera shutter, and it just made the titles come alive.

Cineaste: *While* Alice's Restaurant *is very sympathetic to the counterculture of the period, it also seems to have no illusions about some of its more utopian notions. You've said that the film is not so much about the younger generation as it is about your own generation. Was that because of the focus on Ray and Alice?*

Penn: Well, a little bit, but it's also about my own experience. I went to Black Mountain College, which was a very experimental college, very counter-cultural, and it endured only fifteen years. I had such an association with that marvelous educational place. We lived in a small community in North Carolina, we cooked our own food, grew a good portion of it, and a lot of wonderful people

dropped in, like Willem de Kooning and Merce Cunningham and John Cage. I mean, you'd look up and there'd be someone like Bucky Fuller, people of enormous intellectual or artistic magnitude.

It was a very attractive place, but at the same time it had the seeds of its own destruction within it. It couldn't last, because it was a dream as much as Alice's Restaurant was a dream. So I wasn't passing judgment, I was simply saying, "I admire you kids for having defied the draft, I admire you for all the things you've done, for living your own kind of style, but at the same time I have no illusions that this is going to endure."

In fact, that last image of Alice on the church steps is intended to freeze time, to say that this paradise doesn't exist any more, it can only endure in memory. It's a very long dolly *back*, and yet we seem to go nowhere because we're zooming *in* at the same time. It took us days to make that shot. Technically it sounds right to say let's dolly back and zoom in, but we found that if you don't pass objects you have no sense of tracking back. So we had to cut tree stumps and slide them into the frame at just the right place so that, as we were dollying back, we were revealing the tree stumps but, at the same time, the image was not getting any larger.

Cineaste: *The film paints a somewhat critical portrait of Ray and a somewhat more sympathetic portrait of Alice. Was this based on your knowledge of the actual people or more a reflection of the dramatic needs of the piece?*

Penn: No, I think it was accurate. I knew them both pretty well, they were right down the street. Ray was a dreamspinner, but he was also a bullshit artist of magnitude. And Alice was a very warm, welcoming woman, a kind of idealized mother image. Not only did she cook, but I'm told she also *did* make love with some of those young guys—I mean, you can't beat that for warmth.

Cineaste: *Was the character of Shelly, who dies of a drug overdose, a way to avoid the charge of romanticizing the drug culture?*

Penn: No, unfortunately, although it's not on Arlo's record, that did occur. There was an even more ironic, terrible part to it. Shortly after his death, the wife of the guy on whom we based that character went to the beauty parlor, had her hair and a full make-up done, went home and killed herself. They were both young, in their twenties.

Cineaste: *There were really two distinct oppositional strains in American politics during the Sixties, and people would define themselves as being part of one camp or the other, either the counterculture—the hippies, Yippies, or flower people—or the New Left, including SDS and other political groupings. Alice's Restaurant is interesting in that regard because even though it's about the counterculture, the Old Left element, with Pete Seeger, Woody Guthrie, Lee Hays, and so forth, is represented.*

Penn: As you say, it is a strain in the American culture that needs to be followed. Woody was a major figure in my life as a young lefty—you know, another Solidarity guy. And Marjorie Guthrie, an ex-modern dancer who married Woody, was around during the making of the film.

Cineaste: *How do you see the film in retrospect today?*

Penn: I don't think of it as a particularly weighty film, but I think it's probably the best film made about that culture. That's not saying much—the previous efforts had been terrible, just disgraceful—but I think it had to be documented, to get it down on film. The film has authenticity of attitude and spirit.

Cineaste: *Perhaps because it was released toward the end of the Sixties, it has the feeling of being a more despairing commentary than was perhaps intended.*

Penn: I didn't intend it to be despairing. But we mustn't think of it as having been a revolution. Certain changes were made, but we're going to slip back to the status quo, that was the sense that I had.

Cineaste: In Little Big Man, *was your intention to develop a counter-mythology of the history of the American West?*

Penn: Yeah, it was to say, "Wait a minute, folks, the American Indian has been portrayed in movies in the most unpleasant way possible"—I mean, pure, naked racism—"so let's examine how we have told our own history, such as Custer's last stand." I mean, you go out there to this day, and they feed you a lot of bullshit about the great, brave Custer, but the books don't bear that out at all. He was a pompous, self-aggrandizing man.

Cineaste: *Did you intend any parallels between Custer and President Johnson?*

Penn: Possibly, possibly.

Cineaste: *There were a lot of things in the air at that time. Not only was the Vietnam War going on but there was also the beginning of a revisionist strain in Native American history with books such as Dee Brown's* Bury My Heart at Wounded Knee *and films like* Soldier Blue.

Penn: I was so disappointed when *Soldier Blue* came out, because I had been waiting for six years to make *Little Big Man*. I had the script, but nobody would make it. Even with the force of *Bonnie and Clyde* I couldn't get it made until *Soldier Blue* came out—it was a sort of sympathetic film, but much more romantic, which did rather well. Finally we got the OK to go, but the guys who were running Cinema Center Films didn't understand what I was trying to do with that film.

Cineaste: *The film is clearly sympathetic to the American Indian.*

Penn: Yes, and, in that sense, it's what Thomas Berger wrote. The comic style also clearly comes from Berger—you know, the Jack Crabb character who was 121 years old and who was at all these events throughout history. That's pure Berger plus a good screenplay by Calder Willingham.

Cineaste: *Did you make any significant changes from the Berger novel?*

Penn: Only one major one, to my knowledge, which is that the chief doesn't die at the end. In the novel, he dies. I was all for adhering to the novel, but Calder Willingham and [*producer*] Stuart Millar kept saying, "Wait a minute, this is all wrong, it just ends. All the sense that he's gonna die should be there, but there should be one more turn." They did persuade me, and, by God, I'm so glad they did. To have ended it with his death, and to tug on your heartstrings, would have been so easy. But for him to say, "Am I still in this world?," and, then,

realizing he hasn't died, "Oh well, sometimes the magic works and sometimes it doesn't," is really more in keeping with the tone of the film.

Cineaste: *We've read that the role of Old Lodge Skins was originally offered to Laurence Olivier, Paul Scofield and Richard Boone. Was Chief Dan George a last-minute discovery?*

Penn: I had folks out combing the hustings, and Chief Dan George, who was Canadian, had performed Chief Joseph's farewell as a sort of ceremonial thing and somebody had seen him and put him in a small part in a Disney film. So we were trying to track him down, but, meanwhile, I was getting all this pressure from the studio to get a name because Dustin was not that big a name yet. Actually, we didn't approach Scofield, and Olivier was not a serious consideration. Boone was a serious contender but his agent said, "For the part of Old Lodge Skins? Let me tell you something, Richard is not going to play the part of *old* anything." I was also interested in Donald Pleasence, a strange, terrible idea, and I'm afraid it's mine. I just knew him as a very elastic character actor, and I thought we could get him. Fortunately, none of them accepted my offer, and I was so grateful.

Cineaste: *You apparently didn't feel it necessary to cast the film's Indian roles entirely with Indian actors. What's your attitude on that issue?*

Penn: My attitude is pretty ecumenical in that respect. I know today in Hollywood people say you can't do this because you don't have enough Native American actors or Latin actors or whatever, but that's a lot of bullshit. I used Latin actors, Native American actors, Asian actors, whatever, because it didn't matter to me in that respect. What mattered to me were the two cultures, white and Native American, and how they perceived each other. And when I came to do the score, I asked myself, "What do I really hear here? I hear pure blues, just a guy with a guitar singing blues, a really good black score." So we got a white guy, John Hammond, Jr.

Cineaste: *How important was historical accuracy for you, especially the portrayal of Native American culture? I noticed someone credited as "Historian." What was his role?*

Penn: His role was to keep us from transgressing violently or too egregiously, but not much more than that. He was a nice man from the National Historical Society or some such. I didn't want to have the wrong costume or something, but that was it, because we were going to set our own tone.

Cineaste: *As in* Bonnie and Clyde, *you successfully used an approach which conjoins humor and tragedy, violence and comedy.*

Penn: Yes, and it's an approach that really couldn't exist under the studio system today, because they would preform a judgment about the category of a film as either one thing or the other. What was happening at that time in Hollywood was that enormous power had devolved upon the directors because the studio system had kind of collapsed. We were really running it, so we could introduce this new perception of how to make another kind of movie. I don't mean that movies in the past hadn't had this mixture to some degree, but to

have it to that total degree, to make it the very narrative style of the movie, was I think pretty much unheard of.

Cineaste: *That blending of comedy and pathos seems very characteristic of your work.*

Penn: Yeah, I've used it on the stage *constantly*. It's so important in the theater, the most serious play . . .

Cineaste: *We're talking more than comic relief.*

Penn: Yes, it's more disarming, it's comedy to disarm in order to make the audience vulnerable to a turn that is unanticipated, that will tap into an emotion you were not expecting yourself to feel.

Cineaste: *Another characteristic of your work is the subversion of traditional genre expectations, such as in* Night Moves. *That film seems to have some parallels with* Blowup *because both films deal with the elusiveness of the truth. The Harry Moseby character, like David Hemmings's character in* Blowup, *is never really sure of what the truth is.*

Penn: I hadn't thought of that, but it's perfectly acceptable. I think we were trying to do something just a little more than that, which was to say that in the detective film genre, the detective eventually solved the crime. I mean, Bogart eventually found it out, however painful it was, and Mary Astor was sent up. In *Night Moves* we were trying to say, "Wait a minute, maybe the enemy is us. Maybe Moseby's vision is blocked by his need to have a friendship with this stunt man, who was taking advantage of that friendship." That was the only other sort of quietly psychological aspect that we were adding to that form. It's a pretty dark and despairing film, and I guess I was feeling that way.

Cineaste: *The paranoia links the film to* Mickey One *in a way.*

Penn: Yeah, maybe, but it was much darker than *Mickey One*, which had a kind of youthful hope. In this film, when someone asked, "Where were you when Kennedy was shot?," the reply was, "Which Kennedy?" That was really the capsule of our lives at that point.

Cineaste: *There are echoes of the Kennedy assassination in the enormous conspiracy that devolves toward the end of the film.*

Penn: Yeah, and, you know, I had worked with both Kennedys. I had served as a TV advisor to Jack Kennedy's campaign. During the Nixon-Kennedy debates we were in the Kennedy camp using the medium in a way we thought made for a better presentation. Later I started working with Bobby. I went down to Washington, and we did one radio commercial. We were then going to do a whole bunch of radio and TV stuff as soon as he came back from California, and of course he never did.

Cineaste: *So* Night Moves *was a very personal film?*

Penn: It was personal in that respect, but it's also despairing in that I just felt, "Oh God, this country . . . " I mean, those assassinations—Jack Kennedy, Bobby Kennedy, Martin Luther King, Jr.—were just crushing to people who'd been involved in those movements. I'd been in the Civil Rights movement up to my ears.

Cineaste: *Your next film,* The Missouri Breaks, *was not critically well received, but too often a consideration of the film itself seemed to get lost in stories about the size of the actors' salaries.*

Penn: Yeah, I think there was an awful lot of original work in that film, and I think Brando's characterization is brilliant. We were searching around for it, saying "What the hell moves this guy?"

Cineaste: *Didn't Brando say, "I don't understand this character, so I think every time you see him he should be in a different guise."*

Penn: Yes, and I said, "You're absolutely right." When we got to that last scene, he said, "How about a dress?," and I said, "Yeah, OK, let's get a dress," because I thought this character has got to be the most fragmented personality, since all we had left was that he was going to get his throat cut by Jack.

Cineaste: *He was a fascinating historical character, too—a "regulator" hired by the wealthy rancher to kill the band of horse thieves—and rather perverse in that, although he's there to enforce the law, he's crazier than anyone else.*

Penn: Absolutely, and killing people in ignominious acts—in the outhouse, making love—that he would have had personal abhorrence for.

Cineaste: *What was the difference in directing Brando in* The Chase *and in this one?*

Penn: Oh, in *The Chase* I was much more tight-assed and restrictive. You know, when we're going to improvise, let's clearly improvise. But here I just felt that I had two of the best actors in the world, so what could I do except just turn 'em loose. They were both wonderful. It was like pitting a couple of heavyweights against each other.

Cineaste: *Brando gives a much freer performance.*

Penn: Yeah, because Jack's character has an obligation of group leadership and greater responsibility, so he's tied a little more to the earth, while Brando was just able to go. Jack's attitude was, "What the hell is he going to do next?" Brando's scene with the horse and mule, for example, was totally improvised. He said, "Just give me the horse and let me go."

Cineaste: *The female lead in the film was very interesting, but the character seemed somewhat anachronistic. Was that an intentional nod to Women's Lib of the period?*

Penn: No, that was totally McGuane's perception of a kind of Western woman totally unlike the traditional, demure virgin who would faint at the drop of a hat. I thought she was terrific.

Cineaste: *What attracted you to Steve Tesich's script of* Four Friends?

Penn: I just liked the idea of it altogether, these kids who had grown up through the Sixties, a different group, working class, and the immigrant aspect, which certainly I knew.

Cineaste: *Did you see them as perhaps more typical of kids in the Sixties than the hippies of* Alice's Restaurant?

Penn: Oh, certainly. I thought they were sort of basic American kids, with a streak of romanticism, of naiveté, and gullibility.

Cineaste: *Especially Georgia, but for all her grand ambitions, she finally seems rather unfocused and directionless. At one point, during one of her reconciliations with Danilo, she complains, "I'm so tired of being young!"*

Penn: That's really very much the theme of the movie. That generation got hit right in the heart with the end of the Vietnam War, the sense of no real purpose to anything, and that was the intention of the film.

Cineaste: *There are several moments of surprising violence in the film, most notably the murder and suicide at Danilo's wedding. Was that scene intended to have larger metaphorical significance?*

Penn: It's an immigrant sense that you don't cross social lines. As a young Yugoslav boy coming here into a working-class community, the social lines are very clear to you, and you know your place exactly. Steve himself, as an artist, crossed the line, but he was writing about the people that he knew, the memories of his neighborhood, and when Danilo was about to cross the lines socially in that marriage . . . pow! The whole script was pretty pure Tesich, almost nothing there is my distinct contribution.

Cineaste: *One would think that a working-class father would want something better for his son—you know, "God forbid you should have to work in a factory like I do"—but with Danilo and his father it's the other way around.*

Penn: That's not uncommon, certainly in immigrant families, that attitude of don't aspire to too much, you can't do it. In that regard, I'll tell you a funny personal story. When I was in live TV, and doing every third show on *Philco Playhouse*, my mother, who was living over in New Jersey, would see this credit, "Directed by Arthur Penn," come up at the end. Finally, one day, she asked me, "Tell me, son, what does a director do, exactly?" "Well," I said, "he works on the script with the writer, he hires the actors, he's involved with costumes, he controls the camera angles," and she looked at me and said, "So who does it for you, son?" It was simply impossible for her to perceive her son being that competent.

Cineaste: *It's interesting that you said the script is mostly Tesich's conception, because in some ways it seems to express a real disgust for what came out of the late Sixties, a feeling which I didn't necessarily think you shared.*

Penn: No, I didn't share that, but I don't think Steve would characterize it as disgust. Clearly he's not a political figure himself at all, and, if anything, Danilo is offended by what he sees as political violence in that scene where the burning American flag goes across his windshield. I think the film expresses more a kind of romanticism, a kind of remorse for lost childhood, lost youth.

Cineaste: *He seems to perceive the period as nihilistic.*

Penn: He sees it from the position of somebody who is never going to be a part of it somehow. The nearest he could come to being a part of it was Georgia, who for him was the quintessential American girl, and she eluded him. I don't think the ending is right, I don't think he really gets Georgia.

Cineaste: *After a career of subverting or going against the grain of genre expectations, you directed a couple of straight genre films,* Target *and* Dead of Winter. *Why did you take those on?*

Penn: *Target* is a pure "Let's make a product" type of picture in that I wanted to show that I could do an action picture. Somehow my reputation to the new, incoming studio executives was one of some kind of arty, very distant, strange character who couldn't shoot an action sequence. Well, I made up all that action stuff in *Target*. There's something about the athleticism of directing a movie that's very gratifying, which is, you know, "Let's get out here and figure out how we're going to use that bridge. OK, he's going to run over here, there's going to be a boat passing underneath, he's going to jump from here," and just lay it out like that, on your feet, and do it. All right, that's only one aspect of movies, but it's an absolutely necessary aspect of movies. All the fine directors have it, that kinetic skill, to be able to get out there in a basically new location and say, "OK, this is what we're going to do and this is how we're going to do it."

In the case of *Dead of Winter*, I was helping some kids who were in university with my son. They had written the film but had been unable to get it independently produced. Finally they came to me and asked for help, and I said I'd try with a major studio. So I got MGM, but they exacted a promise from me, which was, "If we put real money in this picture, cover our ass if the kid can't do it." And that turned out to be the case. The kid slated to direct it had cowritten the film, but he couldn't make up his mind which one of the great masters he was going to imitate. It was paralyzing—you know, should this be like Hitchcock, or Welles, or Hawks? The picture was going down the drain, so I just sort of picked it up. I think it's a good little thriller, a chiller/horror kind of thing. They're all right films.

Cineaste: *But I'm sure you're aware that many fans of your work felt these were not real Arthur Penn films.*

Penn: Right, but they *are*. That's who this is.

Cineaste: *How much credence do you give to the* auteur *theory?*

Penn: Well, it's a relative term, I think. The French invented it. You see, for five years, during the war and the German occupation, the French never saw an American film. Right after that, American films flooded in, and these young, fervent film kids said, "Wait a minute, there's John Ford at that studio, and John Ford at this studio, and John Ford at that studio, but they're all John Ford pictures, they're not a Metro picture or a Columbia picture. Let's track these guys, like Nick Ray and more obscure people, to see if there isn't a kind of visible continuum in their work," and of course there is. Whatever the studio or the genre, you could see the distinct stamp in the work of these directors, and I think that became the *auteur* theory.

It was then enunciated in the critical community, and, as you very well know, there are a lot of priests and eventually people take up a really ecclesiastical position, which is that "The *auteur* theory is absolute and everything in a film has meaning because one person". . . Well, bullshit! Nothing I ever experienced on a movie set is *auteurist* to that degree. You know how much you depend on your colleagues and collaborators. You have only to shoot for five or six days to know how many accidents are felicitous and that have nothing to do with you

that come into the movie. You just say, "Thank God, what a marvelous accident," or "That's a good idea, let's keep it." So in that sense I don't think the absolutist *auteurist* theory really holds up.

Nevertheless, there has to be a singular, guiding vision, there's no question about it, and in that respect the *auteur* theory does hold up. But it's only a small part of the experience. It's not the day to day experience that I ever had, and I don't think Truffaut ever had.

Cineaste: *Many of the younger generation of directors storyboard everything before shooting. I gather that's not your approach.*

Penn: No, not at all. I don't even know where the camera is going to be most of the time.

Cineaste: *But you can't go on the set and noodle it out for three hours.*

Penn: No, but what I can do is to let the actors find the scene, and, once they find the scene with me, then I know where the camera goes. Anybody would know where the camera goes.

Cineaste: *Are we talking prior rehearsal?*

Penn: Rehearsal on the set, first thing in the morning. Come in with the actors and let them just find their way.

Cineaste: *Blocking it out as much emotionally . . .*

Penn: Oh, emotionally and then consequently physically, so that once they find the emotion, the physical response comes with it. Then, lo and behold, there's no problem. You say, "OK, bring the camera guys in here. Here's where it is—master shot here, coverage here, closer angle here," and you lay out the day's work.

Cineaste: *What influence has your association with the Actors Studio had on your work with actors? Some of the early performances, like Paul Newman's in* The Left-Handed Gun, *seem to come out of an Actors Studio approach.*

Penn: Yeah, it does, but let me try to put this in proper perspective, because there are a lot of misperceptions about the Actors Studio. The Actors Studio is, in a sense, both the beginning and the end of an era. The American theater, throughout its life, for the most part essentially emulated the English theater. That's a declamatory style of acting—it's verbal, it's vocal, it's oral, it doesn't have to have an emotional equivalent, and it's filled with all those lovely English gestures that have come down through the years to stand for theater. I remember that style of theater even in my own youth, when I was going to theater, in Katharine Cornell, the Lunts, and those wonderful bits of business they did.

Then, during the Depression, along comes the Group Theatre, this crazy bunch of radicals, who are reading Stanislavsky, studying what they're doing at the Moscow Art Theatre, and asking if there wasn't an American equivalent. So they went searching for it, and they found it to some degree, but then the Depression ended, times changed, the Group Theatre lost its lyrical theme, Odets's voice was stilled, and the Group Theatre died.

Now comes a guy named Kazan, formerly with the Group Theatre, but who's now the leading director on Broadway. What used to happen in those days, if you

were an actor, was that you got signed for the run of a play. Although you wanted more than anything else in the world to be in a hit, you also wanted more than anything else in the world to be out of that hit, because it meant that you were now in servitude for a year, eight performances a week, and you had to do it over and over and over again. I can't tell you what a killing experience that is. So a bunch of actors got together with Kazan and said, "Let's have a little place where we can work for each other, at a peer level, and do other scenes," and that's literally how the Actors Studio started.

With that came both the whole Stanislavsky movement toward the interior emotional correlative, the emotional equivalents out of your own life through your own character, as well as the liberty of not being in the play that you were in every night, the liberty to do stuff in this group that was sometimes over the top, and sometimes new behavior began to emerge, stuff that you'd never seen on a stage before. With the birth of the Actors Studio came the closure of one old style of acting and the beginning of an entirely new style. In that first group were Julie Harris, Steve Hill, Paul Newman, there were about thirteen or fourteen terrific actors who started the Studio. Kazan brought in Cheryl Crawford and Bobby Lewis to help him run it, but none of them could devote full time to it. But there was Lee Strasberg, unemployed—unemployable essentially, not a very good actor himself in those days—and he took on the Studio. And I'll say this for him—rain, snow, sleet, nothing stopped him from being at that Studio every Tuesday and Friday, *unpaid!*

That immediately attracted the young kids who came to New York, and the one thing Strasberg insisted on was a very stringent audition process. To get into the Studio, you had to be a maverick and show a real streak of originality, and he picked them all—Steve McQueen, Jimmy Dean, Kim Stanley, one after the other. Brando, of course, was the personification of it. So they learned acting from this style, then they became movie stars overnight, and suddenly the Method, particularly as a style of movie acting, was established. And I will submit to you that it's better cinema acting than there ever was before the Studio.

So that long-winded answer is what accounts for the fact that I cast actors from there whenever I can because I know I'm going to get a really swinging, odd, wonderful performance that's unpredictable. There are now second, third, and fourth generations of actors who have learned the Method and know only this style of acting.

Cineaste: *Dede Allen has described your shooting method as one of providing "top to bottom editorial coverage." Would you explain what she means by that?*

Penn: Well, it's lots of coverage, but I don't shoot that much film in relation to other directors, not by a long shot. I think what Dede is saying is that once the actors and I have rehearsed it and gotten the scene, then I don't waste any time shooting alternate angles. I cover it tight, tight, tighter, because I believe that for editing to really work you need to have the material to alter the rhythm of a scene. As you know, we shoot out of sequence, for economic reasons. I defy

you, no matter how good you are, to know on the second or third Tuesday of the movie what that last scene is really going to be like if you haven't gotten there yet. You have to give yourself material so that when you're in the editing room, and you suddenly see the scene, now in context, you don't have to say, "Oh shit, why didn't I shoot that?" My first reaction to *The Left-Handed Gun* was, "Oh, why didn't I cover it. I was right there, but I didn't do it. I'd love to be in on Paul Newman's eyes right now, but it can't be there because I don't have the shot."

That's why in *The Miracle Worker*, when I filmed that long fight scene, I covered it every possible way, because I wanted to be able to control the rhythm. You see, that's a nine-minute scene, so it's gotta start, it's gotta pick up tempo, it's gotta move, it's gotta pick up hostility, you have to take it up the line, *up the line, UP THE LINE,* to a point, finally, of capitulation. I can do that in the theater, because I see the whole scene in the context of the play, but on a movie, in the third week of production, I can't do it.

That's what I think I brought into Dede's life, because I said, "Dede, we're just going to have to learn to understand my rhythms, and I'm going to provide a ton of material so that we can really change rhythm from what the scene seemed to be when we read it to when we shot it," and, by God, that has stood us in good stead.

Cineaste: *You've obviously had a very good working relationship with her.*

Penn: Dede's a first-rate editor, she's made an awful lot of mediocre directors look very good. She brings a wisdom and dedication to it that almost nobody else I know has. She's a nut when it comes to the editing process. She's tenacious, she won't quit, and she finds solutions. Look at all the people she's trained—Steve Rotter, Jerry Greenberg, Richie Marks—they're the prominent editors of our time. All the Academy Awards go to people who trained with Dede, but she never got one.

Cineaste: *In Hollywood today it seems much more difficult if not impossible, given the astronomical production and advertising budgets we see, to do the kind of serious work one would expect from an Arthur Penn. I'm not even sure if it would be possible today to produce* Bonnie and Clyde *or* Little Big Man.

Penn: Probably not. I think that Hollywood is going to just self destruct. I don't mean it's going to be all that apocalyptic, because they've been self destructive in the past. They self destructed in the time that was really my era, which was when TV came in and knocked them out of the box. They didn't know what the hell to do, so they went out and hired us, just bought us up, lock, stock, and barrel, and brought us to California to make movies.

I think that's going to happen again. I think *Last Action Hero* is an imprint of the gods on their foreheads, which is to say, "You can't continue to do this. You're going to get away with it up to a certain point, but you can't get away with just special effects any more." See *Jurassic Park* for a pure example of a nothing film. He threw a powderball, nothing is there, and I think that's going to catch up with them. Now that's not going to happen overnight. *Jurassic Park* will make money, and they'll have to make a sequel to it. Talk about an existential

destiny! There's Spielberg—a guy with real talent—stuck for the rest of his life in this infantile mode. I mean, *Sugarland Express* had some real talent in it, but it goes out the window very quickly. So the Hollywood studios will continue, probably in the Disney model, which is to send out memos saying, "We gotta cut costs," but they don't know how to cut costs. Costs are in inverse proportion to *ideas!* And they'll never escape their sort of formulaic predestination, they don't have the mechanism to shed that skin.

But independent films will come back. They're fundamentally lucrative—look at Miramax. There will be more *Crying Games*. That's not *that* distinguished a film. It's a rather ordinary film, but, in the present context, it's extraordinary. Change may be forced on Hollywood. The studios could form little units that could make films for almost no money. I mean, two to three million dollars should be enough to make a good movie, plus advertising and so forth. There's no reason why they can't do it except their own nature. I would say that somewhere in the next few years it's going to change. It can't go on this way.

In that respect, the situation today is similar to the Hollywood I first met, which is one where they knew how to make these really sizable movies, and they made them well, but they were crashing in flames. I believe that the ideational narrative is going to rear its head and strike back. It's interesting to see, for example, a film like Sydney Pollack's *The Firm*, where they turned to Robert Towne and another solid, wonderful writer, David Rayfiel, so they seem to be returning to some of the solid narrative traditions.

Cineaste: *Robert Altman seems to have made a comeback now after a long dry period.*

Penn: Yes, absolutely. Bob and I hung out together in Paris for a while. We both said, "Who wants this scene? It's not ours." I mean, we were not bitter, it was just that Hollywood was talking another language and we were doing something else. It goes in stages.

Cineaste: *So the times may be good again for someone like yourself?*

Penn: Conceivably.

13 MIKE LEIGH

I Find the Tragicomic Things in Life

In an era when the "death of the author" has been loudly proclaimed, the work of the British writer-director Mike Leigh disproves this kind of facile generalization and suggests a new model of authorship. Perhaps one of the few figures who will eventually be remembered as equally important within the history of both British theater and cinema, Leigh (who trained as an actor at the Royal Academy of Dramatic Art) is known for creating plays and film scenarios that are the product of an intimate process of collaboration with unusually talented casts. Although the only full-length study of Leigh's stage and screen work to date is entitled The Improvised Play, *it is important to emphasize the fact that the actual performances of his plays and the shooting of his films involve no improvisation whatsoever. By the time a fairly lengthy rehearsal period ends, Leigh incorporates the actors' contributions into a final script and remains as much in control as any traditional director.*

Leigh's films have familiarized viewers with a fictional landscape that is instantly recognizable, and, despite superficial and largely misleading resemblances to older British directors such as Ken Loach, sui generis. With the notable exception of the upper-class milieu of Who's Who *(1979), a Leigh film is usually preoccupied with the alternately grim and comic lives of working-class and lower-middle-class families who find themselves in the midst of crises that are as absurd as they are seemingly insurmountable. Yet Leigh's films are, in the final analysis, not misanthropic, despite the almost ritualistic accusations that his harshest critics fling at him. A fair-minded analysis reveals that he treats his characters with equal amounts of compassion and astringency, a fact that is sometimes obscured by the films' dispassionate tones. Radical audiences have been particularly confused by a left-leaning director who has no inclination to make films that will inspire the working class to mount the barricades.*

By the standards of Hollywood narrative cinema, very little happens in a Mike Leigh film. Although Leigh resolutely refuses to engage in sloganeering, his films are acutely political, since they consistently articulate an often hilarious critique of everyday life. This critique is always rooted in the idiosyncrasies of

individual characters. To call the films character-driven would almost be an understatement, since Leigh's work is constantly fueled by the sometimes endearing and frequently infuriating eccentricities of quintessentially English individuals.

Leigh's film Naked *(1993) is similarly irreducible to political or aesthetic clichés. The film's protagonist, Johnny (David Thewlis), is neither a hero nor a villain and ends up being both victim and victimizer. Despite the fact that critics almost always refer to Johnny as a "drifter" or "marginal character," this Manchester native adrift in London is decidedly not a "homeless person," but an abrasive loner who consciously rejects the humdrum annoyances of domestic life. Like Dostoyevsky's underground man, Johnny celebrates his "own free and unfettered volition . . . inflamed sometimes to the point of madness."*

Cineaste editor Richard Porton and Lee Ellickson interviewed Leigh in the fall of 1993 after a screening of Naked *at the New York Film Festival. After the film had opened commercially in New York and London, we called Leigh at home in London to discuss the film's popular and critical reception.*

Cineaste: *Do you feel that your films are involved in a politics of inquiry, posing questions rather than providing answers?*

Mike Leigh: Absolutely, totally. I don't think they come up with any answers. Interestingly enough, from some people's perspective, that is, people on the far left, my films have come in for quite a lot of hard criticism. For example, *Meantime* and *Hard Labor* were both criticized very severely from the extreme left for wasting the opportunity of propaganda, for not actually coming out clearly with a statement, with answers. Not showing people fighting back, not showing heroes and all of that. Indeed, all of the films—and *Naked* in particular—ask far more questions than give answers. For me, the whole experience of making films is one of discovery. What is important, it seems to me, is that you share questions with the audience, and they have to go away with things to work on. That's not a cop-out. It is my natural, instinctive way of storytelling and sharing ideas, predicaments, feelings, and emotions.

Cineaste: *Don't the criticisms you've cited reflect certain leftists' demands for positive cinematic heroes? Johnny is not a proletarian hero.*

Leigh: Absolutely. It's ludicrous, and all the negative criticism of *Naked* has been along those lines, whether from the left or so-called feminists. The serious feminists haven't had a problem with it at all. I make no apologies for the fact that I continue to discover what I've been discussing for some time after I've made the film. I can see a film years later and actually realize what I've been dealing with. For me, that's what it's about. These things are multifaceted and are made from the gut. In the end, these aren't cerebral films.

Cineaste: Naked *does seem to mark a transitional point for you. Even the*

darker visual style is unlike anything you've done before. The film seems to open up a wide range of possibilities.

Leigh: It does. At that level, I wanted very strongly to move away from a domestic perspective.

Cineaste: *In a way, the domestic perspective was very suitable for television. Did the fact that your early films were made for television influence the choice of subject matter?*

Leigh: Well, to be truthful, I'm very militant in my resistance to that line of thinking. I don't think one thing has anything to do with the other. A film is a film, whether made for the cinema or television. I got a lot of this in England. Even when I made *High Hopes* and *Life is Sweet,* people said, "Well, he's just making those television films again." I think that's a lot of crap. I don't even think the television films are television-like. I've seen them on big screens, and they work.

Cineaste: *Yes, I agree. I just thought perhaps the subject matter was influenced by the choice of form. Television is meant to go into the home, after all.*

Leigh: The truth is that, whether we like it or not, people look at movies, epic movies, every day on television. Forgive me, though, if you weren't slighting the television movies. It's something we all get very defensive about.

Cineaste: *What was the impetus for the apocalyptic tone in* Naked*? Is it related to the state of England today?*

Leigh: No. You deal with one thing, and then you deal with another. That's what I'm dealing with. One could have made *Naked* several years ago, although I do think things are getting worse. There is a sense of impending doom. I just thought that, after completing several films from a more positive perspective, it was time to do this. Obviously *High Hopes* ends a trilogy of more political films, and it was concerned with, in the end, socialist preoccupations. This is a more anarchist view of the world, and maybe deep down, along with layers of Sixties conditioning, one I feel with more conviction.

Cineaste: *Unlike Cyril, the protagonist of* High Hopes*, one couldn't imagine Johnny, the working-class protagonist of* Naked*, visiting Marx's grave at Highgate cemetery.*

Leigh: No, absolutely not. He has a different perspective.

Cineaste: *You're in the Labor Party, aren't you?*

Leigh: No. I am not connected to anything. That's the whole point about *High Hopes.* I may contribute money to the Labor Party. I am a nonmember of anything.

Cineaste: *In some respects, all of your work is imbued with an anti-authoritarian, or even anarchist, spirit.*

Leigh: If my obituary said, "Mike Leigh: Filmmaker and Anarchist Died Yesterday," I would be horrified. I don't primarily regard myself as an anarchist. This issue comes under the category of received politically correct orthodoxy. By instinct, my emotional politics are as much socialist as they are anarchist. In the end, one has deep misgivings about institutions, governments, and humanity's

ability to organize itself so that things make sense and work. That's what I'm talking about. I don't otherwise subscribe to anarchist orthodoxy. We're talking about my gut reactions here.

This strand goes right through my films. You've got it in *Bleak Moments*. You've got it in *Nuts in May*—the dogmatists and the people who are just letting it hang out and getting on with it. The goodies in that film are the guys who are just getting on with it, and the really healthy couple on the motorbike. You've got a strand throughout of people being battened down and trying to fight out in various ways. Obviously this is true in *Meantime*, in reference to Mark, the Phil Daniels character. *High Hopes*, *Life is Sweet*, and *Naked* all have disaffected youth.

Cineaste: *There is frequently a tension between the individual and the collective in your films, isn't there?*

Leigh: Yes. Apart from that, and it's certainly an ongoing theme, there's the tension between conformity and the individual. The preoccupations in *Naked* are preceded by all sorts of things . . . like *Grown Ups*, the film where you have the authoritarian figure, the teacher, next door.

Cineaste: *There is a naive assumption on the part of some viewers that they can't like a film if they can't "identify" with a character.*

Leigh: Some people need that. What we're mostly talking about here is what people feel safe with. People like to know where they are, or they like to persuade themselves that they know where they are. You don't have to know where you are, actually. You go away and discover after a period, by gestation.

Cineaste: *Perhaps part of the problem is that people expected something else from* Naked. *As Ian Buruma has observed, it's not a film about homelessness or Thatcherism.*

Leigh: I think that's it. It's partly, of course, that *Naked*, more than any of my films, certainly in the U.K., has had an image created for it, perhaps inadvertently by the press, quite far from what the film actually is. For example, people say that it's quite funny and quite compassionate, but many people have the impression that it's this relentless, humorless, nihilistic bile. Of course, that's not true. Whatever film you watch, assuming you've seen a film before, you immediately go into one program or another, or plug into an expectation system. If the film is any good, these expectations are constantly confounded. If *Naked* works for anybody, you certainly go through that process.

Cineaste: *I think many people have participated in an active misreading of the film. There is a struggle for clarity in all of your films which make these misreadings frustrating. And sometimes an almost primal misunderstanding is the very subject of your films, which makes it all the more ironic.*

Leigh: You're right. In a way, it is ironic. But somewhere in and amongst all that is the extra ironical dimension that if, in the film, A says X to B, B misconstrues X as meaning Y. I don't put in all kinds of semaphores to make sure that unintelligent members of the audience get it. I just put it in there like it is. The

irony is that people misunderstand message X, just as B misunderstands message X. In other words, some people are dumb. Of course, it's not as straightforward as that. Is it not the case that people are so encrusted with layers of indirectness, and received prejudices, and received notions of whatever? Again, we're back to PC and all that rubbish.

Cineaste: *You achieve something interesting by stressing both great intimacy and a clarity through distance.*

Leigh: That's true. Alienation. My feeling is that—I don't know if it's statistically true of the majority of people—but, for what it's worth, the majority of audiences don't have problems with any of this. They get on with it, because the actual currency of my films is very direct, in real time, and you can understand the parameters of what's going on. But there is this clutter of prejudice. What you're presumably talking about is some kind of semiotics, of what people's language of looking at films is about.

For example, one of the consistent confusions and criticisms—rubbish, really—about my films has to do with caricature and behavioral tics. Part of the actual substance, narrative, thematic—the content of my films—is the detailed study of how people actually behave. In other words, behavioral study. The characterizations are very detailed in terms of actual physical, rhythmic speech patterns—like real people, like you and me. Some people have an odd response to this, because they are used to characters merely being ciphers, and are not used to having people rendered, moment to moment, like real people. The distilled reality of this converts itself into a set of symbols which people become self-conscious about. They can walk out of the cinema and see people behaving in an equally idiosyncratic way, if not more so, and they wouldn't see it in terms of signs and symbols. They would just see it as people behaving in the way that they behave. Viewers who don't have any problems with my films are just responding to the way people actually behave.

Cineaste: *Naked seems to have an almost terminal quality. Most of your other films have dealt with families or groups of people. Everyone is very much alone here.*

Leigh: Yes. It is about displacement—people displaced from their families. I've dealt more with families than just about anybody, but in this film I felt the need to address the situation of people who have drifted away from their families. There have always been people like that.

Cineaste: *Did this preoccupation with displacement precede your usual close collaboration with the actors?*

Leigh: That's both complex and straightforward. As a writer and filmmaker, I have a number of ongoing preoccupations which inform my casting choices, and how I push the characters as I create them. It's academic, in a way, this business of where it evolves in the rehearsals. On one level, you wonder about the streets of London where people are hanging about. On another level, as a parent, I do wonder what kind of a world my kids will live in when they're

my age, or whether this world will even exist. I can't address such things in a film, except by having someone preoccupied by it.

Cineaste: *The neighborhoods didn't seem readily identifiable, except for Soho. Was this deliberate?*

Leigh: Yes. This is very important. You do know where you are in *High Hopes* and *Life is Sweet*. It is very important to stress that this film could be anywhere—New York, Berlin, wherever. It is *a* London. Soho, if I may use the word cautiously, was shot in the most naturalistic mode. We really did shoot in the streets, and people walked through the shots. We filmed all night, and there were no extras. Some of the locations, such as where Johnny goes and talks about the "bowels of London," are concoctions of wasteland London, that one being near Bricklane Market.

Cineaste: *It is, then, a film about the breakdown of community and solidarity—both political and personal solidarity.*

Leigh: Absolutely, and about the crumbling of the edifice.

Cineaste: *If then, things are getting worse in England, how do you see them getting worse?*

Leigh: If we talk about England, in reference to *Naked*, we should do so cautiously, since, as I've said, it's not just about England. However, if we do, the fabric of society is collapsing. People are insecure. There is a sense of disintegration which is, as much as anything else, a legacy of the Tories. But I think this sort of thing is happening everywhere. It's not necessarily a British prerogative. Since the film is, as much as anything else, concerned with a global perspective, I find it difficult to expend too much energy discussing it as a metaphor for the collapse and decay of the United Kingdom. Whereas you could talk about *High Hopes* in those terms. It is important, as well, that *Naked* includes people from different regions.

Cineaste: *There is perhaps a certain nostalgia for the north of England in Naked.*

Leigh: I don't think it's a nostalgia for the north exactly. It's a kind of roots, and these are rootless people. Of course, when Johnny asks the Scottish kid, "What's Scotland like?," he says it's "shit."

Cineaste: *Did you incorporate any personal experiences into the film? Did you observe kids like these on the streets of London?*

Leigh: Actually, I was hitchhiking from Calais to Paris in 1961 and it was raining heavily, really pissing down, and I fell in with a guy called Wilson McDougall wearing a kilt who came from Paisley outside of Glasgow. This guy—who was completely, totally thick—was trying to get to Paris. Eventually, I had to ditch him in Paris because I was going to Marseilles to catch a boat to go work on a kibbutz. This guy just festered at the back of the cranium for thirty-odd years. I suddenly thought, I could include a bit of him in this lad Archie. There are a lot of Archies around. Johnny has certain personal points of reference as well. Things are quite often autobiographical for me.

Cineaste: *Is there a conscious doubling of Johnny and Sebastian, aka Jeremy, the predatory yuppie character?*

Leigh: Yes, certainly. Johnny is complex, and he starts off being very unacceptable indeed. We also learn that in some ways he's very compassionate. It seemed important, in order not to let contemporary male behavior off the hook, to have someone even worse than Johnny, as bad as he sometimes is. They do reflect each other, in that sense.

Cineaste: *It seems significant that Johnny is speechless after encountering Sebastian. He finally doesn't have a retort.*

Leigh: That's right, mainly because he's in a rotten condition. We did investigate alternative scenarios, but, in the end, this seemed more apropos. How do you confront a guy like Sebastian? Louise confronts him, but you know he's going to get into his Porsche, bugger off around the corner, and perhaps rape someone else. That's the problem, short of her actually castrating him, and that didn't seem appropriate.

Cineaste: *And he runs, at the slightest provocation.*

Leigh: He deals with it by walking away. That's what had to happen, and it seemed important that you not get the direct confrontation you might expect.

Cineaste: *That would be too melodramatic.*

Leigh: Yes. Not interesting. Not meaningful.

Cineaste: *It seems of interest that the women are unusually responsive to characters like Johnny and Sebastian.*

Leigh: Well, one is inclined to think that, in these postfeminist times, these so-called liberated times, women are not victims. I don't think this is entirely true. I also think it's important to show what happens if you have someone who is aggressive, cheeky, and charismatic. I think of these things, in a certain sense, on a semiotic level, and I use the word semiotic very reluctantly. This has to do with the aspect of moving imagery which you put in a film. Here is a mover—the central character is charismatic. In some ways, he is sexy and intelligent, but he is not the sort of person you usually find in a movie because, in some ways, he is ugly and unacceptable.

Cineaste: *Isn't this the fascination of the film? You can never pigeon-hole Johnny.*

Leigh: Yes, absolutely. If we take him seriously as a real person, then you have to ask, how do women deal with him? There's one woman who's very strong and copes with him. There's somebody else who is nuts. There are a couple of people who are displaced. And, finally, there's Sandra, who is probably also nuts, but, on the face of it, responsible.

Cineaste: *Johnny is a character who exploits people's vulnerability.*

Leigh: Yes, but, apart from anything else, these things are a function of his own vulnerability. I think the naivest interpretation anyone could put on the film is that there is Johnny and everyone else is a victim. He's as much a victim as everybody else, in a certain respect. Of course he is, socially. The

fact that he is an outsider to start with is a function of society.

Cineaste: *The response to* Naked *from women has been very positive, especially from* The Village Voice *critics. As far as we know, the only woman who termed the film misogynist was Claire Monk in* Sight and Sound.

Leigh: Yes, all the negative reviews have been British.

Cineaste: *The British seem very hard on their own filmmakers, as opposed to their frequent praise of foreign directors.*

Leigh: The British are hard on anything British, and films are no exception.

Cineaste: *I've had the impression that the film was much more enthusiastically received in the States.*

Leigh: The English response to this film has been very cluttered and confused, full of prejudices. There have been two or three reviews from the States, I can't remember which, that have worried about the women. *The Village Voice* is very on the ball, it seems to me. You cannot meet more respectable feminists than that lot. People who attack the film for being a male, misogynist, sexist indulgence or whatever, overlook one overpowering, salient fact, which is that you do not make a film by yourself in an attic. All filmmaking has to be in some way collaborative, and my filmmaking is more collaborative than any. You don't make a film like *Naked*, with those kind of female roles, and have dumb bimbos playing the parts. The only kind of actresses who you're going to get to do that kind of work are highly intelligent, highly motivated, highly politicized feminists. No other kind of actresses would be any good at it. And you don't make a film with those kind of actresses without their total commitment and collusion. Not to mention that you don't shoot a film like that without an intelligent crew who wants to shoot it. Insofar as any of this needs to be said.

Cineaste: *I'm sure that the actresses, in developing their parts, were quite vocal about the film's sexual politics.*

Leigh: Absolutely. We talked about all of the characters in a very thorough and sympathetic way. We were dealing with the very common predicament of various kinds of women. That's what this film is about, you know.

Cineaste: *There's a sense of desperation to most of the characters. This seems especially true of the waitress who is initially kind to Johnny. When she finally throws him out, she seems disgusted with her own neediness.*

Leigh: Yes. Whatever it is she's experienced, she certainly can't deal with it, or confront it.

Cineaste: *To a certain extent, this character's plight is similar to Sylvia's in* Bleak Moments.

Leigh: It's funny you should mention that. When *Bleak Moments* was screened in New York some years ago, a young woman stood up and said, "I don't understand this film. I live in New York and I live alone. If I want to talk to people, I just phone them up." I asked if she was absolutely sure. This is ridiculous. There are probably more women like Sylvia in Manhattan than any other place in the world. Of course, the interesting thing is that in *Bleak Moments* nobody says anything to speak of. In *Naked*, they say so much. I'm sure that if Sylvia was

more articulate, she would speak to Johnny. She'd get on with Johnny, for sure. Johnny has the bitterness of the Nineties, while the characters in *Bleak Moments* have the innocence of the Sixties and Seventies.

Cineaste: *You use humor to leaven the bleakness in this film. For example, when Sebastian lunges at Sophie, she rolls her eyes and says, "Here we go again." It's a funny moment, but also a horrible moment.*

Leigh: Obviously, you know that, of all the characters, she's gotten into these situations endlessly.

Cineaste: *Is this mixture of humor and grimness something you strive for?*

Leigh: I don't strive for it. It's something I strive for least. It comes naturally. It's a function of the way I look at life.

Cineaste: *This kind of gallows humor emerges from the characters, then?*

Leigh: Yeah. You hew it from the seam, ready-made. I find the tragicomic things in life. That's what the films are about.

Cineaste: *You seem to devote a fair amount of attention to the books the characters read and carry with them.*

Leigh: Obviously, Johnny is much influenced by *Chaos*. Both David Thewlis and I were quite taken with it. Once you get into certain areas, it opens the whole thing up. We also got into this whole thing about Nostradamus. Then we discovered this thing about the European bar code. The discovery that the European bar code adds up to 666 was key. We picked that up from a pamphlet. We were walking through Soho, and some nut case offered us this pamphlet. We thought, "Amazing, let's use it." They experimented on the American troops with the laser tattoo. That is definitely a reality.

Cineaste: *An astonishing thing about your films has always been the use of precise detail. This film is a tour de force in that regard. Johnny's character is a masterpiece of detail.*

Leigh: It goes without saying that this cannot be achieved without someone like Thewlis. He's an extraordinary actor and an extraordinarily intelligent man. I pushed the boundaries further back, working in this creative way. I've known him for a bit. He was in *Life is Sweet* and *The Short and the Curlies*. In *Life is Sweet* he didn't get a fair slice of the cake. Because of all sorts of developments, I decided that I had to be really ruthless and say, "It does not make sense if you see this guy again." There was a whole thing about him coming back in the end after the accident, and there was a scene with Andy and him in the pub. We shot it, but we had to cut it. He had been shortchanged.

So, when I was getting the next film together, I thought, "Bugger this, I have to get him in. I have to commit myself to him in a way that I don't normally do. He's going to have a disproportionately good role." Once I'd done that, it just set me buzzing in a direction. If ever I fulfilled a promise, it was on this occasion.

Cineaste: *Claire's Skinner's brief turn as Sandra is also a brilliant piece of acting.*

Leigh: I don't know if it's my favorite scene, but the scene with Sandra gives me such a tickle. Claire Skinner was so successful as Natalie the plumber in *Life*

is Sweet, and I was keen to get her in to do something different. You do the routine thing and check an actor's availability, and, after a while, you make a decision. When we went back, the agent said, "Oh, she's in something else now." It was a television series. But I had to get her in, so l said, "Do this telly series, and you'll have to be a character at the end, and bring up the rear." It was a bonus, because we built up a whole thing about this character. You expect this formidable Florence Nightingale and you get this complete screwball, as nutty as anyone else.

Cineaste: *You seem to start with the actors, and then other elements accumulate.*

Leigh: Yes and no. Sometimes these things are a function of economics. You can't afford to have everyone there all at once for the rehearsal period. Indeed, it would be wasteful because people would be hanging about for so much of the time, and I can only work with one person at a time. So I structure it like a pyramid. I started work with David, Katrin Cartlidge, who plays Sophie, and Leslie Sharp, who plays Louise. Then it gradually builds up from there, and, within that, you can do all sorts of things.

Cineaste: *Did you share a close collaboration with Dick Pope, the cinematographer?*

Leigh: Absolutely, and also with Alison Chitty, the production designer, who worked on *Life is Sweet*, as well.

Cineaste: *The later films seem much more design conscious.*

Leigh: The truth is that, despite all we've just said, there are problems with BBC films. They're all shot on 16mm, and they're shot very quickly. The cameramen are very good, but the crews are often out shooting documentaries. You can't devote the time to the films and have the same photographic standards that you get with feature films. Roger Pratt, whose work is well known in other contexts, shot *High Hopes*. He also shot *The Fisher King, Brazil*, and *Mona Lisa*, among other things, including *Meantime*. We wanted to spend more time to make something more visually extraordinary.

Cineaste: *The music seems to play an important role in* Naked. *It works especially well with certain long takes.*

Leigh: It wouldn't be true to say that one thinks about the music as such, although I've never made a film in which there was so much discussion about the music, and so much argument about what kind of music we should have. Of course, you think about the music as you shoot, only in the sense that you think musically, you think of rhythm. That's part of the craft and the conception of the thing, although you're not thinking with a treble clef in front of you. In the end, the music has to go on last.

I usually don't make the decision about who's going to do the music until after we've shot it. The decision here was inevitable, because it was Andrew Dickson, who did the music for *High Hopes*. I think Dickson did a fantastic job, and really challenged every preconception. This is an amazing score.

Cineaste: *Do you feel a kinship with earlier traditions of British cinema?*

Leigh: I feel an affinity and solidarity with various strands of British film-making. We might not necessarily be talking about *Naked* here, but, to some degree, my roots are in Ealing comedy. Certainly these films were on the go when I was growing up—Mackendrick, Hamer, and the whole range of them. I saw a lot of films from an early age—some of them were British, and most of them were American.

Cineaste: *Like your films, the Ealing films are character-driven and have a certain modesty.*

Leigh: Yes, there's a social context and they are comic. There's a broader British comic tradition. I grew up in the age of radio comedy, and then television comedy, as well as the movies. Certain of the Ealing films—*Kind Hearts and Coronets*, *The Man in the White Suit*, *The Lavender Hill Mob*, *Passport to Pimlico*, and Alexander Mackendrick's *The Lady Killers*—had a great impact on me. *Kind Hearts and Coronets*, for example, is one of the most perfectly told film stories and is brilliantly understated in a very English way. I don't know if that is one of the films I would have been conscious of at an early age because it came out around 1948, when I would have been around five. Whereas other films, like The Man in *The White Suit* and *The Titfield Thunderbolt*, were films I would have seen.

Later, by the time I was in my teens, you have those relatively inferior, still quite good, but sometimes politically suspect films of the Boulting Brothers that followed the Ealing Comedies. Alec Guinness is replaced here by Peter Sellers, who was a great inspiration over a period of time. I think the best of those is a film called *Carlton-Browne of the F.O.*, which I think had a different title in America [*Man in a Cocked Hat*—ed.]. It's about an island in the middle of nowhere which becomes the center of international tension. Then, of course, the so-called British New Wave was going on.

Cineaste: *Free Cinema?*

Leigh: I didn't discover Free Cinema until after it happened because that was in the Fifties, when I was still a teenager in the provinces. Their work, as you know, led to the New Wave of *Saturday Night and Sunday Morning*. Having grown up in an urban world, it was exciting to know that there was a cinema attempting to deal with that, although one sometimes had reservations about whether it was quite real or slightly artificial. Then, quite unbeknownst to me—because in the Sixties I was operating in rather obscure corners of nowhere, doing odd things in basements—what was actually going on at that time was the early Ken Loach stuff, and Tony Garnett and all the *Wednesday Plays*. Tony Garnett later produced *Hard Labor*, my first television play following *Bleak Moments*.

I saw *Hard Labor* on television about two months ago. It's very much my film. It has some very personal things in it and it's autobiographical. Nevertheless, there are things in it that are completely uncharacteristic of my work—improvised footage, walking about in the market—things you wouldn't find in a film of mine before or after. Because Tony had worked so much with Ken Loach, there were things he encouraged, and I was happy to become part of this *Play for Today* style. Honored, too, because these guys are older than me. It

was fine, but it doesn't really belong in my films, it's not what I would do. I was very taken with Loach's films—I remember *Kes*, particularly. There are many ways in which Ken and I have a lot in common, and many ways in which we are at absolutely polar ends of the spectrum.

Cineaste: *Are there political differences as well as cinematic differences?*

Leigh: Politically, I'm sure that he would regard me as, at best, a lily-livered liberal. And quite rightly so.

Cineaste: *Are there other contemporary British directors you admire?*

Leigh: I have a lot of respect for Stephen Frears who, in the *Play for Today* era, was much more successful. He is a very good, eclectic director, and I think what he does is brilliant.

Cineaste: *So an interest in film predated any interest in theater?*

Leigh: Yes. I did see theater, but, without a shadow of a doubt, film was my main interest. Theater was always something there that you could do. I was involved with plays at school. You couldn't make films at school. Indeed, when I got involved with theater, it was because you could actually do it. It was there. You could make theater happen for nothing. You can't make films happen for nothing. It took a while to get sorted out. As soon as I trained as an actor, the first thing I did was to get work in really quite dreadful films, just so I could be there and see what happens.

Cineaste: *What films did you act in?*

Leigh: I was in a film called *Two Left Feet*, not to be confused with its singular successor, and some others.

Cineaste: *We read a piece which talked about your films in terms of specifically Jewish humor, and the influence of your adolescent participation in the* Habonim *movement on your collaborative approach. Do you have any further comments on this?*

Leigh: I have slightly mixed feelings about this, because I think it could be distracting and distorting. Very much in passing, however, it's possible to see a certain kind of Jewish influence. But I think it would be wrong to label these films "Jewish," or for a whole new kind of interpretation to grow out of this. I think it would be nonsense, I really do. On the other hand, given that there's a consistent tragicomic thing going on, it's possible that's a perspective you could put on it. The tragic moments always have a comic irony. In that sense, I could concede that as an element. There is a thesis on Pinter which says the same thing—his background is also Jewish—but it would be eccentric to say that Pinter is like Isaac Bashevis Singer.

Cineaste: *Or it would be dangerous to say that this is some sort of hidden agenda.*

Leigh: Yes. That's what worries me the most. In terms of a conscious or deliberate issue, the only film which deals with it at all—and that very marginally—is *Hard Labor*. The character is working for a Jewish man. He comes by to collect the money for the booth. For anyone to suggest that there is this Jewish or Zionist fifth column would be just ludicrous. In the Fifties, before

Zionism became a dirty word, the *Habonim* was a left-wing movement I was involved in as a kid and as a teenager. I walked away from all of those things, including the Jewish background, when I was seventeen. That organization was part of a propaganda machine to get us all to go live on a kibbutz. In fact, we did a lot of things cooperatively, and worked in groups. The positive thing—because I was as much of an individualist then as I am now—was that we did a lot of things collaboratively. This experience has, in some ways, informed my working with actors on film. Not that what I do is ultimately cooperative, because I'm very much in control of it. So all these matters should be put in a very distant perspective.

Cineaste: *We'd like to ask about your play,* It's a Great Big Shame! *In many respects, this sounded as ambitious as* Naked *and seemed to mark a similarly new direction.*

Leigh: We worked on it very intensively for four months. It then ran for seven weeks. It is a deeply frustrating experience, because it was a very elaborate production. There are plays of mine, particularly *Abigail's Party*, which are endlessly performed, and, in that way, still live. Indeed, it's on video, so you can see the original production. The new play is such an elaborate piece of theater, an integrated piece of pyrotechnics, that I think it would be extremely unlikely—even if we publish it—that it would ever be done much. It's kind of dead and buried, really. In the early days, I did lots of plays which are dead and buried. That's the nature of theater, as distinct from cinema. I suppose that because I've done mostly films, I've gotten used to the enduring nature of the thing.

Cineaste: *Where did the idea of the juxtaposition of the Victorian story and the contemporary black characters' saga come from in* It's a Great Big Shame!?

Leigh: Oddly enough, it came from a quite schematic notion. The Theatre Royal, Stratford East, in the East End of London, where it was produced, is a Victorian theater. It's right in the middle of what is now a very multiracial, working-class area. And it's remarkable that the theater still stands. At one time, there were a number of such theaters all around the London metropolitan area. They've all disappeared, except that one. It's managed to keep going. They have a tradition of doing Victorian, music hall-oriented shows.

Cineaste: *And the modern story is your first extended treatment of black characters?*

Leigh: It's the most extended treatment. You saw minor but important black characters in *Meantime*, and black characters have popped up now and then. To be perfectly honest, casting black actors has become easier with the rise of a new generation of young black British actors. For a long time, it was quite difficult to do this kind of work with black British actors. A lot of the older generation of black British actors, who had mostly come from the West Indies, were not necessarily the best. They were actors because they were black, not because they were actors. Also, a lot of black actors tended to be, as it were, more like white actors who wanted to be respectable.

Because you've got a generation of people who have been born in the U.K.,

there are now a lot of black actors. They've come out of ordinary schools in urban areas where drama is one of the subjects. Twenty years ago, if you wanted to see all the black actors in their twenties, you could probably conduct the auditions in a day or two. It would now take ages, so the standard is much higher. These are also very talented people who don't have a complex about being black. There's a great confidence about it. I worked on *It's a Great Big Shame!* with actors who were really very relaxed and funny. They have a real sense of roots but without being self-conscious and neurotic about it.

Cineaste: *This resurgence of black British actors is not yet really noticeable in films.*

Leigh: I don't think the films have happened yet, but they will. Isaac Julien has had a go. I hope others will be coming along.

Cineaste: *You have become an influential director. Do you think that anyone has successfully emulated your approach to filmmaking?*

Leigh: This is a delicate area. I'll go so far as to say this—if what I do works, it's because I'm a writer, or a filmmaker in that sense, not because of my technical skills. Technical skills are important, but primarily it's conceptual creation. The misconception on the part of some people is that if you follow a formula, you can come up with the same results. I don't think that's true.

14 FRANCESCO ROSI

Investigating the Relationship between Causes and Effects

Francesco Rosi began his cinematic career in 1947, first working as assistant director and screenwriter during the heyday of Italian neorealism, and began his directorial career in the late Fifties. Rosi's films, which have consistently explored significant social and political issues of twentieth-century Italian history, have also always been distinguished by their visually stylish and dramatically powerful qualities. While films such as Hands Over the City *(1963) and* Just Another War *(1970) convey the director's trenchant political analyses of, respectively, an urban housing scandal and the internecine class warfare among Italian troops in World War I, other critically acclaimed works, such as* Salvatore Giuliano *(1962) and* The Mattei Affair *(1972), which examine events surrounding two of Italy's most politically influential but mysterious postwar figures, utilize unusual narrative structures which present viewers with unepected levels of social complexity and even ambiguity. During Rosi's December 1993 visit to New York for screenings at the Italian Cultural Institute of his feature docudrama,* Neapolitan Diary, Cineaste *editor Gary Crowdus questioned the director about both the political and formal qualities of his films. Simultaneous translation from the Italian was provided by Michael Moore.*

Cineaste: *Your films are political, it seems to me, as much because of the way they are structured as because of your subject matter.*

Francesco Rosi: Yes, many of my films—such as *Salvatore Giuliano, Hands Over the City, Lucky Luciano,* and *The Mattei Affair*—are structured as investigations into the relationship between causes and effects. When I devised this method in *Salvatore Giuliano,* this search for the truth became the narrative line of the film. I wanted to pose questions to the audience, questions I either didn't know the answers to or did not wish to give answers to. My films are not *policiers,* or thrillers, but instead aim to provoke, to insinuate doubts, to challenge the official statements and certainties from the powers that be which hide real interests and the truth.

As the narrator, the storyteller, I communicate my impressions to the audience, whom I consider a traveling companion in my investigation into human feelings and into facts that cannot always be accepted for what they appear to be. These facts, these events, need to be interpreted, and this interpretation is what gives rise to ambiguity.

In some of the Italian mysteries that my films have dealt with, a single truth doesn't exist, so I don't want to offer a simple answer. The films are interested in the search for truth and in encouraging reflection. To be effective, the questions the films ask must continue to live in the viewer even after the film is over. After my first few films, in fact, I stopped putting the words "The End" at the conclusion because I think films should not end but should continue to grow inside us. Ideally, they should grow inside us over the years, the same way that our historical memory grows inside of us—and films are our most vital historical documentation. This power of suggestion is what defines the greatness of a film, and what I would even say is its function.

Cineaste: *What sort of political influence does the cinema, vis-à-vis television or the press, have in Italy today?*

Rosi: Some films have anticipated what is currently going on in Italy. One example is my film, *Hands Over the City,* not because of any particular prophetic qualities or talents, but because films are a testimony to the reality in which we live and to a filmmaker's desire to understand, to his or her ability to know how to see. Sometimes a filmmaker can see things before they've become clear to everyone else. Some things are just sitting there waiting to be seen by eyes that know how to see or by the political will to show these things to other people.

The political function of a film is to provoke, and sometimes films produce results. I don't think films can change politics or history, but sometimes they can influence events. For example, thanks to the public showings of *Salvatore Giuliano* in 1962, two Italian politicians—Girolamo Li Causi of the Italian Communist Party and Simone Gatto of the Italian Socialist Party—called for the establishment of the first Antimafia Commission. A few months after the first screenings of the film, Parliament agreed to establish the commission because, in the face of a film like this—which documented the cooperation

between the Mafia, government institutions, and the various police forces in Italy—it could no longer deny to the public the existence of such activities.

Cineaste: *Do you prefer to have your films shown in theaters, or would you be more interested in having them shown on TV so as to reach a larger audience?*

Rosi: I prefer theaters because the destination of a film is movie theaters. The showing of a film on TV can naturally reach a large public, but it's not the same thing. Films shown on TV tend to be seen in a very distracted manner because of all the interruptions that occur at home—the telephone ringing, talking to friends, going to the bathroom, whatever—whereas seeing a film in a theater requires concentration. The moviegoing ritual is part of the mysterious power that films have. When I go to a movie theater and sit down in the dark amidst hundreds of people I don't know, I can feel their response to the film, and it becomes a social event.

Cineaste: *One of the characteristics of classic neorealism that one sees continuing in your work is the prominent use of nonprofessional actors. Would you explain your reasons for that?*

Rosi: Well, a film like *Salvatore Giuliano* was made almost entirely without professional actors because I wanted to make it, in a very real sense, as a psychodrama. That is, I wanted to shoot in the places where Giuliano had lived, in the town where he was from, under the eyes of his mother and family, in the courtyard where his body was found, and, above all, with the participation of many of the people who ten years earlier had known Salvatore Giuliano and who had lived with him.

I wanted to involve these people in my film, because I was sure their participation would convey elements of their suffering. In the scene shot in Montelepre, for example, where the women rush from their homes to the town square to protest the army's arrest of their husbands and sons, these women had been involved in the actual events. I knew that involving them in the film would provoke a huge emotional response, a remembrance of what had happened to them.

There were also only two or three professional actors in *Hands Over the City*. Carlo Fermariello, who played De Vita, the opposition councilman, and who became the lead actor in the film along with Rod Steiger, was not a professional actor. The guy who played the outgoing mayor in the film was a Neapolitan who had previously been a car salesman in Detroit before returning home. And the lawyer who was on the committee of inquiry was a real Neapolitan lawyer. I knew that their participation, because of their personal experience and sensitivity, would add a great deal to the film. When I chose Charles Siragusa to play himself in *Lucky Luciano*, I knew that by not using a professional actor for the part I would lose something in terms of the ability of an actor, but I was also sure I would gain something because of Siragusa's involvement in the actual prosecution of Luciano.

Cineaste: *One sees a real continuity among the key technicians you work with from film to film.*

Rosi: I always prefer working with the same collaborators, because we know each other and our working methods well. Gianni Di Venanzo was the director of photography on my first five films, and, following his death in 1966, all my other films have been made with Pasqualino De Santis. But even on the films with Di Venanzo, Pasqualino was the camera operator on three of them, so we had already begun to develop an intimate working relationship. Pasqualino is a great cameraman. We were able to take shots with a hand-held camera for *The Mattei Affair* and *Chronicle of a Death Foretold* that would be impossible to repeat today. De Santis is an extremely sensitive director of photography, but one who always likes to take risks, to try different ways of lighting a scene. He lights with very minimal means, with few artificial lights. He's also a great connoisseur of film stocks and is always willing to try new things.

Cineaste: *Who makes decisions regarding camera placement and movement?*

Rosi: These are decisions the director makes, and then with the cameraman you translate these decisions technically.

Cineaste: *Do you do this in advance or on the set? Do you do much storyboarding?*

Rosi: I decide the day before how I'm going to shoot a scene. The last thing I do in the evening, before closing up the set for the night, is to explain what I'm going to do the next day. I think this sort of work has to be prepared in advance, but obviously this can't be a set rule, and many times I decide on the camera position when I'm on location. There are many circumstances in which you may have to change everything at the last minute.

Sometimes, for some sequences, I prepare a little storyboard, as in *Illustrious Corpses* or *Chronicle of a Death Foretold*, but I don't use the American system of preparing a storyboard for the entire film before it's shot. I do like to prepare the work in advance so I can explain it first to my cameraman and director of photography to assure that it will be done in the best possible way from a technical point of view.

Cineaste: *How do you work with your editor?*

Rosi: First of all, I only begin to edit a film after I've finished shooting. I never let the editor edit the film on his own. I sit at the moviola with the editor, and we work together because I've thought about the editing while I'm shooting, so I already have the montage in mind. Nevertheless, while working at the moviola I might decide to change many things. With *The Mattei Affair*, for example, many changes were made right at the moviola. This is something you can tell because of all the different kinds of material I used in that film. I don't often shoot a lot of coverage, but many times I shoot with two cameras, not to have more choices but to have different perspectives on the same scene.

Cineaste: *In many of your films, the Mafia is portrayed as a very powerful element of society, and so thoroughly entrenched as to perhaps be ineradicable.*

Rosi: The Mafia has great power, but it is not invincible. This has been proved in Italy over the last few years. For example, a so-called maxi-trial was instigated by a group of magistrates in Palermo—including Giovanni Falcone

and Paolo Borsalino—which showed that a lot can be accomplished in the war against the Mafia. This trial marked a turning point, and recently the state has been hitting the Mafia very hard. This doesn't mean that in a short period of time you're going to achieve significant results against such a complex phenomenon as the Mafia, but it does signal a major change in public opinion. We must also recognize a fundamental change in the Mafia culture itself. The Mafia and the Camorra—the Neapolitan version of the Mafia—are not just criminal societies, they're also cultures, certain mentalities.

When I made *Salvatore Giuliano*, they didn't even say the word "Mafia" in Sicily. But in Sicily today young people organize protest marches against the Mafia, and civic society has responded very strongly to such protests. People are aware of the sacrifice on the part of many judges, policemen, journalists, and even politicians who have paid with their lives in this struggle, and so there is a growing public awareness that we can and must achieve results against the Mafia.

Cineaste: *How do you evaluate the overall political situation in Italy today?*

Rosi: Everything's in movement in Italy today. On the part of Italian civic society, there's a huge demand for change, a very strong protest against a system of political and economic corruption, in connection with organized crime. We can't really say there are definite efforts today that will lead to conclusions, but I and many others believe that there is a movement of sorts that will lead to a second *risorgimento*, a second rising up, like the first *risorgimento* for Italian independence in the nineteenth century.

Cineaste: *What political party is going to be able to take the lead here? Are we looking for a new Garibaldi?*

Rosi: No, there is no new Garibaldi for now. But what is important is that there is all this movement, a very strong demand for change, and a rejection of a system of corruption that has tarnished, more or less, *every* political party.

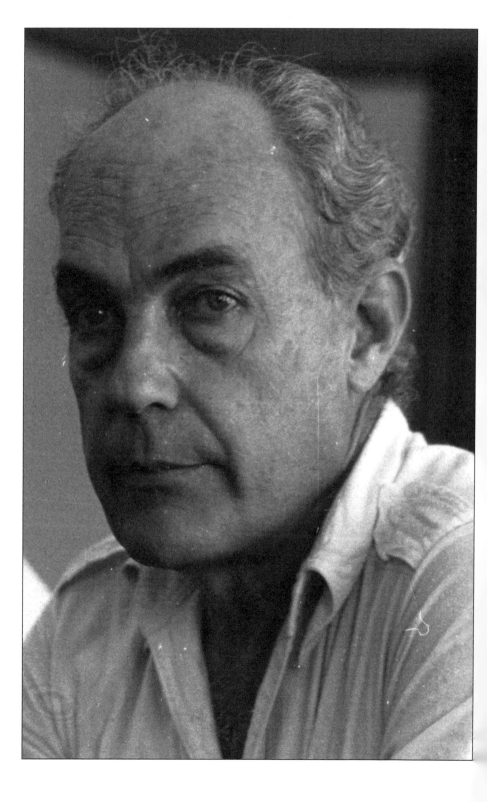

15 TOMAS GUTIERREZ ALEA

Strawberry and Chocolate, Ice Cream and Tolerance

Tomás Gutiérrez Alea (1928—1996) became the most prominent of the film-makers working in Cuba's government-supported film institute, the Instituto Cubano del Arte e Industria Cinematograficos *(ICAIC). Gutiérrez Alea was a committed revolutionary, and his best features explore the social, political, and historical dimensions of the revolutionary process. Frequently, this exploration shows a sharp critical edge as the director examines and critiques the flaws of revolutionary Cuban society.* Death of a Bureaucrat *(1966) satirically spoofs an excessive bureaucratization that hounds Cubans even beyond the grave. In* Up to a Point *(1984), the director takes on the machismo and sexual double standard very much alive amongst Cuban male intellectuals and his own* compañeros *in ICAIC.*

Gutiérrez Alea once again turned his critical gaze to Cuban revolutionary society in Strawberry and Chocolate *(1993), which was freely adapted from the Senel Paz short story "The Wolf, the Woods and the New Man." This comedy-drama follows the development of a friendship between two young men. The straight David is a naive but convinced Communist militant who was brought up on the party line and now aspires to be a writer. Diego is an intelligent, cultured, and sophisticated gay who has seen his options in society disappear because of his sexual orientation. At the end of the film, discrimination and professional and personal pressure are such that Diego opts to accept the help of a friendly foreign embassy in order to emigrate. He leaves in spite of his pro-Revolution sympathies and his friend's claims that there is a place for gays in the Cuban Revolution. A subplot explores the virginal David's romantic and sexual relationships with two women. The action is set in Havana in 1979, a period of considerable discrimination against homosexuals.*

Dennis West, a Cineaste *contributing editor, interviewed Gutiérrez Alea in December 1993 at the annual International Festival of New Latin American Cinema in Havana. The conversation continued in Juarez, Mexico, during the Second Festival of Latin-American Cinema Paso del Norte in August 1994. The interviews were translated from the Spanish and edited by Dennis West and Joan M. West.*

Cineaste: *Revolution is the central theme of almost all your films. How does* Strawberry and Chocolate *fit into this thematic concern, and why take up the subject of the intolerance of some revolutionary* compañeros *precisely at this time?*

Tomás Gutiérrez Alea: I think that intolerance is not just a current theme. This theme could have been examined a long time ago, and if that did not happen . . . well, it was just chance. As for me, I confronted this theme and decided to make this movie after having read the short story by Senel.

Cineaste: *So Paz's short story stimulated you to start thinking about this theme?*

Gutiérrez Alea: Right, but that doesn't mean that I hadn't thought about the theme before. I had just never found a way to approach it. When the short story appeared, I realized that that was what I wanted to do.

Cineaste: *Why is the action of the film set in 1979 instead of 1993?*

Gutiérrez Alea: 1979 represents the end of a historical period, because the Mariel boat lift occurred in 1980, and that caused many things to change. So we preferred not to burden our plot with additional complications. The period before 1979 was also the time of greatest repression or discrimination against homosexuals. There was not really a repression—homosexuals were not jailed because of their homosexuality—but there was discrimination against them, they were marginalized. All that changed after 1980.

Cineaste: *The Revolution's social problems that you examine in addition to intolerance—the black market, homosexuals' right to work, the freedom of the artist, and revolutionary watchfulness or surveillance* [vigilancia]—*are they just as much problems in Cuban society today as they were in 1979?*

Gutiérrez Alea: Yes, of course. I would say that right now the black market has become so generalized that all Cubans, in order to survive, must resort to it in one way or another. Some use it more, some less.

There has always been revolutionary watchfulness. It increases during critical periods; at other times it is less, but there has always been a sense that surveillance and control are necessary. At times there is a real reason to have revolutionary watchfulness, but at other times it may be a pretext to commit certain excesses. It has always represented a threat to the counterrevolution—more particularly in earlier revolutionary times than now—so surveillance is something real. But at times it has become exaggerated and really bothersome. It has dampened people's activities and made their lives impossible. The best way to counter this problem is, first of all, to become aware that this is an aberration, and then to make fun of it a bit—which is just what the film does.

As for homosexuals' right to work, they have always been able to work. However, in given periods homosexuals have been barred from certain types of employment. They have been barred from teaching, for example, since it represents contact with youngsters.

Cineaste: *Is that still the case now?*

Gutiérrez Alea: No, I believe not. Now there is great flexibility in job opportunities for homosexuals. In the case of representing Cuba abroad, for

example, the appointment of representatives used to be handled with kid gloves when homosexuals were involved. Many people were against appointing them because they were considered more vulnerable to scandal and blackmail—and that's true, we've seen it in countries such as England and the United States—but things are very different nowadays for homosexuals. Many Cuban homosexuals are now open about their sexual orientation. Others are not open about it—just like anywhere else—but there is now a new level of awareness concerning homosexuality.

Cineaste: *What about the problem of freedom of artistic expression, which is exemplified by Germán and his sculptures?*

Gutiérrez Alea: There have likewise been different stages in dealing with this problem. Right now it just depends. Look, this film itself demonstrates that things can be said, and it is coming out during a propitious historical moment. A couple of years ago there was a scandal concerning the film *Alice in Wondertown*. That scandal was like a vaccination [*for the government*] because that situation was so utterly stupid and heavy-handed. That sort of situation cannot be repeated; the political cost is too high. So it's a good time for this film to come out.

Ten years ago the sort of censorship in the plastic arts that happened to Germán in the film was indeed common. Nowadays I have seen exhibits of paintings that were much more daring and censorable—"censorable," that is, in quotation marks. Such paintings would have been censored ten years ago, but not now. For instance, I remember one installation that alludes to the exodus on rafts from Cuba. It was quite interesting, very dramatic. Formerly this would have been banned, but not now. So, this question depends on the precise historical moment. That is not to say that censorship has disappeared, but one always finds a way to say things.

Cineaste: *The performances by the two lead actors represent one of the great successes of the film. How did you select and work with these actors?*

Gutiérrez Alea: The selection of the two lead actors was due more to chance than to our competence. Let me explain. Our initial conception of these two characters was quite different from the final version seen on screen. According to our original concept, the gay character should have been a mature individual between the ages of thirty-five and forty. He would not necessarily have been physically attractive, but he would have possessed an interior attraction because of his maturity, wisdom, and personality. He was to have exerted a certain fascination over the other character, but not a fascination based on physical attraction.

The other character, according to our original conception, was to have been a twenty-something-year-old youth who was inexperienced, very naive, very young, very immature, and very beautiful. He was to have been a prototypical ephebus. And originally the gay character was to become immediately enamored of him—love at first sight.

We just couldn't find the appropriate actors to fulfill these initial concepts

of the characters. Finally, we had to make a concession, and I am extremely satisfied with what we did. I think that God's hand helped us to correct our errors. Now I think it would have been a mistake to have a homosexual character who was not as attractive at first sight as the one we have, because attractiveness is one of the qualities the character needs in order for the spectator to identify with him. An empathy needs to be established between the gay character and the viewer. The actor that we chose was able to do this. It all would have been harder with a different actor who did not possess that *gracia* or charisma.

Vladimir [*Cruz*], the actor who portrays David, is very intelligent. He was capable of playing this role quite well; because of his age, he is very close to this character. He is also an actor who possesses a certain charm [*encanto*], particularly in his eyes. But that charm is not initially evident, it must be discovered gradually, and that makes the actor all the more interesting to me.

Cineaste: *Does Diego represent a somewhat stereotypical* loca?

Gutiérrez Alea: No, no. He's definitely not a stereotype. Diego is not really even a *loca*. The equivalent in English of *loca* is "queen"—a gay who expresses himself in a very extroverted, very spectacular manner, who flaunts his homosexuality. His homosexuality is at the center of his social being. Diego, on the other hand, is a gay who has other concerns. He is a refined and cultivated man who is relatively mature, and he conducts himself as a normal person. But, of course, as he says, he likes men.

Now, it is true that at certain times he does conduct himself in a slightly effeminate way. For example, at the beginning of the film, when the characters are in the Coppelia Ice Cream Parlor, Diego conducts himself in an ostentatious way because he is committed to conquering that young man. But, afterwards, as you have seen, little by little, his conduct becomes more sober. In other words, he's definitely not a stereotype.

Cineaste: *Would you describe your approach to working with the actors and with your longtime cinematographer, Mario García Joya?*

Gutiérrez Alea: When it comes to the *mise-en-scène*, the actor is the most difficult and the most important element—the element the director must be most careful about. I have always tried to create a *mise-en-scène* that functions around the actor so that he feels comfortable and his acting feels natural and organic, as if it sprang from him. So my point of departure is always improvisation. We select the key scenes that will define the characters, and those are the only scenes we rehearse. I think that if the actor can capture his character by rehearsing a key scene, he will be able to interpret this character coherently in any other dramatic situation.

I am also careful not to subject actors to rigorously preplanned movements that would make them dependent on the camera. Many times an actor becomes uncomfortable if he feels he cannot deviate so much as a single millimeter in his movements. So we always try to create a *mise-en-scène* where the camera is subordinated to the actors, and Mayito [*Mario García Joya*] has played a key

role in this. We always give the actor great freedom and leeway, so he can play his character in the most organic way possible.

Let's talk about camera work. Over the many years that Mayito and I have worked together, we have developed a style of work characterized by mutual comprehension. We don't have to ask what the other one wants. Our stylistic approach has always been to have the camera function in relation to the players, their situation, and their movements. This is what gives a very fluid dimension to our *mise-en-scène*.

Mayito uses the hand-held camera a lot. His ability is so extraordinary that it is frequently very difficult to believe that a scene was shot with a hand-held camera. His camera is very steady. In addition, Mayito uses some devices that he has invented. For instance, he or an assistant places a rod underneath the camera when it must be stationary, and that rod is removed when the camera must begin to move and follow a character. His inventions work marvelously. You see a tremendous fluidity in these different *mises- en-scène*. I would go so far as to say that the fluidity is even more perfect than if he had used a Steadicam, because when a Steadicam is used the camera floats a bit. Mayito, though, can keep his moving camera perfectly stable.

These kinds of devices are part of an aesthetic perspective, but they have also been invented because of our limited resources. We cannot use the kinds of sophisticated equipment that characterize big-budget productions. We must work very quickly and with only a limited number of resources. All this has instilled in us a spirit of invention that overcomes our production problems.

Cineaste: *In Senel Paz's excellent short story, the protagonist's introspection really stands out. I take it that your occasional use of voice-over narration is an attempt to transfer this aspect of Paz's short story into cinematic terms.*

Gutiérrez Alea: I think there are only one or two sequences where we use this device, and we found this the best way to handle those sequences. But we did not do this because of any need to be faithful to the original short story, because, as you have seen, we are not faithful to the original story.

Cineaste: *Who wrote the script for the film, and why did the screenwriters invent Nancy, who does not appear in the short story?*

Gutiérrez Alea: Senel wrote the script, but he always worked with me. Starting with the original concept for the film, we drafted the project together. He would go and write the scenes after we had discussed them. The entire process of scriptwriting was a collaborative effort, although he did the actual writing himself.

Some things—the character Nancy, for example—were Senel's invention. The creation of Nancy was a fantastic idea because we felt the necessity to make the relationship between the two men more complex. That relationship could not remain as linear as it was in the short story, and we felt that an additional character could help us plumb the depths of that relationship. Senel had already created this character in a previous film called *Adorable Lies*, and it occurred to him to transfer her to this film—the same character with exactly the same

name—but in this different dramatic situation—namely, as Diego's friend.

Cineaste: *I find the character Miguel to be very* machista, *dogmatic, and very close-minded. This character seems rather sketchy in comparison to the two protagonists. Is this done on purpose, so that the character clearly, or symbolically, represents the attitudes of certain militant Communist sectors at the end of the 1970s?*

Gutiérrez Alea: It's true that the character is somewhat schematic. We didn't feel the need to develop him any further. After all, since he is a supporting character, he should be drawn clearly. It seemed to me that he could be sufficiently characterized just as he is—in black and white—a character who is a symbol more than anything else.

Cineaste: *Does one see in the film, as exemplified in the figure of Miguel, the Cuban Communists' fear of things foreign—foreign ideologies, foreign ideas, foreign art? Could you situate this fear in a historical context?*

Gutiérrez Alea: I don't think that's in the film either explicitly or implicitly. Something different is in the film. It is true that a denunciatory and violent extremism arose in the very early stages of the Revolution. Back then it got to the point that a definite effort did exist to prevent or diminish manifestations of foreign culture.

For example, even in music, the most abstract art form, there was a pronounced prejudice—namely, against Anglo-Saxon music. I remember, for example, that although the music of the Beatles was not banned, it was neither played nor listened to. Listening to that music was considered a sign of ideological weakness. But, as I was saying, this occurred in the very early years of the Revolution. This was not the case in the period when the film is set, because by then the Revolution had reached a more mature stage.

Cineaste: *But what about the case of the famous political novel* Conversation in the Cathedral *written by the rightist Peruvian novelist Mario Vargas Llosa? Doesn't Diego use this book to entice David because it's unavailable in Cuba?*

Gutiérrez Alea: Yes, that's right, but the problem with the book is not that it's foreign but rather that its author is a rightist. As a matter of fact, this book does interest us because it's a Latin American novel. Remember that here in Cuba [*the publishing house*] Casa de las Américas promotes Latin American literature. But Vargas Llosa is not promoted because he acted in a very militant and aggressive way against the Revolution. Therefore, he is considered an enemy, but that does not mean we do not consider him to be a great author.

Cineaste: *Would you comment on your use of the poster for* Some Like It Hot?

Gutiérrez Alea: Well, I think this is obvious. At the end of the film, there is a homage to *Some Like It Hot*. At the end of the American film, you will remember, Tony Curtis [*actually, Jack Lemmon*—ed.] says to Joe E. Brown, "But I'm not a woman." And Brown answers, "Well, nobody's perfect." In our film we turn this around a little—"Too bad you're not gay," with the answer being, "No one is perfect." So we use almost the same joke near the end of our film. As for the poster,

we wanted to set up an allusion to *Some Like It Hot* early on in our film.

Cineaste: *One of the central themes of the film is "Cubanness" and the question of Cuban identity. Would you comment on the Cuban altar in Diego's house and the film's splendid use of Cuban music?*

Gutiérrez Alea: That altar, which was in the short story, defines Diego's personality very well. Because Diego is enamored of Cuban culture, of his country. This aspect of his personality makes the ending of the film—when he must abandon his country because he cannot live out his potential fully—all the more dramatic.

As for the music, I have always had a particular enthusiasm for Cuban music. It's always seemed to me that Cuban music displays extraordinary qualities, many of them unheralded. The music of Ignacio Cervantes and of other Cuban musicians from the last century is almost universally unknown. Nevertheless, that music possesses excellent quality and great richness. So *Strawberry and Chocolate* offered us the opportunity to use some of this music, specifically in a scene where the two men are listening to a pair of dances by Cervantes, "Good-by to Cuba" and "Lost Illusions." The nature of these musical pieces, as well as their titles, make them very well suited to the dramatic situation we wanted to develop.

Cineaste: *Would you specifically relate Cervantes's "Lost Illusions" to your thematic concern of lost illusions?*

Gutiérrez Alea: In one scene, the protagonists are listening to this music. They are both enjoying the music, and Diego is enjoying the other man's presence. David starts to feel uncomfortable because of Diego's glances and communicates that to Diego. Since they are talking about the music, Diego says to David, "That's called lost illusions." In other words, the lost illusions refer to Diego's illusions concerning David.

Of course, the theme of lost illusions appears in a more general sense. Diego has also lost his illusions as regards the Revolution. He had wanted to be a schoolteacher, he had participated in the literacy campaign, and he had been abundantly enthusiastic about the Revolution. Then the Revolution treated him badly and marginalized him. So the music and the theme also come together in this way.

Cineaste: *One of your projects in this film is to pay homage to "Cubanness" and elements of Cuban identity. In this regard, is there an effort to recuperate the figure of Lezama Lima? To recuperate little-known Cuban music? To recuperate a beautiful and decadent Havana, a Havana that will continue to exist for who knows how much longer?*

Gutiérrez Alea: Yes, you said it, exactly. This is all dictated by an interior and spiritual need that I feel. As for Lezama, I could just as well have chosen another figure from our literary history. The figure of Lezama acquires a symbolic status because of his stature as a writer and because of the fact that his novel, *Paradise*, had been censored at one time.

Cineaste: *I understand that it is no longer censored and can now be readily purchased in Cuba.*

Gutiérrez Alea: Well, it's no longer censored; but it can't be purchased because there are hardly any books available for purchase now. They'll have to bring out a new edition. But let me say this—his book had never been censored; pages were not removed from it. What happened was that after the book was published, the entire printing was withdrawn from circulation because the book contained a chapter with references to homosexuality. Such a repressive action was idiotic. Later, however, the book did circulate freely.

Cineaste: *Are you attempting to pay homage to Lezama and recuperate him for mainstream-nongay-Cuban culture because he was a gay writer?*

Gutiérrez Alea: Actually, the film doesn't recuperate Lezama, because he is already recuperated. He has an extraordinary reputation. The film does pay very just homage to him—not because he was a gay writer, or part of a gay culture, or a writer who focused exclusively on gay culture—but because he was an author of universal stature who had at one time suffered discrimination.

Cineaste: *A very specific and pointed question. Does Diego's line of dialogue—"How much we need another voice!"—represent a reference to Fidel Castro's vast political power and the possible necessity of further democratizing the Cuban political system?*

Gutiérrez Alea: [*Chuckles*] Well, it seems obvious, doesn't it? Of course, that line is said as a joke, but a joke that contains a great measure of truth.

Cineaste: *On December 10, 1993, at the closing ceremony of the International Festival of New Latin American Cinema in Havana, Strawberry and Chocolate walked away with most of the top prizes. Afterwards, in the Palace of the Revolution, Fidel Castro held a reception for festival guests featuring strawberry and chocolate ice cream served together for dessert. Is this the Comandante en Jefe's way of saluting your film and of signaling an attitude of greater tolerance in his government?*

Gutiérrez Alea: Look, I don't remember that dessert being served.

Cineaste: *Oh yes, it was. I was a guest at the reception and that's the dessert I was served.*

Gutiérrez Alea: Really?

Cineaste: *Really. You didn't know?*

Gutiérrez Alea: No. [*Chuckles*] Well, OK. It must have been a normal gesture, a way to celebrate the prize for a film called *Strawberry and Chocolate*. That night he [*Castro*] invited the actors and me for a drink with him. As we chatted, we realized that he had not yet seen the film. Jorge [*Perugorría*] made a joke that alluded to something in the film, and he did not understand it. If he had seen the film, the joke would have been very obvious. In fact, he told us that he had not had time to view the film yet, but that he was going to see it. He did see it later, but he hasn't expressed any opinion about it.

Cineaste: *I understand that* Strawberry and Chocolate *has broken box office records in Cuba. When did it open? How many viewers have seen it, and why has the film had such social resonance in Cuba?*

Gutiérrez Alea: It opened right after the festival. There were very long

lines to see it, and it ran for something like three months in Havana. Yes, it did break box office records.

Why? There are many factors. First of all, I think, because it's a story that is well told, an effective story with a theme that many people wanted to discuss in public. A theme that up until this time had remained rather marginalized. I'm not referring just to the theme of homosexuality, but rather to the theme of intolerance in general. I think that people really felt a great need to reflect on this theme, and to reflect on it openly. For these reasons, the film became a sociological phenomenon.

Cineaste: *Do you have any idea of the number of Cuban viewers who have seen the film? Is it the greatest record-breaking film in the history of Cuban cinema?*

Gutiérrez Alea: I don't know the numbers exactly. This film cannot be judged in the same light as older films that have been exhibited over a period of many years. Perhaps *Strawberry and Chocolate* does hold the record for the greatest number of viewers. I don't know. But at any rate, it is the film which has attracted the greatest number of viewers in the shortest period of time.

Cineaste: *You have indicated that part of your work as director of* Strawberry and Chocolate *was to stimulate the creativity of the filmmaking collective. Would you elaborate?*

Gutiérrez Alea: Well, I think that's the work of the director. At least that's always been my attitude. Filmmaking is a collective not a personal art, so I attempt to have each participant be, in a way, an author of the film. A film can be greatly enriched if a director succeeds in stimulating this creative collectivity.

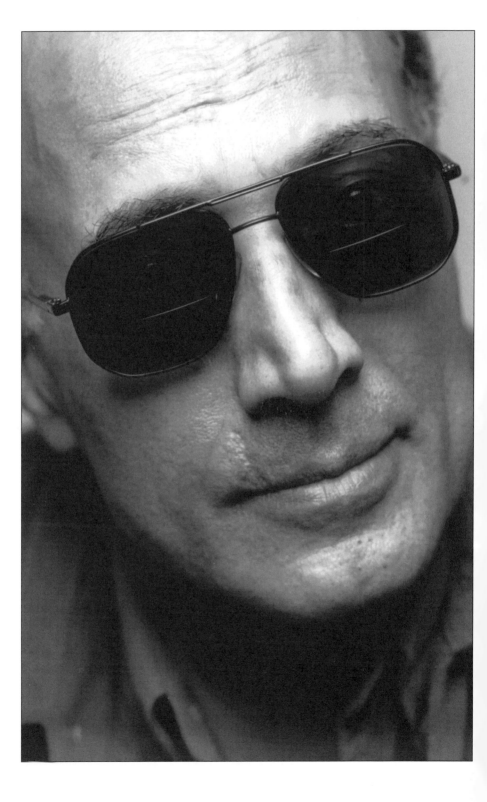

16 ABBAS KIAROSTAMI

Real Life is More Important Than Cinema

*Iranian director Abbas Kiarostami had been the filmfest maven's trump card
ever since Akira Kurosawa gave him a world-class wink: "When Satyajit Ray died, I
was quite depressed, but after watching Kiarostami's films, I thought God had found
the right person to take his place."*

*Historically aware filmgoers might find the comparison faintly alarming. After
all, at the time the great realist director Satyajit Ray won a special achievement
Oscar in 1993, not a single one of his films was in distribution. But the comparison
is aesthetically apt. Ray, whose aesthetic heroes included the Bengali philosopher
Rabindranath Tagore and the French master of realism Jean Renoir, once defined his
filmmaking goal (as quoted in Andrew Robinson's biography) as "to find out ways of
investing a story with organic cohesion, and filling it with detailed and truthful
observation of human behavior and relationships." Kiarostami, who sees himself in
a centuries-old tradition of Persian artists and whose heroes also include Rossellini
and Truffaut, has the same eye for telling detail, the same fascination with the thick
integrity of experience, the same refusal to be confined to narrowly national cultures
or ideologies. While on its own* Through the Olive Trees *functions as an offbeat,
whimsical love story, it is also the third in an improbable and accidental series of
films about a mountainous corner of rural Iran. Within that sequence, it can be seen
as developing and intensifying ongoing themes about image and reality, social
inequities, and the role of the storyteller in society. Furthermore, it is only one facet of
a career that has evidenced a delicate, ideological tightrope walk.*

The series began with a classically neorealist "little film," Where Is My Friend's
House? *(1987). The plot revolves around a young boy's attempt to return a friend's
school notebook before the teacher finds out it has been misplaced. In the second,* And
Life Goes On *(1992), the director of the first film and his son return to the town, after
an earthquake, to look for the stars of the first film. Although they never find them,
they do stumble across touching, wry dramas of death and survival.* Through the
Olive Trees *tells the story of a film crew making a key scene from* And Life Goes On.
*Each film is documentary-like, based in real-life events, features nonactors, is
unscripted, but is fully fictional.*

Pat Aufderheide spoke with Kiarostami for Cineaste *in February 1995, during a
retrospective of Iranian cinema at The American Film Institute in Washington, D.C.*

Cineaste: *Akira Kurosawa's likening you to Satyajit Ray places you in a group of people who—mostly in an earlier era—trusted that a film about "the human condition" could speak for and to everyone, across borders. How did you come by the self-confidence that allows you this conviction?*

Abbas Kiarostami: This is the first time anyone has ever spoken to me of self-confidence in my films. I have heard it in a different version, with a negative connotation. I have been told, "You underestimate the cinema," and "Who do you think you are to make a film like this and expect people to go to it?" Critics say this is not enough, that cinema should be like *Pulp Fiction*, with a strong story including sex and violence.

Someone told me, "If I want to see this kind of film, I can stay at home and look out my window. I can see this kind of thing anywhere. In the cinema I want to see drama, exaggeration." You know, special effects. People also accuse me of being naive.

Cineaste: *What then makes you persist in the face of such objections? What kinds of filmmaking inspired the choices you make in your own films?*

Kiarostami: I have hundreds of small sources of inspiration throughout the day, just watching people in daily routines. I think what happens in real life is more important than cinema. My technique is similar to collage. I collect pieces and put them together. I don't invent material. I just watch and take it from the daily life of people around me.

Also, I'd rather look at the positive side of daily life than the negative, which makes me sleepless and nervous. So I look around and select the things that seem to me the best. I collect and put them together as a package and sell it. I'm not the only one who does this, you know. Florists do the same thing. They don't make the flowers, they just find the best arrangement.

People choose their own work. Some people go after beautiful things. And in cinema it's been made easy for us. We have this camera, which is very sensitive and registers all the details. All that's left is for us, the film directors, to decide when to register them. There's also a personal satisfaction in it—we are the first consumer of what we tell. Positive stories make me feel good.

Cineaste: *Would you tell me about an image from daily life that connected, for you, with the kind of cinema you make?*

Kiarostami: I can't put out of my mind an image that was formative for me—it haunts me. One snowy day I was going to work and saw a mother walking down the street, holding a small child, a baby really, wrapped up in her *chador*. The baby was clearly burning up with fever, and its eyes were nearly shut.

I happened to be walking behind them, and I was staring at the child and waving my hand, the way you do to little children. I thought he couldn't even see me, his little eyes were so swollen up. And the mother didn't even know I was there. When we got to the intersection, I saw to my astonishment that the child, with great effort, pulled out his hand and waved back at me. Well, it shocked and touched me, and it also struck me that nobody was around to see this scene. And I thought, there should be a way to show this moment to people.

Then, this is what happened. That moment was repeated in the second part of the trilogy [*And Life Goes On*], with the child with the broken arm. I waved at him, and this scene happened again—he waved back.

I think what goes around, comes around; you get what you give. I enjoy so much watching good films with a human touch and emotions, and I don't get that kind of pleasure when I see violent movies.

Cineaste: *The way you describe your work process sounds like the Italian neorealist screenwriter, Cesare Zavattini, when he said that the point of story-telling in the movies wasn't to invent but to discover.*

Kiarostami: I can understand and empathize with that, although I don't recall ever hearing it. Of course, I began watching movies by watching Italian neorealism, and I do feel a kinship with that work. But it's more a question of congruence of taste than it is a decision to follow their example.

I think the most important and obvious reason why there is a similarity is the similarity between the present situation of Iran and of postwar Italy. Italy then was under the pressure of the postwar situation, and we have similar circumstances.

Another similarity that may provoke parallels is that I don't adapt from literature or mythology. I get my stories from daily life, like they did. I also don't have big, expensive sets and elaborate production values and special effects. My films are low budget.

Cineaste: *Italy's commercial film industry had been quite developed before the war, of course.*

Kiarostami: And so was Iran's. Iran still has a flourishing commercial film industry. About sixty feature films were made last year, and about eighty-five the year before that, with many more shorts. We have a vigorous entertainment industry. But my style is distinctive within it—I'm not part of a trend that way.

Cineaste: *As well, the Italian neorealists tended to have leftist sympathies or commitments and goals for their films. Now, I am aware that you have been extremely careful in all interviews to avoid discussion of politics . . .*

Kiarostami: No, no, that's not true. Well, I'm not political in the sense of belonging to any political party or leading a revolutionary charge, wanting to overthrow anyone. I don't work for anyone. But if you mean by political that you talk about today's human problems, then for sure my work is political and even strongly so.

Through the Olive Trees carefully explores the personal problems of [*its protagonist*] Hossein, which are grounded in real social problems. He belongs to today's Iran. He's illiterate. He wants to get married, and he doesn't want his children to be poor and illiterate. He expresses these problems very simply, but they're very real.

When you get involved in someone else's suffering, and you try to convey it so that other people can feel it and understand, then this is political. When you're talking about Hossein, that cannot be far from politics, because you're showing something about social issues that politics must deal with.

Cineaste: *So if you had to describe what you want to say in* Through the Olive Trees . . .

Kiarostami: It would be that this is a statement for decency, for humanity. I want to let viewers see into the real lives we lead.

Cineaste: *In the U.S. our images of Iran are colored by the barrage of negative news coverage. Recent films from Iran often seem calculatedly apolitical. Is that a consequence of censorship or intimidation?*

Kiarostami: You know, your view of Iran is skewed inevitably and understandably by the press coverage you get. We don't have heavy political confrontations and discussion every day. When you hear bad news about Iran in the morning, you carry that image with you all day. We hear the news at seven in the morning and don't think about it again until the evening news. We're busy with our lives, whether it's going to rain, and so on. Life in Iran is not as gloomy as you think.

Cineaste: *You've been criticized for using Western classical music in your films.*

Kiarostami: Yes, and what I say is that classical music belongs to the world. It's like the sky, and everyone can partake of it. My aim is to create unity between worlds that are usually apart. It is the duty of the police and immigration officers to create borders, and it is the duty of artists to lessen or eliminate them.

Cineaste: *How does the Farabi Film Foundation work?*

Kiarostami: The Farabi Film Foundation was established after the revolution by some religious people who had a passion for film. It was their personal passion that made it happen. They were afraid that without support in a tough economic situation, the cinema would die. Even now, with the trade embargo and other problems, we pay fifty times the normal price for a reel of film.

Even before the revolution, the Foundation advocated nonviolent, family films. They are interesting people, and we have good relations. They've asked me sometimes to consult with them, and they like my films.

It is private but receives help from the government. The government approved it because it trusted the religious people who started it. They provide labs and equipment to filmmakers on a deferred-payment basis. There are other places to get labs and equipment, but you would have to pay cash. So they're very important. They must approve scripts.

They were crucial at the beginning of the revolution. Now they are under pressure by religious radicals. The radicals haven't taken it over, but they have slowed it down. And the government cut its subsidy to filmmakers in 1992.

I get less financial help than other filmmakers, because I don't need as much. But the Foundation helps me and others with international distribution, and that's the really essential help. No film is distributed overseas without the imprimatur of the Foundation.

Cineaste: *Do filmmakers avoid political subjects in order to get the support of the Foundation?*

Kiarostami: No, I don't believe that's the case. I think that government financing makes it possible for filmmakers not to have to worry about the box office, or about using violence to attract crowds. I think that's why the result is better, too.

Cineaste: *The Iranian films we see in the U.S. at festivals seem almost pointedly humanistic. Is it fair to read these as statements by the artists not only for mutual awareness and tolerance but also against dogmatism and fundamentalism in Iran?*

Kiarostami: I think that's a fair conclusion to draw, but it is yours. You can't praise me and then ask me to endorse your praise.

Cineaste: *Why do so many Iranian films we see feature young children, especially young boys?*

Kiarostami: Well, we have mediocre films that are about grown-ups, but you don't see them here. They're not distributed internationally. I would say that about ten percent of the films made are any good, and most of those are about kids.

Cineaste: *Your films also feature children.*

Kiarostami: I love children, but I don't use them as a means to an end.

Cineaste: *Are there also violent action films produced in Iran?*

Kiarostami: Yes, although they're not funded by the Foundation. They are very popular at the box office. There's violence, but no sex.

Cineaste: *Your films are superbly produced. How do you get such excellent technical support?*

Kiarostami: My crews are always in love with cinema. Sometimes they have experience on commercial films. On my last film I had a superb cameraman and soundman, and we had enough time to do the work.

Cineaste: *Have your films been distributed in the Middle East and Asia?*

Kiarostami: Primarily it is the West that has been interested in Iranian films. I believe there has been some interest in the Pacific Rim, for instance Taiwan. But I think there is an affinity in the West for our films.

Cineaste: *The domestic audience for Iranian films has grown impressively since the revolution.*

Kiarostami: Yes, thanks mostly to the work of the Foundation. Before the revolution, religious people didn't go to the movies because they didn't feel safe there. They now can go to see movies that don't have sex and violence in them, as much as before, and they can relax. They are just discovering the attraction of the cinema.

Consider the scene in *Close-up* when the camera goes to court. Well, it was the love of cinema that permitted it. The mullah in charge of the court loved cinema and particularly the films of Mohsen Makhmalbaf.

Cineaste: *In* Through the Olive Trees, *how much of the central story—Hossein's tangled love affair with the girl—was true?*

Kiarostami: The reality was totally different from what you see. Furthermore, the last sequence transformed during the last twenty days. It

originally ended with them walking away. At the last moment I decided to make the ending more upbeat, idealistic, and more in harmony with the scenery.

Cineaste: *I think the trilogy really shows, as it develops, that in small towns everyone is always acting, because the world there is very small and you have to play several roles.*

Kiarostami: Yes, they were good actors. In the next film, everyone plays a role opposite to his character!

Cineaste: *But doesn't working with nonactors create special problems?*

Kiarostami: One big issue for us was that we realized we were not responsible for the rest of their lives. We were just making one film. We do have an emotional responsibility to them, not to make them feel like celebrities and stars, because we weren't promising them a career in film. We kept them as much as possible within their own environment, and didn't emphasize the acting. Hossein, for example, worked as a gofer, he worked in construction, and he worked in front of the camera.

Working there has changed me, though. I have worked for eight years in this area, and I feel so close to the people and the landscape that I would like to make the rest of my films there.

Cineaste: Through the Olive Trees *did not receive an Academy Award nomination.*

Kiarostami: I think that's a direct result of poor distribution. I am not happy with Miramax, because they did not do any decent publicity on the film. This is a small movie, a low-budget movie, but it's not a pathetic movie, and it did not deserve the treatment they gave it. They decided not to distribute it nationally before the nominations. Perhaps the problem is Disney [*which owns Miramax*—PA]. Big distributors don't pay attention to small films. They were probably too busy with *Pulp Fiction*.

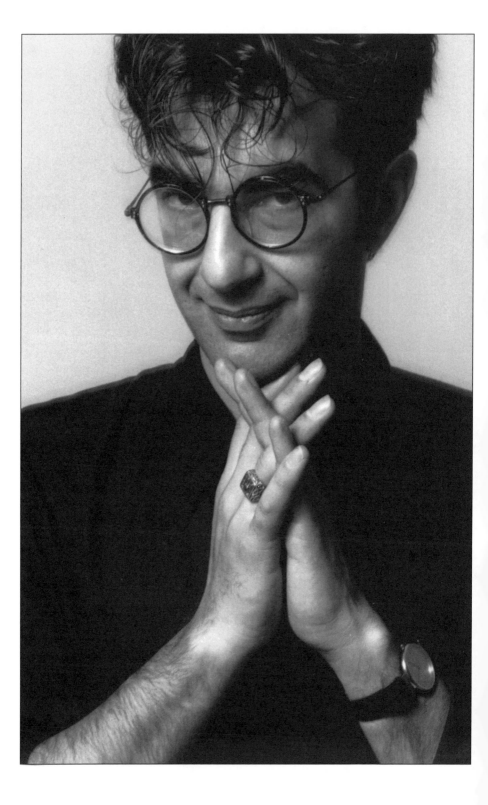

17 ATOM EGOYAN

Family Romances

Atom Egoyan's debut feature, Next of Kin *(1984), typifies the absurdist tenor which suffuses his work. A lighthearted film which provides a glimpse of darker ironies,* Next of Kin *focuses on an elaborate wish-fulfillment fantasy concocted by Peter, a nondescript young WASP who flees his affluent middle-class family to effortlessly become part of a warm but fractious Armenian clan. Never one to offer glib panaceas, Egoyan mercilessly skewers both the puritanical Anglo-Canadians and the feuding Armenians; the Candide-like protagonist's search for ethnic bonhomie proves futile.*

A few ludicrous videotaped family therapy sessions in Next of Kin *foreshadow the all-encompassing preoccupation with video surveillance and voyeurism that comes to the fore in Egoyan's subsequent films. Even if the narcissistic protagonists of* Family Viewing *(1987) and* Speaking Parts *(1989) seem inextricable from the media-saturated landscape—a world which fetishizes the ability to instantaneously record and play back images—Egoyan is not committed to a crude technophobia. He is merely bemused by how new technologies become harbingers of perceptual and cultural upheavals.*

The Canadian critic Geoff Pevere remarks that these early works create a world where "identity becomes as erasable as videotape and as ephemeral as battery power." Family Viewing *deals explicitly with the permeability of one young man's identity, a Toronto WASP named Van. Van's discovery that his authoritarian father has erased an entire archive of video images proves pivotal; amateur pornography featuring the smug dad's sexual romps with his mistress obliterate the son's cherished images of a childhood spent with a now-absent mother and grandmother. Van's unlikely alliance with a phone-sex operator culminates in a strangely upbeat triumph over the enemies of historical memory.*

Speaking Parts, *a less optimistic cinematic fever dream, can be savored as a savage parody of the culture industry's tendency to reduce serious discourse to a series of banalities. Set in an antiseptic Toronto hotel, the narrative plunges us into a vertiginous and often hilarious tale of bumbling solipsists. Clara, a naive young woman, writes a heartfelt but plodding script in an attempt to commemorate her brother's death. But the script is eventually bowdlerized by a*

wily producer who replaces its earnest platitudes with a talk-show format. Both Clara and Lisa, a pouty chambermaid, are dazzled by the film's leading man, Lance. Nevertheless, they usually cannot enjoy his sexual allure in person but must resign themselves to gaping at his image on a video monitor. Even grief has become subservient to electronic razzmatazz; in Speaking Parts's *dystopian universe, video mausoleums convert mourning into a private spectacle. While* Family Viewing *concluded with a qualified optimism,* Speaking Parts *refuses to comfort the audience with even a glimmer of hope.*

Equally pessimistic, The Adjuster *(1991), Egoyan's first wide-screen film, bestows an epic dimension on its protagonists' concerted disengagement from reality. Noah Render, the eponymous insurance adjuster, is an unsavory mixture of therapist and con artist. Superficially empathetic towards his clients, his compassion for the bereaved emanates from a need to control their lives. And Render's arrogance is bizarrely congruent with his wife Hera's job as a film censor—a task that fuses anal-retentive zeal with furtive prurience. By the film's end, the semi-catatonic Renders are eventually victimized by the schemes of staging increasingly violent private fantasies.* The Adjuster *unveils the authoritarian implications of a world where the genuine pursuit of pleasure has been replaced by loss of affect and asocial hedonism.*

Casting a wider aesthetic and thematic net, Calendar *(1993) and* Exotica *(1994)—a low-budget experimental film and a lush, relatively high-budget psychodrama—were incrementally less claustrophobic and even flirted with a renewed sense of hope,* Calendar *offered an opaquely personal gloss on the preoccupation with assimilation already evinced in* Next of Kin *and* Family Viewing. *When a Canadian-Armenian photographer and his Armenian-born translator wife (played by Egoyan and his actual wife, Arsinee Khanjian) return to their homeland, the chasm between North American affluence and a culture wounded by war and deprivation becomes glaringly apparent. The failure of Egoyan's alter ego to confront a submerged past leads to the dissolution of his marriage; his moral hibernation is rife with both personal and political reverberations.*

While Exotica *was indisputably Egoyan's commercial breakthrough, it is also his most problematic work. This elaborately mounted puzzle film unfolds like a quasisurreal parody of a psychoanalytic session: a nubile stripper assumes the role of a surrogate shrink while the opulent sex club referred to in the film's title serves as a commodious couch. Audiences were understandably seduced by the film's rapid-fire plot twists and visual panache, but* Exotica's *soft-core titillation, as well its facile resolution, seemed to pander to an art-house audience.*

The Sweet Hereafter *(1997), one of Egoyan's most textured and compassionate efforts, won the Grand Priz at the 1997 Cannes Film Festival. Cineaste editor Richard Porton spoke with Egoyan shortly thereafter at the American premiere of the film at the New York Film Festival.*

Cineaste: The Sweet Hereafter *is your first adaptation of another author's material. Did you feel that it was time to change gears and integrate other perspectives with your own?*

Atom Egoyan: After I finished *Exotica*, I felt that I had gone as far as I could, given a certain set of impulses that had formed a lot of my work. I was afraid of parodying myself. It was a very confusing time after *Exotica*, because it was a film that broke through. I wanted to surprise myself, and I think that any filmmaker wants to, more than anything, exceed his own expectations.

When I read *The Sweet Hereafter*, I felt that it was a story that I would never have been able to come up with. Yet I saw similarities to my work, and I felt that I could serve the material. It was worth pursuing, since Russell Banks was extraordinarily generous. The book was optioned by another studio, but he was prepared to release it and let me make the film. With his encouragement, and also with this need that I felt to challenge myself, I went into the project. It was a treacherous journey, because I was also involved with a studio film myself at that point with Warner Bros. Which I had to leave in order to pursue *The Sweet Hereafter*. As an independent, you have to understand what that all means and wade through it. I think that I was smart in trusting my instincts.

Cineaste: *But weren't you initially fond of this Hollywood project?*

Egoyan: Yeah, because I liked the script and had a fairly good idea of how it could be cast. But, ultimately, it all got bogged down; there were disagreements over casting. There seem to be two reasons to make an independent film. One is as a calling card, so you can enter the more mainstream industry. The other is that it just suits your nature: you can think and do better work when you don't have to respond to a number of other people. I've become so used to having complete control over my own work that entering a studio-driven project will inevitably be fraught with all sorts of difficulties.

Cineaste: *You're also accustomed to working with what could be called your own repertory company. Given your working method, I'd imagine that it would be difficult to have to deal with actors who, at least in your view, weren't appropriate for the material.*

Egoyan: That's so important. There's a certain degree of necessary self-delusion that goes with filmmaking. You have to be ready to shoot. You have to believe that you're the right person to do it. And sometimes you have to believe that someone is the right actor to play in it. Somewhere deep inside you, you know that may not be the case. But once a project assumes a certain momentum, you have to go with it. And that's when it becomes frightening, because then we lose our rational instincts and you surrender to what you need to believe in to get the project done. It happens all the time, and it's then that mistakes can be made.

Cineaste: *What kind of assistance or feedback did you receive from Russell Banks while you were working on the script?*

Egoyan: It was very important to have Russell's approval and support, even though it wasn't contractually necessary or anything I needed to do. But

since it was the first time I was doing an adaptation, and I was making some major departures from the book, I wanted to get a sense that he felt that I was keeping its spirit. I should use this opportunity to talk about the collaboration I have with the script editor, Allen Bell, who I've been working with on all my films since *Family Viewing*. When I told Allen what this film was about, he said that it sounded like a modern version of the pied piper. This sent goose pimples up and down my arm, because I realized what an amazing controlling metaphor that could be, and I went out and reread the Browning book. Though this seemed so beautiful and rich, it was important for me to have a response from Russell as well. He loved it and became quite envious of it; he felt that it was something he might have used if he had thought of it. Since I had claimed complete authorship for all of my previous films, I wanted to feel that I was being true to what Russell intended. But he never raised an eyebrow or said that I was moving in a strange direction.

Cineaste: The Sweet Hereafter *seems much more determined to offer the audience a sense of emotional catharsis than your early films. Unlike the straightforward trauma of the current film, the earlier films required the characters to engage in some kind of ritual or repetition compulsion.*

Egoyan: Or family romance. Emotional immediacy is exactly the thing that makes the experiment of *The Sweet Hereafter* work so well. Ultimately, all you need to know is that a school-bus accident has occurred and that it's about a community before and after that accident. I wasn't really aware of how simple that fundamental sense of placement would be. Everyone knows how cataclysmic such an accident would be. There is a degree of confusion and timelessness that people will accept because the characters have lost their sense of time as well due to their grief and shock.

Cineaste: *Although* The Sweet Hereafter *marks somewhat of a new direction for you, it also continues to explore the obsession with family dynamics emphasized in your other films, doesn't it? You even highlight this in your director's statement, since you explicitly link the current film with the closing scene of* Exotica.

Egoyan: Yes. I find cinema is a great medium to explore ideas of loss, because of the nature of how an image affects us and how we relate to our own memory and especially how memory has changed with the advent of motion pictures with their ability to record experience. Our relationship as filmmakers to those issues has changed radically over the past fifteen or twenty years. And people in our society have the instruments available to document and archive their own history. In my earlier films, I was exploring this in quite a literal way. But the ways in which our ability—and our need—to remember have been transmogrified comes very much into the spirit of this film as well.

There's nothing casual about accessing memory or the way experience is evoked. There's something very self-conscious, quite determined about it—the way people manipulate or use their own experience to get things they want from other people. Or the way some people want to relate to their loss in a very

immediate and private way and are threatened by having that intruded upon them. But what is great about this material is that, for the first time, the characters are really full-blooded. They're not schematically conceived. In the other films, there was a more figurative approach to the characters, because that's what those films needed. The characters were lost to themselves, so they were really just shells looking for some sort of purpose. But in this film you have some characters who know exactly who they are and what they're doing. It gives a different dimension to the piece.

Cineaste: *Incest seemed like more of a submerged theme in your other films. In* The Sweet Hereafter *it moves to the forefront.*

Egoyan: On reading the book and working on the adaptation, it was one of those situations where something had become a cliché; the entire depiction of incest in films had become very banal and lazy. I felt that there was another experience of incest that many people have experienced, but that has not been depicted in films—instead of it being a coercive act, it becomes something where distinctions are blurred. Lines are crossed, and characters find themselves in situations which are just as damaging—or more damaging—than the other kind of incest. It's more confused; guilt and responsibility are not as easy to assign. These are the incestuous relationships that perhaps have a deeper impact on the individuals involved, because they don't quite know how to extricate themselves from the situation. The reality is that if the accident hadn't occurred that relationship would probably have continued until Nicole was in her twenties, and she would have been even more messed up.

As it is, I think what happens is not so much that she realizes that she's abused but rather that, seeing her father in such an extreme state of denial, and then seeing him bartering her broken body for a reward, she becomes outraged in a quiet but very determined way. So the effect is quite different than it is in the book. I also wanted to see if I could shoot an incest scene from the point of view of the person who is involved as it is occurring. That scene in the barn is my attempt to show how Nicole would have described that scene at that particular moment. It's challenging for the viewer, because you're not quite sure how to evaluate it. But I think it contributes to the extraordinary power of the ending.

Cineaste: *So the point was to compress the experience in one shot so the event takes on a greater resonance by the end of the film?*

Egoyan: In some ways, it's not dissimilar from the way the accident itself was shot—from Billy's point of view, as Billy would have experienced it at that moment. As opposed to the more expected Hollywood money-shot point of view, which would be to cover that accident from as many angles as possible, and to try to experience the visceral effect of what it would be like to be in that bus. That wasn't where I wanted to position that camera. As an independent filmmaker, I have the privilege of being able to construct this incredible stunt and shoot it with only one camera from quite far away. I don't think a studio would have ever allowed me to do that.

Cineaste: *Jonathan Rosenbaum links your work to films by other Canadian filmmakers like Guy Maddin and David Cronenberg, who treat incest as a symptom of Puritanism and repression.*

Egoyan: It's perhaps a cliché to think that we're all bundled up so we play with each other. But, perhaps it's fair to say that one of the residual affects of our colonial experience is a very particular view we have of parents or people who are in positions of responsibility. We are all just now understanding our relationship to both what the explicit British colonial experience continues to be. We probably have to define ourselves through that very complex relationship between those two forces.

Cineaste: *Do you view the concept of the "sweet hereafter" as a utopian antidote to repression?*

Egoyan: Of course, because it is a community that is entirely virtual and that exists entirely on principles that the individuals need to sustain themselves in that community. Certainly, at the end of the film, Nicole has arrived at a point where what she does effectively destroys the community as it existed before but paves the way for a new one. To me, that's what makes it such a crowning moment. It's a complete reappropriation of her own dignity by that decision.

Cineaste: *There's also a connection between what seems to be the father's key line in* Family Viewing—*"I like to erase." Nicole's struggle is against erasure.*

Egoyan: Yes. It's a struggle against cultural and personal erasure.

Cineaste: *After reading the novel, I was struck by the fact that all of the characters, even the less intelligent ones, were unusually self-conscious. I'm sure that this must have appealed to you, but it's also apparent that you've restructured the novel so that Mitchell Stephens becomes the central character. Russell Banks seemed to regard him as only one link in the narrative chain.*

Egoyan: I guess it was just the way I read the book. When I noticed that character, I became very inspired by him. As a director, I'm always drawn to the characters who are close to conducting themselves in the way I do. There's an aspect of my job that involves manipulating people, that involves trying to seduce people and gather people and follow me into a project. In a way, I like any filmmaker, am a pied piper. You try to seduce people in order to get money, you try to seduce a crew, you try to seduce a cast. It's all very much about having other people believe that you have a vision that's worth dedicating themselves to. So when I encountered Mitchell Stephens, with his audacity of going into this town and believing that he had an answer for their grief with his claims of moral responsibility, there was something that made me feel very uneasy, yet quite sympathetic towards him and his projected mission.

Cineaste: *I understand you were quite impressed by Holm's performance in Pinter's* The Homecoming. *How did that influence your decision to cast him in* The Sweet Hereafter?

Egoyan: One of the thrills of working with Ian was being in such close contact with someone who had worked with Pinter—one of my gods. One of the

best gifts he gave after the shooting was over was a signed edition of *The Homecoming*. He's a remarkably generous man.

Cineaste: *Of course, with the exception of* Calendar, *all of the previous films have been set in Toronto. The more pastoral milieu of* The Sweet Hereafter *also transforms your view of the characters. Your earlier films seemed to focus on the erosion of community, as traditional communities were replaced by so-called virtual communities governed by technology.*

Egoyan: They have a sense of community; they know where they're from. They're not lost like urban individuals. This, more than anything else, was the gift Russell Banks gave me. I've never lived in a town like that, and I wouldn't have known how to begin telling a story based in a town like that. In making the adaptation, there was a huge challenge, which is that this community is, in some ways quite virtual and unrealistic. In order for the drama to work, we have to feel that the children of the town completely disappear. If you look at it realistically, there is a school bus picking up kids from the outskirts of town, and there must be a central community, there might be kids who don't need to take the school bus and who just walk to school. So the town is bigger than you feel in the film, and yet you never see that.

That's why in doing the adaptation, I couldn't show the crowd scenes, I couldn't show the funeral. If we represented the whole town, we'd diminish the dramatic effect of the story. A writer has the privilege of being able to do that, because he's able to emphasize particular people so the background becomes abstract. But the moment you train a camera on a huge fairground and see other children, it takes away the fairy tale-like feeling that I wanted to create.

Cineaste: *And your choice of a wide-screen format gives the film the feel of an intimate epic.*

Egoyan: Yes, and this large canvas that you have gives you a feeling of vastness. There's no question that it transforms scenes to an epic level. And there's also this relationship to other films about strangers coming into town.

Cineaste: *Some of the casting seems to reflect your fondness for narrative ambiguity. For example, was it accidental that the actress who portrayed Alison looked quite a bit like Nicole?*

Egoyan: That was entirely intentional and very much a part of my casting. That's what Stephens is spooked by as well. It's probably why he confesses to her as much as he does.

Cineaste: *Didn't a controversy erupt when you decided to show* The Sweet Hereafter *at a benefit at your son's school?*

Egoyan: It only generated controversy among the people who were subjected to it. That was a classic example of complete denial—showing this at a benefit to a group of parents who every morning send their children off to a school bus was a perverse decision. But it was not intended to arouse the degree of shock that it did. Russell told me that he couldn't understand how someone who had just had a child could have made this film. I couldn't understand what I was doing until the film was finished and I had some distance.

Cineaste: *It would seem accurate to term* The Sweet Hereafter *your most affirmative film. For example, both Christina in* Exotica *and Nicole in the current film have been traumatized by incest. But Christina is unable to transcend her childhood trauma, while Nicole succeeds in breaking through and changes.* Speaking Parts, *on the other hand, could be termed your most pessimistic film.*

Egoyan: Absolutely—and *The Adjuster*, as well. Although if you look back at the really early films, like *Next of Kin*, there's a bit more optimism. I think that *The Adjuster* went about as far as you could go in rendering the characters almost completely absurd because of their inability to define themselves. There was something quite humorous at some level about the repetitive patterns of behavior that the people were forced to reenact over and over again. Emotionally, the films are obviously quite bleak. There's not really any invitation to identify with any of the characters. As a matter of fact, you're always very aware of the fact that you're watching them, and that becomes what those experiences are about. They're very much about watching and what happens when a relationship is entirely conducted through a lens, either in a literal or a figurative sense. In a way, the censor's relationship to the images she sees in *The Adjuster* are characteristic of how all of those relationships work. Material is gathered in an archive, and then stored and preserved.

Cineaste: *Were these sequences focusing on censorship in* The Adjuster *your critique of the practices of the Ontario censorship board?*

Egoyan: Yes, this also refers to my own experiences of being censored as a journalist. It is not as extreme as it once was. After the film was made, *Tokyo Decadence* was banned. The censorship board is a fascinating organization, because there's this casualness about the way the board defended themselves. They had this idea that they existed because there was a need to defend certain social values. Though Toronto is a very liberal city, they're a provincial board, and they felt they had a wider mandate to defend the interest of a wider cross section, people who wouldn't go to art cinemas in Toronto.

In the early Eighties, when I was a student at the University of Toronto, we were experiencing the most vicious period of censorship. It was around the time that *The Tin Drum* was banned. I wrote an article about that for a student newspaper and met Mary Brown, who at the time was the head censor. She took me to this room and showed me what she called the shock reel. It was literally a reel that had all the scenes that had been cut and were then pasted together. Of course, this was designed to place the viewer in a state of shock. After the lights came on, she came into the theater, and said rather smugly, "And now you know what we do." That experience was so important because it was so absurd. At that moment, I wanted nothing more than to agree with her, because those were images that I would never want to see. But those images were completely out of context, and some of them were culled from films that I later saw in their complete versions.

Cineaste: *It would be absurd, for example, to evaluate* In the Realm of the Senses *only from the vantage point of the castration scene.*

Egoyan: Yes—or you could make similar points about *Salo*. That idea of context, and the way in which you see an image, are issues which are really important to me, and they are certainly ideas that become part of the narrative structure. I like to replay scenes, moments, or ideas from different viewpoints that challenge the viewer to question the authenticity, not only of where the material or where the images are sourced from, but also why those people need to express those views.

That takes us back to *The Sweet Hereafter*, where we have Mitchell Stephens, a character who is similar to the title character of *The Adjuster* in some ways. While Noah Render was completely numbed by his own lack of self-awareness, and is not particularly a bright man, Mitchell Stephens is a brilliant lawyer who is able to manipulate and to adapt his course, depending on whom he's confronted with. And yet, he's not a wise person. Unlike Nicole, Mitchell is just destined to repeat an immediately satisfying occupation—immersing himself in other people's grief, but without really understanding how to deal with, in the longer term, his profound sense of loss.

Cineaste: *The consistency of your work is remarkable. The deliberate blurring of Nicole and Alison is almost a throwback to the beginning of* Speaking Parts, *a film where the viewer has a great deal of difficulty in distinguishing the two female protagonists for about the first ten minutes.*

Egoyan: It's a problem that other filmmakers don't seem to run into as much as I do. But viewers do feel confused by similarities and parallels in my films. Any viewer is very sensitive to the attitudes that a filmmaker has when making an image. And because I'm so aware of the construct, image, and presentation of characters, and because there's something so delicate about that, people approach my characters with a degree of caution. In a film like *Speaking Parts*, which is so aggressively mystifying, you are quite untethered in making those decisions. You don't necessarily have anyone pointing you in one direction or another. That's what the film is about, ultimately, the fact that people resemble each other and have the ability to play certain roles based on their ability to remind someone of someone else.

It's always a matter of finding a form or texture which reflects the underlying psychology of what the film is about. In *Speaking Parts*, it was about substitution, projection, and people living with other people as images and being able to trade or barter those images. The film has to reflect that. So, almost by definition, it couldn't be an easy film to watch. It couldn't be a film where identification was made comfortable or simple. There are films that could deal with those issues, so that the viewer might be more immediately entertained. But the residual effect on the viewer's subconscious might not be as strong.

Cineaste: *There's a sense in which reality has caught up with what seemed to be the sci-fi premise of* Speaking Parts—*a world of constant surveillance and instantaneously accessible image banks. I recently heard about a college student who voluntarily subjects herself to twenty-four hour video surveillance through the Internet.*

Egoyan: One article I remember reading around that period involved a man whose parents had divorced. He wanted to show his son how happy his parents had been before they became divorced, so he brought his divorced parents together and recreated videotapes of their family life so he could show his son. It probably had an enduring effect on my sensibility.

Cineaste: *Surveillance is usually thought of as Orwellian, but in your early films the characters are quite complicit with their own surveillance.*

Egoyan: This is a way that the characters find out things. In *Family Viewing*, there's a real ambiguity about the role of technology. It's the means by which the father controls the family, but it's also ultimately the way in which the boy recovers his past. It's very easy to take a moralistic position and condemn these technologies, but the fact is that they are with us. It's a question of educating people how to use the technology, instead of demonizing technology or allowing it to become casual. It's important to understand how unusual those things are.

I've been editing this Yo-Yo Ma film, and I'm shocked that all this technology really does, despite the fact that it allows us to do something so much faster than it was ever possible to do with a Steenbeck, is make us more anxious. It's not as though we're using the extra time we're given to allow ourselves to rest or to reduce our stress. It's as though there's this lag between what the technology can provide and our own ability to absorb and understand it.

Cineaste: *At the risk of sounding simplistic, the ambivalence towards technology in theorists like McLuhan or filmmakers like David Cronenberg might lead one to think that this position is typically Canadian.*

Egoyan: As a culture, we are so completely overwhelmed by our access to American identity through technology. All of our major cities are no more than 200 miles from the border. From a very young age, we've all been bombarded with images of a culture that's not ours but seems to mirror certain aspects of our upbringing. But we're fundamentally different in many ways; in order to understand ourselves, we've had to understand our own relationship to these images which have completely crept into our cultural and social makeup.

Cineaste: *Your early films, particularly* Next of Kin *and* Family Viewing, *are about both national identity and ethnic identity.*

Egoyan: Right. I'm aware that I'm a person who came to this country from another culture and had to form an identity in order to think of myself as an assimilated Canadian. Even though I am very much a part of the mainstream fabric of English Canada, I'm aware of what I had to go through to become that way. That predisposes one to think of identity in a general sense as a construct. My suspicion about what it means to be natural has been an ongoing concern.

Cineaste: *In his recent memoir,* Black Dog of Fate, *the Armenian-American poet Peter Balakian observes that he was encouraged to become "more American than the Americans." As an Armenian who was encouraged to become totally assimilated, do you see any similarities to your own experience?*

Egoyan: That speaks very directly to me. My strongest experience in childhood probably comes from being settled in a town where we were the only

Armenian family there and then having to reconstruct myself as an English boy. And learning all those traits and absorbing them so completely that I was more English than the English, or thought I was.

Cineaste: Calendar *quite deliberately circled around Armenian history; the viewer has to fill in the blanks. You don't mention the Armenian genocide, for example.*

Egoyan: Yes, that was quite deliberate. It's a fundamental issue which I'm very nervous about treating casually. It's very interesting the response that some Armenians have towards *The Sweet Hereafter,* because they almost see it as being a clear metaphor for the genocide. That never even occurred to me when I considered my own attraction to the story. When I hear that, it seems almost obvious. But I was so thankful that this didn't occur to me while I was making the film or I would have analyzed it excessively.

The Armenian genocide hasn't just been repressed. It's this very curious type of denial where, in the face of so much openness about the nature of holocaust, the Armenians are in a curious position where the perpetrators have never really admitted it. There's a vagueness about the whole event. And, as it recedes more and more into our history, as the century has found other events to deal with, the necessity about determining what happened in Armenia at the turn of the century seems to be diminished. Yet, as an Armenian, its emotional consequences are still overwhelming.

Cineaste: *Your TV film,* Gross Misconduct, *has never been released here. The subject, a family's relationship with hockey, would appear to be quintessentially Canadian.*

Egoyan: That is one of the best Gothic stories to emerge from this country. It's an incredible, true story about this young boy from a small town in northern Canada, whose father always dreamed that he would be a hockey player and trained him with an incredible degree of violence—the father was quite psychotic. He hammered this obsession with hockey into the boy until he was finally invited to join the NHL. On the night he was playing his first big league game that was supposedly being broadcast across the country, the father in the small town turned on his TV only to find out that it wasn't being broadcast in the western part of the country. He flipped out, took a gun, drove to the local TV station and held it hostage, and demanded that they broadcast the game. At the very moment that his son was being interviewed between periods on each network, the RCMP ambushed the station and shot the father dead. It could never really make it to network TV in the U.S. because it's a fractured narrative.

Cineaste: *Although your films often deal with eroticism, you've avoided explicit sexuality.* Exotica *is, after all, about striptease. The desire to stimulate the viewer's imagination relates to what has been called the "interactive" nature of your films.*

Egoyan: It always surprises me that you can conceive of an erotic scene, but the moment you actually shoot it and construct it, it immediately reduces its ability to excite. And yet, what's interesting about *Exotica* is that it's interactive

in that you know the film is going to unfold in a certain way and you have to determine what you're feeling in response to what you know is inevitable. The film will continue to give out information and give out scenes and give out glimpses of these characters. That is much more attractive, in a way, than a situation where you are genuinely interactive, when you control the narrative.

That's what a lot of filmmakers had to contend with about ten years ago with the advent of the CD-ROM. It was thought that maybe this whole aspect of storytelling would become redundant now that we just need to think of drama as an interactive video game. It's not anywhere near as compelling as having to determine what your relationship to a predetermined story is. One of the results of having a child is that you realize that little human beings want stories. They want to imagine those stories in relationship to images they have as opposed to some controlling set of images.

Cineaste: *I read that you were quite taken with Cronenberg's* Videodrome. *Do you see any affinities between that film and your own work?*

Egoyan: I didn't think I was influenced by the film when it first came out. In fact, I had some problems with it. Looking back on the film now, I realize that it did have a tremendous influence on me. This notion of how we are encouraged to hallucinate and the idea that there are shadow worlds that exist in tandem with our reality was, for me, the most compelling aspect of *Videodrome*. It seems like a very simple film, but what it proposes is very shocking in a literal way. I think the difference between David's work and mine probably is that he gave up a certain formalism, much to his commercial success. His early films, *Crimes of the Future* and *Stereo*, are very esoteric, and he just turned away from that very early in his career. He realized that, if he was to continue making films at that time, he had to work within the horror genre. That gave him a certain freedom to take the conventions of that genre, and, of course, delusion is quite an accepted motif within horror films. *Videodrome* explored that in quite a strident and brilliant way. There were also other films which explored this, such as Godard's *Numero Deux*.

Cineaste: *Your admiration for hallucinatory narratives evokes an observation you made some years ago in which you claimed that "nothing is more artificial than mainstream realism."*

Egoyan: I don't know whether I would still agree with that. Mike Leigh has been one of the filmmakers who has really had an impact on me since I made that statement. I was on the jury at Cannes last year and found his use of realism in *Secrets & Lies* quite a devastating experience. Everyone makes images the way they need to make them. I would be foolish to say that there's nothing more artificial than mainstream realism—it's just artificial to me. I'm completely swayed by the sincerity of many images, which actually allows me to enjoy a film like *Private Parts*. In a perverse way, it's quite sincere. It's very arrogant to be prescriptive about how a film should be made, because one can always be surprised.

Cineaste: *There's an interesting contrast between your films and Leigh's character-driven movies. It's always been possible to offer thumbnail sketches of Leigh's characters, while you've always viewed the characters with a great deal of detachment.*

Egoyan: I've always felt that my own characters were in a place where they didn't quite understand what their own feelings were and what they had to contribute to any relationship. And, in a way, that's an enduring influence of my early exposure to the theater of the absurd, playwrights like Ionesco, Genet, and Pinter. They assumed that there was an inherent mystery in the meeting of any two people and that there is a whole nest of motivations and reasons that are completely belied by the casualness of that meeting. In my early films, I wallowed in that; that was a very exciting place for me to explore. I am naturally attracted to the grotesque and extremes of human behavior—the extent that people will go to convince themselves that something is normal, and the casualness with which people will embark on modes of behavior which, in any other context, would be quite aberrant.

In *Exotica*, for example, there's this man who goes to this sex club every night. There's something quite habitual about that, and he doesn't quite understand the damaging affect of this type of behavior merely because he's allowed himself unquestioned access to repetition. We think we've found a way of coping with our sense of grief, but, in fact, we've only distorted it; we're only reflecting it until we think that we've absorbed it. It doesn't cease to astonish me how I can show a film as intimate as *Calendar* and find that these images, which seem so hermetic and drawn from a seemingly unapproachable personal history, can make themselves public, and people can draw from it and find emotional sustenance.

I've always wanted to resist films which have the ability to make people think that what they're seeing is real. Maybe I'm grown out of that at this point. And certainly the challenge in *The Sweet Hereafter* was to create a very vivid sense of what this community was about and who these people were within a very unorthodox structure. It's completely nonlinear, but because you have a strong sense of who the people are and what the community is about and what the central event is, you have tremendous freedom to play with that structure.

Cineaste: *Of course, New Wave directors like Resnais also liked to fracture time. Was this stylistic choice an intuitive decision?*

Egoyan: There's no great design. For me, it's the most natural way of telling a story. I love weaving time, because I want to be surprised by the images I make. When I write in a linear way, it seems to detract from my desire to actually direct the film. There's not a lot left to discover when I feel that the story is unfolding from point A to point B. I don't have a problem watching those movies or reading those scripts. But when I'm asked to write or make that kind of film, I get very impatient. I find it more exciting when I'm not entirely sure what the alchemy of it all will be and I have to shoot those images and put them together and find out. There's an element of surprise, there's also a greater risk of failure. All of that drives me on.

Cineaste: *And the convoluted structure of a film like* Speaking Parts *satirizes how talk shows trivialize both historical and personal issues and transform them into entertainment.*

Egoyan: Yes, it's very prescient about what's happened to our culture since 1988. On shows like Jerry Springer's, there's this notion of the confessional, the staged moment where the truth is supposedly uncovered in public on television. All the work we do as dramatists to formulate a story seems to be obliterated by the way this type of communication has taken over our imagination. It bludgeons us into taking sides and seems to be the antithesis of what drama can do.

What's perverse about *Speaking Parts* is that the producer actually has a point. He's taken what is probably a very uninteresting and melodramatic script written by Clara and changes it into what may well be quite an innovative television program. Does that give him the right to take that story? And who has the responsibility to tell the story, and at what point does the own person's talent or vision weigh on their right to keep that story and to be the conveyor of it. That is a very provocative issue for me. In *Speaking Parts*, you have a premise which deals with helplessness—our society is divided into people who make images and people who watch images. Authority is granted to people when they have the ability to turn themselves into producers. Nicole succeeds in producing her own history by the end of *The Sweet Hereafter*. She takes the format of a talk show, where people are encouraged to tell the truth, and then subverts it. I was really inspired by her ability to reconstruct her own sense of experience.

It's more hallucinatory in *Speaking Parts*. When Clara appears at the talk show, we imagine that she shoots herself, or Lance imagines that she shoots herself. We're not quite sure who's inhabiting what role. That whole last reel is just a bombardment of various images and projections.

Cineaste: *Did you consciously avoid the shot/reverse shot pattern in your earlier films? You often followed a close-up with a moving camera shot.*

Egoyan: Coming from theater, I was very unsettled by the idea of manipulated time and the ease with which you could distort and break the moment of observation. What was powerful about a camera was the way it looked, and the moment you cut away from its look, you diminished the responsibility of the gaze. I was very consumed with that for the longest time. All of my earlier films continued to deal with characters who felt lost. I thought that the camera was the way to embody the look of that person as they watched the people they left behind. I was very attracted to long, unblinking shots where you would really feel the power of observation. I felt that cutting away would corrupt that. It might have been that, on a purely technical level, I didn't understand coverage. I didn't go to film school, no one had really explained it to me. No one ever told me what I was doing was wrong. But I certainly learned from some very obvious mistakes in film grammar that I made during the early shorts.

I feel that cinema syntax is based on images that we project in our own mind when we dream. This is probably the reason why we found a grammar for cinema so quickly, as opposed to the other arts, where it took centuries of evolution to find and determine notions of perspective. Cinema came really quickly, because I think we found an instrument that allowed us to conjure the way we dream. And, perhaps, in our unconscious state, we have an 180-degree line that we don't cross. And maybe we use master-shot coverage in our dreams. I guess we'll never really know that for sure. But it seems only natural that cinema, which has remained so unchanged since the beginning of the art form, conforms to something that we've all been watching for eons. And that's why a lot of those experiments of the New Wave, which tried to break those conventions, never really took hold.

Cineaste: *Since you're a cinephile, I suppose there's always a tension between film history and your personal vision. You once mentioned* Teorema *as a film that impressed you, and there are at least some superficial resemblances between the Pasolini film and* Next of Kin.

Egoyan: Yes. I'm taken with this idea of an interloper, somebody who finds their way into an environment where you wouldn't think they would be welcome, but where they find or make their own welcome and insinuate themselves. This theme recurs in *The Sweet Hereafter* as well; this lawyer comes into people's homes and makes himself indispensable. Where this comes from, or why, I'm not quite sure. As a child, I was always aware of going into other people's homes and seeing how friends from different backgrounds lived their lives. I also felt that I was intruding or coming into a situation that wasn't mine.

Cineaste: *Your work seems to have generated a certain amount of critical misunderstanding over the years. Some of your harshest critics, for example, failed to acknowledge the bleak humor of those early films, didn't they?*

Egoyan: If you don't see the humor, you're not going to enjoy the films at all. I noticed this with *Family Viewing* especially. The way I can test an audience is the scene in the nursing home when the father makes a mistake about which grandmother he's giving the flowers to. There are people who take that moment really seriously, and I never quite know what they can make of the rest of the film. There's an obliviousness that the characters have to the consequences of their actions which is very funny.

Cineaste: *The early films were considered "cold" by certain critics and viewers.*

Egoyan: It has continued to an extent with *The Sweet Hereafter,* but less so. I just find it really odd, because, for me, a film like *Speaking Parts* is operatic! You cannot get warm and cuddly with the films. That's maybe what people are talking about; they can't simply sit back and have a story told to them and identify and lose themselves. They have to be always aware of their position and their relationship to these images. There are people who will even see this

new film, and given what the subject matter is, find it distant and not really understand that, if it wasn't distanced, it'd be a TV movie! The more classical way to shoot this is to be right up there, *with* them, whatever that means. I'm always be aware of certain things: Why am I shooting this? What is it about this story that needs to be shown? What am I hoping to achieve by depicting these people? If that means that I'm a formalist, fine. Formalism is a concern with the process of depiction and that informs every gesture I'll ever make in movies.

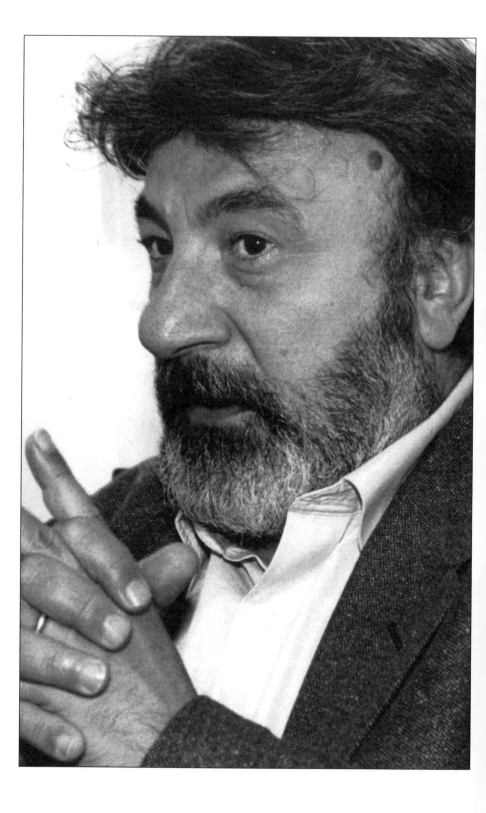

18 GIANNI AMELIO

Beyond Neorealism:
Preserving a Cinema of Social Conscience

*Although much of the Italian director Gianni Amelio's work, primarily films commissioned by Italian television, has not been screened in the United States, the four features to which American filmgoers have had access—*Blow to the Heart *(1982),* Open Doors *(1990),* Stolen Children *(1992), and* Lamerica *(1994)— provide indisputable evidence that he is a figure who deserves more critical and popular attention. Amelio's films display a rare combination of political acumen and psychological acuity. His first two features were inspired reinventions of the political thriller, while the most recent theatrical releases abandon tight narratives for a looser, picaresque style. All of Amelio's films, however, are distinguished by brilliant performances by actors such as Jean-Louis Trintignant, Gian Maria Volonté, and Enrico Lo Verso and are noteworthy for a compassionate engagement with social and political issues that never degenerates into strained didacticism. Cineaste editors Gary Crowdus and Richard Porton interviewed Gianni Amelio during the American premiere of* Lamerica *at the 1995 New York Film Festival, and later caught up with him for some follow-up questions at Manhattan's Italian Cultural Institute. Barbara Nonas provided simultaneous translation.*

Cineaste: *You've said that* Lamerica *is not so much a film about Albania as it is a film about Italy.*

Gianni Amelio: It's a film about two Italies, really—the Italy of my father and the Italy of today in which I live. My father's Italy was poor but full of hope. Today my Italy is very cynical and arid. These two Italies could only meet in a neutral territory, a foreign country. In my film, two businessmen, who represent the new Italy, meet the old Italy in Albania, which is the neutral territory. I chose a country like Albania because I believe Albania today is like Italy used to be. Historically, Italy and Albania are very close and, in a way, Italy has invaded Albania twice—militarily in 1939 and today, or more recently, by television.

I have to explain the presence of Italian television in Albania. Until the death of the dictator, Enver Hoxha, Albania was completely cut off from the rest of the world. They couldn't even listen to the radio. After Hoxha died in 1985 his successor extended some liberties to the people, including making it possible to see TV broadcasts from nearby countries such as Italy which is seventy miles from Albania. Although Italy is very close to Albania geographically, in terms of their cultures the two nations are as far apart as Italy was from the United States fifty years ago.

Cineaste: *Is the archival footage of the 1939 Italian invasion seen under the opening credits intended to suggest a link between Italy's experience under Mussolini and Albania's experience under Hoxha?*

Amelio: You could say that there's a subtle analogy, but maybe it's also very obvious. At one point, for example, the two main characters, Spiro and Gino, are sitting at the base of a mountain with "Enver Hoxha" written on the side. The old man, Spiro, asks Gino what's written there, then, thinking he's figured it out for himself, he says, "Oh, I know what's written there— Mussolini." I don't want to say that the Mussolini and Hoxha regimes were the same—they were very different—but both were totalitarian regimes. Whether it's Spiro, the old man who came out of fascism, or the Albanian people who are emerging from a communist dictatorship, they are both looking to find something different.

Cineaste: *So in a way the film serves to revive the historical memory of fascism in Italy through the experience of Stalinism in Albania.*

Amelio: Actually, I want Italians and any one else who sees this film to remember something simpler but deeper and more important. In fact, if I were to explain the meaning of the film, I would say it is the ability to understand the importance of a piece of bread, which is a theme repeated throughout the film. I think that the memory of history is important to all of us—not to remember the date of a battle, let's say, but to remember who we were, to understand who we are today and where we're going. A person who was hungry once will always be able to understand the feelings of someone who's hungry today.

Cineaste: *In that regard Italians were probably very shocked by news*

reports on the condition of the Albanian emigres arriving on their shores because they had forgotten what poverty was like. How did Italy deal with this unexpected flood of refugees?

Amelio: It was a real problem because Italy didn't have any laws about immigration. In fact, only about ten years ago, for the first time since WWII, did we begin to see people in Italy who have dark skin.

Cineaste: *From Morocco...*

Amelio: From Morocco, Senegal, all of Africa and then, following the collapse of communism, from countries throughout Eastern Europe. In 1991, when two Albanian ships arrived carrying 20,000 refugees each, nothing like that had ever happened in Italy before. When 20,000 refugees all of a sudden arrive in a city of 100,000 people, that creates a big problem. Italians were shocked, of course, and even people who saw these events on TV felt a profound sense of shock and tremendous sympathy for the Albanians. People began to ask what the government was going to do about this situation.

What do you do with 20,000 people who have suddenly arrived? Where are they going to live? Where are they going to work? So at that point there was a—I don't know how to describe it—a strange sense of anguish because all these people were being held in a big soccer stadium while decisions were being made. Some of them escaped because they felt like they were in prison. Unbelievable things happened. The next day, for instance, twelve Albanians were killed trying to cross a highway. Until 1985 there weren't any private cars in Albania, so they didn't know you couldn't cross the highway because cars would be coming. They had only seen Italy on television, so they were shocked by the reality on arriving in the country.

After about a week or so, most of these people were sent back to Albania under an agreement that Italy would provide them with economic assistance. In fact, Italy sent military contingents to Albania to distribute food, clothing, and other basic necessities. What was very unusual was that no Italian soldier sent to Albania was allowed to walk in the streets with any kind of weapons and, after a certain point, they were prohibited from appearing in the streets at all in order to avoid giving any impression of a military invasion.

Cineaste: *How extensive is the situation that the film portrays with two Italian con artists arriving in Albania to set up a phony business?*

Amelio: Before 1991 or 1992, Albania was a no-man's land and, in a situation like that, there's always someone trying to make a profit out of it. I made a film about Italians going to Albania, but a lot of others—Germans, Swiss, and so on—went there as well. Some went to set up real businesses, while others went to set up phony corporations. To establish a legitimate business, you need laws and cooperation between the governments. As an Italian, I cannot go into Albania and set up a factory unless there is an agreement between the Italian and Albanian governments. But it's during a period when there aren't any laws that scoundrels like those in the film arrive. The older businessman, Fiore, talks about a similar situation he'd set up in Nigeria. The one thing all these

business people have in common, though, is that they only care about making money. They're like vultures, they don't care about people.

Cineaste: *Of the two business partners, Gino seems somewhat more sympathetic, perhaps because he's obviously the junior partner and doesn't seem quite as mendacious as Fiore.*

Amelio: Yes, Fiore is definitely more dangerous because he's older, he'd done this before, and he has more experience. What's scary is that he can appear to be a good person. When he gives a speech to the workers in the factory, for instance, what he's saying seems so wise and good, but actually he's just a big liar. The younger character, Gino, is really guilty only of being ignorant. He's about twenty-five or twenty-six years old, so he grew up in an Italy where he never experienced any of these problems.

In one scene, he sees graffiti on a wall which says, "Twenty-five years of socialism!," and he makes a stupid comment to the old man, Spiro, asking, "What did you have here—socialism or communism?" That's because in Italy there are two different parties, the Socialist Party and the Communist Party, so the question just reveals his ignorance. Although Gino is the one who yells and appears like a racist, at the end of the film he's the one who undergoes a transformation and changes. Fiore, had he gone through the same experience, never would have changed.

Cineaste: *Once Gino realizes that Spiro is also a Sicilian, he seems more sympathetic, and we as viewers become more sympathtic to him as well.*

Amelio: Yes, you could say that Spiro gives Gino an idea of Italy of the past, an identification of where he comes from, as well as an opportunity to understand the Albanians. He realizes that the Albanians of today are like his father. He loses everything—his money, his car, his clothes, his passport—and he becomes an Albanian. It's bizarre to think that on this boat full of Albanians going to Italy there are two Italians.

Cineaste: *How did you conceptualize that final sequence on the boat? The montage of the various faces of the passengers is very impressive.*

Amelio: In that scene and throughout the film I was trying to show in the relations between the Italians and the Albanians that, in a symbolic sense, we're all Albanians. Even if today Gino is rich and can live the way he wants, he can't forget that at some point he could become destitute and need help. It doesn't take much. All you have to do is lose your car, your clothes, and you, too, can become destitute. Gino is overwhelmed at the end when he says, "How can I live without a passport?," and the Albanian official responds, "But none of us have passports."

Cineaste: *Would you talk a bit about the experience of working with the nonprofessional actor who portrays Spiro—including why you chose him–and the differences or similarities between that experience and that of working with the children nonprofessional actors in* Stolen Children?

Amelio: I wanted specifically to work with a nonprofessional actor because he's a character who changes his identity during the course of the movie and I

didn't want him to be portrayed by someone the audience could identify.

Cineaste: *But wouldn't an Italian audience be able to recognize his Italian accent?*

Amelio: No, because he's not an actor. Besides, in the beginning he doesn't speak. Other people talk to him in Albanian and he understands and replies in Albanian. For an Italian audience, it is a surprise the first time he speaks Italian, which isn't until about forty minutes into the film.

I also went to the South of Italy to find a nonprofessional because I wanted someone with a southern accent. That way, when he finally speaks Italian, he would have the same accent as Gino, who would discover that this old man is also from Sicily. I met and chose Carmelo very quickly. I didn't audition a lot of other nonprofessionals before I met him, so it wasn't a very difficult task. I was very anxious, however, about the work we would be able to do together. I consoled myself somewhat with the knowledge that old people in front of a movie camera become innocent like children. Children are less innocent than old people but they're more used to playing games, whereas old people are a little bit embarrassed about playing.

In *Stolen Children* I would ask the little boy sometimes to do certain things and he would say, "No." So I would say, "OK, what do you want?," and he would say, "I want chocolate" or "I want a soda." In that respect, I had to bribe him. With the old man it was a whole different ball game. One day he was having a lot of difficulty doing a scene. He kept having to do it over and over again before I finally found out that the problem was that he had to go to the bathroom but was too embarrassed to say anything. The problem of working with a nonprofessional actor is to try to create some kind of rapport between you, and once you have that you can move forward. But you can never, ever give a script to a nonprofessional actor to read.

Cineaste: *How was the film received in Italy?*

Amelio: It's been well received, although with a certain amount of embarrassment. My previous films had positive characters and a very clear message, showing someone doing the right thing, as in *Open Doors* or *Stolen Children*. This film was received in a similar way to an earlier film of mine, *A Blow to the Heart*, which was accompanied by some controversy. The characters in both these films have both dark and light sides, with maybe a bit more emphasis on the darker side, so it was harder for viewers to identify with the characters. It's very difficult for Italians to identify with the two businessmen in *Lamerica*. It's easier for them to identity with Spiro, the older character, because he's more of a symbol. But because he's more of a symbol than an actual person you can relate to, he remains somewhat distant from the audience.

Cineaste: *Although* Open Doors *is a historical film, did you intend its debate about capital punishment to have contemporary relevance?*

Amelio: Nobody makes a period film without thinking that the film's argument is relevant. I wasn't making a film about the death penalty in Italy, though, because it doesn't exist anymore. I wanted to make a film in general

about the idea of tolerance. I'd like to point out that many films have been made about the death penalty, especially in America, but in all of those films the concept is the following...

Cineaste: *He's innocent.*

Amelio: Yes. We can't give him the death penalty because maybe he's innocent. I made a film for the first time about the death penalty in which the protagonist did kill somebody–three people, in this case–who admits to having done it, who has no remorse, and who says, "If you let me go, I'll do it again." People find this very difficult to accept but what I wanted to emphasize is the principle of having respect for human life. It's not a question of whether or not a person is guilty or innocent, it's the idea that I, as a human being, don't have the right to put to death another human being. In other words, if I kill an assassin, a murderer, I also become a murderer, even if it's legal. This is a very difficult concept for most people to accept.

Cineaste: *How did you go about adapting the Leonardo Sciascia story?*

Amelio: It was a very interesting voyage that I took in adapting it. The events actually took place. They were written up in newspapers and Sciascia gathered all the clippings and created this pamphlet. The story focuses on the conscience of the judge who is part of a jury that must decide what's going to happen with the defendant. From the very beginning until the end, the judge is against the death penalty and he never has any doubts about it. For the film I took a slightly different course because I wanted to show what even an enlightened judge would have to go through to make this difficult decision. Towards the end, in fact, the judge almost gives up the battle. At one point, he puts his hand over his mouth, as if to say, "I can't deal with this anymore." What happens then is that a jury member, not a professional judge, takes over and continues the battle. In my film, it's the juror who says, "We must continue to fight this," and who ends up saving the man, although later, after an appeal of the decision, he is eventually executed.

What I wanted to say in the film is that it's not just about law, it's also about conscience. It's not just law that has to exist, but the conscience of law written into every citizen, so that law is something that exists if we as individuals feel that it's necessary. The idea of being against the death penalty must come from each one of us.

Cineaste: *Your adaptation involved some other interesting changes from the Sciascia story. In Sciascia's version, the juror is more of an intellectual and in the film he's a farmer.*

Amelio: All of the characters in the film are different from Sciascia. In the film the judge's father is a baker, so he comes from a very low social class, whereas in the Sciascia story he's a landowner of refined culture—he knows French, he's traveled. In the film he's a farmer who almost by a miracle finds himself in possession of this incredible library. He starts reading the books, which is how he comes to read Dostoyevsky.

Another thing that's very different in my film is the prominence of the

assassin, the accused, whose personality I reveal in great detail. He does have his own sense of passion and of humanity about certain issues.

Cineaste: *He's a committed fascist.*

Amelio: I also emphasize his crude and evil side. I wanted to show someone who was a monster because I wanted to emphasize just how difficult this whole idea about whether or not to condemn someone to death was.

Cineaste: *Why did you make the changes in the class origins of the judge and the juror?*

Amelio: I think these are somewhat unconscious decisions, because I don't necessarily do it on purpose, but what happens is that I end up making the characters as close to what I know, or as close to myself, as possible. I'm from a background even lower than working class because my father was unemployed and had to leave Italy in order to find work.

The more conscious choices involved making the judge someone who risks everything that he has in order to make this decision. I though it made for a much stronger argument to focus on someone who really worked hard to get where he is. The judge's family in the story is not in the film. I wanted to show the judge as probably the only person in his family who was able to go to school, who had come from a low place in society to become a judge, and therefore what a risk this effort entailed for him.

Cineaste: *The juror, on the other hand, seems to function as a contrast to the courtroom audience and the mobs of people shown demonstrating for the defendant's death.*

Amelio: A person is able to distinguish themselves from the crowd only if they have some kind of education, some kind of culture. So the only difference between the juror and all the people yelling in the streets is that the juror has read books. Another difference in this character between book and film is that in the Sciascia story the juror is guided by the church commandment that "Thou shalt not kill," and this is never said in my film. Instead of referring to the Catholic Church, the film refers to the Dostoyevsky book which describes the horror of execution, of actually seeing somebody's head cut off. I didn't want the film to suggest that only religious people who believe in the commandments won't kill, but everyone else might. I didn't want it to have anything to do with religion, I wanted it to have to do with humanity.

Cineaste: *What was it like to work with Gian Maria Volonté?*

Amelio: He was like a coauthor of the film. It was very different working with him than with most other actors. He really challenges himself in the way that he gets involved in his role and the overall production. There are a few other actors who do this, like Robert De Niro, who become thoroughly involved in their work, whereas many actors just leave this work to the director. Volonté had to achieve a total identification with the character, for example, both his good and bad sides, and that caused him a lot of pain. He took on the personality of the character so intensely that it was almost as if he were putting himself in prison.

During the production of the film, for example—and this was very characteristic of Volonté—he lived in a hotel but he never left it and he never even opened the window of his room. During production he didn't go out at night, he didn't meet with other people, and he didn't even want to socialize with anyone who played an enemy of his in the film. He remained like that throughout the shooting of the film so that, in essence, he wouldn't get out of character at any time.

Cineaste: *Did he develop backstory on his character?*

Amelio: I always do this when I work with actors but in this case we worked on it together. I spend a lot of time with actors retracing or creating the biography of their characters including everything that happened to them before the film's story actually begins.

Cineaste: *It's not quite clear whether or not judge Di Francesco is antifascist. There's an interesting encounter in a café between him and the juror during which the latter refers to the "difficult times" they're living through and Volonté challenges him by asking, "What do you mean by 'difficult times'?"*

Amelio: He's afraid the juror may be a spy. The story is set in a very specific historical period of fascism so when the juror refers to the difficult times they're living in, that's an expression that could have a variety of meanings including this could be someone who's trying to entrap you.

Cineaste: *Although the film depicts quite a bit of violence by the murderer, Tommasso, your cinematic portrayal of that violence is quite restrained. The rape, for example, is filmed in a long shot.*

Amelio: I find scenes of violence very difficult to do. I get very embarrassed when filming such scenes, although I know that violence exists and every once in a while it has to be shown. I wanted the film to include this type of violence which doesn't exist in the Sciascia story because I really wanted the killer to be repulsive to people. I felt it was possible to show this and to convey the horror of the scene in a long shot, however, and not necessary for the viewer to be right on top of it.

Cineaste: *Some of the violence occurs off-screen.*

Amelio: I think showing his actions afterwards—he goes home, goes to the bathroom, then lies down on his bed—is even more horrible than showing the details of the killings.

Cineaste: *We understand that* Stolen Children *was inspired by an actual news event, but what was the relationship between that incident and your screenplay adaptation?*

Amelio: An event like that happens every day in Italy and probably a hundred similar events happen every day in the United States. But what happened was really just a departure point for me. The first part of the film is shot almost as if it's a TV movie, showing an incident that really happened but it's only after the title credits and the filming changes that my story begins.

Cineaste: *Many of the film's scenes rely on shots which focus on faces, which explore the emotional geography of the human face, such as the opening shot of*

the little boy's expression, or the marvelous scene later in the film, after the
Carabinieri has apprehended the robber and he's being interviewed by a superior.
You use a slow tracking shot into Lo Verso's face throughout the interview and
the viewer can trace the character's shifting emotions as he's unexpectedly humil-
iated and then realizes he's in trouble. Lo Verso is a terrific actor and you use the
camera in that scene, as you've previously described it, "like a pitiless machine
which X-rays the actor's mind."

Amelio: I agree completely with you. I feel at the height of my directorial
powers when I am filming just one person's face and can see the battle that
they're undergoing just by looking at their face. That's when I feel like Cecil B.
de Mille, who directed big battle scenes and a cast of thousands, but I need to
see only one face and the emotional battle that it is going through.

Cineaste: *Over the years, many Italians have made the journey from the*
South to the North, but in this film we have a journey from the North to the
South. Was that a conscious strategy?

Amelio: Nowadays the immigration from the South to the North, à la Rocco
and His Brothers, doesn't take place anymore. Today these sons of Rocco have to
return to the South because of the economic situation but when they return they
don't recognize it. Sometimes they think maybe they should go back and try to
live there but they immediately realize that their life really isn't there anymore.
A major conclusion of *Stolen Children*–although perhaps a conclusion the char-
acters themselves don't realize—is that there really isn't a difference anymore
between the South and the North, that everyone is the same today, and that ugly
things happen everywhere. I'm very curious, by the way, to see the American
remake of the film.

Cineaste: *A remake? We didn't know one was planned.*

Amelio: Universal is going to do it. The script is ready.

Cineaste: *Who's going to direct it?*

Amelio: I know who it is, but I can't say.

Cineaste: *Well, God help you, sir! By the way, how much criticism are we to*
understand from the scene where the children are rejected by the Catholic insti-
tution. It seems a remarkably un-Christian attitude.

Amelio: In my films I don't make underlying criticisms of institutions—
that's too Manichaean—it's just that people make mistakes and then other
people have to live with these mistakes but I'm not making generalized criti-
cisms. Above all, in *Stolen Children*, the characters are extremely complex. The
title in Italian, by the way, actually translates as "The Thief of Children," but the
thief is a policeman, so there are a lot of contradictions in the characters.

Cineaste: *Some critics, in writing about the film, drew parallels between it*
and neorealist works, particularly because of its use of children, but we see both
similarities and differences to traditional neorealism.

Amelio: A discussion of neorealism cannot be simplified. First of all, neo-
realism belongs to a very specific time in history and the classic period of
neorealism extended from the end of the war to the beginning of the Fifties.

When we talk about neorealism, three directors are always cited–De Sica, Rossellini, and Visconti–but personally speaking I don't know any directors who are more different than these three. Yet all of them have made so-called neo-realist films, so which one is the real neorealist? Is *Miracle in Milan* neorealist or not? Everyone has their own opinion. Beyond that, is Fellini a neorealist?

So I think that to say that *Stolen Children* is a neorealist film doesn't apply. What is clear is that I am a son of neorealism. As an Italian who grew up watching those movies, I've been influenced by them and they have affected my work.

Cineaste: *In a sense, it's almost unfair to try to directly connect every contemporary Italian filmmaker to that historical movement. With that in mind, would you tell us a bit about your own artistic and political formation?*

Amelio: What I'm going to say is very bizarre, very unusual. When I was growing up as a kid, I saw only American movies, and if there's anything that influenced me to become a filmmaker, it was American movies. This was inevitable because American cinema has been the most influential in Europe, as it is today. The Italian public never went to see neorealist movies, by the way, and the only reason they even know they exist is because scholars have defined that period.

During my most formative years, during the Sixties, when Italian cinema was something other than neorealism, if I had to say which Italian director influenced me the most, I would have to say Antonioni. He influenced not only me, but everyone really, including the filmmakers of the French New Wave. *Il Grido* influenced many future filmmakers. Antonioni's films stimulated all of us to study film, to examine its language.

Cineaste: *The use of empty spaces in* Stolen Children *is very much like Antonioni.*

Amelio: Absolutely. In *Stolen Children* there are some very explicit references to Antonioni, like the ending. I went to film in this place in Sicily called Noto because I learned about it from his films. When I was filming *Stolen Children,* I would tell everyone on the crew, "Monica Vitti walked here" and "Antonioni put the camera here."

Now that I'm older, I have also come to appreciate other films from the past, so if you ask me today which other Italian filmmaker has influenced me a lot, I would say De Sica. I never saw any of his movies when they were actually coming out because I wasn't old enough to see them, so I didn't really know about De Sica until much later.

Cineaste: *Would you tell us about your political formation?*

Amelio: That is also very complex. When you hear 'Italian Communist Party,' you probably think of something very different than what it actually is. I don't know how knowledgeable you are about the Italian political left. You might describe the PCI as a radical political party which wants to change the present system of power in order to create something better for people. At the end of the war, after fascism, we had democracy and free elections and all the things which

weren't possible before. But for forty years we had a government that was entrenched and practically immovable because everyone was so intertwined there was really no way of creating change. People had their positions and were never removed. In this context, the Italian left was the most important force that tried to battle this regime.

I come from a very difficult social background—as I explained, one even lower than a working class background—and I'm also from the South, which makes me even more underdeveloped, and because of this background I've always aligned myself with the left wing. The left has been very important culturally and intellectually. It's hard to find any Italian intellectuals in the last fifty years who've come from the right.

Cineaste: *When you were younger were you more involved with Il Manifesto [a breakaway faction from the Communist Party during the Seventies which espoused an anti-Stalinist position]?*

Amelio: I'm very far from them today—sometimes I don't even understand them—but in the Seventies that was the newspaper I bought and that was more my position.

Cineaste: *Speaking of the Seventies, is it true that* A Blow to the Heart *was inspired by the Toni Negri case?*

Amelio: The subject was in the air, it was inspired by the climate of Italy at that time. There wasn't only terrorism, there was a neurotic obsession with terrorism, a demonization of terrorism, which was a very big mistake, I believe, even politically. Since terrorism was being demonized, no one understood the reasons behind it, and there were actually very concrete reasons why it was taking place. If people had only looked at those reasons, it would have been understood. *A Blow to the Heart* talks not about terrorism but about the obsession with terrorism itself. In the movie, the son denounces his own father, who probably isn't even a terrorist.

Cineaste: *You have collaborated with different screenwriters on each of your films. Would you describe the nature of your work on the screenplays?*

Amelio: I choose the story, the subject matter, of my films, and I personally write a lot. When I choose collaborators, it's a question of discussing with them the subject that I've chosen. And when I change screenwriters, it's not as if I've put all my faith in this new person. I'm just looking for a new person I can exchange ideas with. I have a good rapport with screenwriters but a very conflicted relationship with the screenplay itself because, for me, the screenplay is just a series of notes about how to make the movie. In that sense, the script is much more useful for the producer who needs to make all the plans. It also provides a reference point for everyone who's involved in making the film so they can calmly go about their work.

I usually write the scripts quickly, in a very short period of time. Then I let myself be very free in terms of changing my mind, of changing the script while I'm making the movie. In fact, I usually change almost everything that I've written. For example, I almost completely rewrote the screenplay of *Stolen*

Children with my assistant during the shooting. And all the dialog was written during the shooting.

The experience was different for *Lamerica*. We had a very specific screenplay but one of the screenwriters, who paid very close attention to the daily shooting, would rewrite the script with me every day. I like to have someone right next to me with whom I can discuss the subject throughout the entire shooting of the film.

Cineaste: *You also do a lot of improvisation on the set, don't you?*

Amelio: Yes, I shoot a lot that is improvised but you can only do that if the script has been thoroughly prepared first. I would be unable to go to the set completely unprepared, with nothing. So I prepare very well and I have something with me when I arrive but then I often change it. A lot of times, for instance, I change the dialog between one shot and the next. That's why I like very much to work with actors who are able to improvise.

Cineaste: *Music is used quite sparingly in your films. What is your approach to music in the cinema?*

Amelio: I've been collaborating with the same composer, Franco Piersanti, for more than ten years. We share the same ideas about music in films and every time we make a film we search together for solutions. I don't want the music to 'comment' on the images, I want the music and the images to be created at the same time, to be born together. I think that music is so important in films that it's also important to know when not to use it. In my first film I didn't use any music but I think it's a very musical film because to me the sound and noises in a film are music.

Cineaste: *What are the greatest needs of the Italian film industry today? Do you believe the government should play a greater role in supporting Italian film production?*

Amelio: Yes, I think it's important that the state help in a country like Italy, especially by helping young people make their first films. But the film industry doesn't need charity, above all it needs a strategy that would enable people to know, to love, and to understand movies. Italy knows how to produce films but they still haven't figured out how to encourage the public to see them. The real problem is distribution and exhibition in theaters. There should be more support for showing national cinema.

There are many ways the state could regulate this—not by impeding or prohibiting the import of foreign films into Italy, that would be stupid and ridiculous–but, to give just one example, by putting a tax on the dubbing of foreign films, or by lowering the tax for someone who's making a film in Italy in the Italian language, or by lowering the tax on a movie theater that shows Italian movies instead of always showing foreign movies. We've been waiting twenty-five years for new laws for the film industry because the Italian government is much more interested in the future of television than the future of the cinema. After all, it's much easier for them to use television than the cinema for power and propaganda.

Cineaste: *Do you think the cinema can play a role in social and political change?*

Amelio: The cinema plays a role in every part of life but a political message shouldn't be the reason to make a good film. The problem for all of us, as film-makers, is not the argument, it's the language. If you don't work on your cinematic language, you can make a politically correct movie that is at the same time a bad movie.

Cineaste: *So the film grammar must be there, no matter what the message is.*

Amelio: Yes, but I think a bad message—that is, a Manichaean or propaganda message–will always be delivered badly.

Cineaste: *How do you try to avoid being ponderous or didactic with your 'messages?'*

Amelio: I try to be honest, to not cheat myself or others.

19 MARLENE GORRIS

The Lighter Side of Feminism

Dutch writer-director Marlene Gorris made a lasting impact on feminist filmmaking with her first film, A Question of Silence *(1982). Three women, strangers to one another, are arrested for brutally murdering the male proprietor of a women's clothing shop. Pending trial, the court assigns a woman psychiatrist to assess the defendants' mental states. Her probing reveals a pervasive climate of demeaning sexism not only in the defendants' lives but also in her own— perhaps not a justification for murder, but certainly the precondition for the silent rage that impelled it. She throws the trial into turmoil by asserting the murderers' sanity.*

At once tendentious and ambiguous, A Question of Silence *marked an unsur-passed level of militancy in an era of feminist filmmaking that included works by Helke Sander, Chantal Akerman, Sally Potter, Valie Export, and Lizzie Borden, among many others. "The power of* A Question of Silence *as feminist art," wrote critic Linda Williams, "lies in its resistance of all the male paradigms by which female deviance has been understood, in its insistence on the wildness of women's cultural experience, and, finally, in its refusal to narrate the positive, utopian identity of women."*

Gorris's second film, Broken Mirrors *(1984), is considered by some feminist critics even more radical, with its parallel narratives of women working in a brothel and of a male serial killer starving a woman to death. When Gorris's third Dutch-language feature,* Antonia's Line, *had its world premiere at the 1995 Toronto International Film Festival, spectators wondered what effect a decade's changes in feminism—as well as new economic and social conditions for European filmmaking—might have on her work. They encountered a film that maintains continuity with Gorris's earlier militant feminism, yet which offers something strikingly different from* A Question of Silence—*what Linda Williams called "the positive, utopian identity of women."*

Antonia's Line *opens with the impending death in old age of the film's title character, then shifts back in time to the end of World War II to retrace her personal history through the entire postwar era. Antonia, portrayed by leading Dutch actress Willeke Van Ammelrooy, returns in 1945 with her teenage daughter*

Danielle to the village where her own mother is dying. She decides to remain, and her "line"—the trajectory of her life as well as the living community she constructs around her—takes form (the film's original Dutch title is simply Antonia*). The film's narrative displays the growth of her extended family and the emergence of new generations over the village seasons, including her and Danielle's friends and lovers, a grandchild, and then a great-grandchild, who turns out to be the film's narrative voice.*

Warmer and lighter than Gorris's first two films, yet still with a strong feminist backbone, Antonia's Line *became an enormous hit among festival audiences before opening theatrically in North America early in 1996, winning, among other prizes, the Audience Award at Toronto, Best Screenplay at Chicago, and Best Director at the Hamptons International Film Festival. Marlene Gorris spoke with* Cineaste *Contributing Editor Robert Sklar during the last-named event in East Hampton, New York.*

Cineaste: *Audiences, both men and women, seem to be changing their attitude toward feminist film. As a feminist filmmaker, how do you think about these changes?*

Marlene Gorris: When I made my first film, *A Question of Silence*, feminism was very much a living issue. I think one of the reasons I could make *A Question of Silence* was that everybody was so inclined. They believed that those issues should be brought to notice. The same goes for my second film, *Broken Mirrors*. But then, round about 1985, the tide began to turn. As I heard somebody observe this morning on television, feminism became the last "F-word" in American culture. There has been a backlash for the last ten years. The media have been having a field day with anything feminist, denigrating it left, right, and center. However, I have the feeling that over the past few years, maybe even the last year, things have been changing again. Calling yourself a feminist or making a feminist movie is not something to be hidden.

Cineaste: *Were you thinking about how you were going to reach women spectators, or both men and women, as you were making* Antonia's Line?

Gorris: When I'm writing I don't usually think very much about the effect of what I'm writing. Of course, I try to judge the effect I think it would have on whomever sees it. I've never been very fond of saying that films should be for this or that particular target group. I think it's actually a mistake for any film to want to belong to a particular target group, or only one. What's most important to me is that I make a film that I want to make. Hopefully it connects with other people's ideas or wishes, whether male or female.

Cineaste: *Why did you want to make this particular film in this particular way?*

Gorris: I've been wondering about that, because the question's come up, of course. I wrote this film about six or seven years ago, so that's quite a long time ago. It took all that time to get the money together, which in Europe is quite difficult—anywhere it's quite difficult. We finally got it together in a coproduction

with England and Belgium. But as a result I very often can't recall what exactly were the reasons for me to do something in a particular way or not to do it in another way. Sometimes, in retrospect, things get clearer, but sometimes they don't.

I think, after having made three films which were very much concerned with what you might call the dark side of living, and the dark side of the feminist issue, and the dark side of the combination men/women and the relationship men/women, I was now ready to look at the lighter side of relationships. Especially those having to do with love, and maybe with more of a *laissez faire, laissez allez* attitude. Especially with more humor and more tongue in cheek. Tongue in cheek has been quite important in this particular film. It's whatever you want to call it—a fable, or a bit of a myth, or a fairy tale. They're not exactly lifelike people, but wouldn't it be nice if they were lifelike? That's of course where the tongue in cheek comes in. I loved playing around with people's percep-tions of things—like when Danielle wants a child, she's not going to look for a husband, she's going to look for somebody who can make her pregnant. That happens to be the knight on the white charger, and then they go to a castle, but the castle is a hotel—things like that. I played around with things in this film, and it was very enjoyable, I must say.

Cineaste: *Did you have, from the beginning, the idea of Danielle's visionary aspect, such as when she has the vision of her grandmother rising out of her coffin, or of the winged statue striking out to hit the priest?*

Gorris: Yes. Danielle is a very introverted person. She doesn't speak very much. Yet I wanted to get her across, to begin with, as an interesting character, but also somebody with a sense of humor. How do you get that across if the char-acter doesn't speak very much and doesn't do very much? Danielle very often lets her mother do things. Antonia is the active person, and Danielle is into her painting. So one way to brighten her character was to give her a very strong imaginary life in which she could make things move.

Cineaste: *Did you grow up or experience life in a village such as the one in the film?*

Gorris: Well, not such as that, of course, because it is imagination. But I did grow up in a village, and I don't think anybody who grew up in a city could write a script like this. It is not based on personal experience, but when you're a grownup and you look back at your childhood, then certain things crop up and stand out. Those were the things that I used for this film. That doesn't mean that it's autobiographical. It isn't in the least. Whenever you write a script, you take yourself along with it. You figure in it, and I want to figure as little as possible in it, but my fingerprint remains.

Cineaste: *Did you have any filmmaking models in mind? There were moments in* Antonia's Line *that appeared as if they could belong in a Fellini film.*

Gorris: No, absolutely not. This may sound strange, but as far as that's concerned, I don't have any role models. But a name that comes up often in discussions of my films is Ingmar Bergman. Bergman was mentioned for my

first film, *A Question of Silence*, and I think for *Broken Mirrors* as well, and now again for *Antonia's Line*, but I never think of Bergman. I admire some of his films. I think he's a great filmmaker. But when I write, when I direct, I never ever think of Bergman. Yet my work seems to remind people occasionally of Bergman. It's an honor to be compared to anybody like Bergman or Fellini, but I, myself, I wouldn't even dare to get close to them.

Cineaste: *There's a lightness of touch in the film and a joy in life that feels more Southern European than Northern.*

Gorris: Oh, I agree. I think there's preciously little lightness in Dutch films, and that's what I wanted to give to this film. It came into existence almost in the light touches, which is also what I mean by tongue in cheek. You shudder to think about this as a heavy drama. That would be awful, absolutely awful. I wanted to give it the Italian touch—I suppose that's what you mean by Fellini. That was very definitely on my mind—the Italian touch—I hadn't realized this before when you mentioned Fellini, but it was very definitely Italian, yes. Not that I wanted to emulate the Italian atmosphere: as a Dutch person you can't even presume to get near that. But I wanted the light and the lightness to evoke an Italian atmosphere.

Cineaste: *Given that* Antonia's Line *had multinational financing, is there a question in your mind, whether your films represent a national culture as opposed to something more European or more international?*

Gorris: I think those questions should be avoided at all costs. What you have to deal with, what you should start with, is yourself—which is, after all, all you've got. This was a coproduction between Belgium and England and Holland, and I'm neither Belgian nor English. I am Dutch, but I'm southern Dutch, basically. I've lived in Amsterdam for twenty years, but I'm not a representative of a restricted Dutch Protestant society. I grew up Catholic. I'm not anything of anything. I suppose that's what's best, because that leaves you the freedom of being whatever you want to be, or saying whatever you want to say. If *Antonia's Line* had turned out to be an amalgamation of something British, something Flemish, and something Dutch, it would have been pretty horrible, I imagine. All you can do is follow your own nose, really.

Halfway through or three-quarters through the process of getting the money, there was talk about having an English Antonia. I had to fight that notion rather desperately. I thought, "What am I going to end up with? I'll have an English Antonia who can't speak Dutch. How is she going to fit into the rest? Does she speak phonetically? Do we have to dub her?" This, that and the other, one problem after another cropped up. I thought, well, it's all right having a star for Antonia, but she doesn't fit in. So I had to really fight for the person who actually played Antonia. In the end it was a totally Dutch-Flemish cast, and that worked best.

Cineaste: *You never explain where Antonia and Danielle have been before they return to the village in 1945.*

Gorris: I had difficulties about that when writing. I thought, well, they have to come from somewhere, and I was thinking, "Where do they come from?" I made up a story for myself, but, of course, that wasn't really good enough. I never could come up with something I could integrate in the film, so in the end I left it to people's imagination. I thought maybe for the first three minutes they might wonder where Antonia and Danielle come from, but then hopefully they will be submerged in the film and forget about it.

The issue was, after the war they come back to the village. Antonia comes back to see her mother, maybe because she's heard she's ill or she thinks she's dead, to bury her, things like that. It was a dicey thing to do, actually, from a script point of view, because you're always told to give your characters a background. The background is suspiciously absent here. Sometimes you do these things and they work out well.

Cineaste: *At your village location, how did you go about creating a sense of the passage of time, beginning with the village looking as it had been in 1945?*

Gorris: We had quite a lot of problems with that. You can show the passage of time in very many things, but in the end we decided that it would probably be best in all respects—art direction, costume, and makeup—to show it as casually as possible, like the passage of time which, especially in the country, goes quite slowly. You don't see abrupt changes in time. I think within the film that works very well. Suddenly you think, if you think about it at all, "Well, I was in 1948 there, and now I'm possibly in 1967, but it doesn't really matter whether it's '67 or '68 or what have you," and suddenly you think. "Maybe I'm possibly halfway through the Seventies now." But somehow it doesn't seem to matter all that much. You see people and things change, and you see people grow up, but almost off hand, and I think that's a good thing.

In the very beginning, others asked, "How can you have a heroine who's forty at the start and eighty-eight at the end and not change her?" I said, "If all goes well, it will have to be the force of the film that makes you accept that." It's makeup, partly, but I don't want her face to be plastered like Dustin Hoffman's in *Little Big Man*. It'll have to come from inside the actress, from my direction, from the light. For the rest, it will have to come from the willing suspension of disbelief on the part of the audience. If I get away with all that, then I will have done a good job.

Cineaste: *Does the success of* Antonia's Line *with festival audiences indicate that spectators are interested in a more subtle approach to feminist issues?*

Gorris: Well, suppose somebody came up and made an absolutely brilliant militant film. Then, probably there would be people who would say, "Well, the time's just ripe for that." It all depends on what comes along. Things sometimes come along just when they're wanted, exactly in time. Sometimes they come too early. Sometimes they miss the boat altogether. It is always hellishly difficult to predict. Wouldn't it be wonderful if there were

an absolutely militant but extremely important film that dealt with all the issues we want to deal with these days, just like that? A bit like *A Question of Silence* was suddenly there.

I can say this in retrospect, but, of course, when I made it, I had no idea what I was making. Even after fifteen years, especially when giving interviews, I find out that that film apparently made its mark. When it first came along, you couldn't say that. You couldn't know what sort of impact it would have. I personally long for films to have that sort of impact, whatever impact, whatever subject. *Pulp Fiction* was a bit like that. *The Piano* was a bit like that. Occasionally there are these films that sparkle.

20 TIM ROBBINS

Between Ethics and Politics

When Robert Altman said of actor/director Tim Robbins, "There's a new Orson Welles, and he's it," Altman was assessing Robbins's debut as director and screenwriter of the 1992 political satire, Bob Roberts, in which Robbins also played the title role. Whether one agrees or not with the Welles comparison, it could just as likely, however, have been referring to Robbins's versatile involvement in so many of the performing arts, as well as the seemingly limitless promise and potential of this youthful thirty-eight-year-old artist and committed political activist.

As an accomplished actor, Robbins's roles run the gamut—from the folk singer turned senatorial candidate Bob Roberts, who appropriates Sixties counterculture trappings to construct a New Right political agenda, to the equally smug, ambitious, amoral Hollywood producer Griffin Mill, in Altman's The Player (1995). The inner turmoil that consumes the Vietnam veteran played by Robbins in Jacob's Ladder (1990) transforms itself into the clever subversion of Robbins's quietly suffering, wrongly imprisoned inmate who cleverly beats the system in The Shawshank Redemption (1995). Robbins also has played his share of earnest, oversized guys who call upon limitless enthusiasm to compensate for rather limited brain power in comic attempts to succeed in business (The Hudsucker Proxy; 1994) and in baseball (Bull Durham; 1988). Bull Durham was a pivotal film for Robbins, not only because it sparked widespread critical interest in his acting but also because it sparked his romance with longtime companion Susan Sarandon, who played Annie Savoy, his unlikely mentor in matters of poetry, sexual technique, and baseball strategy.

Beyond accruing acting credits in some twenty films, Robbins sustains his deeply rooted commitment to theater, which began during his New York City childhood, long before his undergraduate days in the UCLA drama department. Robbins's theatrical work ranges from acting to playwriting to cofounding the Actors' Gang, an L.A. group dedicated to nontraditional theater. In addition to writing, acting, and directing for film and theater, Robbins coproduced the documentary, The Typewriter, The Rifle & The Movie Camera (1989), in homage to director Sam Fuller and his films.

Nowhere is Robbins's artistic promise and ethical vision more evident, however, than in Dead Man Walking *(1995). The film, which he directed, wrote, and coproduced, is based on the book of the same title, written by Sister Helen Prejean, who argues passionately against the death penalty by recounting her experiences as spiritual advisor to death row inmates in Louisiana. While remaining strongly faithful to the spirit of the book, Robbins manages to create varied and carefully wrought visual effects in the essentially static, dialogue-driven film. Moreover, Robbins presents a compelling and powerful challenge to death-penalty proponents precisely by refusing to back away from the very arguments they voice in support of the death penalty.*

Both Dead Man Walking *and* The Typewriter, The Rifle & The Movie Camera *are products of Havoc Films, Robbins's production company that grew out of a deal with Polygram Filmed Entertainment and Working Title Films to independently finance projects Robbins develops and over which he is given autonomy and full creative control. Cineaste editors Roy Grundmann and Cynthia Lucia met with Robbins at the Havoc offices in the Chelsea section of New York, where he spoke openly and thoughtfully about these projects.*

Cineaste: *Was your interest in the death penalty prompted by Sister Helen Prejean's book or had you been interested in the subject before you obtained the concrete material the book provided?*

Tim Robbins: I had never thought too much about the death penalty. I was opposed to it for moral reasons. Although I had written a college paper on the subject in a philosophy class, it wasn't a burning issue for me. When I read the book, it took me on a journey into things I had not thought about, perspectives and emotions I was unaware of—it's an extraordinary book. It made me aware of issues I hadn't previously considered.

The death penalty is very secretive. Very few people know the specifics of what goes on. We don't think about it in this country, and we accept it at face value, lying in our beds while it's carried out. I find it very strange, for example, that it's carried out at midnight deep in the recesses of the prison. One of the main reasons the death penalty is supported is that it's supposed to be a deterrent. It's the common fiction continually brought up at election time. But if this fiction were true, why are executions performed in such a secretive manner? Of course, the death penalty is not a deterrent. Studies have found that murder rates actually increase when executions occur.

Another thing I'd never thought about is what prison guards go through. There is an extraordinary character in the book who I tried to get into the film. We filmed it, but I felt it got in the way of the main story. The prison guard is tortured by his involvement in the execution. He views himself as a good person, feels that he is being made complicit in what essentially is a murder, and, at one point, pours out his heart to Sister Helen. We're requiring agents of the state to

be complicit in the taking of a human life. Some, I'm sure, are fine with that, but there are others who will be tortured by it for years—in their dreams, their subconscious, their moral tangles. Is it really fair of us as a society to require people, who we pay with our tax money, to kill other people?

The racial inequity is another thing we don't think about—the fact that you stand a much better chance of ending up on death row if you've killed a white person, particularly one with some value to society. Murderers of homeless people, for example, will not be facing death row.

Cineaste: *Did you find yourself making difficult choices with respect to stressing racial inequity?*

Robbins: Not at all. It's all in the book. I'm just being faithful to the book. The fact that he's a white supremacist and talks about bombing federal buildings is in the book. I didn't include that because of Oklahoma City—I didn't want to be trendy. Actually, it upped the ante. We were about to start filming when that happened, and I initially thought we had better leave it out. But then I said, "No," because it's the truth of the book.

Cineaste: *There is a problem with adapting this particular book, since it has a wealth of factual information, but the two people Sister Helen counsels on death row represent a small segment of that information.*

Robbins: When you're telling a story, you can find a way to integrate facts into it. If it comes out naturally, it works, and in this case it's very obvious where it works. I put some facts about racial issues in the screenplay, and we filmed it, but they didn't wind up in the movie. Some of that I put into Hilton Barber's mouth. I had to trim down a few of those scenes, because they became too fact-oriented too early. For me, the first cut pretty much determines what the movie becomes. This is about a nun and her relationship with these parents and with the convicted killer. It's neither about the politics nor about the statistics. It's very difficult to get into listing facts and still keep the emotional component. Any time that happened in the rough cut, it took away. It became polemical and unnecessary.

The film became an emotional journey by bringing people closer in their hearts to someone who is being executed, who is, in fact, a murderer and very difficult to like. As far as executions are concerned, we don't want to hear that this person is a human being. We are executing him because he is a monster. You don't read a lot about executions. They're usually buried in the newspaper, where it's usually about the crimes and the fact that the criminal was killed. You don't hear their last words; you don't hear that they have a mother or a sister or a brother; you don't hear that people wept. That side of the story is never told.

One of the reactions I was most excited about, told to me second hand, was about a radio shock jock in the South, who made it very public that he was going to see the movie and that he'd talk about it the next day. And he came back and said, "I know this is gonna sound strange, but I have changed my mind about the death penalty—and I'm now against it." His listeners were livid, and, ultimately, it came out why he changed his mind. It was the scene when the mother

is prohibited from hugging her convicted son. The DJ said, "I don't care what he did. No person, no mother should have to go through that." Ultimately, it came down to a personal thing. No facts, simple and pure emotions. Something everyone can relate to—the fact that a mother cannot hug her child to say good-bye to him as he is leaving.

Cineaste: *While the film is about a political subject, it really focuses on ethics. Perhaps, that's why it has so much integrity and power. On the other hand, with an issue like the death penalty, there has to be a place where ethics and politics intersect. Do you see that happening in the film? Do you feel the film, on some level, is political?*

Robbins: Ethics and politics clash in one scene in the film: when Sister Helen and the attorney visit the governor, who is against the death penalty, and he doesn't have the spine or the moral courage to say "No." He's simply going to cry "will of the people" when he is faced with the moral choice. He has to do that, because if he doesn't, he might realize he is morally corrupt. So blame it on the people.

This is part of our problem in this country with leadership. There are no leaders. They are followers. They are doing business deals in Washington, and they'll go wherever the wind blows. It's much different in England. Even conservative politicians there know the ramifications and the cost of the death penalty and will not bring it up for a referendum. They know the public is for the death penalty. That's leadership—not to incur the financial or moral cost of the death penalty, knowing mistakes will be made and what it will cost to cross that line.

Cineaste: *It's like that incident with New York's Governor Pataki saying to the Bronx D.A., "You have to seek the death penalty, it's the law now." And the D.A. is not comfortable with that. It goes back to your very point about how the state is forcing its own employees to participate in killing.*

Robbins: Look at how much press Pataki got. It's a purely political thing. It's not about putting to death all the people on death row. It can never be about that. If we were to execute all the people on death row, we'd probably be having executions every day until the turn of the century. We don't have the stomach for that. Morally, as a nation, it would bankrupt us. There was a summer when Louisiana had something like seven people executed. The juries in Los Angeles, after that point, would not go for the death penalty. They couldn't stomach it. All it takes is one person out of twelve to say, "He should be put away for life, but I will not participate in killing him."

The film is directed beyond politics, because I have no ambition to preach to the converted. It's not directed at Democrats or Republicans—it's directed at morality, which crosses political lines. To get into the specifics and the politics would be to alienate and to marginalize. There's so much of that in life—why do it in films? I'm a big believer in this nonpolitical area that is not about partisanship but about something much deeper. I've talked to Republicans who have said that the film has changed their minds on the death penalty, and I've gotten most of my criticism from knee-jerk liberals who feel

the film advocates execution. It seems to me that some of these people are understanding a part of the story perhaps they didn't think about before—the story of the grieving parents of the victims. They are forced, in the film, to walk in their shoes. If anything, it's really important that those people's opinions have been shaken. Because if they're shaken and are still against the death penalty, they're now against it with a deeper resolve. One passage in which the movie really crystallizes the book is when Sister Helen goes to see the parents of one of the victims. It's one thing for Sister Helen to be confronted by the parents, but it's another thing to have the courage to go and see them.

Cineaste: *Towards the end of the film, scenes of the execution are intercut with scenes of the murder. Have you experienced responses in which people for the death penalty have found confirmation for their beliefs in the film?*

Robbins: The scene at the end has been read both ways. Some critics have said it could be viewed that way. But, ultimately, this is all very personal. All of that is fine. If you can get under conservative skins at the same time you get under liberal skins, you must be doing something right.

Cineaste: *Yet, whatever remorse Poncelet is feeling probably wouldn't have happened if he hadn't been on death row.*

Robbins: Yes, but the only thing I can say in response is, that perspective implicitly advocates torturing people. Why don't we torture everyone so they admit their guilt? Why don't we torture them until they accept God? Think about it outside the realm of justice and the criminal system. Take it to a personal level, where you have a person locked in a room, and another person comes in and tells him he's going to die next Thursday at twelve midnight. "I'm going to give you food and water, but you're not getting out of this room and you're going to die." And then Thursday comes, and the guy says, "Well, actually, we're not going to do it today. We're now going to do it in three weeks." That's insane, psychopathic. Aside from the brutality of the actual execution, the prologue to it is clearly mental torture.

Cineaste: *The film makes an important effort to show the human side of the criminal. It merges Robert Lee Willie's admission of guilt in Sister Helen's book with Patrick Sonnier's remorse to create a composite character in order to produce redemption. How central is redemption to what you're trying to accomplish in the film?*

Robbins: Based on my research, redemption sometimes happens, but more often people don't want to blow it, because that red telephone might ring at the last moment. Consider the fear of someone facing that situation. The redemption is in the book. Most people I've heard about who have been executed have spent ten, twelve years on death row and are so far beyond what brought them there. Someone executed in Louisiana a few months ago had been there for over a decade since he'd committed the crime. He claimed he didn't do it.

Many of these issues I couldn't get into. In a number of cases, people have been ramrodded through the justice system and are innocent. We got this guy off in Illinois last year. I have been involved in his case and supported his legal

efforts for the past three years, and a cop finally came forward and said he could no longer live with his conscience and admitted he had lied in court. So the guy was innocent, and they finally let him out of jail—he had a date to die. This is a whole other realm that the movie is not concerned with. I wanted to take the extreme, present the guilty person, the contemptible person, the awful crime. If you're against the death penalty only because sometimes innocent people die, then you're not really against the death penalty. The real moral question here is whether we have the right to kill anyone.

Cineaste: *What came out well in the film is that the crimes were atrocious. But there is a sense that Poncelet goes through a complete transition. He starts out having no remorse, and in the end Sister Helen brings him to owning up to it. Why did you make that so strong?*

Robbins: It's reflecting what's in the book. One of the men was this way. He was arrogant, a white supremacist, he said stupid things to the press, and, in the end, lets go of the bravado and accepts responsibility. A typical thing in spiritual advising is that you have to get the inmate to accept that Jesus died for your sins and God will be there. But she goes beyond that and said that it's about accepting responsibility. Just because Jesus died doesn't give you a free ticket. That's what makes her different from some of the religious women and men I was taught by. There is a real hands-on approach to her faith.

Just because Poncelet suffers doesn't make him into Jesus. That is important for me, because I knew that people would look at the execution scene—the way in which Poncelet gets strapped to the table, with his arms spread out like Jesus on the cross—and think I was trying to make some kind of parallel, which I'm not doing at all. This is really the way the table is made. At first, it is in an upright position. There's a very practical reason for that: it's difficult to get a person who struggles to lie down on the table. It's much easier to walk him in, to strap him in while he stands, to take his handcuffs off and only then to bring him back into the horizontal position. We made none of that stuff up, it's all meticulously researched.

Cineaste: *You mentioned that he is a worst-case scenario. When he goes on his supremacist diatribe, the audience, more than anything else, is given to chuckling about it. They think he's merely off the wall. It makes him less of a monster. Often films about Neo-Nazis present them as either monsters or as children.*

Robbins: The chuckling has to do with the fact that Sister Helen is watching Poncelet's diatribe on the evening news and the audience sees that he's just gone from bad to worse. I had initially included more information on this aspect of his character, but it seemed beside the point. It was also difficult to adapt. In the book, the conversation about Aryan supremacy started going off into a different realm and didn't stay on track. Sister Helen had four or five hours to talk about all of these issues right before his death. So he starts talking about the Aryan nation, the tattoo of the skull, and so on.

In the film, at that point, the scene had to focus on his impending death. It needed to serve more than one function. It was a very dramatic scene. The point

seemed to be that he had extremist political views. Aside from being a racist, he was also a Neo-Nazi. I never viewed it as a childish thing. I viewed it as a representation of the character in the book who felt hate, not love, and that's in all of us.

Cineaste: *In the book, Sister Helen mentions that Poncelet's connection to the Aryan brotherhood came about during his stay at Marion Federal Penitentiary, Ohio. He gets involved with them because they protected him and became his surrogate family.*

Robbins: I'm not a big believer in victimology. Just because someone may have had a horrible childhood or a specific psychological setup doesn't right his crimes.

Cineaste: *The casting of Sean Penn raises all kinds of interesting possibilities. Why did you cast him?*

Robbins: I wanted the best actor I could find, and he was the first name that came into my mind. I think he is the premier actor of my generation. He has a quality about him that doesn't pander to audiences. It is essential that this character doesn't try to be liked. I dreaded getting into a conversation with an actor who'd say, "Can I have a monologue here about my childhood that makes us understand how this guy is a nice guy? Can I have a moment here were we see a poignant sense of him?" It was really important to have an actor who trusted his own talent and the material, so that even though the character is a prick throughout the movie, in the end people will find a place for him in their hearts. To try and get the audience through that difficult road is so much more satisfying than manipulating them.

Cineaste: *We were struck by a photograph published in* The New York Times *in their review of the PBS* Frontline *program devoted to Sister Helen and your film. In the photo Robert Lee Willie looked so much like Sean Penn.*

Robbins: When I cast Sean, I had never seen a picture of Robert Lee Willie. I sent Sean Penn to hang out with Sister Helen. She called me and said that he reminded her of Willie.

Cineaste: *In the* Frontline *segment, one of Willie's victims, Debbie Morris, who was sixteen at the time, speaks about how she really wanted this man to die, but having seen your film, has begun to really reconsider her feelings. It is very powerful.*

Robbins: I haven't seen *Frontline* yet, but I have gotten really amazing letters from victims' families, from nuns, from prison guards, talking about how the film has helped.

Cineaste: *On the other hand,* Frontline *also interviews the Harveys, the parents upon whom the Percys in your film are based. Sister Helen says the Harveys felt crucified by your film. Since you haven't seen the documentary, it may not be fair to ask you to respond to that.*

Robbins: My immediate response is that it's not the Harveys. The Percys are composite characters of the Harveys and the Bourgees. The reason why the Harveys are in that documentary is because they agreed to it. When my film

came out, I was hoping that they wouldn't be bothered by questions, because they are being put through the pain again. Not only did we change their names and make other changes in the script, but we never mentioned them in our press release. I've never steered anyone in their direction. I didn't want to involve them, didn't want them to have to be involved. It was their choice to speak to *Frontline*. It also has been their choice to go to almost every execution at the prison all these years. It's a terrible tragedy that they're going through, and it's even more tragic that they were able to watch the execution of Willie without being able to move on without a sense of closure. For every family like the Harveys, there are other victims' families who feel differently.

Cineaste: *Like the parent on whom Mr. Delacroix is based.*

Robbins: . . . who the producer of *Frontline* said he met with and decided not to film. Take Marietta Ann Jaeger—an extraordinary woman who lost her child and is now part of a group called Murder Victims' Families for Reconciliation, an anti-death penalty organization.

Cineaste: *We think you handled the Delacroix character well, because he becomes the entry point and identification point for people who are suffering as a result of a crime, yet are able to find their way out of it.*

Robbins: It's an awful lot to ask. Let me be honest, I don't know if I'd be able to do it. I totally understand what the Harveys are going through. I felt it was very necessary to portray the victims' parents in a dignified way. I don't think we made them out to be the bad guys. I think they're given a tremendous amount of sympathy. I also got responses from crime victims' families who thanked us for not making them out to be vigilantes and rabid, vengeance-ridden people, because often, in films like this, that's how they're portrayed.

Cineaste: *You showed the execution through lethal injection; whereas the real criminals on whom the Poncelet character is based were executed by the electric chair. We had a disagreement about this. On the one hand, by not showing the brutality of the electric chair, you're copping out on the horrible nature of the death penalty. On the other hand, the whole idea of lethal injection is a cop out by our culture. Because we can't see the organs imploding, we tend to say lethal injection is not so bad. We hear Poncelet speak about it, and certainly, the tight close-ups of the mechanism of the execution revealed that it's no less brutal. What was behind your choice?*

Robbins: First of all, Louisiana is now using lethal injection, and most states are gravitating towards it because they feel it's the most humane way to kill someone. I wanted to take that head-on and reveal the "most humane way" as inhumane. I didn't want to get to the end of this journey and have audiences say, "You're right—electrocution is brutal. Let's do lethal injection." As Sister Helen points out, the firing squad is more honest. At least you're very clear on what's happening. Lethal injection is sneaky.

Cineaste: *It really shows the hypocrisy of the death penalty. The filmic medium, however, is all about visibility. There is an aspect to it that would have been very powerful were it shown.*

Robbins: I was very concerned about that when we were filming it. We *did* film an alternate version of the execution scene. Sometimes, with lethal injection, the person has an allergic reaction to the first shot. If the first shot doesn't work, the second and third shot are incredibly brutal. The body is shaking, there are convulsions, foaming at the mouth. It's sick. We *did* film that. Sean really pulled that off. He did it both ways and did it many times and was totally exhausted. But then I looked at that footage, and I first cut in the sedate version and felt it was exactly right, that it was so insanely brutal and premeditated that I didn't need to push that button.

Cineaste: *But then the film opens itself up to the danger that people think, "Oh look, it's not so bad."*

Robbins: I think those people are never going to change their minds. There are probably twenty percent on both sides that will never change their minds. The middle ground is really what I'm interested in. There are some people who will resist feeling compassion for him throughout, and that's just part of who you are.

Cineaste: *But then you also edited in the other version to see if it worked?*

Robbins: I never needed to. In the overall context of the film, it was a brutal ending. One of the major issues was also whether we should have juxtaposed the murder with the execution. I felt it was really necessary to take people to the point of compassion and tears and then challenge them in a very real and honest way and ask, "Can you still feel compassion?" If audiences think they can at that point, then they are really feeling something.

Regarding your concerns with people who might say it's right that we kill criminals, I've known about that from the moment I viewed the film for the first time. It's always been a matter of whether you concern yourself with it to the point where you become dishonest. I just count on the humanity of people that they will come to reject it. It might not happen right now or the next five years. But if people become acquainted with the facts and the story, I believe that the seventy percent of people now in favor of the death penalty—and by the way, at the time of the filming it was eighty—will constantly be reduced to the point where politicians will follow people and reject the death penalty.

But this change is not going to be initiated from pundits. It's going to happen from wardens, prison guards, victims' families, and religious leaders. The people in the pulpits in this country can do it. I'm a hopeful person. In full knowledge of the politics of the conservative Christian churches, I still believe there is a moral center that, if it gets tapped into, can become very potent. The real challenge to the religions is to stand up on that pulpit and say, "We're going to end capital punishment." It's not whether they reject the death penalty or not, but actually whether they go out there and lead the religious community, write letters, march, do things in an active way that brings about change. I think that this is the issue that can sway the course of the moral life of this nation.

Cineaste: *You said that Susan Sarandon brought the book to your attention. Did she collaborate further along the way, in addition to her outstanding perform- ance as Sister Helen?*

Robbins: Oh sure. I showed her every draft of the script. And I have to say that was the most difficult thing. I don't have as much confidence in myself as a writer as I do as a director. Writing is such an isolated, hermit-like creative process. When you come out of it and someone says, "Well, it's not a work of genius," it pisses you off. When you're an actor, you can blame it on the director; as a director, you can blame it one someone else; but as a writer, it's just you. So when I churned out the drafts, it was difficult. But Susan has great insight, great instincts and, from the character's point of view, was invaluable as far as where the conflict was and where the resolution was. She helped tremendously—as much as I hated it at the time. And her performance was glorious. To play a role that listens, reacts, and achieves the depths of emotion and storytelling in silence is masterful.

I do believe film is a director's medium, and I believe that a script is a great blueprint, but once you're on the set, it has to be able to be changed. I don't hold anything I write to be sacred. My training in the theater is the reason why. In the Actors' Gang, we would write a rough draft, rehearse it, rewrite, rehearse, rewrite, and give the performance in three weeks. So nothing could be held sacred. My cowriter and I would bring a script one night, hear it read, see it improvised, go home that night after rehearsal, work till three in the morning and rewrite it. When the pressure is on, it helps a lot not to have an ego.

Cineaste: *You had something produced at the New York Public Theater a few years ago. Do you do much theatrical work in New York?*

Robbins: No, I don't. Mainly because I have young children and I don't want to miss that. It is enough of a demand to be on a film for ten, twelve weeks and work those kinds of hours and miss that part of your child's life. Directing is a whole other story, because often it involves a full year. I don't want to get into a situation where I'm having to go to a show every night and perform. I'm sure, when my kids are teenagers, they'll say, "Daddy, why don't you direct some theater, act in a show or something."

Cineaste: *Let's talk about what brought you to do the Sam Fuller project.*

Robbins: A few scotches and a conversation in a bar in France in 1987. I had never known about Fuller, and then Jonathan Demme introduced me to him. I had a blast talking with him about life, love, America, politics, and history. I told him about *Bob Roberts*, which, at that point, was something I was trying to do but which I wouldn't be able to do for another four years. I just loved him. I thought he was a really original person, iconoclastic, independent. I wanted to find out more about him. So I went back to the States and tried to find his movies, which was very difficult. When I found them, I was blown away. The immediate question for me was, "How can he no longer make films? Why, after doing something like *Shock Corridor* and *The Naked Kiss*, had he not been able to work in Hollywood for more than ten years?" I tried to ask him straight-on, but he doesn't have any bitterness about it. There had been a change in Hollywood since the time when he'd walk into an office, pitch a story to Zanuck, and Zanuck would say, "Do that film!" In the late Sixties and early Seventies that was no longer possible.

Cineaste: *That's what Scorsese says in the film. But you'd almost expect the opposite, that with the breakdown of the studio system, somebody like Fuller, whose films didn't really fit into the studio mold very well, would have more opportunities.*

Robbins: Well, if you look at *Shock Corridor*, you can easily see some studio boss saying, "No fucking way—what's this guy doing? A black man with a Ku-Klux-Klan sheet over his head?!"

Cineaste: *Yes, Fuller, in many ways, embodies the paradox of the studio system. This system allowed for the B-picture, which is where a lot of the really interesting stuff was going on. Everyone always talks about the studio system as being so monolithic. That is not true, and it never was true.*

Robbins: You're right. And what a fascinating life Fuller has had. The more I found out about it, the more fascinated I became. When I developed this company, Havoc, I didn't want to cut one of those deals where you read lots of scripts and do nothing. So, within the first month of the company's existence, I told them I wanted to do the Fuller documentary, and they said, "We didn't set up this deal for documentaries." So, with their blessing I started looking for money elsewhere and found it at the British Film Institute. We went to Paris and filmed Sam, and then there was no money left to finish the film, so it took another year to find some more money to do the interviews with Scorsese, Jarmusch, and Tarantino.

Cineaste: *So they became involved only at a later stage? Why did you choose those particular directors?*

Robbins: I think they represent three different kinds of styles and approaches, all influenced in some way by Sam. With Scorsese, it's the camera movements, the betrayal of criminals, the nonjudgmental approach to marginal characters of society; with Tarantino, it's the courageous energy and the snappiness of the script; and with Jarmusch, it's the content, the lack of fear in addressing issues about American culture and society. They're also from three different generations.

Cineaste: *In the film, the scenes with you and Tarantino going through all of Fuller's treasures in his L.A. garage almost seem patronizing, as though Fuller were dead, as if you were raiders of the lost ark. How did these scenes come about?*

Robbins: Adam Simon, the director, knew about the garage and wondered if it was possible to film there. We talked to Sam and his wife Christa about doing it, and they told us to go ahead. There was no resistance at all. I thought it was a great opportunity to see that helmet and those diaries that we'd read about. I didn't feel that it was disrespectful. It would have been much better to have Sam there, but he was in Paris then.

Cineaste: *When you were in the garage, was there still the smell of Fuller's cigar smoke?*

Robbins: No. But seriously, it was basically untouched since he had left after *White Dog*. There were still notes on the desk about that film.

Cineaste: *Whenever you hear Scorsese talk about Fuller's movies, he seems so keyed in to the visual moments and so aware of them, but when Fuller speaks, he doesn't speak much about the movies directly. He is very unselfconscious; he doesn't mention camera work or script. It's all about his life and the story.*

Robbins: I hope our film brings more people to his films because they are these unearthed gems.

Cineaste: *What's your favorite?*

Robbins: I'd say *Shock Corridor* is my favorite. I love the fact that, when *Steel Helmet* came out, it was reviewed in one newspaper as being a pro-communist statement, and, by contrast, *The Daily Worker* wrote that this movie could have been made by Douglas MacArthur. I think that's a high achievement.

Cineaste: *In a way, it's not unlike* Dead Man Walking, *since people have read it one way or the other. Since we're coming to the end of this interview, can you tell us what your next project is?*

Robbins: I'm acting in a movie called *Nothing to Lose* with Martin Lawrence. I'm doing the anti-*Dead Man Walking.*

Cineaste: *You seem to embody a cross-section of the performing arts. You act, you write, you direct, you do radio plays, you even sing. Robert Altman says that you're the young Orson Welles. Are you continuing to do all of this?*

Robbins: I sure hope I am not the young Orson Welles! He had great difficulty getting a film produced after *The Magnificent Ambersons.* I'm not going to direct for a while, because it's too time-consuming, and, as my son says, acting takes a lot less time. But I'm going to continue writing and will probably take some time off in the fall to write. I'm also continuing to produce about six to seven shows a year at the Actors' Gang Theatre in Los Angeles.

21 JOHN SAYLES

Borders and Boundaries

John Sayles describes his film Lone Star *as "a story about borders." It is set in Texas, which, Sayles explains, "is unique among the United States in that it was once its own country. It was a republic formed in a controversial and bloody way. And its struggles didn't end with the Civil War. There is a kind of racial and ethnic war that has continued. That continuing conflict comes into the clearest focus around the border between Texas and Mexico." But this geographical boundary is only one aspect of the film's concern with borderlines. "In a personal sense," Sayles comments, "a border is where you draw a line and say 'This is where I end and somebody else begins.' In a metaphorical sense, it can be any of the symbols that we erect between one another—sex, class, race, age."*

In an even larger sense, Sayles adds, Lone Star *is also concerned with "history and what we do with it. Do we use it to hit each other? Is it something that drags us down? Is it something that makes us feel good? You can get six different people to look at the Alamo, and they have six different stories about what actually happened and what its significance was. The same goes for your personal history. At what point do you say about your parents, 'That was them, this is me. I take responsibility for myself from this day on.'"*

John Sayles discussed his approach to these themes in Lone Star *with Joan M. West and* Cineaste *contributing editor Dennis West at the 1996 Seattle International Film Festival.*

Cineaste: *Borders and boundaries—geographical, social, ethnic, and personal—are a central theme of your film. How did previous border films, such as* Touch of Evil, The Border, *or* The Ballad of Gregorio Cortez, *influence your approach?*

John Sayles: I was very aware of borders and the way they can be geographical or manmade. Within the movie, there are lines between people that they choose either to honor or not to honor. It may be this enforced border between Mexico and the United States, it may be one between class, race, ethnicity, or even military rank. There's an important scene where Joe Morton's character, an army colonel, says, "I want to know what you think," and the private says, "Really?" She has to say that because privates do not get to say what they think to colonels and you have to have a special dispensation. On the other hand, once you cross that border, you may find out things you don't want to know. You may find out that the streets of America are not paved with gold. You may find out what Joe Morton's character finds out, which is that this is not a gung-ho private, this is somebody who's going to say things that make him question himself. His character is having a crisis of faith—although it's not in the church, it's in the military—about what he's done with his whole life.

When you cross the border and go into some kind of new territory, you don't necessarily have the power that you had on your side of it. When Sam Deeds crosses the border, the Mexican guy says, "You're just some gringo with a lot of questions, I don't have to answer you. That badge doesn't mean anything down here." I think that's one of the reasons that people like borders—they can say, "South of this line, I'm a big guy, and I run things here." Or it may be as literal as, "This is my land, and, if you come on it, I can shoot you."

A lot of imagery in the movie was taken from the Alamo. The bartender, for example, says, "This bar here is the last stand, Buddy." When Sam goes down to Mexico, the Mexican guy draws a line in the sand, which refers to a famous moment from the history of the Alamo, when Travis drew a line. Of course, the Mexican draws the line with a Coca Cola bottle, but it is still a line drawn in the sand. During the Gulf War, George Bush used that same imagery of drawing a line in the sand.

In the other movies you mentioned, I'd say Tony Richardson's *The Border* was more about drugs and identity. It was also a little more romantic, with Jack Nicholson as the border patrol guy falling in love with the Mexican girl he saw on the other side. That film made it seem a lot harder to cross the border than it really is. She could have come across a hundred and fifty times with her brother. It wasn't very realistic that they would ever catch him. It was also a little bit more of a shoot-'em-up than I wanted to do. *Lone Star* is not a thriller. It involves a murder mystery, but nobody ever pulls a gun on Chris Cooper's character, so it's not a thriller in that way.

Touch of Evil was influential in just thinking about that idea of a legend. Orson Welles's character is a legend in his own time, but the first time you see him he's this monstrous character. He's the kind of legend who didn't die in time, he's hung

around, and now he's going to ruin his own legacy. As for *The Ballad of Gregorio Cortez*, both the movie and the song, as well as the *corridas* in general, were important to me. There are dozens of these songs, and many of them have to do with people who probably were pretty bad guys, but because they fought the *rinches*, which is what the border people call the Texas Rangers, they became heroes. Fairly early on in my research I read a book called *With His Pistol in His Hand* . . .

Cineaste: . . . by Américo Paredes

Sayles: . . . right. I also read an unfinished novel of his which was published recently. But just going back and finding more *corridas* and reading the lyrics of them was very useful for me in understanding that long history of conflict on the border.

Cineaste: *How would you explain your continuing interest in Latinos and Hispanic-American cultures?*

Sayles: My feeling, basically, is that I've made a lot of movies about American culture, and, as far as I'm concerned, it is not revisionism to include Mexican-American culture or African-American culture or any of the many other different groups. If you're talking about the history of the United States, you're *always* talking about those things, from the get-go. As Sam Deeds says, "They were here first." And then the other guy reminds him, "Yeah, but the Native Americans were there before." So I don't see those as specialties. As far as I'm concerned, they're just part of the picture, just part of the composition.

I've lived in a lot of places in the United States, and the odds are that sooner or later you're going to live in a neighborhood where people don't necessarily speak English, which I think is one of the things that makes the United States an interesting place to live. Where I'm coming from, in fact, is pretty much the opposite of Pat Buchanan's idea of this monoculture which is being invaded. English-speaking culture is just one of many cultures. It has become the dominant culture or subculture in certain areas, but it's a subculture just like all the others. American culture is not monolingual or monoracial. It's always been a mix. As one character says, "We got this whole damn *menudo* down here."

Cineaste: *Does* Lone Star, *then, represent your vision of the U.S. as an increasingly multicultural society with more and more bicultural couples?*

Sayles: I would say no to the first part and yes to the second. As I said, it's not *increasingly* multicultural, it's always been so. If you go back and turn over a rock, you find out, for example, that maybe a third or more of African-Americans are also Native Americans, and a much higher percentage of African-Americans are also white Americans. You know, as they used to do in New Orleans, if you're 1/64th black, you're black, and it doesn't matter what you look like.

I do think there are more interracial couples. One of the interesting things I noticed during the Gulf War, seeing so many people interviewed on TV, was the large number of interracial couples, both of whom were in the military. There were also many black officers interviewed, including Colin Powell and people like that, who were asked, "What do you think of this war?" and they'd say, "Well, it's my job to go." They'd be asked, "Why are you in the army?," and they would say, "It's the

best job I could get." I was fascinated by the idea that the United States Army, which used to be a bastion of segregation and racism, has gotten to the point where, although it's not the most liberal place in the world, it has become more liberal than the private sector. As a black person, you have a better chance of getting a job there and moving up if you do a good job than you do in the private sector.

Cineaste: *History is a central theme of* Lone Star, *and your seamless transitions in some scenes between past and present seem to represent the continuing weight of the past.*

Sayles: It is kind of an obvious conclusion, because there's not even the separation of a dissolve, which is a soft cut. The purpose of a cut or a dissolve is to say this is a border, and the things on opposite sides of the border are meant to be different in some way, and I wanted to erase that border and show that these people are still reacting to things in the past. There is a preoccupation with history in the film, whether it's Sam Deeds wanting to find out the personal history of his father, or the grandfather looking back into the roots of the black Seminoles. Pilar is a history teacher for a purpose, including that meeting about how they're going to teach history in the text books. Even Joe Morton's character is dealing with the history of black and white relationships. When he asks himself "Am I just a mercenary?" it's not only because of his personal feelings, it's also in a way a historical question, asking "Can I be a black soldier in the United States Army and not be a mercenary like one of those black Seminoles who just chased Indians for the whites?"

Cineaste: *Many of* Lone Star's *important characters—Sam, Delmore, Chet, Pilar, and Bunny—are examined in terms of their relationship to a father figure, and even the town and county themselves are seen in relation to their sheriffs. How does this relate to your treatment of the theme of history and to the patriarchal Hispanic tradition of the* caudillo, *the strongman figure?*

Sayles: Something that was very much in mind was taking a story and being able to move in both directions with it, of taking something that's a little more particular and being able to spread it out to the political—taking a story like Sam Deeds's and, as he does with his investigation, looking into what is basically his own family history. It tells you something about the whole community, but sometimes that becomes a metaphor for personal history. For me, very often the best metaphor for history is fathers and sons. Inheriting your cultural history, your hatreds and your alliances and all that kind of stuff, is what you're supposed to get from your father in a patriarchal society. Both Texas Anglo society and traditional Spanish society were patriarchal societies, especially on the border, which had a history of *rancheros*, with Don this and Don that, who had these big spreads with *peons* working for them. It was very pyramid-like, whereas in other parts of Mexico, it was much more influenced by Indian hierarchies, which are not pyramid-like, where men and women have separate roles but it's a little more circular. There may be a village chief, but he might change every year, so it's more about communal ownership rather than one guy owning the land, and whose eldest son is going to own it in turn, and it's going to be passed on that way.

It was also important for me to include the story of Pilar and her mother. I think people generally take the same-sex parent as their role model, and so here's Pilar finding out about her family history very, very slowly. She may not even know that her mother was born in Mexico. Her mother may have said, "My people are down there, but I was born here," or "I married your father, and he was a citizen." Who knows what legend she's been told. Her mother is very closed about that, because in the culture in which she lives, there's a certain amount of shame in being a *mojado*, a wetback.

Cineaste: *Pilar's mother represents a conservative Mexican-American attitude to contemporary immigration issues, and I assume you did that very deliberately.*

Sayles: Yeah, not only to show that factor but also to show that, when talking about borders and lines between people, very often when people cross those borders they want to slam the door behind them. They may have been banging against that door themselves, but because they have internalized the system and given it value, their attitude changes once they get on the other side of the border. The army is a perfect example of that. You may start out saying, "Officers are stupid," but once you're made an officer, you probably change your mind, and you definitely don't say, "Now that I'm here, I'm going to abolish rank." That's been the tragedy of the Mexican revolution—you get Porfirio Diaz, who does these great things, but after they get rid of the old guy, Diaz becomes the *caudillo*. That has been repeated time and time again in Latin American cultures, where revolutions have turned into just a change of *caudillos*.

Cineaste: *Would you comment on Sam and Pilar, the last couple seen in the film who have crossed their borders and, if you care to deal with a related question, will their children be born with a pig's tail?[1]*

Sayles: [Laughs] Well, their children won't be born with a pig's tail because, as Pilar says, "I can't get pregnant again." One of the things I wanted to do with that is ask, "OK, what actually is that rule?" I'm interested in the difference between when people do things because of good practical and emotional human reasons, and when they're just following the rules. So here are Sam and Pilar—they were raised separately, they're adults now, there's no question of one being the older brother or the older sister and in some kind of position of power over the other one, so it's a fairly equal relationship in that way. They're not going to have children, so they're not going to pass on any horrendous birth defects, so what is that rule about? She says, "If that's what the rule's about, I'm not going to have children." What they're left with is the realization that, "OK, we have this chance to do something that is going to be seen as enormously antisocial but it's good for us," and they choose to cross that border of moral opinion.

But it is only an individual accommodation, and that was a lot of my point with the ending, it's not going to change society. They're going to have to leave the society they're in, they can't stay in that town. You may be very nonracial, you may be married to a black person, but if you're in the middle of the Watts riots, that's not going to help you. That individual accommodation you made has not changed the social situation, or hasn't changed it enough so that what society is still doing is

going to honor your change. Interracial couples that I know are careful about where they go. If it's a black and white couple, for example, there are places with white people where they don't go, and there are places with black people where they don't go. Only on the edges of those societies is there a place for them and their kids. In the hearts of those societies, sometimes, they're just not welcome.

Cineaste: *I understand* Lone Star *is a Texas-produced brand of beer. Why choose* Lone Star *for the title of your film?*

Sayles: Well, the same reason, I think, that Lone Star chose it as the name of their beer. Texas is the Lone Star state. Texas chose the lone star because they were an individual who wanted to become part of a group. Once they broke away from Mexico, they said, "Well, we are a republic," and choosing a lone star for their flag was a wannabe gesture toward the United States. I associated that with the character of Sam Deeds, who is an individual who stands very much outside of the group, looking at it, and who is supposed to eventually join it, but in this case he decides not to. You feel at the end of the movie, no, he's not going to run for sheriff again.

Cineaste: *Would you comment on Wesley Birdsong, the Native American roadside merchant figure?*

Sayles: As long as I was portraying the other people down on that border, I figured, well, I cannot leave this guy out. What I found interesting in that area of Texas is that although the reservations cover a lot of land, there isn't a huge amount of political fighting going on between the reservations and the state the way there is in the Dakotas, Montana, or Wyoming. In Texas they really have been relegated to reservations that are out of the way and out of mind, so that Native Americans you meet are very likely to be in the general population and therefore somewhat isolated.

Cineaste: *Is the Native American merchant a Kickapoo, and was he a veteran of the Korean War?*

Sayles: Yeah, he would be a Kickapoo down there. I didn't get into their history in the movie, but those are people who have been everywhere, including both sides of the border. It's a very split tribe right now, with about four different outposts, stretching from the Midwest to Kansas to Oklahoma to Texas to Mexico. The idea is that he was a friend of Buddy Deeds, who was a veteran of the Korean War, so Wesley may or may not have also been a veteran. It's not unusual to go into an Indian reservation and find that most of the guys have been in the army just for something to do. There are an incredible number of VFW posts on Indian reservations.

For me, what's important is when Wesley says, "I tried living on the reservation, but I couldn't take the politics." Reservations are extremely political, with very tough infighting, and what he has decided to do, once again, is to take that individual accommodation. Where you see him is, as he says, "between nowhere and not much else." He is extremely isolated, and he happens to like that, but that's where that choice can take you. The choice to escape the politics, to escape history, to escape that struggle and to do the antisocial thing, can leave you enormously isolated.

He is very self-possessed, and he seems fairly content, so he is the upside of that kind of isolation, whereas Bunny, the ex-wife of Sam Deeds, is the opposite of that. She's kind of like the Ghost of Christmas Future, she's the person who has not escaped her family history. She's somebody who is a warning to Sam. In twenty years she's going to be in that room, bouncing off the walls, talking about how, "I loved my daddy, I hated my daddy." He'll be five years dead in the ground, and she will still be living in his shadow, and she's never going to get out from under it.

She's almost like a throwback to what would have happened to Mary McDonnell's character in *Passion Fish* if she hadn't come back to the world of human relationships. Her strongest personal relationship, other than the one with her father, is going to be with the Dallas Cowboys, who are always going to be there for her. They are cyclical, and, in a way, outside of history. They will always be there, and they don't have to know that she's there for her to feel like they care. So she has escaped in that way. I've often used the metaphor, in *Brother from Another Planet, Passion Fish,* and *City of Hope,* of television as a drug. Some people are addicted to alcohol or crack, but for others that fantasy world, that received world of soap operas or football or whatever, becomes a constant electronic drug that's available to you.

Cineaste: *This is the first feature that you have shot in Super 35mm format. How did that decision relate to the visual style of the film?*

Sayles: Super 35mm basically is just a different way to get a widescreen look. We shot widescreen on *City of Hope,* and, in that case, it was a practical decision because we were switching between all these characters. We were very crowded sometimes, with two people in the foreground and three people in the background, and we needed more room for them so the image size didn't get too small. We could keep the image size fairly big on them and fit more people on the screen, because we were doing so much trading in the master shots, which was a stylistic thing which distinguished *City of Hope.*

One of the things we wanted to do in *Lone Star* was to show the horizontal look of the border. It's not mountainous, it is a very long, absolutely flat horizon line, and we wanted, at least in the beginning of the picture, to isolate people in that flat, wide land. It takes about a county's worth of acres to raise a hundred head of cattle down there, and widescreen gave us that feeling of just a few people fighting over that little thin strip of river where the good land is and which is surrounded by scrubby desert. Super 35mm is just a different way to get a widescreen look where you use regular lenses, but because you use more of the frame, you don't have to hang quite as much light. Making an ambitious movie on a low budget, you have to move a little faster.

Note:

[1] A reference to the incest motif in Gabriel Garcia Marquez's classic novel *One Hundred Years of Solitude.*

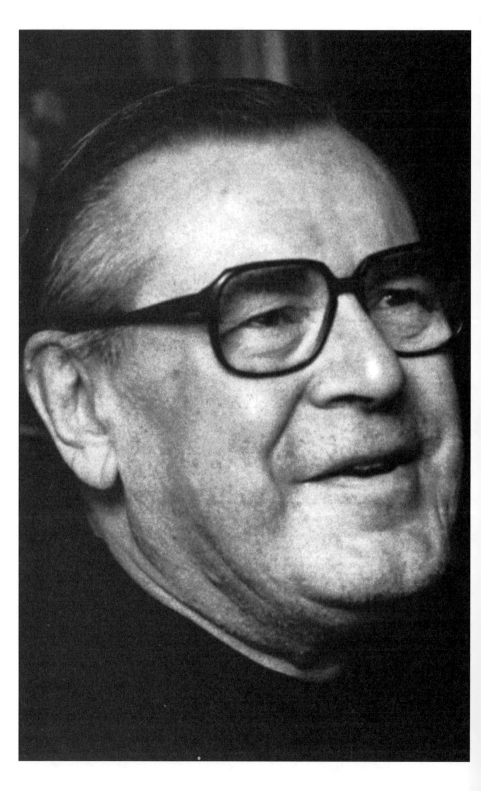

22 MILOS FORMAN

Porn Again

The controversy inspired by Milos Forman's The People vs. Larry Flynt *has focused attention on one of America's most notorious pornographers and* Hustler *magazine's virulent misogyny. Unfortunately, this ongoing debate has yielded considerably more heat than political or moral illumination. Distinctions between* Hustler's *frequently vile brand of porn, First-Amendment issues, and Flynt's personal life have become hopelessly blurred. Gloria Steinem, for example, points out that* Hustler's *fondness for simulated rape and torture—a truly peculiar notion of erotica—is unquestionably degrading to women. Yet her understandable impatience with attempts to brand Flynt a "free speech hero" does not negate the fact that the smut peddler's censorship battles have, however unwittingly, helped to safeguard the rights of his opponents, whether antipornography feminists or right-wing fundamentalists.*

From an equally problematic perspective, Laura Kipnis (a Marxist as well as a feminist), hailed Hustler *as the most class-conscious mass-circulation publication in the United States and expressed a surprising admiration for its "Rabelaisian" humor. Kipnis's vigorous devil's advocacy of this much-reviled publication is certainly provocative, but her argument either ignores—or subtly apologizes for—most of the repellent images usually cited by* Hustler's *detractors. In her view, Flynt's obvious contempt for Church and State takes precedence over his penchant for depicting women as naked trophies.*

These polemics at least raise complicated, and often disturbing, issues. The People vs. Larry Flynt *, an enjoyable and well-crafted entertainment, skillfully avoids confronting most of them. Affirming its status as an archetypal Hollywood product, the film airbrushes the contents of* Hustler—*a perverse, rags-to-riches saga commemorating a country bumpkin's triumph over the forces of repression and sanctimoniousness is more palatable fare for a mass audience. Scott Alexander and Larry Karaszewski's witty script (more a skillful series of interwoven vignettes than a traditional biopic) and Forman's unerringly empathetic direction of his cast (Flynt is played with intelligent restraint by Woody Harrelson, while Courtney Love gives an astonishingly convincing performance as his fourth wife, Althea Leasure) prevents* Larry Flynt *from being nothing more than a static panegyric to the First Amendment.*

Cineaste *editor Richard Porton interviewed Forman in November 1996, a little over a month after* The People vs. Larry Flynt *'s premiere at the 1996 New York Film Festival and a month before its commercial release. Pausing periodically to puff on his cigar, the director, obviously happy about the advance praise for his first film since 1989's* Valmont, *talked passionately about his fondness for improvisation, the travails of casting a film, and the evils of censorship.*

Cineaste: *Did Oliver Stone originally plan to direct* The People vs. Larry Flynt?

Milos Forman: The authors told me they had a bad experience with Columbia Pictures during *Ed Wood.* They said to themselves, "Let's first present it to Columbia. They'll certainly turn it down, but we'll learn the art of presenting. Then we'll go somewhere else." They were so sure that Columbia would turn them down that they simultaneously sent it to Oliver Stone. To their amazement, Columbia said yes. Meanwhile, Oliver said, "I don't want to direct it, but I'll produce it." Columbia and Stone then joined forces as producers.

Cineaste: *Was it a relief to work on a film which was not an adaptation of a novel or play, given the fact that critics and audiences often compare these movies to the original source and authors feel possessive about their work? For example, didn't Ken Kesey give you a hard time during the filming of* One Flew Over the Cuckoo's Nest?

Forman: I never met Ken Kesey, but I respected him very much. When I joined the project, the producers and Kesey were no longer on speaking terms. As much as I admired Kesey, I think he was wrong. I read a script that he wanted filmed. It was not really a screenplay, but another version of the book. From what I was told, Kesey not only wanted to write the screenplay but also wanted to direct the film and play McMurphy. I was a little confused.

I was also a little nervous with *Larry Flynt,* because little changes are made when the actors come in and the locations are found. I am not trying to rebuild reality so it fits the screenplay. If the screenplay doesn't fit reality, I want to rebuild the screenplay. I was afraid about the authors' reaction, but they were very open to changes.

Cineaste: *Unlike many scripts, it reads very well on its own.*

Forman: The script is wonderful. When I joined the project and learned how much material the writers had gathered, I realized it could have been ten movies—a whole life. To sift through it and find a structure was a challenge. It's not an ordinary, boring biopic, stuttering from one episode to another. They really built an ingenious structure. Even if I changed the names and it was not about Larry Flynt, it would still be a wonderful screenplay.

Cineaste: *How did your collaboration with the screenwriters shape the final film?*

Forman: It was a wonderful collaboration, and they felt that I genuinely

liked their work. They didn't consider me an enemy. We worked first on cutting it down to a reasonable length. The script was good, but it was overwritten. That's fine, because you have something to work with. So we worked together on the final structure, shrinking the story slightly. The whole script would have been a three-hour film.

Before I start shooting, I always like to act out the whole script with myself and somebody else playing all the parts. The writers played this ping pong with me. We went through the script so we could say aloud the lines and hear if they sounded right and rang true.

Even during the shooting, I discovered that Woody Harrelson, Courtney Love, and Edward Norton all had this rare talent for improvisation. After they learned the lines by heart, I started to encourage improvisations. I respected the writers so much that I always called them and told them what was happening and how improvisation affected the scene. This helped convince them that the writers and the director are a team, coauthors and not adversaries.

Cineaste: *Perhaps it helped that you were originally a screenwriter yourself.*

Forman: That's correct. I have enormous respect for writers, because I started as a screenwriter and I know how it feels when you spend weeks and weeks on something, and then, without much responsible stream of thought, somebody else starts changing things around and then blames the author if it doesn't work.

Cineaste: *According to what I read, your major disagreement with the authors concerned an elaborate fantasy sequence which featured Flynt's "born again" conversion.*

Forman: Yes. If you told me that you had a vision and that you converted to God, I would believe you, although perhaps with reservations. But if you start telling me something that is totally beyond my imagination—how Jesus Christ appeared to you, as well as Lenny Bruce and some other characters—then I'd think that you were on some kind of acid trip. That's why I suggested that they try to give hints of this conversion in some visual way, without trying to convince the audience that Larry Flynt really saw Jesus Christ and Lenny Bruce and other characters. So that was one thing. The other thing was probably a lesson I learned when dodging the censors in Communist countries. I learned not to put labels on the characters by saying, "This is a good guy, this is a bad guy"—the socialist realist approach. Together, we just toned down the extremes, so the characters would become more nuanced.

Cineaste: *How much of the script was shot and then discarded?*

Forman: There are certain scenes which were shot but are not in the film because of dramatic structure. The character of Dick Gregory just didn't contribute anything to the narrative, for example, so it didn't make any sense to keep him or the scenes featuring Larry Flynt running for President. Those scenes were shot, and I liked them very much, they're very funny, but all the antics Larry Flynt performed paled in comparison to the fact that he was running for President. It didn't have any payoff. Audiences would have assumed that this was

the nitty gritty of the comedy or tragedy, and nothing really happened—it fizzled. Those scenes went out, because they made the film stutter and made it long. That was very disappointing when I was putting the film together, but it was entirely my decision, not because of pressure from the studio.

Cineaste: *I gather that you've been improvising with actors since you first started making films in Czechoslovakia. Are you continuing the techniques you pioneered with those early films?*

Forman: It worked for me then, that's why I'm trying to make it work for me here. And it already has—certain parts of *One Flew Over the Cuckoo's Nest* were improvised, like the first meeting with the superintendent and McMurphy. Since it worked wonderfully, I felt encouraged to try it again. Courtney, Woody, and Edward showed incredible talent. It's not very often that an actor can, with the same credibility, memorize the lines from the script and then improvise—not as an actor, not as Woody or Courtney or Ed—but as the character.

Cineaste: Valmont, *on the other hand, seemed to employ a very tight script which allowed little room for improvisation.*

Forman: Yes, this film was very different from *Valmont* or *Amadeus,* although even in those films I tried to make the language more comfortable to today's ear. Still, the language is slightly different. It was eighteenth-century language, and that's very difficult for anybody to improvise.

Cineaste: *That brings us to the casting of the film, something you always seem to regard as a very important task.*

Forman: Casting is *the* most important element because, after all, that's what the audience sees on the screen, and these are the people I'm asking the audience to believe. To cast right is, for me, ninety percent of directing. If I cast right, I can work less.

Cineaste: *You've continued the practice of mixing professionals with nonprofessionals that you began with your Czech films.*

Forman: Yes, especially in this case. I always try to cast people who I think will bring some sort of electricity to the set, which helps everybody else. For example, when we have Donna Hanover Giuliani, New York City's First Lady, playing Ruth Carter Stapleton, everybody is excited. "That's Mrs. Giuliani, that's great." Everybody works better. The same thing was true with James Carville and D'Army Bailey, the legendary judge from Memphis. It was also very exciting for people to have Larry Flynt playing a judge. That was one of the reasons to opt for nonprofessional actors.

Cineaste: *Does this interest in using nonprofessionals come from your early interest in neorealist films such as* Il Posto?

Forman: In Czechoslovakia, we weren't reacting to the films made by Hollywood directors such as Ford and Wilder. We were responding to the stupid and phony films that the Communist Party was asking for. This thirst for credibility was a response to that phoniness.

Cineaste: *Is it true that Czech President Vaclav Havel was instrumental in choosing Courtney Love for the role of Althea Leasure?*

Forman: Well, I wouldn't say instrumental. Now, after the fact, everything seems to have been easy. I go through insecurities and doubts when I'm making these decisions, so what I like to do, when I confront crucial questions like casting the main characters, is to make screen tests and then show them to my closest friends and ask for their opinions. In the case of Althea Leasure, I had three candidates, three young ladies who were equally wonderful and each very different. Although, my heart was already going for Courtney Love—Rachel Griffiths and Georgina Cates were the others—I was not sure that I was making the right decision, that maybe I was seduced by her personality, not her professional ability. I showed these screen tests to a few people, including Havel, and I was very happy that he enthusiastically voted for Courtney Love.

Cineaste: *Although she didn't have much experience as an actress, she apparently immersed herself in the role and greatly identified with this character.*

Forman: Courtney is probably the most fascinating young lady I ever worked with. It's not just that she imposed her own personality on the script, she also did an incredible amount of homework, and it shows. She saw every single TV clip of Althea ever shot. She met with many people who knew Althea when she was alive. Her personality blends and is transformed by Althea's so perfectly that you don't see the seams.

Cineaste: *One noteworthy thing about this film is the cinematography by Philippe Rousselot, while many of your previous films, both in the U.S. and Czechoslovakia, were shot by Miroslav Ondricek. What was the look you were aiming for?*

Forman: When I was preparing this film, Ondricek was already signed to do another film, so I couldn't use him. I didn't know that the man who shot *A River Runs Through It* was a French guy. I just liked the look of that film, the simplicity, tastefulness, and cinematic vision.

I only require two things from a cameraman: the colors must be right—black must really be black and not gray—and human flesh must look like human flesh. The faces should not be red or yellow. It's not very easy for a cameraman to achieve that, but everything falls into place if he does. Something you can't really discuss very precisely is the fact that the cameraman has to know at every moment what you are trying to convey to the audience. It's difficult to tell him how to light, but it's very important that he knows that one scene is supposed to be dramatic and others are supposed to be funny or lyrical. Philippe was very sensitive to all of these things. The whole film suffers when you don't have a good relationship with a cameraman. The actors subconsciously feel the tension.

Cineaste: *It's intriguing that, although Larry Flynt is a well-known figure, he almost becomes something like a fictional antihero—not unlike, say, McMurphy in* One Flew Over the Cuckoo's Nest.

Forman: I would rather compare him to Mozart in *Amadeus*, because that film had the same sort of surprises and problems. In the case of Mozart, I knew only half of his personality, which was very boring. All I learned about Mozart

at school was that he was an obedient little boy, a prodigy at school, composing this divine music and being well above the nastiness of human character: a role model put on a pedestal garbed in marble. This made him so boring that even his music became less interesting. Suddenly, when I read the play, I asked Peter Shaffer—"Is this true?" And he said, "Read Mozart's letters." Then I discovered that this genius had a second half that was much less admirable, but was much more flamboyant and childlike, even vulgar and obnoxious. The fact that the sale of classical music records rose one thousand percent all over the world after the film was released proves that showing this man not as a one-dimensional angel, but as a full-blooded human being with all his pros and cons, helped enormously to popularize what's good about Mozart—his music.

I went through the same process, but in reverse, with Larry Flynt. I knew only the sleazy side of Flynt, but I knew nothing else about him. When I finally read the script, my first question to the authors was also, "Is it true?" They said it was, and this was confirmed when I started to read articles about him. So all I did was to add the other half to this personality who lived only in a sleazy world. I discovered there was a second half to his personality that was admirable, almost noble, and that's what makes him interesting.

Cineaste: *You've often said that you're more interested in characters who are ambiguous, neither heroes nor villains.*

Forman: If someone is a clear-cut angel or a clear-cut devil, what else can you add that is interesting? But if you learn that this angel has a devil's hoof, that really arouses your interest and curiosity and confusion. It's interesting to deal with such a character, because if you discover that the devil is growing at least one angel's wing, it's suddenly so confusing that it's fascinating.

Cineaste: *How extensive was Flynt's cooperation with the project?*

Forman: He didn't have the right to veto anything in the script or interfere with the production. But I wanted to meet with Larry Flynt. First of all, as a courtesy, because I'm making a film about him. If someone was making a film about you, you'd want to know the details. Secondly, I wanted him to tell me all the factual mistakes that might have been in the script—places, dates, things like that—because I didn't want, in case the film should anger him, to give him any reason to attack us by saying something wasn't true.

We had a long, eight-hour script conference to which he came prepared as I never saw any actor prepared. Every page had meticulous notes. He didn't try to influence anything, even though he said that there was a lot in the script that was very embarrassing for him. But I said, "Well, if it's true, what can I say?" And he said to me, "Even if there are things in the script that I didn't say, if I *could* have said them, I have no objection at all. I'll object only if I think that I never would have said that." What happened after that was more amazing. He occasionally said to me, "I wouldn't say it like that." But when I'd insist that what was included in the script was better, more to the point or funnier, he'd reply, "You're the director, it's your responsibility, you do want you want." That was a great attitude.

Cineaste: *Were you attracted to the project because of your own experience with censorship under a Stalinist regime?*

Forman: Definitely, because I lived for a long time in a society where censorship was strong. And I know the devastating effect it has on the quality of life, not only for artists but for the entire society. With censorship, as I experienced it, life becomes very boring and society very cruel. There is no way you can talk about anything which the government doesn't want you to discuss.

Cineaste: *Why do you think authoritarian regimes are so nervous about pornography? What is the threat?*

Forman: They are not nervous at all, believe me. They are just using it to gain the trust of the population. It's not a threat, they know that. What's important is that to fight pornography will open the door for them, because nobody is against fighting pornography and prostitution. Once they have their foot planted firmly in the door of your home, it never stops there. What has to be recognized is that a censorship commission is not judging anything according to the law, but according to their taste. Whatever doesn't conform to the censor's taste is banned, and taste is so vague and indefinable. Suddenly, you find out the space inhabited by the "pervert" has become bigger.

If the Communists say that pornography and prostitution are poisoning the health of young people and exposing them to immorality, the same Communists can declare religion the opium of mankind. So Jesus Christ becomes a pervert, and because Beethoven wrote the "Missa Solemnis," he is a pervert. Then they discover there is a lot in Shakespeare that is inspiring dissent, so he is a pervert, too, because he talked badly about people who should be revered. That's poisoning the people's trust in the government; it's perverse, and it has to be banned. Finally, whoever doesn't conform to official government policy is called a pervert. So it starts with fighting pornography. Everyone applauds, and that only encourages the government to further the cleansing process and make it stronger.

Cineaste: *Do you see parallels between the former Communist government's policies and Falwell's antipornography campaign?*

Forman: Yes, absolutely. They are all calling for censorship—Charles Keating, as well. Look, if you think that this is something that can't happen here today, on television a few days ago, Bork, a man who almost ended up on the Supreme Court, called for censorship and suggested changing the Constitution and the First Amendment. The Founding Fathers were so wise in the way they formulated the First Amendment. There will be no law abridging freedom of speech and freedom of expression. It's so clean and simple. If they wanted to add some loopholes, it would have been very easy, but obviously they knew why they formulated it the way they did.

Cineaste: *Of course, it's part of the comedy of your film that the people who are upholding civic virtue turn out to be a lot sleazier than Larry Flynt.*

Forman: Don't use the word "sleazier," because that's again a question of taste. They are being hypocrites, because they're asking other people not to do things which they themselves are secretly indulging in. Keating is

known for having archives of pornographic magazines and videotapes.

Cineaste: *That was probably true of the Czech apparatchiks as well.*

Forman: Listen, nothing was more vilified in the culture during the Communist era than American movies. The only movies that the Communist President and his cronies screened at night at their castle were American movies like *Gilda*. Hypocrisy is endemic to this kind of climate.

Cineaste: *That kind of hypocrisy is featured in the movie when copies of* Hustler *are passed out by Charles Keating at the "Citizens for Decent Literature" meeting and the audience is obviously sneaking a peek.*

Forman: Of course, in Czechoslovakia we were very happy about that kind of hypocrisy, because it allowed us to see American movies. Since we were friends with the projectionists, after the Communist leaders had seen the Hollywood film and gone home, we would sneak in after midnight and the projectionist would screen the film for us.

Cineaste: *There were cracks in the system.*

Forman: Right.

Cineaste: *Could you explain the controversy with the original* Larry Flynt *poster, which depicted Woody Harrelson—clad in an American flag loincloth—crucified upon a woman's crotch?*

Forman: That was the decision of the MPAA. I don't like it , but I respect it. That was one of the ironies of this film, even if it's not very important. I like the new poster we have. But it's ironic that we were making this film about how dangerous and devastating censorship is, and how we must all fight it, and the first thing that happens is that our own organization—the MPAA—censors us. I talked to Jack Valenti, who I respect and whom I admire for many things he does for the movie industry. He explained his objections, which I still don't agree with. In order to protect freedom for our films, he said, let's not provoke them with a poster. What is important is to keep freedom of expression for the actual movies. There is enormous pressure in the Senate and the Congress from the right wing to establish some kind of censorship for films, television, and records.

Cineaste: *Would you ever consider going back to Czechoslovakia to make a film?*

Forman: No. This is the best country in the world to make a film, and I'm spoiled. To go back there and visit friends, yes; to work, no.

Cineaste: *You remarked once that you never could have directed* The Unbearable Lightness of Being.

Forman: I was offered that film, but in those times it was impossible to shoot a film in Prague. This is such a funny idiosyncrasy. I could shoot a Swedish story in Afghanistan or an American story in Australia. But I couldn't bring myself to shoot a Czech story outside of Czechoslovakia, because I would suffer at every step and think to myself, "This is not real. This is not Prague, these people don't look like Czech people, it's all fake."

Cineaste: *Are you still in touch with Milan Kundera? What was he like as a teacher?*

Forman: I see him from time to time, but he's becoming a more reclusive man, a strange bird. He was a wonderful teacher, the one who really excited us about reading books, and that's always important for a professor to do—to inspire the students to read, to actually look at a book. Reading is still enormously important, especially during this period when visual media are bombarding us all the time. He was the one who introduced me to Laclos, to *Les Liaisons Dangereuses,* when I was eighteen or nineteen years old. I fell in love with that book, and even then I thought of making a movie of it.

Cineaste: *Why do you think there was such an explosion of talent in Czechoslovakia during the Sixties?*

Forman: I finished film school in 1955. Before the war, Czech cinema was producing thirty or forty full-length features, a lot for a country of ten million people. In the Fifties and early Sixties, when the film school was producing new graduates, there was no work for us for several years because production dwindled to two or three full-length features a year. When Khrushchev denounced Stalin and produced the famous thaw, the door suddenly opened a crack. There were so many standing people before that crack that we just burst in, and it took an invasion of Russian soldiers to crush this rejuvenation of Czech society. I did not believe it was possible to reform Communism and have socialism with a human face. But we could at least use a certain relaxation, and we did.

Cineaste: *You were already here in the U.S., weren't you, when the Soviet invasion took place?*

Forman: At that moment I was in Paris, but I was already, with the permission of my government, working on *Taking Off,* my first American project. I couldn't really function as a writer in a language I don't fully understand. I like that film, but I understand why the audience really didn't like it. It was a very European film, an open-ended story. The American audience wanted to know what it was all about.

Cineaste: *Your current film seems to have contributed to the rehabilitation of Larry Flynt's reputation.*

Forman: I already explained to various people that if they have a different opinion of Larry Flynt after seeing the film, I don't necessarily want them to have a different opinion of *Hustler* magazine. I never bought a copy of *Hustler* in my life. I don't particularly like it. I think it's tasteless. But it's very important for him to be able to publish it, and for whoever who wants to read it to have the opportunity to buy it. It shouldn't be banned. That's censorship, and once that starts you never know where it will end.

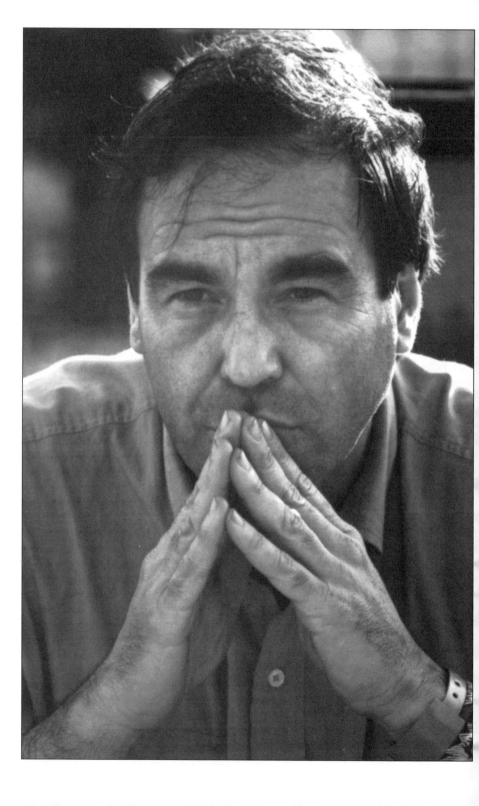

23 OLIVER STONE

History, Dramatic License, and Larger Historical Truths

Throughout his directorial career, Oliver Stone has tackled some of the most politically controversial and historically significant events in recent American history, including U.S. involvement in both El Salvador (Salvador) and Vietnam (Platoon, Born on the Fourth of July, and Heaven and Earth), the assassination of President John F. Kennedy (JFK), and the political rise and fall of President Richard Nixon (Nixon). As a testament to the provocative nature of his films, press coverage of them regularly spills over from the film review sections to front-page news columns, op-ed pages, and editorial cartoons. Indeed, in glib journalistic circles today, Oliver Stone's name has become a shorthand reference for a paranoid conspiracy theory view of the world.

Stone's films, especially historical films such as JFK and Nixon, have also become the subject of heated debate among historians, many of whom seem as disturbed by what they perceive as the director's "politically biased" agenda as by his misuse or disregard for "historical facts." It was this type of criticism, in particular an interview with historian Mark C. Carnes in the revised paperback edition of his book, History According to the Movies, which prompted a February 1997 interview with the filmmaker by Gary Crowdus and Dan Georgakas. In it, we wanted to not only give Stone a chance to respond to some of his harshest critics but also to explore some of the critical issues involved in making historical films.

Cineaste: *How do you define dramatic license?*

Oliver Stone: I think of dramatic license as a restaging of any reported action—reported, not necessarily factual—using actors, costumes, make-up, the condensation of events, and the invention of dialogue which occurred behind closed doors, to illustrate your conception of what occurred. What occurred, of course, is the big issue. As the historian Hayden White points out in his book, *Tropics of Discourse*,[1] the narrative interpretation provided by historians is definitely subjective, because there are simply too many facts to include in any historical work, so facts have to be deleted in order to give an interpretation.

Cineaste: *That's an important book. He also says that the facts have to be embedded in a narrative structure in order to make them comprehensible to the reader.*

Stone: And often for historians, the pattern is not clear, it does not emerge from the facts. But I also think we should put the concept of dramatic license in a broader context. Dramatic license is also what politicians use to start a war. The Gulf of Tonkin incident in 1964, for example, was finally revealed to be largely a fabricated event, so in that sense President Johnson was using dramatic license—and that's a fairly egregious example of it—to move the nation toward war. This event was hidden and buried for many years, and you'll still find people who'll argue about it, but there is no question that we provoked a lot of the North Vietnamese response with our commando raids into the north—raids which Johnson, not Kennedy, started.

Or how about the fourteen or so *Time* magazine covers during the Gulf War which demonized Saddam Hussein? That again is dramatic license, because not all the facts behind the Gulf War were revealed—who owns the oil, what are these cartels, who owns Kuwait? These questions were not dealt with in any depth. Whenever we go to war, media coverage of the war, especially in its early stages, involves dramatic license.

Mike Wallace and *Sixty Minutes* is another example that comes to mind. During my research recently for my Noriega script, I had a chance to see an old Mike Wallace interview with Noriega. Wallace was using dramatic license—because I know the facts about Noriega to some degree—and it was clear from the outset that Wallace had an axe to grind, that he didn't trust Noriega, that he hated him. He was saying the most outrageous things that wouldn't hold up today, even though Noriega is in jail.

In terms of my own work, I certainly don't feel that I abuse dramatic license. I do a lot of research, and I adhere to my own sense of integrity. That comes from the discipline of going to school and studying history and current affairs. I take it in, I absorb it, and I interpret it. I may be wrong in some of the details—you can't get it all right, that's for sure—because the details are very shifty. But certainly I pay attention to details and try to get them right.

Cineaste: *Would you ever create a totally fictitious character in a historical film for dramatic needs?*

Stone: Yes, I have. In *JFK*, for example, the character of Willie O'Keefe, who

was played by Kevin Bacon, is a fictitious character. I used him, because there were about five homosexual characters involved in the relationship of Clay Shaw with Oswald and David Ferrie. It was impossible, however, given the length of the movie and the complexity of that relationship, to describe five characters, and there was not one significant character from the five who stood out. In my mind, that necessitated a fictitious character to represent all five, to represent the basic conclusions of the five homosexuals that Garrison involved in the trial, and some of whom he'd gotten to testify.

Cineaste: *I think that's valid. I don't think that's a totally fictitious character. You've simply conflated several different people for purposes of dramatic necessity.*

Stone: I was very clear about what I did at the time, and even mentioned it in a footnote in the published script. Nevertheless, some critics made a big issue out of that in an effort to deny the whole movie, in the same way that others have called me a conspiracy theorist and compared my doubts about the official history of the JFK assassination to UFO theories or the belief that Elvis is alive.

Cineaste: *How would you define the difference between "historical accuracy," which historians often cite, and the "larger historical truths" that dramatists like yourself are interested in portraying?*

Stone: First of all, it's important to recognize that the initial history, history as we know it reported by historians, is shaped, in a very real sense, for the needs and perceptions of that generation. White mentions that in his book. If you look at American history, for example, you will find eras of historical writing that look at the American Revolution—or Washington or slavery—in vastly different ways.

A very strong case in point is the screenplay I've been writing on Alexander the Great. Alexander has been used by generations of historians, and always for different purposes. When he died, his reputation was totally denigrated by his enemies in Greece, and it took several centuries for him to come back into favor. When the Romans were into their imperialist phase, Augustus Caesar reinvented the cult of Alexander to justify his own imperial longings. Alexander was again reviled by some Christians during the Dark Ages and was then revived by the medieval romanticists. His reputation has shifted through every century right up to the present day. It's a fascinating trajectory, and it really reveals the subjectivity of history.

To get back to your original question, though, the larger historical truths that I think good dramatists go after involves dealing with the absence of a pattern in the historical record. If you look at Nixon, all the decisions are awash in forty-six meetings and four hundred phone calls—the man was an endless phoner, he would make calls all night to canvas the reaction, to do his own poll-taking. So every decision was the result of a lot of hesitation, doubt, of back-and-forth discussions, and in a movie we don't have time to show all those meetings and phone calls, so you go for a pattern, for a larger truth. A decision was made, so you simplify the decision-making process, you show the motive—as, for example, in our bombing of Cambodia scene—and you thereby imply

judgment on a character. Historical accuracy—or, to be more precise, *semi*-accuracy, which I doubt in any case—generally involves the absence of a pattern.

Cineaste: *But if, as Hayden White writes, all historians must of necessity rely on narrative and interpretive devices, and since the notion of objectivity in writing history has been pretty much demolished by historians such as Peter Novick,[2] what accounts for some of the more vitriolic attacks on your films by historians? Is it possible, as our Contributing Editor Robert Sklar wrote in his review of* Past Imperfect, *that what may underlay some of this hostility is historians' own sense of uneasiness over the extent to which narrative and interpretive elements are involved in their work?*

Stone: That may be the case. In one of his essays, White points out that historians, when attacked by other social scientists, will always say that, "Well, history is not a true science," but when they debate with artists or dramatists, they contend that history is a science, or a semi-science. It's an interesting strategy.

The concept of historian really began with the dramatists. Dramatists predate historians. The original historians—beginning with Homer—were dramatists, storytellers. We don't know what really happened in the Trojan War, but Homer certainly describes a great battle. Historians came into being, really, during Greek times, and they were highly subjective. They've been tearing Plutarch apart for years, but there's even some truth in Plutarch. There's truth everywhere, but you've got to dig at it. What you really need is a broad intellect that is able to take in contrary points of view, perhaps up to ten to fifteen different points of view, and to synthesize them.

Cineaste: *I understand that you received a surprisingly positive reception recently at the American Historical Association here in New York.*

Stone: Yes, I participated in a panel discussion with George McGovern and Arthur Schlesinger, Jr., on *Nixon*, the movie and the history. It went very well, although I don't think one positive reception indicates any sort of rapprochement between historians and filmmakers. George McGovern was very supportive. Schlesinger was very dry. He was very much the professional historian, criticizing the movie as all nonsense and illusion. "There are facts," he said, "and here are the facts." He was questioned by other historians about some of the facts in his own books on JFK, such as the omission of the Guyana situation and the removal of Cheddi Jagan, for which he had no answers. A sort of interesting wave of antipathy was evident.

Cineaste: *Was it a younger audience?*

Stone: It was mixed. After the meeting Schlesinger said to me, "You're a great filmmaker but a lousy historian." I felt like saying, "Well, you were a great film critic at one point"—he used to be a film critic, you know—"but unfortunately as a historian I think your earlier work was better."

Cineaste: *As a result of your various debates with historians, do you think they've learned anything from you, and, vice versa, have you learned anything from them?*

Stone: Whenever we talk, whenever there's a rational debate, instead of

posturing for the camera, I do find something positive happens. On the other hand, I've found that the TV interviews I've done end up distorting what I've said. I'll do an hour, for example, only to find that they cut it down to a sensationalistic four or five minutes. I won't even mention Dan Rather because he took such an extreme position on *JFK*—he attacked it three times in a so-called objective national broadcast.

Sam Donaldson was a very nice man—fun to be with, kind of a character—and he did a long thing on *JFK*, including filming me at Kennedy's grave at Arlington, but when it came down to his show, *20/20* or whatever it was, it was like he was going for the jugular. In the movie we said that, at the time of the assassination, the phone system was down in Washington. Well, he learned that only part of the phone system was down, but as Fletcher Prouty told me, it was a key part of the system that involved a lot of the government offices. But on his show he remarked that, "Stone even got this wrong about the phone system," which is a minor detail in the film.

More recently, Bob Costas did the same kind of thing on *Nixon*. He did another hour-long interview with me, during which he was very sweet, but when it was edited he also went for the jugular by taking stuff out of context, such as the famous scene of John Dean meeting Howard Hunt on the bridge for the payoff. We acknowledged to Costas that that meeting had not occurred, but he cut to Anthony Hopkins saying, "Well, it was in Nixon's imagination." I never said that, but Costas put those words in my mouth by using Anthony Hopkins, instead of using my characteristic answer, which is that the result is the same—a payoff was made to Hunt. Actually, Dean used an intermediary who used an intermediary to contact Hunt's intermediary. Well, since I was getting to the end of an already very lengthy movie, I didn't want to introduce three new characters to make the payoff, so I took the dramatic license of simply showing the result, which was showing the two men on a bridge and Dean making a payoff to Hunt. For Costas, however, that scene implied that the whole movie was off.

Cineaste: *That kind of criticism is so incredibly naive about the way movies are made.*

Stone: It happens all the time, because they are working on a very primary, naive level.

Cineaste: *It's perhaps more understandable to see TV journalists operating that way, but it's considerably more disturbing to see the same kind of hatchet job in a presumably reputable professional magazine like* The American Historical Review. *Have you read Joan Hoff's review of* Nixon *in their October 1996 issue?*[3]

Stone: Yes, I did. Although her review was one of the worst, I must say that sort of thing washes off me now. One thing historians or academics always say when they do their hatchet jobs, and this includes film critics as well, is to grant that Anthony Hopkins and Joan Allen are great, but that the director stinks. They separate actor from director, but to me that is inconceivable, because any serious director who works on a movie, from beginning to end, is organic with the actor. The boundaries between director and actor vanish, they dissolve.

Joan Hoff really doesn't know much about films, so in praising Hopkins and Allen and separating them from the director, I think she made a fundamental mistake. What she likes about Hopkins is precisely the fact that she liked the film but had to hate it because of an agenda she had against filmmakers intruding on her historical territory.

Cineaste: *The editor of that magazine's film section, Thomas Prasch, claimed in the same issue that you were contemptuous of and dismissive of historians.*

Stone: Prasch is just wrong. I studied European and American history extensively in school, it was my favorite subject, and I continue to read history. I do admire many historians, such as Howard Zinn, Alan Moorehead, and dozens of others. That's not to say that I buy them 100%, either, any more than I do a movie. In a book, however, you can go into far more exhaustive detail and depth, and you can sell your argument a lot easier. I always doubt a history book, however, until I've looked at another one on the same subject.

When I wrote *Nixon*, for example, with Steve Rivele and Chris Wilkinson, our three markers, from the right to the left, were Jonathan Aitken from the right, Stephen Ambrose from the conservative center, and Fawn Brodie from the left.

Cineaste: *You chose not to get into some of the more sensationalistic analyses of the Watergate affair, such as Jim Hougan's* Secret Agenda.[4]

Stone: Yes, I read Jim's book, and I think we met him, too. It's an interesting theory, but I doubt it. If I didn't, I wouldn't have backed away from it.

I do believe fundamentally that Watergate was about this Larry O'Brien and Howard Hughes business, the accumulated secrets gathered over the years by O'Brien from Hughes. Hughes is a key figure here, but I hardly mentioned him in the movie because, ultimately, this matter is shrouded in mystery. We will never quite know. Nixon is dead, Howard Hunt didn't know what he was doing [*laughs*], nor did Liddy. They were all pawns, mechanisms, like Lee Harvey Oswald, and it's hard for them to see the big picture. I don't know that even Nixon saw the big picture, because, like Henry II and the assassination of Thomas à Becket, he had put something into play that his minions carried out.

The key element, the key theme in the film, for me, is the sense of secrecy surrounding Richard Nixon, the sense of Secrecy, capital S, and the sense of Lie, capital L, that comes from a deeply ingrained psychohistory. In that regard, I think the deaths of his two younger brothers was the key turning point in his life. There was a tremendous love for those two brothers, they were the movie stars of the family, so to speak, and Richard always lacked the charisma those two boys had. It's so weird that, later in life, Nixon intersects with two other charismatic brothers who also die under very violent circumstances. It plays as a bizarre echo in his life, and I think it's really the basis for an investigative study. Surprisingly, no one in any of the histories that I read has pointed out this duality. As a scriptwriter, though, I saw it and felt it was the key issue to get into, along with the issue of the mother, and mother vs. Pat.

Nixon, of course, is an extremely enigmatic character. Historically, we're still trying to figure him out, and it will take a long time. Kissinger, with his memoirs, is fighting for his own place in history, but we know from other histories of Kissinger that a lot of what he wrote is just untruths. Nixon was a master revisionist of his own history and wrote six or seven books after he left office, revising everything he had done. He was a master at that and was very conscious of his place in history, so we will have great difficulty in really understanding the "facts" about Nixon. Hopefully, these new tapes being released will provide some insight. Unfortunately, they're not getting transcribed and distributed.

Cineaste: *Only a tiny fraction of them have been released to date.*

Stone: Yes, only a segment, but an important segment. I think we're now up to, what is it, 200 to 300 or so hours? But we've got to get them transcribed, and the government is not providing that service. The newspaper coverage of them, if you noticed, discusses only some of the more sensational items, but I think there's a lot of stuff in there.

Nixon fascinates me. He was a reviled man, but part of me has always been for the underdog, and I went against the grain, not because I loved him, but because I don't like the idea of categorizing and simplifying people. A lot of people said I was more than fair to Nixon.

Cineaste: *In that sense, you should probably take credit for the fact that you took criticism on the film from both the left and the right, the left complaining that you were too sympathetic and the right . . .*

Stone: Yes, and a lot of people trashed the film before it came out, before they had even seen it, people like Bill Safire and Chris Matthews, who were really ugly. When I wrote a polite letter of protest about what Safire said about me, he wrote another column about it, and just destroyed me as some kind of paranoid, Nixon-like individual [*laughs*] who was trying to interfere with the freedom of the press. It was bizarre. I mean, you can't win with those thin-skinned guys. They sure dish it out, but they don't take it so well.

Cineaste: *As a result of the critical firestorm that greeted* JFK, *did you change your approach to historical filmmaking to any extent when you made* Nixon?

Stone: I don't know if I have the correct answer for that. To a certain degree, yes, because I had gotten burned a lot, and my sensitivities were hurt. I was reviled in many places, although I was praised in other places, but I certainly got killed by the media. It's like McCarthyism, like being the victim of a blacklist, and I definitely got singed.

I mean, I definitely recognize the importance of dissent. I was in the Soviet Union in 1983–84, when I was researching a screenplay on dissidents there, and I met twenty to thirty of these people in ten cities, and I was just blown away by their strength and their courage. I admired them, but I never thought that I'd be in a similar situation in my own country, within a few years, of being viciously attacked for the dissent that I've expressed.

Cineaste: *Perhaps you ought to consider it a sort of backhanded compliment. If you had made a mediocre film, no one would have cared. Remember, for example,* Executive Action, *a 1973 film on the JFK assassination, which sank without a trace?*

Stone: Well, thank you. I think perhaps I was more cautious in *Nixon*, and not necessarily for the better. *Nixon* was a more somber piece. John Williams, who wrote the musical scores for both films, perhaps summed it up best, because the *JFK* score was about blood and thunder, while the *Nixon* score was brooding, sullen, and very dark. I don't know if I pulled it that way because I was more cautious or just because Nixon took me in that direction. So I don't have the answer to that.

Cineaste: *In recent years, we've become used to attacks on you by journalists, by political commentators, by historians, and you've even become a favorite target of editorial cartoonists. It's been very surprising, however, to see filmmakers like John Sayles, Marcel Ophuls, and Bertrand Tavernier join the chorus of your critics. What do you think of their descriptions of* JFK *as "scandalous," "outrageous," "fraudulent," and the like? Aren't similar charges of "manipulation" and "brainwashing" somewhat hypocritical coming from any filmmaker, even a documentarian like Ophuls?*

Stone: I think in many of these cases the filmmakers have really not read the research on the JFK assassination, they have not been to the mountain of material accumulated. I think the true scandal is that the lie has been established by the Establishment, and they are buying into it. Ophuls should know better, because he has, in his estimable film, *The Sorrow and the Pity*, revealed the great lie about collaboration at the heart of French WWII history. I don't understand why he doesn't utilize that same intelligence on the JFK case. Perhaps as a documentarian he is outraged and offended that I used pseudo-documentary forms and techniques. I did so, as I've often said, to establish the very nature of reality as a veil, to show the trickiness, the illusion between what is fact and what is fiction, and what we have been led to believe about the Kennedy assassination. I was amazed that he would attack the movie. Perhaps as a Frenchman he doesn't realize that the Kennedy assassination is as significant in American history as the French lie about WWII.

In Tavernier's case, I gather he comes from critical circles, and his comments are voiced more like a critic, but I don't have an opinion about what he said. It just seems to me that artists should seek to understand one another, and not to broadcast or publish their opinions of other artists' films.

I'm really amazed at Sayles's comments, because I think it's very easy to condescend to another filmmaker and to assume that my motives are entirely manipulative. Perhaps Sayles should ask himself instead if my motives are not born out of passion and love for this country. I think what hurts me is that he assumes my motives are negative, which I find demeaning.

In any case, I don't feel that Sayles has done his research on JFK. If you do, I think you must conclude, based on the vast body of evidence available—the

Zapruder film, the autopsy in Washington, the witnesses, the Oswald and Ruby background—that anyone who doubts that Kennedy was assassinated by more than one shooter is in serious need of a brain.

Cineaste: *It seems to me that historians should, in a sense, be thankful to you because films such as* JFK *and* Nixon *have placed historical issues into a national public forum and have not only stimulated a greater interest in history but also, at their best, have encouraged more critical thinking about the interpretive nature of* all *historical representation.*

Stone: In my experience, the films do encourage people to read. I have received so many letters from people, especially young people, who say, "You made me go out and read more." I think we need this. Finally, it's about raising questions. You want to know more. A movie is like a first draft, it's something that engages the interest, but it has to work on its own terms, it can't work like a book.

Cineaste: *I also don't know any other filmmakers who have published extensively annotated and footnoted editions of their scripts, supplemented with historical documents, such as those you did for* JFK *and* Nixon.

Stone: Yes, those were huge efforts, and I wish more attention had been paid to the *JFK* one, because we gave the basis very clearly of all the facts we had researched. It was totally ignored by those publications condemning me.

Cineaste: *Do you have any plans for new historical films?*

Stone: I would love to make another one, I don't want to give them up, but certainly my ability to make another one has been damaged by the box-office failure of *Nixon.* The film was sort of ignored in general by the critics—some of them don't even look at my work anymore, they have such a blind spot about it— and from a commercial point of view, audiences didn't seem interested in a film on that character. They just didn't like him.

Nevertheless, I feel that I was really able to use the *JFK* capital that I got to make *Nixon* without censorship. It was tough to make, believe me, but we got it out. I know of very few filmmakers in America who have been able to do two wholly political subjects without compromise. I don't know, maybe its been one step forward, and two steps back—I don't know how it works—but maybe somewhere along the line I can make another one.

Cineaste: *What did you think of* Evita?

Stone: Well, as you know, I wrote a script for Evita; it was based on the play by Rice and Webber, but it wasn't translated in the proper way. I think it was important to establish the fact that she changes. She was too sedate in the first half. She should have been hungrier for power, more lascivious, more of a "hooker," and in the second half I wanted to see a real transition into what I think she became, which was a hero to the masses. So it's a very interesting duality there, a paradox, but I didn't see that in the movie.

Cineaste: *Any comments about the* Larry Flynt *movie?*

Stone: I think *The People vs. Larry Flynt* worked, but it got hurt because of the pornography issue. It's sad, because we really had high hopes for it. But

there it goes, another one gone up in the smoke of controversy. Controversy is not necessarily a good thing for a movie. I've always said that, but people don't believe me. Sometimes controversy makes people stay away.

It was a wonderful film and got wonderful reviews, but it got murdered at the box office, partly because of feminist protests and boycotts. I've received hundreds of the exact same postcards announcing boycotts of all my films by feminists. I mean, OK, don't go to see that one movie, but don't boycott all my films. That's the equivalent of saying, "Get out of town. You can't work in this business anymore." I think that that kind of absolutism—whether it's voiced by Jerry Falwell, Gloria Steinem, or Joe McCarthy—is like playing God.

Notes:

[1] Hayden White, *Tropics of Discourse: Essays in Cultural Criticism* (Baltimore and London: The Johns Hopkins Univeristy Press, 1978).

[2] Peter Novick, *That Noble Dream: The "Objectivity Question" and the American Historical Profession* (Cambridge and New York: Cambridge University Press, 1988).

[3] Although the review of *Nixon* by Hoff, of The Center for the Study of the Presidency, is quite short, she describes the film as "Oliver Stone's latest historical travesty," characterized by its "arrogant distortion of the historical record," in which he imposes on viewers his "paranoid, conspiracy-driven mentality," instilling more "cynicism and paranoia in the public," ultimately committing "the representational, pornographic rape not only of Nixon but of the presidency itself."

[4] Jim Hougan, *Secret Agenda: Watergate, Deep Throat and the CIA* (New York: Random House, 1984). Hougan's book contends that the Watergate affair actually involved sexual espionage involving the attempt to expose a call-girl ring, the clients of whom were the real target of the bugging operation.

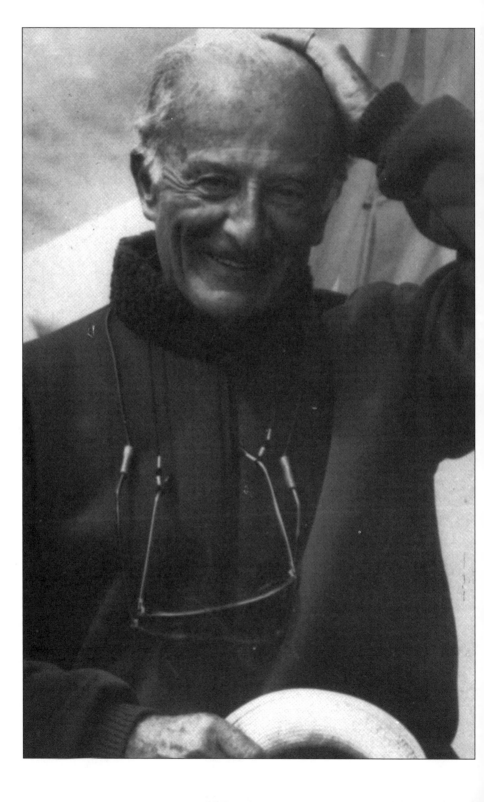

24 FRED ZINNEMANN

A Past Master of His Craft

Fred Zinnemann (1907—1997) was an Austrian Jew who was born in Vienna in 1907. He remembers the anti-Semitism of his school days: "At best we were treated with an ironic sort of politeness, but what I needed was human contact and respect." The young Zinnemann rejected medicine, his father's profession, and the law, which he studied at the University of Vienna, and—having been inspired by King Vidor's The Big Parade *and Erich von Stroheim's* Greed— *chose instead to attend an early film school, the* École Technique de Photographie et Cinématographie, *in Paris in 1927. He then worked as an assistant cameraman in Berlin before setting out alone for America in 1929, arriving in New York on the day of the Wall Street crash.*

The same year Zinnemann worked for Robert Flaherty on an abortive European project, during which he gained a lifelong respect for the documentary pioneer's independent spirit. His first credit as a director was for Redes *(The Wave, 1934), a Mexican government film that used the fishermen of the Gulf of Vera Cruz as nonprofessional actors to tell their own story. When the film was shown in Los Angeles in 1937, it won the young Zinnemann the welcome security of a contract with MGM, and the direction of eighteen short subjects over the next five years. After his first B picture,* Kid Glove Killer *(1942), he made a breakthrough with* The Seventh Cross *(1944), an A picture that Zinnemann thought particularly timely because of its recognition of the existence of "good Germans," albeit in a prewar setting.*

Zinnemann was briefly suspended after turning down successive assignments, but The Search *(1948) and the location-shot film noir* Act of Violence *(1948), his last film under his MGM contract, gained widespread critical and industry recognition.* Act of Violence *provides social substance to the generic conflict between light and dark, as Robert Ryan's figure from the wartime past undermines a sunlit Californian success story. More important, however, for Zinnemann's rising reputation, was his collaboration with independent producer Stanley Kramer, an association that produced* The Men *(1950),* High Noon *(1952), and the adaptation of the play* The Member of the Wedding *(1952).*

While some auteurist critics have seen Zinnemann's direction as impersonal, a more positive view would stress the strength of his commitment to notions of realism and authenticity within the classical Hollywood tradition and would explore his thematic concern with questions of individual conscience and identity. Gary Cooper as Marshal Will Kane and Paul Scofield as Thomas More have become classic icons of liberal cinema, while it was Zinnemann who fought Harry Cohn to secure the casting of Montgomery Clift as the doomed "lone wolf," Private Robert E. Lee Prewitt, in the Oscar-laden From Here to Eternity *(1953). Zinnemann's unglamorous depiction of the Army barracks setting in 1941 Hawaii contributes to a film that was a brave statement for its time, and which still works as a drama of how individuals cope, or fail to cope, with organization.*

Zinnemann's relative detachment is most successfully seen as a style of its own in The Nun's Story *(1959). The film's slow pace, the careful depiction of the rituals of convent postulants, and the different emotional tone of the African scenes, all provide an intensity to the interior struggle of Sister Luke (Audrey Hepburn). The ending, as her return to the world outside is treated neither as triumph nor tragedy, is a reflection of the director's ability both to be involved with his characters and to draw back from imposing a particular interpretation.*

Arguably this detached, observational style also makes The Day of the Jackal *(1973) an effective entertainment. A similar style is less successful in a drama with a weaker individual, particularly in* Behold a Pale Horse *(1963), in which the opening newsreel footage of the Spanish Civil War raises unrealized expectations of a stronger political analysis. The film nevertheless features an unusually sympathetic depiction of a guerrilla leader, played by Gregory Peck, who keeps the Republican flame alive from across the border.*

After the success of From Here to Eternity, *Zinnemann directed nine films in thirty years, before his retirement after* Five Days One Summer *(1982). A* Hatful of Rain *(1957) and* The Sundowners *(1960) were quietly received, and Zinnemann's comeback film in critical and commercial terms was* A Man for All Seasons *(1966), from Robert Bolt's classic play. There are striking images and performances here, although Paul Scofield's certainty and asceticism as Thomas More keeps the audience at a distance.* Julia *(1977) brought together Jane Fonda and Vanessa Redgrave, symbols of the Sixties left, in a lush rendering of a slight, supposedly autobiographical story by Thirties icon Lillian Hellman.*

Once, when Jack Warner was finding fault with Zinnemann's efforts to film Hemingway's The Old Man and the Sea, *the director sent this reply to his boss: "Will cooperate but request greater courtesy your future messages." The message captures the mix of charm and steel that observers of Zinnemann saw as characteristic of him. When* Cineaste *associate Brian Neve visited him at his London home in November 1996, just four months before his death, Zinnemannwas self-effacing but also fiercely proud of his achievement, an attitude that was in part a response to his awareness that critical opinion—if not*

that of leading directors—had in recent years moved against him. Nevertheless,
Zinnemann's virtues as a director—in particular his commitment to the human
consequences of his films and to the cinema as a collaborative art—have
become more evident as they have become rarer in contemporary filmmaking.

Cineaste: *Would you say that Robert Flaherty influenced your style?*

Fred Zinnemann: Flaherty wrote me a letter of introduction in 1931, and as a result I got a job at Goldwyn. He influenced me in every possible way, not only technically but also in what I learnt from him by being his assistant, his whole spirit of being his own man, of being independent of the general spirit of Hollywood, to the point where he didn't worry about working there. That's probably why he made only five or six pictures in his life. But he influenced me in his whole way of approaching the documentary, which he really initiated with films like *Nanook of the North.*

I learned from Flaherty to be rather uncompromising and to defend what I wanted to say and not let someone else mix it up. He had the true feeling of a documentary director—he took life as it was. This influenced me enormously, because I found myself almost subconsciously following his style in films like *High Noon, The Men,* and particularly in parts of *The Search,* which I made after the war. This was not really a documentary, but it was in a style beyond the then-fashionable approach, which involved a mandatory happy end and marriage as the solution to all problems.

So, first of all, my choice of subjects pushed me in that direction, and time and again there was a documentary kind of treatment—in *The Nun's Story, The Day of the Jackal,* and even *Julia.* I've always tried to base my films as closely as I could on the reality. Even in casting, if a woman was described, as in *The Search,* as a Czech, then I really wanted a Czech, not a Hungarian. There are so many subtle, subliminal things that go into making a film, that I have to insist on getting that particular kind of nuance from the authentic person, rather than getting an approximate idea of "virtual Czech" or "virtual Hungarian."

Cineaste: *I like* The Search *very much, especially the scene with the children in the ambulance who suddenly fear that they are being taken to their deaths and flee. Was that influenced by Italian neorealism?*

Zinnemann: It was influenced by Flaherty, not by the new realism in Italy. At that time nobody had even heard of Auschwitz, and very few people knew anything about what had happened in Europe. It was a new approach to picture making at that time. I think we were the first Hollywood company that went out on a distant location, because before then the factory process was much more strictly observed by the studios. They wanted to have complete control of making a film, so they avoided working on distant locations where conditions were not

controllable by the studio. They would send out a second unit to photograph a background, bring the background material back, put it on a screen, and then play the action in front of it. So you could get a Chinese rice field with a non-Chinese actress playing Chinese. We could have made *The Search* in Hollywood, obviously, just as we had to make *The Seventh Cross* in Hollywood because it was wartime, and one could not go to Europe. But I learned all of that when I directed my first picture, *The Wave,* which was commissioned by the Mexican government.

The Wave was, in a sense, also a legacy from Flaherty because it involved people who were friends of his, like Paul Strand. The director, Henwar Rodakiewicz, had a conflicting commitment and asked me to take over. The government at that time was liberal. It was just before the great Mexican President Cardenas, who was himself an Indian. So what we were doing was following the government's socialist program. I was at that time still politically naive, but what I found exciting was that it dealt with oppression. I had always thought that human rights were above property rights, but I belonged to no party. I was never politically organized.

Cineaste: *Were you happy with how* The Wave *turned out?*

Zinnemann: I was surprised that anybody wanted to look at it, because at the time I had no idea whether I communicated with anyone. It was an experiment. So I was very pleased that there was that much attention given to it. But I was not pleased with the ending. The earlier part was better, and I was very happy to be working with fishermen who were not actors but fishermen. It makes a hell of a difference, even down to the way they tie their knots. This, to me, is the essence of picture making.

Cineaste: *Were you impressed at this time with Soviet filmmaking, and especially with Eisenstein?*

Zinnemann: Enormously, yes. Eisenstein, and *Potemkin* especially, was important in my development, not only because of the concept of montage in shaping the film but also because it was about oppression.

Cineaste: *What aspects of* The Seventh Cross *appealed to you?*

Zinnemann: *The Seventh Cross* was bought by MGM and written by Helen Deutsch, who was a good writer. It was at a time when we were fighting Germany, and every German in the eyes of the American people was a monster. The book and the film made the point that even in Germany there were people who had the courage to go their own way and stand up against what was happening. I thought that was very important and exciting. Of course, the fact that Spencer Tracy was playing the lead made it even more exciting, because I was still really an apprentice. You see, I go by the old idea of guilds, in which there are three stages. You are first an apprentice, then you become a journeyman, and, if you are still in one piece, you eventually become what they call a master. This sounds pretentious, but it is a fact that at that stage you have

more or less mastered your craft. I do not particularly like to think about myself, but having done so, I feel that my apprenticeship was over after I had completed *The Search*. When I returned to America I made *Act of Violence*, and I felt that I already knew what I was doing, rather than going by instinct, as before. From *Act of Violence* until the end of *The Men*, I was a journeyman, and after that, for better or worse, I felt that I had arrived at where I was the person in charge. Maybe those early days were really the best, who knows?

Cineaste: Act of Violence *has a distinctive look to it, with the location shooting and high-contrast lighting.*

Zinnemann: The cameraman, Bob Surtees, was a brilliant photographer, and an old friend I had known in Germany. We got to know each other in 1928 when we were both assistant cameramen and used the same dark room. Bob was a very creative, marvelous photographer, one of the best that I worked with. I've had good luck working with wonderful cameramen. Another interesting thing—you don't mind if I ramble?—is that directors normally like to work with one cameraman and stay with him, like John Ford and Gregg Toland, and so on. People have asked why I did not do this. The answer is that I cast cameramen like casting actors, in terms of the style of the picture and what I hope the photography will bring to it.

If you make a picture like *High Noon*, and you want to make it feel like the world felt in the days of the Civil War in America, that kind of gritty, dusty feeling, you had to get a cameraman who knew how to handle that, like Floyd Crosby, who was not the greatest man to photograph a woman. But if, on the other hand, you had a picture like *Julia*, where you had two actresses who were close to forty, or just beyond forty, and who had occasionally to look like teenagers, you had to have a very good portrait photographer, and that was Douglas Slocombe. He was a wonderful cameraman, and great at this kind of romantic, warm feeling. Had *Julia* been photographed by Floyd Crosby, it would have looked totally different. So I changed cameramen as the material dictated.

Cineaste: *What was the political atmosphere like in the late Forties? Was it a great shock when the House Un-American Activities Committee began its hearings on Hollywood in 1947?*

Zinnemann: One could not say that it was a shock in terms of surprise, because everything was moving towards that. There was increasing tension, brought about by the fear in America of the communist conspiracy, the notion that there were lots of communists under the bed. In fact, there were quite a few crypto-people, most of them not even card-carrying members. But there was a tremendous suspicion, and the American people in normal times are not suspicious. The McCarthy thing did not come as a surprise, but it developed gradually as his speeches and radio appearances went on. People became politically suspicious, and they were helped by many of the politically far-right. This whole

phobia about communism went on and on, and is still going on, although now they are called liberals. It was not a shock. It was something that one saw coming, just as one had a sense that war would be coming in 1939, when all the saber-rattling started to become reality.

Cineaste: *In Kenneth L. Geist's biography of Joseph Mankiewicz, the director H.C. Potter is quoted as saying that you were blacklisted for a time during this period, when your name was used by a group that was declared subversive, and that you appeared before an American Legion Committee to clear yourself. Can you confirm this?*

Zinnemann: Yes, probably. I'd forgotten that, but it may have been true. Many filmmakers were attacked at the time of the famous Directors Guild meeting. This was the meeting when John Ford, who was far right, turned it around and really destroyed De Mille and his whole group. At the height of the McCarthy business, C.B. De Mille and his group, who were the Board of the Screen Directors Guild, decided that all members should take a mandatory loyalty oath. First of all, they said that any new members should take it, but then they decided that everyone should, as an expression of loyalty to the country. Well, a lot of people felt that they did not need to demonstrate their loyalty and objected to the idea of being coerced into doing it.

There were then about 600 members in the Guild, no more than that. Of the 600, there were fourteen who said "No," who were, I believe, Communists. There were about 500 who voted "Yes," and about fifty-five or fifty-six who did not say anything one way or the other, including myself. So we then received a polite reminder from the Board, a letter saying that such and such a day would be the deadline, and please be sure to sign, which I did not do. Next there was a cable, which sounded very tough and very officious. Again I did not respond, and at that point scare tactics started, with people on motorcycles coming late in the evening, asking for the signature.

There were about ten to fifteen of us, with John Huston being very prominent at that point. The only thing we could do was to call for a general meeting, at which the whole membership would have to vote—a referendum in other words. But, in order to be able to call a general meeting, you had to be a member in "good standing," and what the C.B. De Mille people had done before was to pass a bylaw saying that in order to be in good standing you had to sign the loyalty oath. So, in the end, twenty-five of us signed this thing, and the well-known general meeting did take place.

It was a good feeling to stand up against these people, but of course you didn't know quite what was going to happen. It was all right for the very successful, who were sure of their jobs, but for the young directors, without a strong record in the industry, it was more difficult, because there was a blacklist. There was a bush telegraph among the studios as to what color you were—black or red or white. And it is possible that, in connection with that, I

went to the Legion, probably to sign that oath, without which the meeting could not have been held.

It is curious that I don't remember it. I am sure that it must be true. Certainly there was never any question of being asked about names—ever. In order to call a general assembly of the Guild the rule was that there had to be twenty-five directors in good standing who could ask for such a meeting. And in order to be in good standing you had to sign the loyalty oath. Which is why Potter and I and a number of others signed it, not for any other reason.

Cineaste: *Did the political pressures during that period make it more difficult to make more realistic or socially conscious films?*

Zinnemann: Generally, very much so, but in my case, no. I don't know how it happened, but I know that at the time that we made *From Here to Eternity* the Army was absolutely sacred because of Korea and the victory in WWII. So one would have thought that to make a picture like *From Here to Eternity,* which was critical of what went on inside the Army and what it did to individuals, would not be possible. Except that Harry Cohn, who was a very bright showman and someone with a sense of what the public would accept, bought the book. Everyone thought he was crazy. It took him two years to get a reasonably good script—in fact, it was a very good script—by Daniel Taradash. Then I was asked if I would like to direct it, which at the time was amazing, because it was the prize assignment of the year at Columbia.

I was not aware of any overt difficulties, except certain things that the Army could not live with. They did not want us to show what happened in the stockade where Sinatra got beaten up, which was fine with all of us because you saw the result of it, with Sinatra coming out and falling dead. The other thing was that the real villain of the piece, the captain (Deborah Kerr's husband) was promoted to the rank of Major in the book. The Army insisted that he get his comeuppance, by either resigning or being court-martialed. So this was the one, unavoidable compromise, but it was worth making, because I could not have made the picture without professional soldiers who knew how to march and drill. If you had a lot of extras slouching around, it would have been nonsense. We also had the free run of the entire location in Hawaii where the thing really had happened. But those were the only difficulties we had with the Army. We had some problems with the Church, but they were very understanding about the beach scene, which was very startling at the time.

Cineaste: *When you made* High Noon *were you aware that Carl Foreman intended it as a comment on Hollywood in the McCarthy period.*

Zinnemann: No. I read much later that Carl saw the piece as an allegory of his own personal experience. I did not think of it in political terms. To me the film was about conscience and degrees of compromise. Most people, when they encounter such a situation, will rationalize their way out of it, they will always have a reason why they can't help. This was the main theme, from the coward,

to the man who really would help if he were not the only supporter, as against the drunk and the kid, who are so out of touch with reality that they want to help the Marshal.

Cineaste: *How did you regard people such as Elia Kazan and Clifford Odets, who named names?*

Zinnemann: It is hard for me to say, given that I was not in the same situation. I hope I would not have done it, you know, and I hated it. Maybe they were weak, but you can't judge other people unless you really know what's behind it. Eventually you find out that they were victims of something that may have happened when they were small. The whole question of why somebody is a criminal is difficult. You can't just sit and read headlines in a newspaper and be sanctimonious about it. So I don't approve of Kazan or Odets at all. In Kazan's case the important thing is that he made some fantastic pictures and contributed a tremendous amount, in theater and film. At the same time, I admire Arthur Miller very much, given the way he behaved at the time.

Cineaste: *Was the crane shot, towards the end of* High Noon, *unusual at the time?*

Zinnemann: It's curious, but although it is a shot that technically would have been possible before, I don't remember ever having seen anyone do it that way. I wanted to express the fact that this man was totally abandoned by everybody, and all doors were closed to him. He had nowhere to go, except to face the music. In the last analysis, I am a visual person. I'm not very good with words but I think I can express things visually that somehow connect with the audience, because audiences seem to remember them for a long time.

The crane we used was an enormous monster which could be rented for the day. Across the street George Stevens was shooting *Shane*, I think. We borrowed it from him for a day, and it needed ten people to move it. Now you could do it with a zoom shot, but it would not be the same thing.

Cineaste: *After the success of* From Here to Eternity, *why did you choose to make* Oklahoma!*?*

Zinnemann: Because I was offered it, and I found it fascinating to try a new medium, this huge screen. And to work with Rodgers and Hammerstein was a great pleasure. Looking back, I'm surprised that they picked me—it had no logic. They did it because I was a "hot" director at the time. *Oklahoma!* had come out on the stage during the war, at a time when everyone was very depressed. Suddenly there was this gorgeous music, and this upbeat feeling about the world being a great place, and everyone took courage from it. So everyone had a good deal of affection for this particular musical, even though it has no story, other than that of who gets to take the girl to the dance.

Cineaste: *It is very difficult to see now in the original Todd-AO format.*

Zinnemann: You can hardly see it in that form. It was criticized at the

time, by those who said that it was much too big, that you could drive a jeep through the girl's ear. But now people seem to like the spirit of it.

Cineaste: *Was it true that you hired a ballet troupe for* The Nun's Story, *for the scenes with the postulants in the convent?*

Zinnemann: Yes, it is true. We needed good faces for the close-ups of the nuns. In terms of the movement of the various ceremonies, we needed people who could respond to rhythm, not just extras who would shamble around. So we did get twenty or thirty people from the ballet, who were perhaps a shade too precise. You know, looking back, I feel critical of the fact that it all looked kind of glamorous. Originally I had wanted to shoot all of them in black and white and have only the tropical scenes in color so that the austerity of Europe would contrast with the bursting tropical fertility of the African scenes. But I got beaten down on that—win some and lose some. At least one could argue with the studio boss about it.

Cineaste: *I was struck by the last scene, where Audrey Hepburn finally leaves the convent. The camera stays inside, so there is less of a sense of triumph than had the camera been outside.*

Zinnemann: We had a very good composer, Franz Waxman, who wrote good music for the ending. I did not want to use it, and he was very upset, so we finally had a meeting with the head of the studio, Jack Warner, who was a good showman. He said that every Warner Bros. picture had music at the end. I said that if the music was upbeat, would it not that suggest that Warners was congratulating the nun on leaving the convent? So we won. I always wanted her to go out in total silence, with just one bell at the end when she goes round the corner.

Cineaste: *In the recently published* Sight and Sound *dossier, a letter from you to Harry Cohn was published, in which you suggested that the release of* From Here to Eternity *be delayed in Europe. Can you explain why you wrote that letter?*

Zinnemann: You would not believe it, but at the time Americans were loved in Western Europe and were looked upon as the saviors who had gotten rid of the Nazis. I felt that showing a picture like *From Here to Eternity* in Europe would damage this euphoria. Cohn didn't understand the point, and, in any case, the film was making a lot of money for Columbia.

Cineaste: *What impressed you about Emeric Pressburger's novel, which became* Behold a Pale Horse?

Zinnemann: Thinking about it now, I cannot tell you. The film didn't really come together, and the book didn't either. At the time I could not find any other projects that I wanted to do. But I was not very happy about it, except that some of it was interesting to make. I met a lot of people who had been resisting Franco, many anarchists who had left Spain and were living just across the border so they would not lose the smells of their country. Many of them were in Perpignan. It was interesting, but it did not really feel right except in a few spots. There were one or two of my pictures that were like that.

Cineaste: *How did you plan the visual style of* A Man for All Seasons, *and the very strong sense of the distance between Chelsea and Hampton Court?*

Zinnemann: There were a few technical problems. There was no place we knew of that had the right kind of house and a river, all in one. There is a scene where the king jumps from his boat into tidal mud, so it had to be a tidal river. You had to find a time when the tide was out and the sun was at the same time in the best position for photography. That gave us one or two days a year. All the river mouths in England are full of modern shipping and modern architecture, so we had to find part of a river that looked pristine.

Somebody discovered a place near Southampton where the owner had the rights to the river. So we rented the location, which was usually a kind of garage for yachts, for five or six weeks. At the end of that river we built a wall, and then we built the same kind of wall in Oxfordshire, where there was an Abbey we could use. So in the film the king would climb the wall in Hampshire and descend from it in Oxfordshire. It is nice to have a challenge like that.

Cineaste: *How do you remember working with Orson Welles?*

Zinnemann: It was totally unpredictable, but a lot of fun. He had a great sense of humor. We made Cardinal Wolsey's room very small on purpose, so you felt that there was not any oxygen in it, that he took it all up. The art director, John Box, did a brilliant job. Everything was in red, the Cardinal and the walls, and he sat there, big and fat, looking totally unlike Wolsey, but it really didn't matter. In addition, for research, having the Holbein portraits of all these people was terrific. We did not use all the details because it would have cost too much, and anyway people would have been watching the costumes instead of the actors, which is a great danger in costume pictures.

Cineaste: *When you made* The Day of the Jackal, *how important was the characterization of the Jackal? Was it important, for example, that he be an upper-class Englishman?*

Zinnemann: Not all that much. The important thing was to have a man who can become invisible. There was nothing special about him, so he could be one of the crowd. If you had a big star, it would have ruined the whole movie. This was part of a long battle I had with the studio, who wanted a star. There were several stars who wanted to be in it, but then the film would have become a vehicle for the star, and that was not the story. Edward Fox happened to be sort of upper class, but that was not mandatory.

Cineaste: *When Robert Shaw, as King Henry VIII, emerges out of the sun in* A Man For All Seasons, *was that an image you planned?*

Zinnemann: It was the idea of Robert Bolt, the writer, who always wanted to get the feeling of him coming out of the sun. There is one thing that maybe should be said about the director. Basically he takes the script and brings it to life. It comes up in arguments about who is the author of a film. David Lean said that the author of the script is the writer, the author of the photography is the

cameraman, and the author of the editing is the editor. They are all associate authors, but the principal author is the person who puts it together and makes it come to life. No one else can do that, certainly not the producer. Legislation which suggests that the person who finances a film is the author is ridiculous. Billy Wilder is the author of his films, not Paramount!

There are going to be many battles fought over this, because the financial boys want to be the authors. In America they managed to remove the clause stipulating moral rights of authorship from the Berne Treaty. It is a very important question, and, unless it is resolved eventually in favor of the director, you will always have films like *"Terminator 26,"* without imagination, and with a colossal amount of money wasted, with half of it not visible on the screen. We were trained to try and see the biggest part of the dollar on the screen. Some of these old Hollywood proverbs were pretty wise. Another was that you meet the same people going down as you met going up. It was a great life, I must say, and it is now totally different. There is a tremendous amount of talent, but there is a very worrying lack of what I have to call soul, because I cannot call it anything else.

Cineaste: *Did you have disagreements with Lillian Hellman over* Julia?

Zinnemann: Lillian Hellman wrote a book called *Pentimento*, with chapters which supposedly dealt with her life. In a short story called "Julia," she wrote about a woman she knew and had helped in Germany, which was not true. Lillian Hellman in her mind owned half the Spanish Civil War, while Hemingway owned the other half. She would portray herself in situations that were not true. An extremely talented, brilliant writer, but she was a phony character, I'm sorry to say. My relations with her were very guarded, and ended in pure hatred.

Cineaste: *You were very disappointed not to make* Man's Fate *in the late Sixties. Why did the project collapse?*

Zinnemann: There were many reasons for that. A couple of weeks before filming was to begin the studio changed hands, and they were in very bad shape financially. It was a panic situation, and they had to cut loose several productions. They asked me to cut the actors' salaries, but I refused. Then, two weeks before filming was to start, I got a cable saying that the picture had been canceled. I suppose they could not do anything else under the circumstances. I tried to sue MGM on behalf of the creditors, and I don't think that they got their money. I feel badly about that to this day.

Cineaste: *Are you pessimistic or optimistic about the cinema as you have known it this century?*

Zinnemann: I would like to be optimistic, because we have brilliant directors and writers and actors, but I tend to be pessimistic. We have enormous powers of persuasion, and we are role models for the rest of the world, but we no longer have a positive attitude towards life. Until that is changed, I think it is not going to be good.

My own credo is borrowed from the words of William Faulkner, who expressed them in his speech when accepting the Nobel Prize in 1951, and which have stuck in my memory ever since: "I believe that the human spirit will prevail forever. It is our privilege to help it endure by lifting people's hearts, by reminding them of Courage and Honor and Hope and Pride and Compassion and Pity and Sacrifice, which have been the glory of their past."

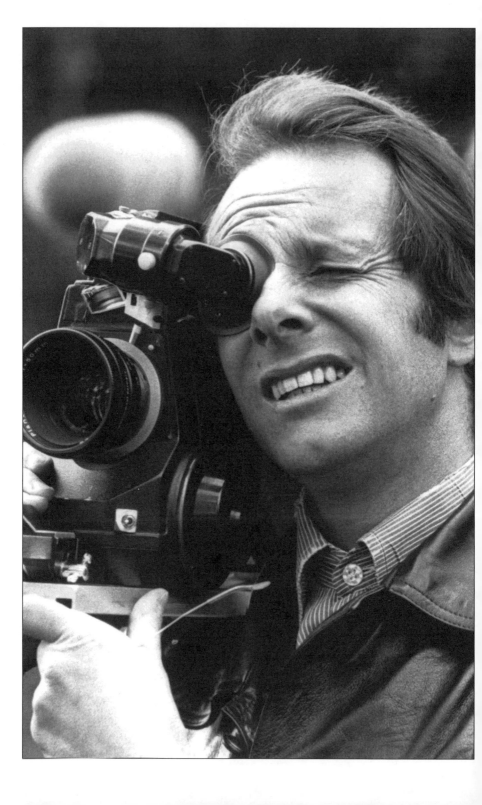

25 KEN LOACH

The Revolution Betrayed

Ken Loach, unquestionably one of Britain's most important filmmakers, is best known for his gritty and compassionate portrayals of working-class life. Early in his career, a series of socially conscious BBC films established the fact that Loach was both a skillful artist and a crusading social critic. Cathy Come Home *(1966), an accomplished blend of fictional and documentary techniques, was one of his most successful—and controversial—early efforts. Although Loach occasionally returned to television (the even more controversial* Days of Hope *[1976] was a landmark BBC miniseries), he subsequently moved on to feature films, most notably* Kes *(1969),* Family Life *(1971), and* Ladybird, Ladybird *(1994), that are justly regarded as milestones of British social realism.*

Following the American premiere of Land *and* Freedom *(1995) at the 1995 New York Film Festival,* Cineaste *Editor Richard Porton spoke with Loach by phone from Nicaragua, where he was on location for his next film,* Carla's Song, *a political thriller which takes place during the Sandinista/Contra war of the late Eighties.*

Cineaste: *Was* Homage to Catalonia *the departure point for Jim Allen's screenplay for* Land and Freedom?

Ken Loach: It wasn't exactly the departure point, although obviously it's a very important book. Several books were very important, and that was one of them. We also looked at a book called *The Red Spanish Notebook* by Juan Bréa and Mary Low, two kids who were there. In addition, we looked at Gabriel Jackson's study, Victor Alba's history of the POUM, and Hugh Thomas's *The Spanish Civil War*. We also talked to a lot of eyewitnesses to fill in the details. The story of the Spanish Revolution is part of the folklore of the left, so it's always been in the back of our minds to do something about it.

Cineaste: *The subtitle of the film—"A story from the Spanish Revolution"—is key, since, although documentary films have dealt with these events, fiction films have generally not dealt with the betrayal of the left by the Communist Party.*

Loach: We were very concerned with this. We put the subtitle in because, immediately, from the start of the film, we wanted people *not* to start thinking of the Civil War but to think of the social upheaval as well. Part of the mythology of the war is that the left was united against fascism. Another part of this mythology is that all of the so-called democratic countries were against fascism. Both those things weren't true, as we now know.

Cineaste: *Would you talk a bit about your collaboration with Jim Allen on the script? I understand that the flashback structure wasn't originally part of the script.*

Loach: The film took a very long time to develop. We started with a very broad canvas. The story just kept breaking down. All the effort was to find a set of relationships that would put the political conflict into a personal framework. There's no use making a film where everything says the "right on" thing when you have no personal drama. It took a long time and many false starts to find a group of people and conflicts which would mirror the political conflict. We tried very hard not to make it seem like a mechanical acting out. We wanted it to be an emotional story as well, with people who had the limitations as well as the hopes of their times.

Cineaste: *How many drafts did the script go through?*

Loach: Hundreds, I would think. I couldn't tell you. It just kept evolving. And it was evolving while we were making the film.

Cineaste: *How did you decide to make the character of Blanca an anarchist? Was it thought that there should be some representation of the anarchist position in the film?*

Loach: Yes, partly that. There was also the fact that a lot of the women we talked to in Spain were anarchists—terrific people, particularly in Barcelona. One woman who, at least until a year ago, was operating a stall in the Barcelona market, told us about fighting on the front with her boyfriend. We didn't want everyone to be stamped out of the same political mold. We wanted to reflect the confusion of the time and all the varied personal stories, because a lot of it was

haphazard and people ended up fighting along with others for merely accidental reasons. It all happened in a great hurry where everyone rushed off to the front.

In some ways, it was chaotic. But it was also a great, spirited, popular movement. And, of course, Blanca goes along with the POUM because of her boyfriend. I know a man who lives near me in England who went and fought for the POUM. He was very young—seventeen or eighteen—but he just went because he had a good heart.

Cineaste: *Is Jim Allen's position close to the POUM?*

Loach: Well, that was, in general, the position we identified with, since they were anti-Stalinist Marxists. I hesitate to use the word Marxist, because it can be used as a kind of weight around your neck. They don't see the film, they just see the label. So I try to avoid using the word. People think they know what you mean, but they hang you before they see what you have done. In a way, what concerned us much more than the finer points of the politics was the great amount of human spirit, energy, and potential that was betrayed. Those people had enormously affirmative, heartwarming qualities. People were brave and strong and full of ability—that's the optimism, and the tragedy, of the film.

Cineaste: *These qualities are especially evident in the sequence dealing with the collectivization debate. How was this sequence planned? I understand you used a mix of professionals and nonprofessionals. This is one of the film's high points.*

Loach: Well, I hope so. It was a question of finding people who still felt passionate about this issue. Spain's still quite a political place—Franco at least did that. He was quite politicizing. You can find anarchists who still have a very strong position. It was very possible to find people who were full of passion from the nearby town. All the villagers were nonprofessionals, with the exception of the guy who chairs the meeting and the man who is the main opponent of collectivization. He was an actor, because I needed someone who had a bit of grit, to get something going. All of the positions taken by the actors did correspond to their actual positions, except for Tom Gilroy, the actor who plays Lawrence. We didn't want to make him a caricature but to make his position against revolution as strong as possible. What was very important was that we didn't want to undervalue this argument. It was an honest dilemma, so we wanted to entrust that argument to someone who was an honest and intelligent person. And, ideally, the audience might go along with him for a time. It's quite good if, at the end of that debate, some of the audience is with Tom.

All the time it suits the purposes of our politicians to talk about how cynical people are, how they don't like politics, and how things will never get any better. It suits the status quo to say this because it leaves power in the hands of the people who already have power. Nobody gets challenged. The more this myth of cynicism and just look after number one and don't care about anyone else is perpetuated, the more people lose power. The more you can say, "Look, people have great potential," the more volatile things will get.

Cineaste: *Would you say there are parallel themes in some of your other films written with Jim Allen, particularly* Days of Hope, *which deals with an analogous betrayal of the left during the 1926 British general strike?*

Loach: Well, yes. It's obviously a common theme. I think it's the story of the century, really, that there is this great force which is capable of change but it doesn't always lead to something effective. There are other similarities, of course, such as the question of fascism, although it didn't call itself that in Britain. But there was the need to undermine workers' organizations. And there's the support for fascist regimes when they can deliver a compliant working class or deliver a convenient space for the placement of Western capital. You don't have to look much further than America to see that. So there's this hypocritical claim that the West is democratic, when it's only encouraging fascism to do the work that democracy can't do.

Cineaste: *Did you talk to many of the POUM veterans?*

Loach: Yes. There were a few memorable days when we went round many of the battlefields with a man named Joan Rocabert, who had fought with the POUM. He took us around to many of the actual places where he had fought and told us exactly what had happened. He was an extraordinary man, and what he told us was very vivid. Much of what we recounted in the film had actually happened to him. He was arrested a few miles away from the front by the new detachment from the Popular Army. That was very dramatic—or should I say traumatic—for him. After we had taken that journey, we incorporated many of his experiences into the film. This was a great help, especially with the last scene.

Cineaste: *And of course we now realize that the Soviet Union was behind the purge of the left.*

Loach: Yes. There were orders from Moscow. It was the time of the purge trials. The same line used to go after the POUM was used against Trotsky and the Old Bolsheviks. It was exactly the same language and around the same time; the Moscow trials were in 1936. This was the Stalinist way of dealing with opponents.

Cineaste: *Of course, the odd thing about the POUM was that, although labeled "Trotskyist" Trotsky himself was quite critical of them.*

Loach: Yes, and they were critical of him. Although, perhaps they had more in common with Trotsky than they were prepared to allow. They both represented anti-Stalinist Communism. The epithet of "Trotskyism" is also used in Britain against anyone who is a militant or a radical. It is a term of abuse which has stuck for sixty years; it's rather ironical.

Cineaste: *Was there a conscious attempt to construct affinities between what is happening in Britain today and the situation in Spain during the Thirties?*

Loach: No, not really a conscious attempt. We just tried to tell the story as directly as possible. We just tried to pare it down to the bone—to inform the audience of the struggle for people to take power and the political forces that opposed them. If there is a pertinence to the British situation, we shouldn't talk

just of Britain but of the whole Western world. The issue today is all about democratic control of resources, democratic control of capital. That's a demand which can't go away, because we're driving civilization over the precipice. The drive for production and new technologies are increasing poverty, unemployment, and over-production. It's an accelerating spiral; control is in the hands of the big corporations. It's even beyond anybody's control, beyond the state even. The multinationals are operating according to the laws of their own markets. So the question is: Who controls? Who controls land and technology? Who controls markets?

Cineaste: *I've heard about screenings of the film where people who fought with the Abraham Lincoln Brigade have had heated arguments with those who espouse the POUM position.*

Loach: People who fought with the Abraham Lincoln Brigade have a huge emotional investment, like all of the veterans of the international brigades. In many cases, their lives have been based on what they did in Spain. So it's very reasonable for them to disagree and find fault with what this film is about. That's OK. As Jim Allen says, they were the cream of their generation. The last thing we would want to do is not acknowledge and admire what they did.

Cineaste: *I read that Santiago Carrillo, the former head of the Spanish Communist Party, attacked the film.*

Loach: Oh, yes. He wrote an article, but his criticisms weren't as strong as I thought they would be. Basically, he reflected some of the arguments used in the film—the POUM were irresponsible adventurists, and so on. He thought that the people who talked of revolution at the time were splitting the left—you know, the usual arguments. I don't think they can now assert that the leaders of the POUM were fascists. I think they now have to admit that this was a terrible lie. It did make a good discussion in Spain between Carrillo and the general secretary of the POUM. They battled it out; that's OK. The response from people in the international brigades has been varied. Obviously, some of them have been quite antagonistic, but others have been very supportive. They're all very old now. The important thing is not to let it be merely an argument between old men. That's fine, but there are more important things involved than digging over the fine print of the politics of '36.

Gary Crowdus founded *Cineaste* in 1967, while studying film production at New York University, and he has headed the editorial board ever since. He was an associate editor of the now defunct *Film Society Review.* He has worked in film and video distribution with The Tricontinental Film Center and Unifilm (1968-1972). He is presently President of Distribution at The Cinema Guild. He is the editor of and a contributor to *A Political Companion to American Film.*

Dan Georgakas has been an editor of *Cineaste* since 1969 and is coeditor of the first *Cineaste Interviews, In Focus: A Guide to Using Films,* and *Solidarity Forever,* a historical text based on the film *The Wobblies.* He also is coeditor of *The Encyclopedia of the American Left,* co-author of *Detroit: I Do Mind Dying,* and author of *The Methuselah Factors—Strategies for Longer Life.* He currently teaches media, ethnic studies, and history courses at New York University.